Mass Violence and the Self

Mass Violence & the Self

FROM THE FRENCH WARS OF RELIGION TO THE PARIS COMMUNE

Howard G. Brown

CORNELL UNIVERSITY PRESS

Ithaca & London

First published 2018 by Cornell University Press

Printed in the United States of America

Library of Congress Cataloging-in-Publication Data

Names: Brown, Howard G., author.
Title: Mass violence and the self : from the French wars of religion to the Paris Commune / Howard G. Brown.
Description: Ithaca : Cornell University Press, 2018.
 Includes bibliographical references and index.
Identifiers: LCCN 2018014899 (print) | LCCN 2018017113 (ebook) | ISBN 9781501730702 (pdf) | ISBN 9781501730726 (epub/mobi) | ISBN 9781501730610 (cloth : alk. paper)
Subjects: LCSH: Violence—France—History. | Political violence—France—History. | Psychic trauma—France—History. | Collective memory—France—History. | Identity (Psychology) —France—History. | Group identity—France—History. | Self (Philosophy) —France—History.
Classification: LCC HN440.V5 (ebook) | LCC HN440.V5 B78 2018 (print) | DDC 303.60944—dc23
LC record available at https://lccn.loc.gov/2018014899

CONTENTS

Plates follow page 132.

ILLUSTRATIONS

FIGURES

Plates (following page 132)

ACKNOWLEDGMENTS

Intellectual debts are even harder to repay than professional ones. What is the currency of remuneration for intellectual stimulation? Outside of reference notes, I can think only of acknowledgments such as these and hope that they have not lost their value due to steady inflation. Reading Charles Taylor, *Sources of the Self: The Making of Modern Identity* (1989) for intensely personal reasons in the early 1990s planted an intellectual seed. That seed received little attention and no academic watering, however, until more than a decade later, that is, until I read Dror Wahrman, *The Making of the Modern Self: Identity and Culture in Eighteenth-Century England* (2004). At the time, I was finishing another book and was starting to work on visual representations of revolutionary violence in the period I had just written about, that is, the first decade after the overthrow of Robespierre in July 1794. My initial interest was in discerning how images that served the purposes of propaganda gradually gave way to more contextualized, and thus more historical, alternatives. The rare and beautiful *Tableax historiques de la Révolution française* in the complete edition of 1804, which I discovered at the Carl A. Kroch Library at Cornell University, offered ideal material for such a project. It also led me to the superb study of an earlier set of historicizing prints from the French wars of religion, Philip Benedict, *Graphic History: The "Wars, Massacres and Troubles" of Tortorel and Perrissin* (2007). Extending my search for similar work on later periods led me to reread Robert Gildea, *The Past in French History* (1996) where I found new meaning in his interpretation of the relationship between the Paris Commune and the formation of the working class in France. Finally, Jeffrey C. Alexander, Ron Eyerman, Bernhard Giesen, Neil J. Smelser, and Piotr Sztompka, *Cultural Trauma and Collective Identity* (2004) convinced me that the concept of psychological trauma offered a powerful analogy for collective responses to major episodes of human suffering, notably events of mass violence. These works are in no way responsible for the heuristic framework adopted for this project, but they should be recognized for inspiring scholarly creativity and a search for better understanding.

Essential inspiration also came from interacting with colleagues, especially in the context of presenting my evidence and interpretations publicly. I am

deeply grateful, therefore, to the kind and generous colleagues who invited me
to present papers at (in order of appearance) York University (Canada), the Uni-
versity of York (United Kingdom), the University of Connecticut, Vanderbilt
University, Cornell University, the Center for Medieval and Renaissance Stud-
ies at Binghamton University–SUNY, the University at Buffalo–SUNY, Brandeis
University, the University of Leicester, Princeton University, and the Smithso-
nian Institution, Washington, D.C. Powerful intellectual stimulation also came
from presenting papers at conferences, notably at regular conferences such as
the Biennial George Rudé Conference, the Consortium on the Revolutionary
Era, the Society for the Study of French History, the Society of French Histori-
cal Studies, and the Western Society for French History. The personal and pro-
fessional sustenance provided by such gatherings would be hard to overstate.
Though I could not name all of the people who gave insightful commentar-
ies, asked provocative questions, or offered perspicacious remarks, they had a
powerful collective effect on this project. Others who were even more engaged
I am able to name: David Bell, Jeffrey Freedman, Yair Mintzker, and Liana Vardi
helpfully read at least one chapter each, as did about a score of participants
in the Old Regime Group in Washington, D.C.; Steven Englund and Jonathan
Karp both graciously read the full manuscript in a late draft and engaged in
prolonged discussion of it. Readers' reports also proved highly valuable in help-
ing to clarify both my aims and my claims. Diane Butler has been even more
closely involved with this book. Not only did she help to infuse the project with
the expertise of an art historian, she listened carefully to innumerable passages
that had little or nothing to do with images. She also patiently endured tedious
obsessions, understanding that scholars must pick a few nits from time to time.

Professional support also takes financial forms, and my research has bene-
fited greatly from a series of research grants, supplemental travel awards, and
a publication subvention (to cover the cost of the leaded-pages insert) from
the Dean's Office of the Harpur College of Arts and Sciences. Binghamton
University also granted me two leaves for professional development. These
leaves were especially useful because they each came attached to a semester
of leave after three-year terms as chair of the history department; these two
well-spaced years of release from academic duties prevented this project from
falling victim to other commitments. Being able to combine money with time
allowed me to consult numerous libraries and archives where staff members
repeatedly offered helpful expertise. I am especially grateful to Ms. Véronique
Fau-Vincenti of the Musée d'histoire vivante (Montreuil, France) who sup-
plied me with precisely the images I needed after a planned trip to Paris had
to be unexpectedly canceled. Finally, Marc Newton, of the Department of Art
and Design at Binghamton University, expertly adjusted all the digital images
that I had taken myself in preparation for their publication herein.

A Discourse on Method

This book investigates personal and collective responses to four periods of mass violence in France from the sixteenth to the nineteenth centuries. In particular, it tries to assess how representations of those events influenced collective identities and the growing salience of the self. The recounting of the actual events will be limited to those elements deemed most relevant to an exploration of the psychological impact they had on the people who lived through them. Rather than try to recover the experiences of victims of violence, however, the purpose is to examine how suffering due to mass violence was communicated to individuals who were not directly victimized and to explore the broader cultural reactions that such representations generated. Special attention is paid to visual images. The four incidents of mass violence chosen for this study varied considerably in form and scope. They took place during the wars of religion (especially the Saint Bartholomew's Day massacres of 1572), the Fronde (especially the crisis of 1652 around Paris), the French Revolution (especially the Reign of Terror of 1793–94), and the Paris Commune (especially the "Bloody Week" of May 1871). In each case, the focus is on the earliest textual and visual representations of mass violence and personal suffering, notably those conveyed by novel media ranging from printed engravings and mass-produced pamphlets to illustrated newspapers and collodion photography. These four episodes had profound effects in their own right, but they also serve as proxies for other incidents of civil strife during these three centuries.

Due to their sheer intensity, incidents of mass violence offer promising subject matter for an analysis of psychological responses. Historians are generally wary of engaging psychology per se. They seek to explain the actions of individuals in the past in terms of their motives and passions, but tend to be uncomfortable with behavioral models. For a time, some scholars thought that psychohistory could offer new biographical insights, that is, until Freudian schemas fell from favor. However, a recent interest in the history of emotions has encouraged some historians to expand

their horizons to include elements of psychology and even neuroscience.[1] Such methodological adventurism has inspired the approach of this book, which seeks more to explore and explain than to argue or prove. This book assumes that the emergence of a modern, more interiorized self between the sixteenth and twentieth centuries has been sufficiently proven, but not adequately explained. Therefore, it is hoped that this book will add to that understanding by exploring responses to mass violence and suggesting that these should be included among the many forces that helped to make the self a more prominent part of personal identity. This work is avowedly teleological because there is overwhelming evidence that over the past several centuries in the West, individuals have increasingly based social relationships on forms of personal agency and subjectivity that derive from a more autonomous, interiorized sense of self. Additionally, there is an implicit claim: that periods of mass violence generated certain cultural changes that interacted reflexively with evolutionary changes in the self. Such an approach suggests that during such events, many individuals who did not directly experience the violence reacted to representations of the suffering of others in ways that fostered a more introspective and psychologically articulated sense of individual identity.

To mention psychological responses to mass violence and personal suffering is to evoke the concept of psychic trauma. However, this study is not a history, or even a prehistory, of the concept of psychic trauma, which first emerged in France in the 1880s. Rather, it explores the distinctiveness of different responses to mass violence over time before psychological trauma became the principal framework for understanding the effects of extraordinary suffering. The relationship between mass violence and the increased significance of the self in these three pivotal centuries reminds us that responses to mass violence, even in our own day, are different in societies less imbued with pervasive individualism. As the pace of change accelerated and the array of choices in life grew increasingly varied, individuals came increasingly to reflect upon and to perform their personal identities. Many forces helped to stimulate this more salient self: the Protestant challenge to Catholicism, increased social mobility, new theories of natural rights, increased literacy, urbanization, even consumerism, all played influential roles. This study suggests that reactions to mass violence also acted as catalysts that accelerated and intensified the development of the self. This would seem to be especially true when experiences of mass violence are interpreted and represented in ways that help to generate a cultural or collective trauma. Social and cultural processes of this magnitude impact both collective and individual identities in ways that demand more intensive

psychological processing, thereby helping to generate important elements of the modern self. Before proceeding to the four historical case studies that have been used to explore these complex relationships, however, some conceptual issues need to be addressed and definitions clarified.

Seeing, Reading, Feeling

Self-portraits entered the Western artistic tradition during the fifteenth century in Italy. This development accompanied a spread of mirrors in European society and a novel concept of the artist as a specially gifted creator. And yet, combining the new technology with the new concept did not suddenly constitute the self.[2] Rather, images of oneself become more meaningful when they are compared to images of others, and not just in a visual sense. Observing how others respond to circumstances informs one's response to similar circumstances, to others, and even to oneself. Such observation is most effective if done directly, in person. Indirect observation, that is, having to rely on representations of the experiences and responses of others, depends heavily on effective representation. This effectiveness derives from the power of the medium, on one hand, and the credibility of the representation it conveys, on the other. Some pictures are not worth a thousand words, but the cliché that they are expresses the ability of images to encapsulate an event and impact memory. Allegories and caricatures can be powerful framing devices, but they can only perform that role for viewers who already know something about the subject. Even representations of reality, including photographs—the ultimate eyewitness—tend to require captions to elaborate their meaning and give them credibility.[3] Moreover, credibility does not depend on their realism so much as their correspondence with what is believable and, often just as important, what is already believed. What is believed and believable about the responses of others, especially when expressed through representations, requires activating the imagination. Imaging makes imagining easier. Furthermore, if images depict the experiences of others, then imagining their emotional responses to those experiences will involve reflecting on one's own potential responses under similar circumstances. Such thinking underpins empathy, even without face-to-face interactions.[4]

These basic patterns are especially apparent when representations entail emotional suffering. Emotional suffering may be explicitly represented, either verbally or pictorially, or it may simply be assumed on the basis of circumstances. Depicting or describing acts of violence prompts assumptions about human suffering. Knowledge about the context of the violence

will shape those assumptions, as will perceived similarities between viewers and victims. Sharing a similar social identity with others who have suffered due to violence, whether as a mother, a monk, or a magistrate, generally heightens the emotional response. Responding sympathetically to representations of violence inflicted on substantially dissimilar persons depends on imagining basic similarities between oneself and others despite obvious physical, social, and cultural differences. By developing more effective representations of the emotional experiences of others, Europeans cultivated the ability to imagine the emotional responses of distinctly dissimilar persons. The capacity to sympathize with family members, friends, and neighbors thereby expanded beyond parish boundaries and the common limits of social equals.

Cultural historians have thoroughly mapped the emergence of sensibility in the eighteenth century. On this basis, Lynn Hunt persuasively argues that during the middle decades of the eighteenth century in western Europe, various epistolary novels acted as powerful catalysts in an expansion of fellow-feeling. Samuel Richardson's novels *Pamela* (1740) and *Clarissa* (1747–48) and Jean-Jacques Rousseau's *Julie* (1761), for example, were best sellers because they enabled readers to experience vicariously the inner life of characters quite different from themselves. Such novels, therefore, implicitly "made the point that all people are fundamentally similar because of their inner feelings. . . . In this way reading novels created a sense of equality and empathy."[5] Hunt further argues that the resulting ability of readers to identify with characters whose social identity differed radically from their own combined with the growing moral autonomy of individuals to inspire the basic idea of human rights that emerged in the late eighteenth century. Such an approach underscores important changes in the ways in which individual personhood was understood and experienced. Ideas about interiority and the psyche evolved from the Christian soul to the Protestant conscience to the Freudian conscious and subconscious. These concepts inflected the experience of personhood as it changed over centuries, but they only provided part of the fuel for that slow-burning evolution. This book explores how other types of tinder, namely representations of violence and the suffering of others, also helped to form shared identities through empathy and to foster more individualized selves in the process.

In order to explore the impact of representations of incidents of mass violence on shared and personal identities over three centuries of French history, this book relies on two concepts, "collective trauma" and the "modern self," as heuristics that help to stimulate fresh inquiry. They also provide thematic threads to string together disparate historical moments. In order

to avoid burdening the case studies with intrusive conceptual scaffolding, however, the guiding concepts will be developed here first. As noted earlier, the concept of individual psychic trauma first emerged, and then expanded steadily, in direct relationship to the greater salience of the self as inspired by the conditions of modernity.[6] Little has been written, however, about how past events that might be considered collective traumas have also played a part in developing a more modern self because the vast bulk of work on collective trauma has been done in contemporary societies where personal identities are more provisional than in the past.

THE SELF

One's sense of personal identity is the fruit of psychological acts that combine emotion, thought, and volition with socially mediated frameworks of identity. Living in a modern mass society, with its disorienting physical and social mobility, pushes individuals to perform the relentless psychological work of fitting together an unprecedented array of choices in life with the need to feel a sense of belonging. Thus, the psychological work individuals perform in the process of developing their own personal identities as both social projections and interiorized understandings, that is, in defining their "selves," has become an increasingly subjective and constructive task.[7]

This is not to say that only in the recent past have individuals come to understand their identities through introspection. In a foundational essay on the self across time and place, Marcel Mauss asserted that "there has never existed a human being who has not been aware, not only of his body, but of his individuality, both spiritual and physical." However, Mauss also suggested a trajectory of the self based on this universal awareness of individuality growing more complex in response to particular social and cultural changes. He described it as arising from "the innermost depths of our being," gradually evolving "to be made clearer and more specific, becoming identified with self-knowledge and the psychological consciousness."[8] He highlighted the notion of citizenship as developed in the classical world, as well as the impact of Christianity. Together these forged a moral person with a sense of inner life that derived from attending to his or her conscience. Moreover, this moral person, balanced between a civic identity and a conscience, acquired a sacred character with the advent of individual rights. In Mauss's terms, the *personnage* (character) that played the social roles assigned to it evolved into the *personne* (person) that had metaphysical value because of its own consciousness and individual agency. The core of this person is the self, or a form of individual psychological awareness.

Thus, the understanding of the modern, individualized self used in this book begins with three basic ideas about the "modern self" first articulated by Mauss: (1) it is more than a universal sense of individuality; (2) it develops in an evolutionary manner in response to social and cultural change; and, (3) it is a form of consciousness best understood psychologically.

Each of these aspects of the self needs to be developed more fully. First, the sense that all human beings have a sense of physical and spiritual individuality is the basis for the self; however, it is not sufficient to explain the extent to which individuals in modern societies have come to think in terms of both understanding and performing their own personal identities. An analogy helps to reveal the relationship more clearly: awareness of one's own individuality is to the self what trade is to capitalism; capitalism is based on trade, but the increasing financial complexity of capitalism has made it a more pervasive force in shaping social institutions than mere trade alone. The difference between having a sense of individuality and having a sense of psychological identity (a modern self) is of critical importance to this book. It is not the extent of this distinction in any particular person that matters, however; it is an understanding of broadly shared cultural norms that is being sought.

Second, whereas both a sense of individuality and trade are largely time-less and universal, capitalism developed in specific historical contexts, and so too did the self. The self has a history, and a particularly Western one at that. Capitalism derived from changing financial practices (double-entry bookkeeping, joint-stock companies, bond derivatives, etc.); the self developed in response to changing social and cultural practices. Therefore, a history of the self in Western civilization, for lack of better terms, is as unavoidably teleological as the history of the bureaucratic state. Historians who are able to discern expressions of individuality in premodern societies often find these sufficient to begin discussions of the self. Even if such scholars deem certain cultural fragments—household account books, *livres de raison*, *ricordanze*, etc.—to be revelatory of personal identity, they are far removed from evidence of an autonomous, introspective, and authorial self.[9] According to the moral philosopher Charles Taylor, the emergence of the modern self in Western societies is the product of changes in four ways of understanding individual significance based on (1) a sense of inwardness, (2) a sense of what makes daily life worth living, (3) forms of narrativity that stress personal development, and (4) individual agency within a network of social bonds. Historical changes in these four areas have combined, says Taylor, to enable modern individuals to think of having selves in the same way as they think of having bodies. Moreover, the self is perceived to be the core of an individual, the essence of personhood.[10]

The third aspect of Mauss's understanding of the self, that it is a form of consciousness made more understandable by psychology, needs to be examined even more closely. Mauss assumed that ideas about the self helped to make it a distinctively Western experience. This was an unspoken nominalism in which ideas helped to explain experience in ways that actually shaped experience. Charles Taylor's approach is similar, though far more elaborate, in that he too focuses on changes in conceptual thinking. He equates these conceptual changes with changing cultural understandings as well as actual personal experiences. As a result, and despite the breadth of his title, Taylor's *Sources of the Self* is largely an intellectual history of the concept of "self." Some aspects of his intellectual history have been contested,[11] but it remains the most convincing account of what Roy Porter dubs the Authorized Version of the rise of selfhood. This version links Socrates, Augustine, Montaigne, Shakespeare, Descartes, Locke, Rousseau, Hegel, Nietzsche, Freud, Sartre, and other such luminaries in a long chain of Western thinking about human self-awareness. The peak on this upward climb is supposed to be an individual identity based on an authentic, autonomous, and unified "inner self." Such an understanding has spawned such expressions as "being true to oneself," "self-esteem," and "self-actualization."[12] However, in the second half of the twentieth century, deconstructionists, notably Paul de Man and Michel Foucault, began to challenge this narrative of progress, reducing it to an "idle teleological myth, a hagiography of humanism."[13] Such critics consider it delusional to think in terms of an "individualistic self" because we are constituted by semiotic systems, discourses, and cognitive structures of which we are largely unaware and over which we have little control. The self is not a secularized soul, nor the fruit of our own endeavors, they claim; it is neither authentic, nor unified; in fact, it is no more than a ghost, a misleading apparition of individual agency and identity formation. As such, the supposed self is not really an important constituent part of actual individuals.

This postmodern critique of the distinctive self may be gaining support from scientific work on the human brain. Lynn Hunt has drawn attention to the challenges and opportunities historians face in trying to incorporate the latest findings from neuroscience and evolutionary biology.[14] She uses the phrase the "embodied self" to express the idea that studying the physical expression of emotion can provide access to the illusive concepts of mind, consciousness, and self. However, she notes that neuroscientists have not been able to establish any clear relationship between these more abstract concepts. We know that the mind and the body are interactive and interdependent, rather than two parts of a Cartesian dualism, because scientists

are able to identify neural patterns in the brain that clearly provide the basis for mental images and ideas that constitute the conscious mind. To date, however, those images and ideas have only been accessed through personal introspection, not through scientific tools. As a result, both consciousness and a sense of individual subjectivity remain highly illusive in neurological terms.[15]

Despite current limits on scientific explanations for the mind, consciousness, and the self, it is quite possible that the growing salience of the self, understood as embodied psychological processes that provide a personal sense of integrity, continuity, and authenticity, is not so much the result of long-term evolutionary change as it is the fruit of intermediate adaptive responses to complex cultural environments. The basic sense of individuality that Mauss deemed a timeless attribute of all human beings is likely the result of genetic adaptation among *Homo sapiens* living in extended kin groups. Therefore, the more elaborate self that characterizes the modern condition is at most an epigenetic adjustment that has been stimulated by social and cultural forces over a relatively short span of time. Evolutionary biologists have developed the idea of epigenetic adaptation to explain how certain physical and emotional forces, such as prolonged malnutrition or profound anxiety, can lead to inflexible responses to various health challenges for several generations. "Epigenetic processes thus give individuals and populations the capacity to respond biologically as well as culturally to changing historical circumstances and to adapt quickly to new or altered niches in the natural and social world."[16] Such adaptations can produce rapid change in the human gene code among certain populations, as happened with the sickle-cell trait that provides resistance to malaria among individuals of African descent. Such demonstrable biological distinctiveness prompts questions about other forms of adaptation. In short, is the more prominent self that has emerged since the Renaissance at least partly the fruit of such biological adaptations, rather than being wholly a cultural construction?

The interdependence of mind and body becomes especially evident under certain unusual conditions. The cerebral cortex and the brain together process an extraordinarily large amount of neural data obtained from the five senses, the muscular system, and unconscious memory. The brain turns this massive and constant flow of data into a multidimensional model of the body in space, whether at rest or in motion. This "body schema" is a complex cognitive process that operates overwhelmingly at a subconscious level. However, it can also be accessed in a limited way by consciousness. Take for example the phenomenon of the "phantom limb,"

that is, the perception that a missing limb is the source of pain or itchiness even years after being amputated. At first, such responses were deemed to be a psychological problem. More recently, neuroscientists have produced evidence that the sensations associated with a phantom limb (or missing fingers, teeth, etc.) are the result of the brain imposing established patterns on otherwise absent or anomalous signals from the nervous system. The apparent feelings that this produces are subject to conscious assessment, which makes it possible to retrain the brain through visualization exercises. Such knowledge highlights the plasticity of the physical brain in relationship to the conscious mind. One of the bases for this plasticity is the brain's natural function of turning the neural data it receives into cognition. This function sometimes reorganizes inconsistencies in the data it receives in order to make them "make sense."[17] Thus, findings in neuroscience make it possible to imagine that the modern self is an epigenetic response to the changing conditions of modernity that have created something akin to a "phantom village" in each of our minds.[18]

To understand this proposition, we need to appreciate some basic features of social interaction before the Renaissance. Despite widespread and long-standing acceptance of Jacob Burckhardt's notion that the Renaissance established modern individualism, the term itself only appeared in the middle third of the nineteenth century in the wake of greatly increased social mobility and ideologies of citizens' rights. There is reason to pause when applying a term that arose in response to nineteenth-century conditions to those of the fifteenth century. In fact, prior to the great religious upheavals of the sixteenth century, individualism as a defining feature of the social order did not exist. Rather, the vast majority of Europeans were embedded in tightly knit communities in which densely woven social networks based on family, kin, guild, confraternity, parish, village, or neighborhood offered little scope for individualism as a culturally acceptable level of solipsism that took the place of corporate and familial roles and responsibilities. Social positions were highly regulated and personal choices in life severely limited. Having a sense of individuality and even personal agency in some aspects of life did not create the sustained psychological demands that characterize the modern self, however. Moreover, any local consensus about a particular person's character proved exceptionally difficult to alter even over long stretches of time. Personal transgressions—a boy's theft of a butcher's knife or a woman's rebuke of the local priest—were collectively remembered by friends and neighbors for a lifetime or longer. Relying on the repeated rehearsal of one's own memories in order to remain a distinct individual with a unique trajectory through life was not required or

encouraged. "Rather memory was embedded, embodied, *in* social rela-
tions."[19] Living, working, eating, sleeping, trading, worshiping, gossiping,
all done in close proximity to well-known others, produced a face-to-face
familiarity that blunted the possibilities of either individual autonomy or
"self-fashioning."[20] Participating in collective rituals, affirming support for
the same religious and moral principles, and remaining attached to com-
mon sites such as the local church, cemetery, market square, or manor
house gave the vast majority of early modern Europeans a ready under-
standing of who they were in the social order. Friendship and enmity arose
from social positioning based largely on kinship and status.[21] The power of
such community constraints in determining a person's identity did not elim-
inate a sense of interiority: one always had to fit one's thoughts, beliefs, and
motives together with actual words and deeds. Nonetheless, the constraints
of social position, the rhythms and rituals of life, especially rural life, and
the consistency of the sources of information about oneself combined to
make it far easier for individuals to acquire and sustain a sense of personal
identity and integrity over a lifetime.[22] Furthermore, limited access to infor-
mation beyond the community ensured that alternative possibilities rarely
challenged traditional assumptions.

How have individuals responded psychologically to the steady erosion
and virtual disappearance of these tightly knit and highly insular commu-
nities? We know that the social stability they provided has been replaced
by larger institutional structures, especially the regulatory power of the
state. But such alternative institutional arrangements provide little protec-
tion against the emotional and cognitive challenges of not living in a small,
highly stable (even if not static) community. Perhaps, therefore, persons
who have lived in societies with growing levels of both individual freedom
and social anomie have gradually acquired new psychological means of
survival through a form of epigenetic adaptation experienced over several
centuries.

The work of the neurobiologist Antonio Damasio provides a concep-
tual basis for the modern self as an epigenetic adaptation. Damasio has
expanded his work on the neuroscience of emotions into a broad inquiry
into the relationship between the mind, consciousness, and the self. Evo-
lutionary adaptation made human minds ever more complex. In addition
to the basic mental processes needed to maintain biological homeosta-
sis, humans acquired memory, reasoning, and language, thereby making
it possible to create "homeostasis at the level of societies and culture."[23]
Moreover, the pursuit of basic biological homeostasis, as shaped by mil-
lions of years of evolution, has in a matter of centuries been joined by the

pursuit of sociocultural homeostasis to produce actual neurological change across generations. He writes, "the interaction between these two kinds of homeostasis is not confined to each individual. There is growing evidence that, over multiple generations, cultural developments lead to changes in the genome."[24] His working hypothesis is that the self, which he considers distinct from simple consciousness, is a product of both biological and social impulses to achieve homeostasis. He is convinced that even after minds acquired both consciousness and selves, the evolutionary process, possibly stimulated by the demands of self-knowledge, continues to develop the self.

It is no distortion of Damasio's argument to say that the demands of self-knowledge arose from the breakdown of tightly knit communities in which individuals suffered a loss of generally consistent and empathetic social messages about their identity and so needed to reflect more on their sense of identity and personal trajectory in life in order to preserve psychological stability. Such self-reflection organizes consciousness for the purpose of combining "biological homeostasis" with "sociocultural homeostasis." In other words, consciousness is an evolutionary development that optimizes life regulation, and the self is an evolutionary development that uses consciousness to generate autobiographical understanding based on memory and language as well as social emotions, such as empathy or compassion, and other sophisticated means that individuals apply unconsciously to generating sociocultural homeostasis. Thus, on the basis of Damasio's interpretation of his research in neurobiology, it is possible to imagine that the modern self is an epigenetic development best described as a "phantom village" of the mind in which psychological processes provide necessary compensation for the absence of consistency, stability, and innate empathy in the lives of most individuals living in mass societies. Just as the experience of pain or twitching from a phantom limb is the result of neurological impulses repackaged by the mind, rather than psychological defects as previously thought, the modern self may be a phantom village created by highly complicated neurological impulses generated by changes in the human genome that enable individuals to cope with the emotional and psychological challenges of postindustrial, socially fluid, and information-saturated societies.

Given the current state of neuroscience, it is not possible to prove or disprove the existence of this phantom village, that is, to show that the modern self is an epigenetic adaptation that took shape over a few centuries, or, to put it in Damasio's terms, that the self is an increasingly complex means to manage consciousness in ways that help to achieve homeostasis socioculturally as well as biologically under the peculiar circumstances of modernity.

Nonetheless, elements of this concept remain useful to a historical inquiry into the development of the modern self as a *psychological process*. Whether or not neuroscience will substantiate his larger explanation, it is significant that Damasio distinguishes between the protoself, the core self, and the auto-biographical self. He bases the first two on the neural production of emo-tions, which socialization and acculturation turn into specific feelings suitable to specific circumstances.[25] He considers the autobiographical self to be a higher level of consciousness management in which lived experiences are reconstructed and replayed (i.e., remembered) in order to constitute a nar-rative of personal change that connects the past to the present and provides the ability to anticipate the future. Human brains automatically construct such narratives in order to enhance the chance of survival. However, despite remarkable developments in neuroscience, Damasio and his fellow travelers have not proven the existence of a distinct autobiographical self.

On the other hand, historians and literary scholars have plenty of evi-dence that autobiography and the modern self have arisen together. It is only rather recently, in historical terms, that individuals have kept a for-mal record of their life histories. The urban elite began to generate various kinds of ego documents, such as *livres de raison*, travel accounts, and per-sonal journals, during the fifteenth and sixteenth centuries, but autobiog-raphies properly speaking only became commonplace around 1800.[26] The historical emergence of autobiography as a distinctive genre of life writing illustrates the increased need for introspective narrativity as a component of the self in order to constitute a personal identity in a social setting. Liv-ing in a sixteenth-century community meant relying on friends and neigh-bors to maintain a collective narrative about one's own identity over time. As a result, developing a sense of personhood relied less on personal mem-ory. On the other hand, by the time autobiography began to burgeon in the late eighteenth century, the role of local collectivities and social networks in attesting and confirming personal recollections had begun to erode, in some cases rather notably. Some aspects of this social memory-making had been supplanted by bureaucratic record-keeping; however, persons who left their native communities, such as the many thousands of émigrés who fled France during the 1790s, were compelled to rely more heavily on their own internalized memories.[27] The increased effort this required to sustain a personal narrative as the basis for an autobiographical memoir served to enhance a sense of self. The proliferation of autobiographies inspired by the intense and disruptive experiences of the French Revolution conveyed the normalcy of such approaches to life writing, thereby prompting others to reflect more intensely on their own life stories.[28]

Consciously or unconsciously organizing one's own experiences into a narrative of personal development provides a sense of continuity and coherence. At the same time, it helps to constitute the self as a *psychological process*, even while that process is experienced as something like a distinct soul or "the real me." The self as a psychological process, on one hand, and the self as an experience of consciousness, on the other, interact and overlap; the self is both the synthesizer and the synthesis that constitutes personal subjectivity. "Ontologically there may be something illusionary here; experientially there is not," observes David Levin.[29] Thus, carefully elaborated concepts of the self, cultural processes that develop the self, and actual experiences of the self have all changed, and interacted with one another, over time.

All of this confirms two critical points about studying the self. First, external evidence of changes in the self as a psychological process and as an organizing principle for lived experience (cultural history) is much harder to trace than are changing ideas of the self (intellectual history). Second, the search for such evidence is inevitably driven by a teleological understanding of the self as something developmental that is either a phantom village (i.e., the mind's way of representing epigenetic adaptation to massive social and cultural changes that have taken place in the West over the past several hundred years) or a psychological response to these changes that has given the universal sense of individuality an increasingly complex and salient presence in the consciousness of those who live under the conditions of modernity. Acknowledging that the former is highly speculative and beyond our current expertise, we are compelled to turn our attention to the self as a historically generated cultural experience. To do so requires providing a clear definition of the modern self as understood and experienced in the West in late modernity (i.e., the early twenty-first century). Such a definition is more precise than the common, but rather vague, understanding of the self as simply the quiddity of personal identity.

This study is premised on the following understanding: the "modern self" is the product of historical changes that increasingly encouraged individuals to maintain their personal identities through an enhanced sense of inwardness. Such thinking is qualitatively different from simply having a sense of individuality, whether physical or spiritual, and involves the psychological process of sustaining a personal identity. The modern self is a psychological construction that is deemed to be and is experienced as the core of an individual, one that is formed by relating, especially through introspection, one's own thoughts and emotions to the perceptions and expectations of others. The self as a psychological process includes maintaining a sense of personal continuity, coherence, and authenticity across the many

changes and experiences of life. The self arises from the conscious balancing of sincerity and duplicity, as well as of remembering and forgetting. In short, it is both a psychomachy of the moment, an ongoing struggle between interiorized understandings and social projections, and the fruit of a personal teleology as consciously constructed. Finally, as individualistic as the self appears to be, it also depends on widely accepted ideas of how personal identity is constituted.

As noted earlier, there are a number of good conceptual or intellectual histories of the Western self. Some of these, such as that of Charles Taylor, extend the explanation for the growing significance of the self over the past five hundred years to social and cultural forces as well. Despite making concern for suffering and personal dignity important aspects of the self, however, Taylor pays no attention to experiences of violence, threats to life and community, or personal as well as shared victimization, all of which interacted with an increasing sense of an individualized self. Historians have sought to understand how premodern societies defined and responded to atrocity and massacre,[30] but the generation of collective traumas in early modern Europe and their interaction with evolving constructions of the self are topics that have yet to be explored.

COLLECTIVE TRAUMA

The concept of "collective trauma," often called "cultural trauma" or "mass trauma," has been elaborated by scholars in the social sciences and humanities as a means to understand past suffering and its implications for the present. The emphasis is on understanding the ways in which past incidents of mass violence and sustained repression shaped societies and individuals alike. The cultural forces that have helped to give disparate individuals a sense of shared identity are at the heart of this endeavor. It is not surprising, therefore, that the clinical paradigm of "psychic trauma" in individuals has become an important analogy when developing explanations for how social groups, even whole societies, are affected by mass violence. The original concept of psychic trauma has become common parlance, perhaps too common, given how much it has expanded and the extent to which it continues to be debated.[31] Nonetheless, the societal analogy of collective trauma remains heuristically and historically useful.

Europeans had long noticed that individuals who experienced some form of violent shock could become deeply melancholic or even completely deranged thereafter. However, it was not until the nineteenth century that they began to understand and address these consequences in psychiatric terms. Matters began quickly to congeal in the 1880s when medical

researchers developed the first properly psychiatric diagnosis of what was dubbed "traumatic hysteria." The German neurologist Paul Oppenheim originally coined the term "traumatic neurosis" to describe the link between a violent event, such as a railway accident, and unusual mental and emotional responses thereafter. The phrase acquired a more psychological—as opposed to physiological—meaning thanks to the work of Jean-Martin Charcot, Alfred Binet, and Pierre Janet, who investigated cases of hysteria. Finally, Sigmund Freud made psychic trauma an essential element of his explanation for the relationship between mind, memory, and personality. In the process of this research and theorizing, trauma changed from being understood as a somatic response affecting the nervous system to being a largely unconscious processing of a catastrophic experience. Such unusual psychological processing did not correlate directly with the original event and could vary widely between individuals. In other words, researchers came to conclude that it is not the nature of a dramatic event per se, nor even the personal experience of it, that damages the mind; rather, it is a highly subjective psychological processing of the original experience that leads to "traumatic neurosis."[32] This new diagnosis of psychic trauma would have been impossible without a more elaborate understanding of personhood as grounded in the psychological processes of the self.[33]

The concept of individual psychic trauma that emerged in the late nineteenth century became in the late twentieth century a powerful analogy for how social collectives respond to violence and repression. In much the same way that the psychic trauma suffered by an individual is not the direct result of a particular event, but rather of its subjective experience, memory, and subconscious processing, collective trauma is not an automatic response to dramatic events, but the fruit of various forms of personal, institutional, and cultural mediation. In other words, a collective trauma is more than mass suffering. Rather, it involves communicating the experiences of victims of mass violence so effectively to those who did not suffer from the original events that they nonetheless feel that their own sense of identity is altered, thereby significantly restructuring social relationships. As Jeffrey Alexander explains, "cultural trauma" (his term for what is dubbed here a collective trauma) is a social process "that defines a painful injury to the collectivity, establishes the victim, attributes responsibility, and distributes the ideal and material consequences. Insofar as traumas are so experienced, and thus imagined and represented, the collective identity will become significantly revised."[34] The component parts of Alexander's explanation provide a useful guide for inquiring into cultural responses to episodes of mass violence. Above all, this definition directs attention toward analyzing, first, the

representational elements that generate the dominant narrative of social suffering and, second, the consequences of such a narrative in altering notions of individual and group identities. Moreover, Alexander's approach has the advantage of moving beyond individual trauma and the possibility of it being spread vicariously. In other words, a collective trauma does not depend on an aggregation of individual traumas or even less on multiplying beyond immediate victims the number of individuals who suffer from clinically discernible trauma.[35]

Not only did the language of modern psychiatry not exist until after the events covered in this book, the way in which individuals responded psychologically to cataclysmic events differed significantly from those of our own times. In other words, the evolution of concepts such as "shell shock," "battle fatigue," and "post-traumatic stress disorder" (PTSD) are more than simply signposts in the development of psychiatry as a discipline; they reflect broader changes in the nature of suffering during war. These changes are the fruit of changes in the actual conditions under which soldiers fight as well as in the psychological makeup of modern warriors. Thus, even in the absence of the concept of psychic trauma, a general history of warfare would provide many examples of the psychoneurotic effects of war. However, these usually emerged alongside serious physical problems that soldiers typically faced from malnutrition, disease, and exposure. This combination of adverse conditions makes it difficult for historians to detect the balance between the mental and physical effects of war in the past.[36]

In addition to changing psychological definitions and understandings of trauma, increasing the importance of the self as central to personal identity may have made individuals more vulnerable to psychological suffering.[37] In other words, it is likely that the more important the self is in constructing individual identity and preserving a sense of coherence and authenticity, the more common psychological trauma will be. This reflexive relationship may help to explain why the concept of individual trauma has been subject to ongoing inflation in fields such as clinical psychology and the law.[38] This inflationary trend has been especially pronounced in the field of cultural studies, notably in the work of Cathy Caruth, as well as in a highly dubious strand of psychiatry that promoted "recovered memory syndrome."[39] Various scholars have reacted to this conceptual drift by urging differentiation between the experiences of perpetrators, victims, and bystanders, as both an ethical and historical imperative.[40]

Given this understandable reaction to the exaggerated application of the concept of psychic trauma in the past generation, it is important to delimit its use here. To study the reflexive relationship between personal

suffering and collective trauma requires paying particular attention to victimization—its production via violence, its distribution via public media, and its consumption via the psyche—in specific historical circumstances. Just because individuals have always suffered does not mean that they have always understood that suffering in the same manner. Moreover, "emphasizing the recollective reconstruction of an event over its actual occurrence by no means trivializes the traumatic experience. . . . Rather, it acknowledges the central subjectivity of perceiving and remembering in the psychology *and history* of trauma."[41] The diagnosis of PTSD and the use of phrases such as "a shattered self" are evidence that cultural understandings, and therefore personal experiences—that is, the cognitive phenomenology—of violence have changed dramatically over time. As Joan Scott has noted, "Experience is at once always already an interpretation *and* something that needs to be interpreted."[42] Historical changes in the experience of violence are the result of the interaction between personal tragedies and wider cultural phenomena. This interaction becomes especially dynamic when certain experiences of violence are widely disseminated among members of a particular social group.

Scholars of psychological trauma generally agree that individuals can feel like victims even if they have not actually suffered direct personal tragedy. Sharing a common social, ethnic, or religious identity, or having the sense of belonging to a larger community—an "imagined community," as Benedict Anderson puts it—makes it possible for people to feel victimized without having suffered directly from the source of the trauma. Moreover, communicating the experience of suffering to others can help to forge new social identities. The level of suffering such indirect victims of collective trauma can experience depends on how effectively the original violence and its immediate effects can be communicated beyond face-to-face relationships. As already noted, for a sequence of historical events to be considered a collective trauma does not require that those events include a great multiplication of clinical levels of individual trauma. Nonetheless, it does entail the proliferation of experiences of emotional suffering, insecurity, and sense of loss (rarely fully manifest as severe psychological damage) beyond those individuals who were directly and personally victimized. This proliferation of emotional stress results from interpersonal empathy, which depends significantly on how effectively the original violence and its immediate effects can be communicated to those who did not experience them firsthand. Collective trauma as a concept, therefore, presumes that suffering has been effectively communicated and experienced beyond direct, interpersonal interactions. In other words it depends on mediated communication.

It is important to distinguish between communicating a sense of suffering to members of a community based on face-to-face interactions and communicating suffering to a larger public through various forms of mediation. In the first instance, the audience is in a strong position to assess voice, accents, intensity, anger, tears, and similar expressions of emotion. In contrast, representations of suffering to a larger public increases the likelihood of skepticism. Someone who lacks a natural commitment to the victims may raise questions about their real identities or the authenticity of their suffering.[43] To be clear, however, such mediated communication is critical to a collective trauma; however, it is not necessary for this communication to be so powerful as to distress members of the audience to the point that they experience actual psychic trauma themselves.[44] Rather, collective trauma results from damage done to the social cohesiveness of larger groups. It undermines a sense of community, erodes interpersonal trust, and discredits institutions intended to provide stability and support.[45] As a result, many individuals are left feeling unusually high levels of insecurity, fear, and loss, even when these do not cause debilitating psychological responses.

In short, then, collective traumas are not natural or inevitable responses to large-scale violence. Rather, they are interpreted by individuals who use a variety of institutions and media to represent dramatic and often violent events to others. Those others then become an implicated audience. Thus, collective traumas are culturally constructed in ways that often distort, exploit, or obscure the actual events and personal tragedies from which they are derived. Moreover, a collective trauma depends on numerous individuals experiencing a broadly shared and yet highly personal empathy, as opposed to simple pity or even sympathy.[46] This ability of individuals to empathize with others despite spatial and social distance is a key nexus between collective trauma and the modern self.

Sympathy, Empathy, Compassion

In order to understand how a reflexive relationship between collective trauma and the modern self could develop, it is helpful to distinguish between sympathy, empathy, and compassion. Sympathy derives from an ancient Greek word that originally meant "fellow feeling." When the concept passes through Latin, it becomes the basis for "compassion." A further etymological alteration took place via German, when a term for entering into someone else's feelings (*Einfühlung*) was translated in the early twentieth century using an English neologism: empathy. Sympathy and empathy have frequently been used interchangeably, even in specialized literatures

ranging from philosophy and history to psychology and neuroscience. However, making a distinction between them reveals important aspects of how the self relates to others.

Sympathy is the least precise of the two terms. Its elasticity explains its uses in areas outside the realm of human relationships, such as musicology. Even when used strictly in the arena of interpersonal relationships, sympathy has been stretched to serve as the basis for shared aesthetic taste (David Hume), as the foundation of morality (Adam Smith), or as the mainspring of altruism (Arthur Schopenhauer). Others have eschewed sympathy as belonging to the realm of magic or the occult (René Descartes) or as a weakness that needs to be resisted (Friedrich Nietzsche). Simply to tag with reductionist shorthand the complex ideas of these great thinkers does an injustice both to their theories as well as to the many other profound thinkers who have contributed substantially to the discussion of sympathy. That said, the core concept of sympathy as first articulated by the ancient Greeks is based on a recognition that human beings have an innate ability to respond emotionally to the signs of suffering in other human beings (as well as in animals, fictional characters, and persons already dead). For the moment, it is helpful to preserve this narrower understanding of sympathy, one in which human suffering (and not other emotions or experiences) is essential.

Science has recently confirmed what philosophers claimed as far back as Juvenal: that humankind has a natural impulse to sympathy. The latest research in neuroscience has identified "mirror neurons" that produce electrical impulses in the human brain of an observer of someone else's actions that replicate the same electrical impulses that would result if the observer were actually doing the activity being observed. This applies to observing someone else's emotions as well. "This research strongly suggests that humans are endowed with a variety of cortical pathways that display congruent patterns of stimulation when certain actions, sensations, or emotions are performed or felt and when those actions, sensations, or emotions are merely observed."[47] These "mirror neurons" seem to provide a biological basis for sympathy. They also indicate that sympathy requires less cognition than some of the concepts with which it is often conflated.

Many theorists integrate an urge to alleviate the suffering of others into their basic understanding of sympathy.[48] However, this urge is better defined as compassion, especially in the phrase "pity and compassion." Making a distinction between pity and compassion, like making one between sympathy and empathy, is both historically contingent and contested. Thinkers as influential as Augustine and Thomas Hobbes defined pity in ways that

better fit modern understandings of compassion. Moreover, the "emphatic hendiadys of 'pity and compassion'" was extremely common in early modern France.[49] When expressed alone, however, pity could become tainted with a sense of superiority. It could thus promote condescension and fail to generate the sense of ethical obligation that accompanies feelings of compassion.

In addition to making distinctions between sympathy, pity, and compassion—even though these terms have often been used interchangeably—it is helpful to articulate the distinctiveness of empathy. This also has been attempted, but with mixed results. The distinctions that follow are admittedly not universally shared, but rather derive from following only certain conceptual tributaries to the fluvial debate.[50] For our purposes, sympathy and empathy are both prompted by a combination of biology and culture, but empathy is more complex in that it involves actively imagining the suffering of someone else in ways that combine emotional mimesis and conscious comparisons. Sympathy occurs readily in face-to-face situations. Interpreting facial expressions and body language to discern an experience of suffering (or other emotions such as excitement, joy, or anxiety) in someone else often sparks an "emotional contagion." This emotional mimesis creates communion without thought or precision. On the other hand, if this emotional response is combined with introspection, that is, self-reflection, it can blossom into empathy. "In empathy the self is the vehicle for understanding, and it never loses its identity."[51] In other words, empathy means processing sympathetic responses in ways that preserve, and even enhance, the distinction between one's own personhood and the personhood of someone else. By turning basic, almost instinctive sympathy into empathy, an individual comes to understand and appreciate more completely what it might be like to be the other person who is suffering. In short, empathy is the natural impulse to sympathy combined with imagination and introspection. Thus, empathy is a source of the self because it depends on a thought process that imagines the personal worth and dignity of someone else as, in some basic ways, equal to one's own personal worth and dignity. If and when conceptual precision is helpful, it can be said that empathy springs from sympathy, transcends pity, and inspires compassion.

Moving from sympathy (emotional mimesis) to empathy (self-conscious sympathy) to compassion (desire to alleviate suffering) happens most readily in face-to-face relationships. Completing this trajectory is more difficult when suffering is not witnessed in person but is mediated through texts and images. Similarly, the more similar the other is to oneself, the easier it is to empathize with that person. Should that person remain resolutely an "Other" in which the capital *O* represents insurmountable and potentially

threatening difference, then empathy becomes extremely difficult and compassion rarely arises. In contrast, if the suffering of distant others (even if they are "Others") is communicated effectively, it may stimulate empathy. Thus, the more developed the self is, and the more developed cultural notions of the shared dignity and equality of persons are, the more likely it will be that empathy, and the possibility of compassion that it entails, can be generated by mediated representations of the suffering of others. As we have noted, such responses involve self-consciousness. Therefore, as the self becomes an increasingly salient feature of personhood, the possibility of generating empathy grows despite a lack of direct interpersonal interaction. Broadly shared empathy, that is, an empathic parallel to emotional contagion, requires similar forms of imagination and self-consciousness to be experienced by many individuals at the same time.

The emergence of a broadly shared, even if not deeply felt, empathy is the emotional basis for a collective trauma. This emotional dimension is not directly addressed by Jeffrey Alexander in his effort to define the process of cultural trauma. And yet his model depends on an affirmative answer to the pointed question, "Is the suffering of others in some sense also our own?" If the answer is yes, it is only because we as individuals have responded empathetically to evidence that others have endured considerable suffering and loss. As should be evident by now, such a response promotes self-consciousness. In other words, the increasing importance of the self over time is, at least partly, the fruit of responding to representations of the suffering of others in ways that combine introspection with emotional resonance. This process also has the potential to enlarge the circle of "we." Personal identities then become more strongly based on collective identities that extend beyond communities that are based on direct face-to-face interactions. These collective identities are constituted by sharing responses to suffering. This is how collective trauma and the self develop in reflexive relationship to one another.

Seeking to understand the mutually reinforcing relationship between the psychological dynamic that constitutes the self and the mediated experience of suffering that produces a collective trauma involves methodological approaches that most historians eschew. Nevertheless, the methodological risks taken in this book may help to shed light on one of the most distinctive characteristics of modernity, a characteristic that has even been strengthened by postmodernism, namely, the development of humanitarianism. Historians seeking to explain the origins of humanitarianism emphasize the role of ideas. The idea that feelings of sympathy are innately human goes back to ancient philosophers, but the idea that all of humankind

deserves to be treated compassionately only became commonplace following the Enlightenment. The cultural importance of the shift from merely recognizing innate sympathy to making it the basis for human ethics would be hard to overstate.

Beginning in the late seventeenth century, moral philosophers gradually replaced the overwhelmingly negative view of human nature emphasized by Christianity (as well as Thomas Hobbes) with a more positive view that stressed humankind's innate compassion for fellow human beings. Even many religiously inspired moralists began to argue that God had supplied men and women with "inborn feelings of compassion, sympathy and benevolence as a way of directly guiding mankind to virtue." This "opinion became a virtual philosophical and psychological dogma" during the eighteenth century.[52] The new thinking culminated with David Hume, who explored the workings of sympathy and compassion with particular sophistication. Such thinking enriched the Enlightenment's obsessive interest in the "natural rights" of all mankind. The more sophisticated understanding of sympathy blended with the discourse of natural rights to create a broader concern for all of humanity, thereby offering an intellectual solvent for categories of exclusion.[53] Further steps on the road to "humanitarianism" were inspired by the cult of sensibility that peaked in the late eighteenth century. As many recent scholars have underscored, the so-called age of reason was also powerfully, and perhaps even more pervasively, an "age of feelings."[54] Sympathy, pity, and compassion became the central features of a wave of sentimentalism cultivated by novels and plays, as well as lawyers and philosophers. Expressing feelings of emotional distress, including openly weeping, in response to the sufferings of others provided the basis for a new moral code. In this way, a general concern for humanity combined with a culture of sentimentalism to provide the intellectual and emotional prerequisites for humanitarianism.

Actual humanitarian action, however, only emerged in response to particular issues and crises. These notably included concerns over the physical cruelties of the penal system, the injustices of slavery, and the suffering of victims of mass tragedies. Just why certain issues and events elicited collective acts of compassion, in the form of either new legislation or international relief efforts, while other instances of widespread suffering were largely ignored remains difficult to explain. Certainly media representations played an important role. To be effective, however, these had to resonate with otherwise detached and normally complacent readers and viewers. One recent history of humanitarianism, notable for its balanced approach to the mixed motives and consequences of humanitarian intervention

across borders, highlights the powerful relationship between ethics and self-perception. "While killing, destruction, and unnecessary suffering can give us pause and move us to act, arguably it is when we feel implicated in the suffering that we undertake the emotionally wrenching process of critical self-reflection. It is our behavior and not the behavior of others that unsettles. Humanitarianism is sustained by a particular story that we tell ourselves—that we are good, loving individuals. There are moments when this narrative of the compassionate and loving self becomes impossible to sustain."[55] Being fully aware of the suffering of others and yet doing nothing about it can lead to a crisis of conscience. When such a crisis occurs, it provokes a reexamination of oneself, followed by atonement through an act of sacrifice and a renewed commitment to others. Such an explanation of humanitarian action is clearly premised on the idea that turning personal feelings of empathy into collective acts of compassion requires three elements: (1) the suffering of others to be effectively communicated to those who were not directly victimized, (2) individuals to sense implications for their own sense of self in how they respond to such mediated representations, and (3) for the response to fit with more broadly shared conceptions of moral responsibility toward others, including others who differ significantly from oneself. A historical exploration of the reflexive relationship between the construction of collective traumas and the growing salience of the self helps to explain the development of humanitarianism as a distinctive feature of modernity. Paradoxically, appreciating the intensification of these relationships on a global scale also helps to explain the "compassion fatigue" that faces so many humanitarian efforts today.

HISTORICAL CASE STUDIES

Each of the four cases that follow examines different aspects of the relationship between collective trauma and the self. Although these two concepts and their reflexive relationship to one another inspired certain lines of inquiry in each case, the purpose is not to generate rigorous comparisons between the four historical episodes. On the contrary, the distinctive particularities of each episode of mass violence and contemporary responses to it has led to rather different emphases in each case study. Despite these distinct differences, these four studies ultimately combine to produce something of a general historical trajectory. This arc begins with the role that representations of religiously motivated massacres played in constituting powerful shared identities that extended well beyond local communities; it ends with surprisingly individualized responses to the Parisian slaughter of

May 1871 despite presumed responses to it on the basis of class identities. (This is not intended to suggest, however, that France had its own *Sonderweg* to the modern self based on select episodes of mass violence.) The following descriptions of each case study will help to highlight key observations developed by this approach in the chapters that follow.

First Case: Massacres in the French Wars of Religion. Sixteenth-century France was held together, and only barely, by having a hereditary monarchy, not by any widely shared sense of "Frenchness." Life was largely lived in face-to-face communities in which the self was powerfully constrained by continuous contact with the same persons, places, and cultural practices. The Reformation seriously disrupted these continuities in many communities by offering alternative ways to secure God's grace for eternity. The resulting religious tensions erupted into widespread civil strife, including several notable massacres in 1562. Over the next decade, periods of intense fighting were separated by periods of formal peace based on royal edicts that granted variable forms of toleration to Protestants. Most historians describe these events in terms of two religions confronting one another across the kingdom. What is generally missed, however, is the extent to which open conflict and collective violence served to define and reify religious differences. More specifically, it took repeated periods of intense civil strife to weave the various Calvinist communities scattered around France into a national church that combined both institutional coherence and a psychological sense of shared experience and fellow feeling. Martyrologies played an important role in spreading this feeling, especially once ordinary victims of religious massacres gained an almost equivalent status.

The intensification of Catholic polemic against the "so-called reformed religion" (*religion prétendue reformée*) in the 1560s combined with Calvinist responses on the local level, including public worship and violent iconoclasm, to constitute a robust Huguenot identity. This shared identity was not only generated by emerging institutional structures, whether religious or military; it also resulted from the emergence of an emotional identification between reformers in one community and reformers in other, often distant, communities elsewhere in the kingdom. Huguenots were a minority in most communities in France, even those in which they came to dominate. Their presence, therefore, destroyed the single, more or less unified, community that they had shared with their Catholic neighbors. The emergence of a coherent Huguenot church across France provided an alternative to the loss of a unified and inclusive community at the local level.

Catholic violence against Protestants was an attempt to restore this sense of unity both at the local level and at the level of the kingdom. However,

the greatest outburst of such violence, the Saint Bartholomew's Day massacres of 1572, failed to extirpate the "heretics." The slaughter sharply cut the number of Huguenots, but this resulted more from apostasy than from either violent death or flight into exile. Mass abjurations occurred even where there had been little violence, and certainly no massacre, and are evidence of a collective trauma for Huguenots. This raises questions about the role of personal conscience, especially for so-called Nicodemites who chose outwardly to return to the church while still secretly adhering to key elements of Calvinist theology. For example, how important was communal worship in defining the self, even among Protestants whose theology gave them direct personal access to salvation? Mass abjurations also suggest the effectiveness of communicating the experience of massacre to those who were spared extreme violence. What role might a series of prints, done by Jacques Tortorel and Jean Perrissin, that included depictions of earlier massacres have played in stimulating sympathy or provoking panic among Huguenots? These unusual prints used a range of pictorial strategies for showing mass violence and the emotional response it provoked in victims. Such images not only resonated with the Protestant pamphlet literature of the day, they provided a potential means to stimulate empathy in coreligionists.

Catholics, too, appear to have experienced a collective trauma due to a pervasive eschatological anxiety over failing to purge heretics in their midst. This helped to stimulate a greater sense of shared identity, as revealed by the emergence of the ultra-Catholic League in the 1580s. Numerous processions of hooded flagellants subsumed the lay individual in collective acts of expiation, and sometimes led to violent pogroms. This violence was not unrelated to Catholic images that systematically depicted Protestants as monkeys or mice, thereby dehumanizing them. The church's emphasis on God's immanence in the world, in contrast to Calvinist claims about his transcendence, also made Protestant iconoclasm into much more than property damage; indeed, it was viewed by Catholics as an attempt to murder the spiritual community that extended across generations. They also believed that the destruction of sacred objects endangered their immediate physical well-being by removing sources of protection from natural disasters.

Thus, both Protestants and Catholics in France experienced violence and the reification of religious differences that it provoked as inspiration for more *self*-reflection in determining the relationship between themselves, their local communities, their natural environment, and their God. A greater sense of individual piety was accompanied by a stronger sense

of shared identity. Representations of suffering caused by sectarian conflict made it possible to identify with, and feel empathy toward, others living in distant communities who were not individually identified and, in fact, were largely unknown.

Second Case: The Fronde and the Crisis of 1652. The people who participated in the series of revolts and rebellions that destabilized France between 1648 and 1653, collectively known as the Fronde, never had a common cause, let alone a shared identity. In fact, complex motives, temporary alliances, double-dealing, and overt betrayals characterized the period to such an extent that historians have rarely devoted much attention to broader cultural trends spawned by the civil strife. Most histories of the period are a densely woven web of political intrigue, personalities, and posturing, rendered more confusing by a lack of ideological commitments or even innovative political ideas. These internecine struggles led to the publication of an extraordinary number of pamphlets, some fifty-two hundred in all, dubbed *mazarinades*. Somewhat surprisingly, however, most of them were not actually directed against Cardinal Jules Mazarin, the hated first minister of the regency government. Nonetheless, the vast bulk of them were partisan efforts to tip the balance of the civil war through words. Historians have done sophisticated work on the *mazarinades* as propaganda, ephemeral literature, and evidence of events. They have found that even those not laced with satire, ridicule, or lewd innuendo tend to be factually unreliable. Whether they can be used to study public opinion at the time remains particularly contested. Nonetheless, a certain number of pamphlets published during the Fronde, notably those pertaining to religiously inflected responses to the upheaval, reveal important developments in the area of increased interiority, empathy, and collective responses to the devastation wrought by the civil war in the countryside.

The focus on pamphlets published during the Fronde is essential for two reasons. First, a competitive newspaper market had yet to emerge in France. The only important newspaper of the period, Théophraste Renaudot's *La Gazette*, was the fruit of an exclusive royal privilege. This dependence on government support limited its coverage of the consequences of civil strife. Second, the Fronde generated almost no printed images of violence, destruction, or mass immiserization. Perhaps this is because the thousands of pamphlets produced at the time were intended for a sophisticated elite, and therefore, including crude wood-block prints—the only economical means available—would not have added greatly to their literary force. This lack of images in the *mazarinades* was matched by a surprising lack of etchings or engravings as well. Fifteen years before the Fronde,

Jacques Callot had published a series of eighteen etchings entitled *The Miseries and Misfortunes of War*, thereby consolidating for himself a prominent place in the history of Western art. These were technical masterpieces of the highest order. They were also, more importantly, profoundly humanistic depictions of the violence and suffering produced by the marauding style of warfare that characterized the period. The series of deeply disturbing scenes depicts civilians and soldiers alike as victims of the most brutal forms of collective violence. However, there is no evidence that these images were intended to serve either as reportage on current events or as protest propaganda. The slightly adulterated "third state" of the series may have been published in response to the Fronde, but this is unknown and doubtful. What is known, however, is that, for reasons that are not obvious, there was no spate of printed images to match the torrent of printed words released by the Fronde.

Despite the absence of images of violence, a variety of *mazarinades* did describe the violence and suffering experienced by the rural populace at the hands of ill-disciplined troops, especially in eastern and northern France. In fact, these issues became the focus of an exceptional series of almost thirty pamphlets, collectively known as the *Relations*. These were some of the most widely circulated pamphlets of the entire period. Furthermore, they employed a novel approach to contemporary events, best described as "compassionate witnessing," in order to mount a relief effort for victims of the devastation. The *Relations* proved instrumental in producing an unprecedented wave of charitable activity. This sudden emergence of an early form of Christian humanitarianism had roots in the evolution of baroque piety during the first half of the seventeenth century. Prominent changes had included teachings on the possibilities of lay piety, the emergence of lay religious organizations, including important ones for women, and trends toward more interiorized forms of religious experience. Early Jansenism and new teachings on communion were particularly significant in this regard. Thus, it would seem that the *Relations* proved spectacularly persuasive because their evocative descriptions of the suffering inflicted on civilians, likened by a contemporary to vivid paintings, moved members of the Parisian elite from simple pity to sincere compassion. Thus, the style and overt appeals of this particular series of pamphlets struck an unusually empathetic chord with the elites of Paris, whose previous concern for the abject poor had been strictly limited.

The political crisis of 1652 may also have played a significant part in generating this more positive, active form of sympathy. This possibility becomes more apparent when religious attitudes are restored to the political

narrative. Despite a truly massive intercessory procession of the relics of Sainte Geneviève, the patron saint of Paris, which had been intended to ward off an impending attack, the capital found itself flooded with refugees and then occupied by the Prince de Condé's rebel army. Days later, a *frondeur* mob attacked a major assembly of municipal leaders, setting fire to the Hôtel de Ville and killing a shocking number of prominent officials. This combination of catastrophes seems to have afflicted the *bons bourgeois de Paris* with a collective trauma. Their individual soul searching, a term to be taken literally at this time, seems to have inspired them to rally both to the cause of the rural poor devastated by civil war and to a return to an assertive monarchical order. The implications for the enhanced significance of inward thinking and *self*-conscious identity formation become more readily apparent when prominent pamphlets are analyzed for such attitudes, rather than simply for political thinking or factional alignment. The baroque era certainly perpetuated cultural conventions that strictly limited overt expressions of individualism. Nonetheless, notions of individuality, subjectivity, and authenticity were stirred by the profound civil strife of the Fronde, even as their resolution was framed in religious and collectivist responses prescribed by the cultural norms of the period.

Third Case: The Thermidorians' Terror. "Liberty, equality, fraternity." Each word in this famous slogan from the early days of the French Revolution implied a change in human relationships that would emphasize the individual and enhance empathy for others. Enlightenment ideals might have provided greater impetus for a more individualized self, but it was the actual experience of revolutionary change that had the greatest impact. The effort to reshape the social and political order on the basis of individual rights proved far more difficult than the early revolutionaries initially imagined. Trying suddenly to dismantle the corporative order of the ancien régime and replace it with a secular polity constituted through representative democracy provoked enormous resistance, much of it mounted in the name of the traditional community. By 1793–94, republicans had opted for a variety of measures that combined systematic coercion and mass violence to defeat opposition to the new regime. These measures were accompanied by much tough talk, and even some political theorizing, about the need for "terror" to ensconce the new regime. The key lawmakers who overthrew Maximilien Robespierre in the parliamentary coup d'état of 9 Thermidor II (27 July 1794) quickly characterized the Jacobins' regime as a "system of terror" that had psychologically debilitated millions of individuals. The Thermidorians depicted this "reign of terror" as a bloody and pervasive tyranny that rivaled anything that history had ever known. Thus, what we

now know as the Terror was given its basic shape by the Thermidorians in 1794–95 through a massive and truly unprecedented outpouring of verbal and pictorial representations of extreme violence and mass suffering, all of it perpetrated under the Jacobins' aegis.

However, historians have generally not been careful to distinguish what most French men and women experienced during the so-called Terror of 1793–94 from what they later learned once the period was over. Thus, it was Thermidorian politicians and publicists who turned regional repression into a national trauma. Starting in the late summer of 1794, they navigated a torrent of revelations about various atrocities, notably systematic drownings at Nantes, mass executions by cannon fire at Lyon, and the execution of hundreds by guillotine at Paris, Arras, and Orange. The shocking details of systematic slaughter mixed with a spate of prisoners' accounts that publicized the many personal tragedies generated by the Jacobin tyranny. Revelations of atrocities, which emphasized perpetrators, and accounts of tragedies, which emphasized victims, revived a powerful sentimentalist rhetoric that placed special emphasis on feeling empathy and compassion. These virtues had been essential features of the eighteenth-century cult of *sensibilité* but had been curtailed by a Jacobin emphasis on stoicism and an abstract love of humanity. Thus, contrary to the claims of such scholars as David Denby and William Reddy, the Reign of Terror did not sound the death knell of sentimentalism in France. Such a shift in public attitudes and emotions only occurred after 1795, that is, after the Thermidorians had defined Robespierre's regime as an unprecedented tyranny of mass atrocities and individual tragedies, but then failed to consecrate that understanding through a managed retributive justice that would have punished the leading perpetrators. Instead, a generalized official persecution combined with a surge of vindictive violence turned tens of thousands of Jacobins from perpetrators into supposed victims themselves. They too could now lace their appeals and protests with the sentimentalist rhetoric of innocence and suffering.

The revolutionary upheaval, especially the years 1793 to 1795, spawned thousands upon thousands of personal accounts of public and private conduct alike. These self-justifications, veritable "autodefenses," came in a variety of forms. They were delivered orally before revolutionary surveillance committees or in political clubs, sent to authorities as manuscript pleas for justice or mercy, or printed and distributed for public consumption. Regardless of the occasion, every autodefense constituted something of a partial autobiography. As such, they involved a degree of self-reflection and self-presentation not previously required on such a wide scale and across so

many social strata. Rapid increases in literacy during the eighteenth century and an explosion of newspapers and pamphlets during the French Revolution helped to make this turn toward self-revelation much easier as well. Consequently, by 1795, France was awash in representations of personal suffering, individual injustices, and family tragedies. Rather than try to sort out the disputable conduct of a mass of individuals, the National Convention opted for a blanket political amnesty in October 1795. Only then did sentimentalism truly lose its political power.

The massive infusion of pathos into politics during the Thermidorian period helped to magnify the psychological impact of the violence of 1793–94, as well as to stretch that impact into 1795 and beyond. Repeatedly exaggerating the repression and violence of the Robespierrist regime and amalgamating various sorts of "victims" (ranging from overt counterrevolutionaries to revolutionary rivals) into a barely differentiated mass helped to define the Reign of Terror. More specifically, the organizing strategies, images, and tropes used to represent violence during the Thermidorian period, whether that violence was criminal or political, collective or individual, revolutionary or antirevolutionary, suggests that the suffering of individuals was successfully communicated to create a wider collective trauma experienced by many more French men and women than actually suffered serious persecution under the revolutionary government of 1793–94.

Furthermore, the profound social and political changes wrought by the Revolution, especially replacing a corporative social order with a polity based on citizens imbued with individual rights, accelerated the emergence of a modern concept of the self. This more mutable and more psychologically constituted sense of identity made French men and women both more susceptible to fear and more inclined to empathy. Under these circumstances, individuals who had been victimized by violence came to experience it differently, and individuals who had not experienced it directly developed a greater sense of the suffering of those who had. The result left more people convinced that they had been through a collective trauma. This in turn made them feel vulnerable and unwilling to put their trust in the institutions of the fledgling republican regime. Thus, the Thermidorians' Terror was a recollective reconstruction of events that became a collective trauma experienced at the full range of levels, from the individual, to the community, to the region, to the nation. In that sense, the Thermidorians helped to create a national consciousness of suffering, one that helped to enhance a general sense of belonging to the same nation, for better or for worse.

Fourth Case: The Paris Commune and the "Bloody Week" of 1871. The idea of "psychic trauma" did not exist before the 1880s. Nonetheless, it

probably owed something to the final upheaval treated here, that of the Paris Commune and *la semaine sanglante* ("Bloody Week") with which it ended. Jules Claretie, a leading journalist who covered those tragic events, published a novel a decade later in which he asserted a scientific link between mental illness and civil war. "Not only bodies are killed, but also minds, and thought has its walking corpses," he added succinctly.[56] Moreover, it has recently been argued that the disastrous events of the early Third Republic, together with a gradual medicalization of societal problems, fostered the emergence of a "proto-science of mental trauma."[57] This makes the Paris Commune an appropriate final case study of responses to mass violence before those responses were shaped by modern theories of psychic trauma.

Paris had become the capital of revolution in Europe well before 1871. The Commune put a cap on this sequence, due to both the massive death and destruction that accompanied it and the backward-looking nature of its ideology. Much of the scholarship on the Commune has treated it as a working-class uprising, and the stunned and angry response to it as a bourgeois reaction. This is anachronistic in important ways. Most of the people arrested for participation in the Commune did, indeed, labor for a living, but mostly as skilled artisans who did not have a working-class consciousness or a sense of shared identity. Roger Gould has persuasively argued that neighborhood solidarities provided a greater impetus for participation than did class.[58] However, the basis for neighborhood solidarities needs to be better understood. An exceptionally high percentage of Parisian workers had not been born in Paris, but rather in the provinces or even foreign countries. Moreover, most of the workers who were native Parisians had recently been displaced from the center of the city to the newly incorporated suburbs by Emperor Napoleon III's massive redesign of the city known as *haussmanisation*. These basic facts suggest that efforts to explain responses to the Commune, both for and against, stress shared class or urban identities, thereby missing more distinctive features of Parisian identity formation. What did it mean for hundreds of thousands of men and women, most of them peasants with few skills, to leave the villages and small towns of provincial France, or even other parts of Europe, in search of a better life in a city of almost two million persons? Most immigrants to the city experienced squalor and exploitation, but many others turned opportunity into success. More important, all of these new residents found it necessary to redefine themselves, to create new personal identities, if not wholly, at least substantially. Moreover, Paris could credibly claim to be the capital of modernity. Department stores and indoor arcades, wide boulevards and sculpted parks, all offered unprecedented venues to fashion and

refashion a public persona. These changes had helped to promote the new, and still controversial, notion of individualism. It is worth looking, therefore, at more distinctly individual responses, rather than ones characterized by shared class identities, to discern how Parisians experienced the cataclysmic violence and widespread suffering of the Commune.

Once again, relatively new media served to intensify the communication of violence and suffering. The development of lithographic print-making multiplied the number of copies that could be made and added to the ease of including color. The emergence of affordable illustrated newspapers in the 1860s greatly widened the audience for printed news. Their use of field artists to sketch events almost as they unfolded and the rapid conversion of sketches into detailed and sophisticated wood-block prints combined to provide astonishingly vivid reportage. The rapid advance in rates of literacy, especially in Paris, also provided a market for separately published histories of events, some of which were available well before the thirty-six thousand prisoners could be interrogated or the ruins had stopped smoldering. Though unable to capture motion due to lengthy exposure times, collodion photography added to the proliferation of images that shaped responses to the Commune. These came in the form of individual portrait photos of Communards (many as unidentified corpses), striking images of the ruins of monumental buildings and prosperous avenues, and odd photo-montages that seemed to reenact various atrocities. Just how such an array of unprecedentedly realistic depictions of mass death and destruction may have impacted Parisians, especially the great majority who did not participate directly in the fighting of Bloody Week, deserves attention. It is especially noteworthy that many of the bourgeois who wrote so damningly of the Commune also expressed pity and even empathy for the friends and families of the dead and imprisoned. In fact, within a few months, public attention, which was always led by bourgeois opinion, had turned to the plight of the working poor and how to ameliorate it. The catastrophe of the Commune provoked greater hostility in neighborhoods populated largely by workers than has been generally noted; and its aftermath inspired more compassion from people of all social strata than is usually assumed.

A closer look at contemporaries' immediate responses to the Commune suggests the importance of a more salient sense of individualized self in empathizing with others. It may also help to account for the long-held version of the Commune as a working-class insurrection. Robert Gildea has argued that this is part of a larger "myth," one in which workers, rather than being seen principally as perpetrators of violence, became the victims of bourgeois violence. This reversal of perspectives resulted from a successful

socialist rehabilitation of Communards at the time they were granted amnesties in 1879–80.[59] Thus, it was only when Bloody Week became a collective memory of trauma, in other words, when it became a chosen trauma, that it provided the basis for developing a working-class consciousness in France. This explanation gains greater force from the ambiguities of May 1871. Being able to portray workers as the principal victims of *la semaine sanglante* was made possible, in part, by a general ignorance about who precisely died, how they died, and what happened to their bodies. Although the total number of victims was about eighty-five hundred, or between one-half and one-quarter of long-held estimates, the very fact of having such a disputed number of dead points to great uncertainty at the time. Thus, the myth owed much to the uncertainties that enshrouded the identities and ultimate fate of so many who died during the Commune. The process of individualization also played a paradoxical part. By employing the new collodion photography to identify *fédérés* killed in battle, as well as by staging lavish funeral processions for them, the Commune helped to magnify the personal sense of loss after Bloody Week. Loved ones were either preserved in pictures of mutilated corpses or simply went missing, unidentified and dishonored, buried or burned. Recriminations over the "crimes of the Commune," such as the hasty execution of hostages, including the archbishop of Paris, mixed with personal consternation over the atrocities of the repression.

A vast outpouring of images, whether in illustrated newspapers or cheap hand-colored prints, alongside the rapid publication of a tidal wave of immediate histories and personal diaries, most replete with expressions of horror as well as empathy, made ordinary Parisians feel that they had personally witnessed an enormous slaughter, whether or not they had lost loved ones or even seen dead bodies. Contemporary accounts, including private diaries and quotidian narratives, record emotional responses that are not explicable by class identity. Rather, they take on their fullest meaning when placed in the context of a more pronounced sense of self. The social and cultural conditions of modernity arose in Paris earlier than in most other places; that immediate responses to mass violence there may have reflected and stimulated a more individualized and potentially empathetic sense of self should not be surprising.

CHAPTER ONE

Massacres in the
French Wars of Religion

The Saint Bartholomew's Day massacres of 1572 marked the high tide of religious killing during the French wars of religion. The French regent, Catherine de Medici, had arranged the marriage of her daughter and the king's sister, Margueritte de Valois, to one of the aristocratic leaders of the Calvinist Huguenots, Henri de Navarre, in August 1572 as the basis for a more secure and stable peace between Catholics and Protestants in France. Instead of building a foundation for religious cohabitation in the kingdom, however, the gathering of Huguenots for the wedding celebrations in Paris provided a provocative opportunity for militant Catholics to deal a crushing blow to their political and religious rivals. The resulting slaughter of Protestants in Paris radiated out to more than a dozen provincial towns in the following weeks. The month of massacres sparked by Saint Bartholomew's Day breathed a fierce new life into the religious and political strife that had been tearing France apart for more than a decade.

In addition to prolonging deadly conflict, the events of 1572 proved critical to the construction of collective religious identities in France. The Saint Bartholomew's Day massacres were more than an escalation in sectarian violence; they marked a caesura in the wars of religion due to the profound psychological impact they had on both Protestants and Catholics.[1] This impact was not as straightforward as might be assumed simply by the scale of the violence. The psychological and cultural impact of the massacres of 1572 can be better understood by examining the ways in which information about them was disseminated and apprehended. It took effective communication of the experience of wholesale slaughter to nonparticipants, that is, those who neither witnessed nor directly suffered from the violence, to link individual suffering to larger group identities.

France in the sixteenth century was immense and diverse. Anyone who traveled across the vast kingdom would have been struck by its enormous variety of local cultures, languages, and dialects. Frenchness was an exceptionally abstract concept that had little to do with personal identity for all

but mobile members of the elite. Before such thinking could become commonplace, religion provided the foundation for early forms of collective identity that extended beyond villages, towns, or regions. Shared group identities arose from the delineation and consolidation of distinct differences between Catholic and Calvinist religious beliefs and practices. In contrast to common assumptions, only part of this process occurred before sectarian violence erupted. In fact, much of the process of forming and consolidating distinctive religious identities in sixteenth-century France took place in response to violence experienced directly and indirectly.

The symbiotic process of collective violence and the reification of religious differences encouraged French men and women to identify more strongly with the suffering of coreligionists. Such shared religious identities had to be created strictly in cultural terms. Differences of race, ethnicity, sex, or class are easily deployed as the basis for shared identities. Many other social, economic, and cultural factors may hinder the development of a sense of shared identity along these lines, but the foundational elements—skin color, native language, reproductive capabilities, or wealth and education—are too obvious to be easily hidden or ignored. Such was not the case with differences between Christian believers in sixteenth-century Europe. They shared a common understanding of God as the omnipotent creator of all things, the greatest of which is humankind because the quiddity of every person is an individual soul. They also shared the belief that everyone requires God's mercy in order for the soul to be spared eternal suffering as just punishment for sin. Thus, differences that arose among believers in the middle of the sixteenth century were not inherent from birth; they were largely chosen differences. Moreover, given the fluidity and inconsistency of religious practices at the time, acquiring a distinctive and yet shared religious identity required making such choices repeatedly. The role of violence in determining those choices needs to be underscored. Both actual violence and news about it were critical to developing shared identities beyond local communities. Identifying with the suffering of individuals in distant villages or towns meant feeling pity, and even compassion, for individuals who lived well beyond the face-to-face social world that dominated sixteenth-century lives. Various means of communication, including travelers' accounts, personal letters, sermons, religious processions, iconoclastic expeditions, and partisan pamphlets, all served to propagate, explain, and even incite sectarian strife.

Visual images of religious violence, though little explored, also helped to make the link between personal suffering and a sense of shared identity that underpinned collective emotional responses. Mass-produced images

of religious violence first appeared in France shortly before the massacres of 1572. The sudden emergence of such images contributed to shaping a new religious culture among the Huguenots. Alongside an outpouring of polemical pamphlets and partisan "histories" of the early wars of religion, these images effectively communicated persecution and suffering well beyond the reach of the traditional "social media" of the sixteenth century: sermons, hymns, feasts, and markets. Thus, printed forms of communication helped to magnify the impact of the massacres of 1572 in ways that turned the events into a distinct collective trauma. The psychological effects on Protestants led to a massive wave of abjurations and helped to make the nascent Reformed Church in France more intensely Calvinist. Thereafter, embracing the identity of Huguenot meant accepting the status of a permanent "Other" both in the local community and in the kingdom as a whole. Catholics, too, received a psychological shock from the events of 1572. Among other consequences, the failure of the massacres to extirpate "heresy" served as a catalyst to regenerate Catholicism in France as a religion that both inspired and required greater personal piety. By raising the stakes on religious affiliations and commitments, therefore, the French wars of religion stimulated the sort of psychological processes, such as introspection and fellow feeling beyond face-to-face communities, that underpin a more pronounced self.

The Reformation of Religious Identities

The various movements for religious reform that emerged in western Europe in the sixteenth century, whether branded Lutheranism, Zwinglianism, Calvinism, or even Tridentine Catholicism, reflected a widespread desire for a more intense spiritual experience. The emergence of Western individualism during the Renaissance has often been exaggerated: the vast bulk of Europeans alive in the fifteenth century had neither the means nor the opportunity to refashion themselves in ways that would have surprised their neighbors. Nonetheless, in the early decades of the sixteenth century, the economic consequences of price inflation and the concentration of political authority in princely states combined to loosen the feudal bonds of community. The printing revolution and the spread of literacy to master craftsmen and artisans also left towns less in thrall to traditional social hierarchies. These trends fueled social mobility, whether upward, downward, or sideways. They also brought greater awareness of events elsewhere, including beyond borders and across seas. Uncertainty about the future, both in daily life and in the afterlife, mounted noticeably as well. These various

forces fostered movements for religious reform that could provide both a renewed sense of community and a greater confidence in attaining personal salvation. Thus, by the 1530s and 1540s in France, a significant number of the faithful sought a more intimate relationship to God and became concerned that the traditional church could no longer provide for their spiritual needs.[2]

This search for greater spiritual fulfillment raises the significance of the self. Charles Taylor has noted that the new "reformed religions" of the sixteenth century encouraged a more personalized, that is, more psychologically interiorized, experience of faith. He views this more intensely interiorized religious sensibility as an impetus for the development of the self in Western societies. However, Taylor considers Protestantism in largely individualist terms. He contrasts Catholicism, in which a layperson is "a passenger in the ecclesial ship on its journey to God," with Protestantism, which is not a ship in the Catholic sense and thus has no passengers: "Each believer rows his or her own boat."[3] This may characterize Luther's doctrine of the priesthood of all believers, but it does not do justice to the complex relationship between religious change and the development of the self in the sixteenth century. First, those who opted for reformed religion did not necessarily do so for reasons of doctrinal difference. They may instead have objected to abuses, ignorance, and immorality among the clergy and may not have rebelled against the church had its leaders been quicker to put their house in order. Second, those who responded to the "gospel" did not always do so in order to attain salvation through grace; they may simply have seized an opportunity to register a righteous protest against the established order. The New Testament taught the dignity of each person, even the most humble, in the eyes of God. This message appealed less to the abject poor, those who depended on Christian charity, than to those who had a measure of independence thanks to craft skills, education, or lineage. Religious reform served to consolidate this sense of dignity, and possibly to improve social standing at the same time. Third, individuals rarely acted in isolation, but rather tended to join a reformed congregation as members of a family group, craft network, or seigneurial village. New converts were highly sensitive to the attitudes of kin and community to their religious choices.[4] This sensitivity helps to explain why so many of the people who engaged in alternative religious practices later found them insufficiently rewarding to sustain themselves, especially in the face of serious persecution.

Taylor is not wrong to draw attention to the power of Protestantism to stimulate development of the self: at the core of Protestant teachings stood a novel theology that created a more personal, interiorized relationship to

God. But adopting an alternative theology was not the only way in which the emergence of Protestantism in France created experiences that stimulated the psychological processes of the self. The conflict it generated with the vast bulk of the populace who remained loyal to the church also proved instrumental in fostering more interiorized forms of piety and the formation of religious identity. Moreover, Taylor overlooks the power of increased Catholic piety to generate a more pronounced self as well. The restricted success of Calvinism in France—at their apogee reformed churches attracted no more than one-tenth of the population[5]—indicates that its theology was only one way to respond to the strong expectation of a deeper faith and better assurance of salvation.

Catholicism developed its own reform dynamic in the late sixteenth century. This proved highly successful and eventually predominated in the seventeenth century. But sixteenth-century Catholicism was never monolithic. It remained internally divided, notably over how to respond to the threat posed both to the traditional community and to the unity of the kingdom by religious reformers. Catholics who found Protestants an especially distressing presence developed forms of militancy that also intensified their sense of identity and increased the interiorization of religious piety. Thus, the theology of Protestantism clearly encouraged deeper self-reflection on the part of individual believers; however, outbursts of collective violence that turned into prolonged sectarian conflict exponentially increased the intensity of this self-reflection. Central to this experience was the formation of a distinct religious identity as Huguenots. This identity appears more easily formed in hindsight, centuries later, when "collective identities" have become a conceptual commonplace.[6] As cultural constructions that took shape in a single lifetime, however, turning neighbors into religious "Others" did not happen easily. Emerging religious identities derived in significant measure from the ability to communicate the physical suffering of coreligionists to fellow believers who may not have personally experienced violent persecution. Not equally, but no less importantly given the size of the population involved, was the intensification of Catholic piety in response to the prolonged presence of Huguenots in France.[7]

What did it mean to be a "Huguenot" in the middle third of the sixteenth century? To what extent did reformers in Toulouse share affinities with reformers in Troyes? How much did they know about one another? What basis did they have to empathize with distant coreligionists? Such questions provoke complicated and ambiguous answers, especially before the Saint Bartholomew's Day massacres of 1572. Scholars rarely emphasize the fledgling nature of the so-called reformed religion at the start of the

French wars of religion in 1561–62. Most histories of the conflict have been written as if a unified and doctrinally fixed Protestant Church existed across the kingdom by 1561. This is quite misleading. "Confessional schemas did not really operate at the time: the frontier was drawn very progressively," states Thierry Wanegffelen; "in order to explore it, the traditional confrontational vision must be abandoned."[8] The differences between the many pockets of heterodox reform that sprang up like mushrooms after a rain are difficult to identify due to their often clandestine nature. As one would expect from any sudden surge in religious experimentation, the various strains of Protestant Reform in France lacked both unity and uniformity in the early 1560s.

Even the scale of conversion to Protestantism has been much exaggerated. The oft-repeated claim that France had 2,150 reformed "churches" in early 1562 has been debunked. In fact, there were only about 860 reformed congregations in France, or 40 percent of the number claimed, and even this modest number was not reached until at least a year later. Moreover, two thirds of these "churches" had only been recently constituted and so still stood on rather shaky ground. In fact, the extreme diversity of reformed "churches" forced Calvinist leaders to exclude many gatherings that they deemed illegitimate due to insufficient doctrinal consistency or institutional discipline.[9] Heterodoxy may have inspired as much as a tenth of the population of France to dabble, at least briefly, in some form of reformed religion, but it is misleading to claim that these were all Huguenots. Even a recent historian of the Huguenots wonders "what later generations, schooled more thoroughly in the faith, would have made of some of [the 'Protestants']" included in estimates for the extent of Protestantism in France in 1562.[10] In short, the assumption that a populous and coherent Protestant church inspired the civil wars in France neglects the powerful role that religious conflict itself came to play in the construction of Huguenot identity.

A steady rise in royal persecution of religious reformers in the 1540s and 1550s served as a barometer of their growing influence. But the difference between reformers who struggled to reinvigorate Catholicism and reformers who adopted overtly Protestant doctrines was not easy to tell. Even the growing number of public executions masks the extreme difficulty magistrates had in determining when heterodox ideas crossed a theological line and became genuinely heretical. For every twenty cases of heresy brought before France's different *parlements* (the highest courts in the land), only one heretic was condemned to death.[11] Heterodox individuals who adopted reformed practices were known variously as *luthériens*, *évangéliques*,

or members of *le religion*.[12] The epithet *huguenots* first emerged from the failed "conspiracy of Amboise" in 1560 when Protestant noblemen gave the reform movement the lasting taint of political subversion by trying to kidnap the king.[13] Missionary preachers sent from John Calvin's Geneva sought to define the doctrines and practices of most French Protestants. Once in the field, they confronted an indigenous groundswell of religious reform that could not be easily harnessed or disciplined. Even after the great surge of the late 1550s, reformed churches remained so idiosyncratic and diverse that historians have almost given up trying to explain either the pattern of their emergence or the range of their practices. "The extreme diversity of [local] situations, the criteria for making choices and for responding, explains the apparently inexplicable and in any case 'illogical' distribution of Calvinists in mid-sixteenth-century France," concludes one authoritative overview of the situation.[14] After a sophisticated survey of possible factors involved in localized support for the Reformation in France, another expert concludes that, at base, the motivation was essentially religious and determined in the privacy of personal consciences. The most that can be said, therefore, is that the triumph of Calvinism came from responding to the opportunities presented by evangelical fervor in ways that reassured level-headed adherents who wanted a Christian faith built on clearly defined parameters for beliefs, worship styles, and personal morality, and who rejected Anabaptism or other populist extremes that could destabilize the social order.[15]

Calvinism may have offered a well-structured alternative faith, but it was often presented in such rigid terms that many reformed congregations were excluded from the fold. Even after several decades of spreading reformism, the first attempt to establish some doctrinal unity among French reformers did not come until 1559. That year, a dozen to fifteen regional leaders, representing no more than seventy-two local churches, gathered secretly in Paris for what has been dubbed, too grandly, the first national synod. The resulting agreement was significant, but also uncertain, unstable, and insufficient to create a national church or a common orthodoxy.[16] Future synods debated many basic elements of French Calvinism, and thus, the work of religious and political consolidation did not reach its formal climax until the national synods of April 1571 and May 1572, which finalized the Confession and the Discipline.[17]

Viewed from the ground up, rather than from the traditional top-down perspective of a heroic teleology of construction, it becomes clear that the great surge in reformed churches from 1558 to 1562 owed more to novelty and diversity than it did to consistency and unity. Most individual religious choices made in the sixteenth century remain inscrutable.[18] Moreover,

confessional allegiances proved remarkably fluid over the next decade. Even in the urban centers where reformers had the greatest success, such as Lyon, Nîmes, Rouen, Toulouse, and Troyes, the local Protestants remained a loose coalition of heterodox believers until the outbreak of the first religious war in April 1562. A major royal edict in January that year tried to prevent widespread civil strife by legalizing "the reformed religion." However, it also put severe restrictions on where Protestants could worship and required synods and consistories to be approved by the crown. This forced Calvinist leaders to assert greater discipline over their followers. As a result of their new legal status, and the conflict it provoked with Catholics, the rather uncoordinated Protestants in various cities became more clearly defined Huguenot communities, ones more determined to consolidate their positions in the local urban environment. When a Protestant army seized Lyon in April 1562, for example, the enthusiasm of proselytizing rapidly gave way to an assertion of hierarchy and social discipline.[19] A similar pattern prevailed in some twenty other towns and cities that experienced a short-lived Protestant ascendancy in 1562, notably Rouen, Caen, Orléans, Montpellier, and Nîmes.[20] In short, consolidating Protestant domination in any given locality was not achieved through a wave of conversions, but by combining religious discipline with force of arms. Moreover, despite the consolidation of reformed gatherings into Huguenot churches, very rarely did entire communities adopt Calvinism. France at the start of the civil wars did not resemble a leopard with Protestant spots, where homogeneous confessional zones contrasted with the more common Catholic background.[21] Rather, the religious diversity of the kingdom resembled a nudist who had broken open a beehive. The stings were highly localized, even though the pain was widely spread.

The most recent work on the matter provides an abundance of detail on the difficulty experienced by noble leaders, who had mixed motives based on the wider politics of the kingdom, in coordinating their actions with pastors and other religious leaders, who generally had more local concerns. It took repeated and prolonged civil strife, as well as some 150 pieces of political polemic published over a dozen years, to forge a coordinated effort, which did not fully take shape until 1570–71.[22] In the meantime, two largely parallel networks developed in response to the challenges of survival: a political and military one based on the nobility and a more exclusively religious one based on local churches and regional synods. The emergence of a militant Protestantism among the nobility badly disrupted power relations across the kingdom. Nobles who chose to defend the Protestant cause often did so as part of existing clientage networks, which helps to explain the high

proportion of nobles who chose to support the new religious practices. Such networks were equally important in consolidating Catholic militancy. But individual choice in matters of belief should not be ignored. The first edict of pacification in 1563 explicitly granted to nobles who had the powers of seigneurial justice personal freedom of conscience in their own domiciles, thereby encouraging individualistic tendencies. Such provisions fed a trend in which new personal beliefs frequently convinced nobles to turn against friends and patrons alike.[23]

In contrast, reformed religion made the least headway among peasants, that is, unless their seigneurs had adopted the new practices. Village life was not conducive to individualistic thinking. Literacy had barely penetrated the rural population, and social mobility proved extremely limited. Rather, collective action and family constraints strongly favored traditional habits and mores. As a result, religion weighed heavily on the rural population, perhaps even more than taxation. The rural elite of independent farmers seems to have been particularly concerned to avoid religious diversity. Instead, they wanted reforms that would end clerical abuses and create a more vibrant religious life, especially by having priests live in their parishes. Thus, the overwhelmingly Catholic peasantry thought that the clerical establishment and the intercession of saints provided the fundamental mechanisms for a community-based salvation. Any "heretics" in their midst would threaten that collective salvation.[24]

The first of the civil wars provoked a great flight from reformed religion back to traditional churches, especially in northern towns such as Orléans, Troyes, and Rouen.[25] The widespread persecution and consequent rejection of Protestantism posed grave challenges to establishing a shared religious identity. During the halcyon days of expanding Protestantism, Calvinist pastors often took participation in a communion service as a sign of conversion and vehemently denounced those who returned to Catholic practices as apostates. And yet such individuals may not have viewed their original action as a confessional choice. They had not really navigated doctrinal differences; rather, they had adopted practices that brought varying forms of social or emotional satisfaction. Deliberate changes of faith became much harder, and thus much more psychologically intense, once violent conflict ensued. Thereafter, "participation in the troubles as a member of 'the party of the Religion' seems to have become much more significant than taking Communion." Only those individuals who refused, despite the violence and coercion of the first civil war of 1562–63, to attend Mass again, to participate in the procession of relics, or to have their children baptized, as so many thousands of erstwhile reformers did, could be counted as genuine

Huguenots. Facing down persecution, regardless of the consequences, became confirmation that they belonged to God's elect, tested for their faith in ways that mirrored Old Testament accounts of the Israelites' tribulations.[26] Calvinists soon took suffering to be good for the soul.

Those congregations that survived after 1563 were reified into individual churches that stood apart from their local communities—and often outside the law, as well.[27] During periods of peace between the wars, most communities sought forms of accommodation that would enable religious opponents to live alongside one another, if not in harmony, at least in peace. When religious violence did erupt, it remained diffuse and localized. Thus, it took prolonged civil strife to knit Huguenot communities into a national church, one that went well beyond institutional ties to cultivate a psychological sense of fellow feeling. In the process, the hostile dialectic between Catholic polemic and Huguenot response proved central to the "elaboration of an Huguenot identity."[28] The resulting emotional identification with other, often distant, Huguenots competed with, and often came to supersede, the traditional sense of a singular, more or less unified, local community once shared with Catholic neighbors.

In the meantime, a bitter debate over governance within the reformed religion stretched across the later 1560s. It pitted those who favored more autonomous and participatory congregations (Jean Morély and Peter Ramus) against those who favored more hierarchical and discipline-oriented consistories and synods (John Calvin and Theodore Beza). The debate was only definitively concluded in favor of the latter by the tragic events of 1572, when Ramus and some key followers perished in the massacres.[29] In the meantime, many of the French reformed churches did not require their pastors and elders to exercise disciplinary functions through the consistory *à la Genève* because they feared that harshly disciplined members would return to Catholicism and then possibly betray the congregation along with its leaders.

Calvinist theology offered a direct personal relationship to God, but it did not create modern individualism because it came packaged in powerful community constraints. Adherents announced their beliefs in congregational assemblies where the prayers offered to God came from the entire community. In order to participate in communion, an adherent had first to obtain from the lay consistory a marker, known as a *méreau*, attesting to moral worthiness, which required mending frayed relationships with other members of the community. Consistories also monitored adultery, fornication, drunkenness, and indecent popular feasting, as strict moral conduct became a sign of belonging to God's elect. Although sermons,

Bible reading, and religious instruction all inculcated the need for a clean conscience, it took a protracted struggle to impose these practices on new believers. Huguenots even found it difficult to enforce consistent teaching of the catechism, including in their heartland of Languedoc. Nobles and village notables had repeatedly to be prevented from assuming special status during the four annual communion services, which eroded the theological egalitarianism of the reformed religion. Efforts to impose strict austerity on funerals practically failed altogether, and infant baptism in the regular church continued as a form of spiritual insurance policy.[30] In short, the struggle to establish a measure of unity and uniformity among reformed churches in France, thereby creating a true French Calvinism, lasted much longer than is usually understood.

In addition to sustained church discipline, it took repeated outbursts of collective violence to refine the ore of reformed religion into the precious metal of French Calvinism. Two great waves of iconoclasm in 1561–62 and 1566–67 accelerated the purification process. Taking part in acts of iconoclasm, especially when they were planned and regulated, worked to distinguish committed Protestants from wayward Catholics. Iconoclasm also served to consolidate a Protestant faction once it seized power at the local level. The destruction of sacred objects marked a definitive rupture with the past and an overt repudiation of religious rituals that had constituted the traditional community. Acts of iconoclasm were also blamed for subsequent threats to health and welfare, whether personal or communal, that ranged from disease to drought.[31] Catholic leaders responded by harnessing popular demands for revenge. Once they regained their dominant position in a community, sectarian differences calcified. This hardening led to sustained suspicion of apostate families. During the late 1560s, when "former members of the Reformed church brought their infants to the Catholic church [at Rouen] for baptism, the parish clergy placed a little 'H' or 'huot' in the margin, indicating that the family continued to be seen, and closely watched, as Huguenot."[32] The persecution associated with such attitudes provoked hidden crises of conscience and duplicitous conduct in many believers. One of the very rare diarists of the period, Nicolas Pithou, a Huguenot leader at Troyes, found the early troubles so terrible, and the miseries and calamities in his town so great, that it was only rational to think "that God wished utterly to ruin and confound this poor church."[33] To remain a Huguenot meant putting faith above reason, and often above social and economic self-interest, as well. In doing so, individual identities were reshaped by a few short years of public participation in reformed religion and "the troubles" that such activities spawned.

In summary, despite the rapid expansion of Protestantism around 1560, it took years of intense civil strife thereafter, years characterized by growing hatred from the majority of the population, sectarian taxation, frequent personal assaults, and outbursts of collective violence, to make fully apparent the extraordinary level of commitment required to worship as a Huguenot. Royal legislation and local persecution compelled Huguenots to express their faith in one public manner or another, such as walking many miles to an approved meeting site located far from town. Public actions of this sort did not create an indelible physical marker, or even impose a yellow star, but it did make members of "the religion" easy to identify and persecute once tensions escalated into violence. Thus, by 1572, it had become clear that to be a Huguenot was "to be a different kind of Frenchman, to belong to a distinctive, largely separate community, [to] take the doctrine, the manner of worship, and all the nuances of thought, styles of speech and conduct [of Calvinism] . . . it was to be a stranger in one's own land."[34] Such conditions made the collective singing of psalms vital to sustain the faithful. These veritable battle hymns of the evangelicals carried a threefold message: David had suffered much, but eventually triumphed over his enemies; the suffering and triumph of Christ had been predicted and fulfilled; and, most importantly, the suffering of the true church, as well as its final triumph, had likewise been prophesied.[35] Individuals who sang such songs naturally acquired a greater sensitivity to the plight of their coreligionists suffering persecution elsewhere.

The emergence of a coherent Huguenot church across France helped to offset the loss of a cohesive and inclusive community at the local level. The Reformed Church in France was based on creating an alternative, shared sense of identity with men and women who were not known personally to one another, and who, if they had met each other on the road, would have been deemed potentially threatening strangers. The fostering of such a shared identity had implications for individual perceptions of self. Being no longer as dependent on a face-to-face sense of community to define one's position in society and anticipated trajectory through life meant cultivating a more distinctive and more personalized narrative of past, present, and future. Believers who persevered in their Calvinist faith had deliberately to reject the sociability offered by a reinvigorated Catholicism, one that put even greater emphasis on community solidarity. Few believers could hold out alone. Individual commitments were essential, but individualistic actions were not. Communion remained a collective ritual to obtain personal absolution. Faith took wing in an assembly as songs and prayers went up to God from a collectivity.[36]

Just as most historians have assumed that French Calvinism had constituted a coherent national church, and a corresponding set of shared personal identities as Huguenots, *before* the civil wars, they slip easily into treating Catholicism as a single, unified religion even though the church's basic orthodoxies and institutional practices remained hotly contested at the time. The years 1543 to 1562 brought a series of edicts that defined orthodoxy within the Gallican Church. Many of these amounted to either affirmations or clarifications of existing doctrine. Nonetheless, this consolidation of past orthodoxy was not inevitable. The national religious council in 1561, known as the Colloquy of Poissy, made a serious attempt, despite its ultimate failure, to find some doctrinal common ground that could heal the growing schism in France. The following year, the regent, Catherine de Medici, appointed a leading member of the notoriously militant Guise family, Charles de Guise, Cardinal of Lorraine, as head of the French delegation to the Council of Trent with the surprising purpose of trying to prevent hard-line policies from being adopted. To that end, she gave the cardinal instructions intended to secure a number of remarkably conciliatory concessions. These included communion of both kinds, the use of French in church services, an accord on clerical marriage, and reform of the system of ecclesiastical benefices. Lorraine cared little for dogma and devoted his efforts to reforming practices.[37] His efforts did not succeed. The Council of Trent ended in 1563, after the outbreak of civil war in France, when it adopted important reforms intended to impose an array of religious practices that sharply increased the role of the parish clergy in the social and spiritual life of the laity. Over time, these reforms came to replace medieval Christianity with the modern Catholic Church. More precisely, they created Tridentine Catholicism, which lay at the heart of the overlapping concepts of Counter-Reformation and Catholic Reformation. Henceforth, a good Catholic would attend Mass every Sunday and holy day and would receive the sacraments from a priest, including at the critical stages of life: baptism, marriage, and extreme unction. Penance would be performed at least once annually in preparation for the Eucharist at Easter.[38] Most leaders of the Gallican Church, however, proved unenthusiastic about the prescribed reforms, thereby greatly delaying their implementation.[39] In fact, it took two decades of intense religious strife to give ecclesiastical leaders the incentive and the opportunity to remake a French church that was "in effect, a conglomerate of autonomous communities."[40] "Tridentization" may have been presented as a restoration of the former church, but "it was in reality a new religion that was put in place in France starting in the 1580s."[41]

Like French Calvinism, officially stigmatized in various royal decrees as the "so-called reformed religion" (*religion prétendue réformée*), the reinvigorated Roman Church, best termed Tridentine Catholicism, intensified the religious experience of lay men and women. Although the Council of Trent explicitly repudiated such Protestant notions as the priesthood of all believers, the new Catholic orthodoxy provided other means to develop a more intense and more interiorized form of spirituality. This is not immediately obvious. After all, Tridentine Catholicism firmly asserted the necessity of an ecclesiastical hierarchy for spiritual purposes. Not only did the Bible and the liturgy both remain in Latin, but administering the sacraments remained essential and exclusive to ordained clergy. "Justification" (or the righteousness of salvation) could not be attained by faith alone, as Luther claimed. Nor did God confer grace on passive recipients; individuals preserved a free will to reject it. By insisting on both the centrality of the sacraments and the free will of individuals, the Council of Trent created a theology that put greater emphasis on actively practicing and propagating the faith. Thus, like the Protestant Reformation, the Catholic Counter-Reformation dramatically added to the pressures and expectations placed on individual believers. Even within mainstream Catholicism, salvation became increasingly a matter of personal religious practices in addition to collective worship.

The intensification of religious piety among Catholics developed later than among Protestants. Moreover, it did so first through a reinvigoration of traditional forms of religion that had long offended many clerics. The popular search for piety inspired a "recollection and spastic revival of earlier religious forms" during the middle and later decades of the sixteenth century.[42] The laity increasingly engaged in the public procession of relics, took pilgrimages to sites imbued with sacral authority, and staged elaborate masses for the dead. Such rituals seemed to promise greater access to God's grace for the individual and his community.[43] The swelling number of lay confraternities that emerged in towns across France in the late 1560s and early 1570s suggested the direction of things to come. These new confraternities were a response to religious conflict. They put great emphasis on communal solidarity while also cultivating a more intense individual piety. Penance provided the common currency. It combined mental self-scrutiny, or internal discipline, with ritualized collective actions, such as more frequent communion, acts of charity, processions and even public self-flagellation. In these various ways, penitential confraternities sought to build Catholic solidarity and personal, interiorized piety in the face of persistent "heresy." Taking the oath of loyalty to one of these confraternities

gave laymen something akin to a sacred calling in which individuals would "take up the cross," thereby providing "arms and men for the church militant in a holy crusade against French Protestantism."[44] Some confraternities proved terrifying enough to local Protestants that they abjured their faith rather than have their shops pillaged and their houses ransacked.[45]

The emergence of militant confraternities reflected new directions in French Catholicism. In fact, ultra-Catholics associated with the Holy Union, better known as the League, that emerged in the 1580s developed forms of religious practice that varied considerably from those of moderate Catholics (derided by zealots as *politiques*). Historians have devoted much attention to the tensions between the Guise-led League, which opposed Henri III for failing to extirpate heresy, and Catholic *politiques*, who supported his more pragmatic approach.[46] However, the differences in religious practices between these strains of Catholicism are not well known. That said, it is evident that associates of the militant League put greater emphasis on God's immanence in the world, which meant greater involvement in religious processions, memorial masses, and penitential confraternities. Such activities helped to ensure that participants' emotional investment in religious performances would strengthen the bonds of community while also increasing the sacral importance of the liturgy and the sacraments for individual salvation.[47] Thus, personal identity for Catholics remained strongly embedded in local communities, even as it became increasingly personalized.

The more intense forms of religious culture that emerged during the wars of religion in France—Calvinism and ultra-Catholicism—both featured a more personalized piety and, therefore, contributed to a more articulated self. The intensification of religious experience also made it easier to empathize with coreligionists. A burgeoning sense of self together with more coherent religions increased the sense of sharing a religious identity. Lay confraternities, processions, and holy sites had long been elements of very localized and highly diverse religious practices, but their reinvigoration in the later sixteenth century combined with more standardized forms of religious practice advocated by Tridentine Catholicism to make religion a more important force in shaping personal identity. The new forms of piety also fostered a sense of Catholicism in the face of Protestantism on a larger scale than the local community. But what explains the differences in timing? Why did the intensification of personal piety among Catholics take almost a generation longer to develop than it did among Protestants? Denis Crouzet's monumental study of the "warriors of God" provides an intriguing explanation.[48]

ESCHATOLOGICAL ANXIETY

Though not interested in the self per se, Crouzet's work largely assumes the centrality of psychological processes in the sectarian strife of the sixteenth century. He argues that astrologers such as Nostradamus, whose predictions received unprecedented distribution thanks to the recently invented printing press, helped to generate a profound "eschatological anxiety" in mid-sixteenth-century France. Catholics responded to this growing fear of the Apocalypse by seeking to purge their communities of heretics, witches, and atheists. This impulse made Catholic violence against Protestants "sacral" and "mystical," and thus a means by which to prepare the faithful for the Second Coming of Christ and the Final Judgment that would entail. Just as the doctrine of transubstantiation rested on a belief in divine immanence in the material world as a means for man to partake in the sacred, violence committed for the purpose of purifying communities also represented a form of divine immanence in human affairs.

In contrast to Catholic eschatology and divine immanence in the world, Calvinism offered a providentialist and rational response to fear of the Final Days. Huguenots were taught to see the Eucharist as merely a symbolic representation because, rather than infuse the material world with his presence, God transcended it. The surge in adherents to reformed religion in the late 1550s, coupled with a wave of missionary preaching, generated a sense of revolutionary possibilities, a hope that a new, more godly world could be created by purging society of its papist practices. In the 1560s, therefore, Huguenots engaged in waves of iconoclasm that damaged thousands of churches, convents, and sites of pilgrimage throughout France. Calvin's increasingly hard line toward "idolatry" justified the turn toward iconoclasm, especially when it was executed in an orderly fashion by local leaders. That may have been the Calvinist ideal, but iconoclasm just as often resulted from collective destruction perpetrated by angry crowds fueled by feelings of revenge and retaliation. Such outbursts usually responded to previous actions by Catholics. These included the execution of local Protestants or, more often, attempts to preserve religious unity in a community, notably by assaulting individuals who declined to kneel before the statue of a patron saint or a procession of relics. As a result of this theatrical coercion, reformers found the cult of images increasingly intolerable, and so made it the first would-be superstition to be rejected along with the Eucharist.[49]

The reformers' destruction of religious images and ornaments sought to prove that such artifacts did not embody a sacred presence in the world, but were man-made symbols of false belief. Iconoclasm sharpened distinctions

between Catholic notions of God's immanence and Calvinist notions of God's transcendence. Whereas the Roman church's teachings on the role of sacred images and objects had long been muddied by concerns over popular superstition, outbursts of iconoclasm inspired a deeper commitment to the cult of images as part of Tridentine Catholicism. The popular response at the time reveals a greater sensitivity to the destruction of images than to the deaths of fellow Catholics,[50] though the latter remained relatively rare at first. As Natalie Davis famously argued, religious riots owed much of their structure and content to both religious and secular rituals. Catholic and Protestant rioters shared much the same goals: to achieve the ends of preaching (that is, to defend true doctrine and refute false doctrine) through violence and thereby to rid communities of religious pollution. Differences in religious doctrines and practices, however, led to notably different forms of violence. Catholic rioters favored the killing of supposed heretics, followed by mutilating their corpses and disposing of them in the purifying waters of a nearby river. Protestant rioters preferred to attack the symbols of Catholic worship as false idols and instruments of the Antichrist (i.e., the papacy). They included priests and canons, but usually spared ordinary parishioners. The zealots of both sides legitimized their violence by deploying a repertory of actions derived from the Bible, the liturgy, official justice, and folk practices of public humiliation. Rioters who adapted these ritual frameworks felt little remorse: theirs was guilt-free violence.[51]

According to Crouzet, divergent responses to existential fear explain the differences in sectarian violence first highlighted by Davis. The Saint Bartholomew's Day massacres of 1572 conformed to the basic pattern but provoked a differential response in participants. On one hand, the persecution already suffered by the Huguenots enhanced their stoicism in the face of persecution. Not only did many Calvinists manage to survive the wave of massacres, they remained strong enough to form a political and religious organization capable of protecting public worship across much of southern France, as well as to resist the brutal royal sieges of La Rochelle and Sancerre in early 1573. Moreover, successfully resisting the monarchy's attempts to wipe them out made French Calvinists more receptive to the much greater emphasis that Theodore Beza, Calvin's successor at Geneva, put on the doctrine of the predestination of the elect. Thus, according to Crouzet, the events of 1572–73 enabled the Huguenots to liberate themselves from fear of the Apocalypse and then increasingly to separate the affairs of the world from religious belief. On the other hand, Catholics interpreted the successful violence directed by Huguenots against their religion as the scourge of God for having failed to extirpate heresy. A period of Catholic self-doubt

followed by penitential fervor served to revive eschatological anxiety. This renewed concern with the Apocalypse underpinned the militant Catholic League of the 1580s. Once they had become convinced of their own piety again, Catholic zealots blamed the continued presence of heretics in the kingdom less on the Huguenots themselves and more on the mercurial new king, Henri III, whose polices had failed to purify the kingdom.

Crouzet's analysis is too schematic and often ignores critical developments, such as the precipitous decline in the number of Protestants in France as a result of the earlier wars of 1562–63 and 1567–68, and especially as a result of the Saint Bartholomew's Day massacres of 1572. Nonetheless, his penetrating cultural analysis suggests that there is good reason to view the wars of religion as a transformative period in the interaction between the self and collective trauma. If nothing else, the sources that helped both to spread "eschatological anxiety" and to communicate the effects of religiously justified atrocities and massacres invite more careful consideration of their psychological impact.

FROM MARTYRDOM TO MASSACRE

Huguenot responses to persecution depended considerably on how to understand the relationship between religious commitment and personal suffering. The first war of religion in 1562–63 marked a watershed in Protestant understandings of what it meant to die for the faith. In this short space of time, the framework for religious death passed from martyrdom to massacre. In the previous decade, the judicial execution of individuals for heresy had been framed by Protestant martyrologists as part of a long tradition of resistance to oppression. This tradition extended from the early church of biblical times through the Cathars, Jan Hus, John Wycliff, and up to Protestants executed in France between the 1520s and 1550s. The martyrology of Jean Crespin, in particular, became a runaway best seller released in ever-expanding editions with an increasingly historical tone. The first edition of 1554 was a small pocket book easily concealed. By 1564, it had become a folio edition of more than a thousand pages that was best read from a lectern or pulpit. Crespin's massive martyrology proved especially influential and inspirational, being one of the most widely read Protestant books of the period.[52] Not everyone who died for the faith, however, qualified as a martyr. Only a judicial procedure could authenticate the purity of attitude of a Protestant executed for heresy. Even after intense religious strife erupted in the early 1560s, the overlap between political and religious violence seemed to require that a distinction be made between

earlier heroic martyrs and recent victims of massacre. As massacres multi-
plied during the 1560s, the expanded edition of Crespin's work published in
1570 removed the term "martyrs" and replaced it with "true witnesses to
the truth of the Gospel, who signed it with their blood."[53] Such a title cov-
ered the distinction that continued to be made between "martyrs" and the
"persecuted faithful."[54] These terms separated role models to be emulated
from coreligionists who died tragically. Such a distinction recognized that
individual believers could choose to die as martyrs by not renouncing their
faith once arrested and put on trial, but individuals who died in a religious
massacre had little choice about their fate. Ordinary Protestants may have
been inspired by martyrs and even imagined being called upon to emu-
late them by undergoing a spectacular trial and public execution; however,
ordinary Protestants surely found it easier to imagine themselves simply
being slaughtered by a group of Catholic fanatics. Thus, learning about the
fate of coreligionists murdered en masse for their faith, often in uncertain
circumstances, created different emotional resonances than learning about
individual martyrs whose deaths were well documented. Whereas martyrs
might inspire stoicism and emulation, victims of massacre could inspire
empathy and a sense of shared suffering.

Maintaining a clear distinction between "martyrs" and "persecuted
faithful," however, became increasingly difficult in the course of the 1560s.
Widespread civil strife led to numerous acts of religious violence; therefore,
those who continued to attend Calvinist services did so more aware of the
serious risks they incurred. In the religious language of God's final judg-
ment, the wheat of true belief was being separated from the tares of false
witness. Widespread thinning of the ranks of Protestantism through perse-
cution, abjuration, and Nicodemism (outwardly conforming to Catholicism
while secretly remaining Calvinist) meant that individuals who continued
to practice the reformed religion were making choices that could well cost
them their lives. Thus, in the version of his martyrology published in 1570,
Crespin began to blur the distinction between the long chain of Christian
martyrs and victims of recent massacres. Although he still did not include
individual victims of collective violence in his collection, he concluded his
final volume on a contemporary note, stating that thousands of people "had
been martyred all at one blow, when, in the place of one hangman, there
had been an infinite number of them, and that the swords of soldiers and
the people had been the law, the judge, and the executioner of the strangest
cruelties that have ever been perpetrated against the church."[55] A key differ-
ence remained, however: Crespin included in his collection of martyrs only
individuals whose identity and experiences could be formally attested. His

most important cases were individuals who had left clear evidence (statements in court, letters to loved ones, pastoral epistles from prison) that demonstrated that they had died explicitly for their faith. Such documented deaths bore eloquent witness to the stoicism granted by the grace of God. Proven martyrs truly were his elect. In contrast, the vast majority of those who died in the massacres from 1562 to 1572 were largely unknown to coreligionists elsewhere. If Huguenot deaths were anonymous and obscure, how could it be said that their lives had been exemplary and pure? If their deaths were to bear witness, if they were to illustrate divine grace, not just human cruelty, certain basic questions needed to be answered. Who had been killed? How had they been killed? What had they suffered? To be truly meaningful, yet another question needed to be answered: Why had they died?

The answers to these questions became increasingly urgent following the massacres of 1572. It was only after this collective trauma that Huguenot publicists came to accept an apparent oxymoron—"massacred martyrs."[56] As already noted, the apogee of judicial martyrs came just before 1561, the year Huguenots turned to widespread iconoclasm and Catholics perpetrated their first massacres. During the following decade, both forms of violence, iconoclasm and massacre, helped to establish the permanent "Otherness" of the Huguenots in France. Agrippa d'Aubigné in *Les Tragiques*, an epic poem about the wars of religion, separated the "temps des feux" from the "temps des fers," thereby distinguishing between the time of martyrs (fires) and the time of massacres (iron).[57] However, between 1562 and 1572, few Huguenots faced individual prosecution as heretics. Nor did they simply go like lambs to the slaughter. So what then was their status if they died at the hands of sectarian soldiers and armed mobs? The pastor and publicist Simon Goulart responded to these concerns with an effort (only partly successful) to make the victims of massacres virtually equivalent to regular martyrs. Goulart's subtle conceptual move sought to combat the twin challenges facing Huguenots: persecution as rebels, rather than heretics, and apostasy. His approach culminated in an enlarged edition of Crespin's martyrology published in 1582.[58] There, Goulart expanded Crespin's conclusion to the edition of 1570 ("thousands of good people martyred at one blow") into a prologue to his new book 10, which covers massacres in France from 1563 to 1572. The prologue explicitly declines to debate the qualifications of martyrdom; instead, Goulart claims that a "plain and simple narrative will suffice" and that his account will "pay particular attention to those who were notoriously put to a shameful and cruel death through hatred of the true Religion." He then concludes book 10 by justifying his inclusion of

those who had not been fully confirmed in the faith alongside those who were "more firm" because they all had their lives crowned with the honor of suffering for his name.[59] Clearly new attitudes toward suffering for the faith had emerged in response to sustained persecution, repeated massacres, and widespread apostasy. French men and women who had remained true to the reformed religion despite murderous persecution and then perished in a massacre now met the most basic requirement of martyrdom, namely, that they had died for the cause of the true church. Such an understanding conformed to Saint Cyprien's ancient minimalist maxim "la peine ne fait pas le martyre, mais la cause" ("it is not the suffering/punishment that makes the martyr, but the cause").[60] Making the cause synonymous with the true church (i.e., Calvinism) facilitated situating victims of religious violence alongside recognized martyrs. This more historicized ideology of suffering and dying for the cause added to the emotional basis for a shared alternative religious identity, as well as for the more profound self-consciousness that it entailed.

PICTURING MASSACRES

The transition from isolated martyrs to large-scale massacres that had been made early in the wars of religion appeared some years later in an unusual series of prints by Jacques Tortorel and Jean Perrissin entitled *Quarante tableaux ou histoires diverses qui sont memorables touchant les Guerres, Massacres et Troubles advenues en France ces derniers annees* (Geneva, 1569–70), known in English as *Wars, Massacres, and Troubles*. Among the first prints in the series is a depiction of the execution of a Protestant member of the Parlement of Paris, Anne du Bourg, on 21 December 1559 for advocating lenient treatment of accused heretics and refusing to recant his faith. The image bears all the hallmarks of martyrdom. It appears early in the series, however, and is the only such image in it. The trajectory from a famous act of martyrdom to numerous religious massacres and sectarian battles was at once historical and representational, and, therefore, both cultural and psychological.

Tortorel and Perrissin's series of prints was a landmark in the history of printmaking. It was the first synthetic pictorial account of contemporary events in France. Although single-leaf prints depicting current events had been pouring from print shops in Italy and Germany for decades by 1570, French printmakers generated only twenty-nine known single-leaf prints devoted to current events in the three decades between 1553 and 1582. Almost all of these individual prints depicted sieges or battles, and none showed a massacre. Thus, the sheer number of images—thirty in the early

edition of 1569 and forty in the full edition of 1570—together with their size, variety of subject matter, and richness of detail make the series by Tortorel and Perrissin the most important visual source depicting massacres during the French wars of religion. Philip Benedict has thoroughly examined the evidentiary provenance and physical production of this series.[61] His magisterial study provides a basis for assessing the role that depictions of massacres played in shaping Huguenot responses to the wars of religion.

Robert Scribner, in a pioneering study of the German Reformation, provides a sophisticated and persuasive argument for the effectiveness of sixteenth-century printed images with a religious message (often accompanied by text) to influence the emotions of viewers. He underscores the need to understand these printed images as part of complex forms of communication, not as objects encountered in a social vacuum. The other forms of persuasion at the time included preaching, singing, and theater, each of which is rather localized in impact and challenging for historians to assess.[62] More important to historians' understanding of contemporary attitudes has been printed matter. Many pamphlets and books circulated widely, thereby shaping larger collective responses to the tumult of the time. The great poet and historian Agrippa d'Aubigné later noted that those who had witnessed the persecution of Protestants firsthand (as he had) well knew "what to believe from the news sheets and books that recounted distant things to them [so] that the ashes [of martyrs] became a fine powder that spread to many places."[63] Rather than focus primarily on printed matter that reported events in order to understand responses to those events, however, historians need also to appreciate how existing printed matter guided initial responses to the latest events.[64] In other words, the spreading of the "fine powder" of news about massacres that took place prior to 1572 helped to shape immediate responses to the Saint Bartholomew's Day massacres thereafter.

By its nature as a series of prints with text, and by its publication in 1569–70, *Wars, Massacres, and Troubles* gave contemporaries, especially Protestants, a powerful guide to understanding, interpreting, and responding to these new acts of mass violence. Such a claim rests on several factors. First, the print series reached a large audience; it was, by the standards of the day, mass produced: well over six thousand copies.[65] Moreover, they were not especially expensive—a half livre tournois or slightly more per set. French Calvinists tended to be more urban, independent, and literate, and generally materially better off than most of the rest of the population. Individual prints were also sold separately and, therefore, could easily have circulated quite widely. Second, these thousands of copies reached France in a short space of time, between 1570 and 1572, after which production stopped due to

bankruptcy. Third, even before the series had been expanded to forty images in 1570, a highly successful copy of twenty-three images in smaller format had been pirated and was being printed en masse at Cologne by one of the best-known and most prolific printers of the day, Franz Hogenberg. Fourth, the print series both complemented and supplemented a spate of Protestant pamphlets on the religious strife in France. Many of these were scrupulously assembled into collections, which became virtually a new historical genre at the time.[66] Thus, Tortorel and Perrissin's series of prints belonged to a vital historiographical movement, one that helped to turn compilations of polemic, reportage, and witnessing into more coherent texts capable of conveying an interpretive narrative of past events (i.e., history).[67] Tortorel and Perrissin made their series of prints less like propaganda, and therefore more marketable to Catholics, by including distinctly historical characteristics. This involved presenting convincing circumstantial detail, avoiding errors so as not to be discredited by enemies, and including episodes that did not flatter the Huguenots (e.g., military defeats at Dreux, Jarnac, and Moncontour, and the massacre of Catholics at Nîmes known as the *Michelade*). These essentially historical features also made the print series a more powerful medium to communicate the suffering of others to individuals far away from the communities where the violence took place because they added credibility to the emotional elements included in the images. Thus, by striving for accuracy and eschewing vituperative partisanship, Tortorel and Perrissin enhanced the persuasive power of their images.[68]

Taken together, these features of the *Wars, Massacres, and Troubles* made the series an original and powerful means to communicate personal suffering through images and text. To be sure, not everyone who viewed these images, and read their accompanying text, brought the same perspective to bear. In fact, even sectarian differences did not fully determine viewer responses. Some Catholic viewers may have considered the violence necessary to purge heretics, whereas other Catholics would have been moved by the suffering depicted. (Catholics often sheltered Protestants during a massacre, though some did it to extort a ransom.) Protestant responses, too, could vary to include emphasizing God's punishment for sin or the need for stoicism in the face of persecution. Combining text and image heightened affective responses from viewers, as Scribner makes abundantly clear: "Above all, the relationship [between images accompanied by text and their viewers] was affective—not simply a matter of objective rationality, but something engaging the emotions. . . . Of course none of these connecting lines flowed purely one-way, and a viewer-reader could question an image, even as the image worked upon his or her emotions."[69] In addition to

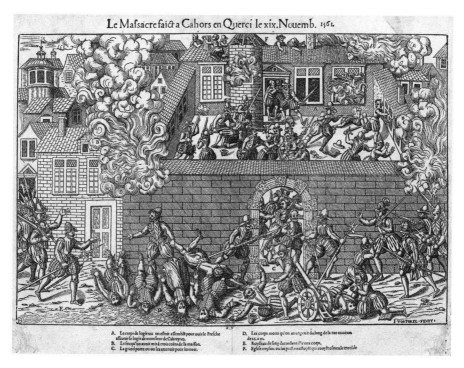

Figure 1. "The Massacre at Cahors in Quercy, 19 November 1561."

Woodcut and etching by Jacques Tortorel and Jean Perrissin, plate 10 from *Wars, Massacres, and Troubles* (Geneva, 1569–70). Bibliothèque Nationale de France.

this intensified engagement with the printed image, Tortorel and Perrissin depicted the suffering of victims as part of a Protestant metanarrative of the wars of religion up to 1570. This narrative framed the violence as Catholic aggression, and thereby helped to foster a greater sense of shared identity among diverse Huguenot communities. Here the logic of representing victimization becomes fully evident. Representations that depict violence as the persecution of an individual or group perform two functions: they decry the breaking of social bonds caused by the violence, and they create new bonds between the viewer and the individuals represented as victims.[70] A closer look at four of these prints will make this process apparent.

"The Massacre at Cahors in Quercy, 19 November 1561" seeks to convey both the ruthlessness of the perpetrators and the innocence and vulnerability of the victims (see figure 1). The perpetrators are numerous and well armed with arquebuses, halberds, swords, and even a small cannon. Furthermore, they are all energetic, rushing, shooting, stabbing, and sabering their victims. In contrast, the Huguenots are unarmed and defenseless,

their psalters dropped just in time to clasp hands in prayer or to beg for mercy. Many of the worshipers are depicted with gestures of alarm and fear. None of them puts up serious resistance, and only one even shields himself from the deadly blows. Three corners of the building have been set ablaze, which adds to the obvious panic and inspires efforts to escape across the rooftop. There is no question that this is an unprovoked massacre of congregants who believed that they were worshiping legally, behind the walls of a private home and out of public view. In contrast, the killers are depicted as determined to make a public display of their efforts. They herd victims toward the main entrance to be systematically slaughtered. According to the key, some twenty-five to thirty corpses are then deliberately arrayed along the street where their blood runs together to form a stream. Though the artists have included only two women, the men clearly range across the ages. The pair of victims in the right foreground appear to be a father praying over his murdered son before he succumbs to a decapitating blow himself. That almost all of the Huguenots are shown with their hats knocked off conveys the degradation and loss of male honor they suffered during the onslaught. In short, the whole scene is that of massacred martyrs, men (for the most part) who were brutally killed, possibly by fire, and without fighting back, simply because they were caught in Protestant worship together. This event was little known at the time, but its inclusion in *Wars, Massacres, and Troubles* served to make the conceptual transition from the martyrdom of Anne du Bourg in 1559 to the more indiscriminate massacres of the first civil war launched by the massacre at Vassy in 1562.

"The Massacre at Vassy the first of March 1562" is a print of even greater intimacy and pathos than its predecessor (see plate 1). By removing the fourth wall between the action and the audience, the printmakers bring the viewer almost into the scene itself. Also, the figure depicted hiding behind the pulpit to the right of center seems to stand in for the viewer regarding the explosion of violence from within its midst. The intimacy of the scene allows the artists to depict a variety of facial expressions, including the fear of the man on the ground in the lower right corner and the throes of death on the woman run through with a sword in the lower foreground. The gasping, hands-over-mouth, wide-eyed horror shown on the figure embedded deep in the crowd at the center of the image clearly serves to prompt appropriate emotional responses from the viewer. The general panic is palpable from the many arms thrown in the air, the entangled mass of struggling bodies, and the wild scramble to escape across the roof. Other details in the scene also made it more

likely that viewers would respond emotionally. Female Huguenots could have sensed the urgency of the woman in the center foreground as she tries to stop a Catholic soldier from bringing his sword down on the fallen man before him, or have empathized with the sheltering embrace given to a young child by the woman just behind her. Male Huguenot viewers would have especially identified with the sense of helplessness conveyed by the obvious inability of the worshiping men to protect women or children, let alone to defend themselves. Furthermore, famous details known from widely circulated pamphlets, such as the theft of the poor box and the blowing of trumpets, are included to bolster the veracity of the scene. Finally, the whole event is explained as a Guise-led massacre by the presence of both Francis, Duke of Guise (letter *B*), and his brother Charles de Guise, Cardinal of Lorraine (letter *E*). The intensity of this print lives up to the importance of the event, which led directly to the first war of religion. Its greatest effectiveness lies in its ability to communicate suffering in strikingly immediate and emotionally provocative ways to a wide variety of individuals who were not themselves members of the Protestant community at Vassy.

"The Massacre at Sens in Burgundy done by the populace in the month of April 1562" lacks either the symbolic significance or the emotional intimacy of the previous two prints (see figure 2). Nonetheless, it achieves its intensity and effectiveness through a combination of careful narrative structuring and sheer brutality. At Sens, it was not leaders of the ultra-Catholics, but the civic militia and ordinary town dwellers who committed the massacre, and the artists leave no doubt about their armed villainy. Rather than capture a single moment in time, this image depicts events that lasted three days. Diachronous vignettes are scattered throughout the print. For example, the letter *E* in the center is explained in the coded playlet as the wife of master Jaques Ithier, doctor, first trying to prevent the pillage of her neighbor's house, then being stripped of her clothes, and finally being dragged by her neck to the river. The rampaging brutality is clearly evident in the river, where naked men and women (one face up and obviously pregnant) are attached in threes and fours to floating timbers and carried off by the Yonne River. Acts of explicit cruelty, human degradation, and base thievery abound throughout the image. The destruction of property in town and country alike is also a notable theme in the accompanying text. The combination of venal pillaging and human butchery that dominates the print would have made an especially strong impression on Protestant burghers in other towns.

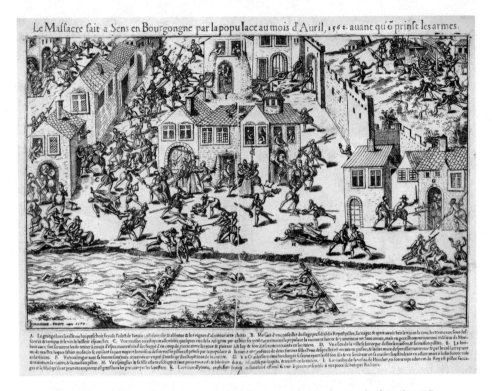

Le Massacre fait a Sens en Bourgongne par la populace au mois d'Auril, 1562. auant qu'ō prinst les armes.

Figure 2. "The Massacre at Sens in Burgundy done by the populace in the month of April 1562."

Etching by Jacques Tortorel and Jean Perrissin, plate 12 from *Wars, Massacres, and Troubles* (Geneva, 1569–70). Bibliothèque Nationale de France.

Despite being set outside and including an entire cityscape, "The Massacre at Tours done by the populace in the month of July 1562" manages to combine proximate intimacy with even more shocking brutality (see plate 2). The desperate agony of struggling against drowning is readily visible on several victims' faces, especially that of the man behind the largest boat. Clubbing people in the water and even chopping the hands off a woman clinging to a boat highlight the grizzly determination of the killers. More gruesome yet are the vignettes to the far right. There, behind the cadavers being devoured by dogs and ravens, is the town's leading royal official, court president Jean Bourgeau, suspended from a tree while his heart and entrails are torn out in a vain search for swallowed coins. Throughout the image soldiers assist in massacring women and children, as well as men. The accompanying textual key points the viewer's attention to the pathos at the center—literally—of the image. Along the wall, a Huguenot child is held by one soldier while another shoots it with an arquebus as part of a cruel wager (*H*); on land a woman is

shown stripped naked before being run through with a sword (*I*); and in the water a mother and her newborn baby both gesture toward heaven, one with her upturned face and the other with a raised arm (*K*). Here is natural innocence dispatched with unnatural cruelty. These highly charged elements of the print engage ordinary Huguenots to contemplate their own potential fate at the hands of Catholic fanatics: suffering, degradation, and death, all the while focusing their attention on God. The cold-blooded nature of the butchery is apparent even in an alternative, more laconic, legend that replaced the lettered key in some editions: "The population of Tours rises up against those of the Religion and massacres up to about two hundred of them; taking them first from a church, where they had been imprisoned, in the faubourg of la Riche, and made to wait two or three days without water or food; then killing and drowning them." The contemporary Agrippa d'Aubigné was so moved by the "pathos-laden vignettes" in this print that he included them in his epic poem *Les Tragiques*.[71]

Wars, Massacres, and Troubles also included several scenes in which Protestants killed Catholics. However, these scenes employed pictorial strategies that did not include nearly the same level of cruelty or emotional expression as the prints depicting the massacre of Protestants. "The Seizure of Valence in Dauphiné" (25 April 1562) is a diachronous scene that ends in the death of the Catholic governor, Pierre, Sieur de la Motte-Gondrin. No torment or degradation is depicted; he simply ends up hanged at an open window. In "The Seizure of Montbrison" (July 1652), the only nonmilitary violence included in the image are three rather distant bodies being thrown from the castle tower. Only the "Massacre Done at Nîmes" (1 October 1567) comes close to depicting the brutality of a Protestant massacre of Catholics. In this case, the *Michelade*, as the event was generally known, took place at night and only after considerable deliberation about who would die and who would be spared. The textual key provides only three pieces of evidence: the location, the identities of several principal victims, and "the well into which were thrown thirty to forty persons, equally consuls, lawyers, monks, priests, and soldiers." These were not, in other words, ordinary Catholics, but men (only men are shown) responsible for imposing Catholicism on the population of Nîmes. Moreover, none of the perpetrators is identified, nor is any cruelty recounted pictorially, although the viewer is not spared the sheer brutality or physical struggles needed to kill unbound men by sword and halberd. Tortorel and Perrissin were historically minded enough to include these various acts of aggression on the part of Protestants, but the nature of their depiction was clearly not intended to inspire emotional responses from Catholic viewers, and may even have been inclined to minimize them.[72]

Thus, Tortorel and Perrissin's prints offered detailed and graphic violence in a pictorial form unprecedented in French publishing. Such images were not only shockingly novel; they remained unsurpassed until Jacques Callot's series of etchings known as *The Miseries and Misfortunes of War* appeared more than a half century later. Moreover, the images of Tortorel and Perrissin did not simply offer a pictorial history of the early years of the civil wars in France. As a novel medium distributed on the eve of another wave of similar events, these depictions of sectarian massacres had an immediacy and emotional power that surpassed all but eyewitness accounts delivered in face-to-face encounters. Tortorel and Perrissin enhanced the ability of their prints to provoke emotional responses, especially among fellow Huguenots and possibly among moderate Catholics, by using a variety of visual and verbal techniques. An easily overlooked, and yet truly ominous, element of these prints is the apparent lack of motive for the barbarous actions of the Catholic perpetrators. It is reasonable to assume, therefore, that such novel and graphic representations evoked pity and even empathy for Huguenot men and women depicted as victims, at least among those who, after years of sectarian conflict and persecution, had increasingly come to identify with them as coreligionists.

Although all four of these massacres took place in 1561–62, the print collection depicting them did not begin to circulate in France until eight years later. By then, France had experienced three separate wars of religion (1562–63, 1567–68, 1568–70). This trajectory of religious strife was well documented by pamphlets and collections, especially from a Huguenot perspective. Catholic versions circulated, too, but they were generally less common, less concerned to provide evidence, and more vehemently polemical. Following these three outbursts of extended sectarian violence, the Peace of Saint-Germain-en-Laye (5 August 1570) conceded extensive toleration to the Protestant minority, including public worship in numerous localities and specified "safe towns" that excluded both Catholic militias and royal troops. This was the first treaty to be officially described as "perpetual and irrevocable."[73] Thus, the forty prints in *Wars, Massacres, and Troubles* entered France at a time when there was growing reason for them to be viewed largely as a pictorial chronicle of a period now over, something to be remembered, not to be relived. But worse was yet to come.

Sources of a Collective Trauma

On 24 August 1572, the Catholic populace of Paris, believing that it was carrying out both the king's will and God's will, followed the example set by royal soldiers and slaughtered about two thousand Huguenots in the

capital. This Saint Bartholomew's Day massacre was not a day, but a season, as Jules Michelet famously noted, for massacres followed in a dozen provincial towns and cities, including Rouen, Lyon, Toulouse, and Bordeaux. Whereas the numerous massacres that had taken place in the six years from 1562 to 1568 had resulted in roughly three thousand deaths across the kingdom, those of 1572 killed at least twice as many people in a few weeks. Estimates at the time, however, were often far higher. Common estimates included ten thousand killed in Paris and fifty thousand for the entire kingdom.[74] More important than precise totals was who died and how they were killed. The killing began when royal forces carried out orders to murder several dozen Protestant noblemen, starting with their most influential leader, Admiral Gaspard de Coligny. Rather than remain a limited, preemptive strike, this first wave of killing inspired an orgy of murder that left the streets of Paris littered with corpses and the Seine River tinted by blood. Three days of butchery and looting mixed private grudges of long standing with public rituals of justice and purification. Contradictory signals from the king and court facilitated the series of provincial massacres that followed over the next six weeks. With the apparent exceptions of Bordeaux and Rouen, these other massacres also involved violent mobs that perpetrated horrific acts of brutality such as mutilating corpses and cutting open pregnant women.[75] A kingdom-wide killing spree of such magnitude, one that began with the murder or capture of their aristocratic leaders, sent a "traumatic shock" through Calvinist communities everywhere.[76]

The shock of the Saint Bartholomew's Day massacres interwove three elements—political, existential, and psychological—that turned them into a collective trauma for Huguenots throughout France. Catholics had frequently depicted Huguenots not only as heretics, but as rebels against royal authority. Charles IX confirmed this charge by immediately putting his royal stamp of approval on the massacre in Paris. Seen from the Huguenots' perspective, therefore, their horror "did not consist uniquely in the violence of the massacres, but at least as much in their circumstances: the ruse of a king drawing his nobility into a trap, having his subjects surprised in their sleep, after having promised them peace and protection, in order to have them massacred without a trial."[77] Royal treachery and religious fanaticism had combined to produce mass murder on an entirely new scale. From the Huguenots' point of view, the massacre made Charles IX a tyrant. Despite Calvin's long insistence on obedience to political authority, Protestant political theorists turned this collapse of trust in the king into the legitimate basis for resisting authority.

The widespread massacres combined with a subsequent royal ban on Protestant worship to provoke an existential crisis for Calvinist congregations

throughout France. The major towns and cities where the massacres took place saw hundreds, even thousands of Protestants return to the Catholic Church. Orléans witnessed fifteen hundred abjurations, Rouen registered more than three thousand, and Paris had some five thousand or more.[78] Large numbers of abjurations also took place in towns where there had been no massacre, such as Dijon. Catholic authorities there (as well as elsewhere) had gone so far as to gather local Protestants into a castle keep for their own protection. However, having to sign a declaration promising "to live Catholically" in exchange for their release started a small wave of abjurations that extended beyond those temporarily under guard. Having a certificate of abjuration mattered to everyone concerned: canonists considered it essential, priests saw it as a guarantee of seriousness, and penitents wanted to have it as irrefutable proof of their recovered Catholicism in case of a future massacre.[79] In other towns, no coercion was necessary to initiate the process. Huguenots who had sworn never to return to Catholicism even if burned alive as martyrs were returning "not in ones or twos, but in large groups to sing in the churches."[80]

The existential crisis that confronted Huguenot churches in 1572 erupted at the personal level as well. Many of the thousands of Protestants who abjured did so simply due to fear of also being killed.[81] Other Protestants, however, abandoned their new religion because they interpreted the multiple massacres of 1572 and the royal decree banning its exercise as divine condemnation of it. For example, the pastor Hugues Sureau Du Rosier abjured in September 1572, then personally helped to convince the captive princes Henri de Navarre and Louis de Bourbon to abjure, and finally fled to Heidelberg in 1573 where he later recovered his Calvinist faith. Once in exile and restored to "the true religion," he published an account of his religious travails in which he began by denying that he abjured out of fear of death. Rather, he explained, he had viewed earlier massacres as evidence of God's corrective punishment of his chosen people, but the events of 1572 had so devastated the reformed churches of France, leaving them little hope of recovery, that he must have been mistaken. From this pastor's initial point of view, the events of 1572 showed God's "indignation" and "detestation"; they were signs that he "condemned the profession and exercise of our religion." Sureau Du Rosier's account may be rare, but he published it because his thinking was not.[82] No census of the newly outlawed reformed churches was taken in 1573, but a decade later, Jean de L'Espine, a well-informed contemporary, claimed that French Protestant churches had lost two-thirds of their members, and not all of those losses were due to fear alone.[83]

One can hardly imagine a more tangible manifestation of the psychological elements of a shared trauma than individually signed abjurations, most of which were linked to collective ceremonies of reintegration in

communities around the country. As one contemporary observer noted, "All of these unfortunates were obliged to abjure; they had to sign a formula of abjuration. These abjurations were a real torture for them."[84] Hundreds of reformed congregations all over France were torn apart as members were forced to decide whether to abjure, remain faithful, or turn to Nicodemism. As a modus vivendi, however, the choice of individuals or families to hide their true beliefs behind a facade of Catholic conformity entailed an especially intense combination of self-reflection and interiorized piety. Nicolas Pithou's rare memoir provides an account of the anxiety that he experienced over his choice of religion. Writing in retrospect and in the third person, Pithou describes a psychomachy between public persona and interiorized belief that can play such an important part in the self: "[attending Catholic Mass] on Sundays, counterfeiting himself on the outside and presenting an appearance other than he was [on the inside (later struck out)], fearing possibly to be known and identified as what in truth he was on the inside [i.e., a Protestant]."[85] He contrasts his fear of God with his fear of men and the loss of his property, and then shamefully admits to temporizing. Even though he believed that interior belief needed to be manifest externally, he rejected the idea that external actions undertaken against his conscience would destroy his identity as a true Christian, that is, as a Protestant. Such choices and rationalizations put a severe psychological strain on individuals, especially because Huguenot leaders vehemently condemned Nicodemism as a betrayal of both God and fellow believers—and, thus, the very opposite of martyrdom—that sapped the foundations of any local congregation.[86]

That the massacres of 1572 provoked a collective trauma for Huguenots can hardly be in doubt. So obvious and natural does this reaction appear, however, that the mechanisms that helped to constitute it are often ignored. News of the massacres first spread by fleeing refugees and networks of correspondence, and yet these often provided incoherent accounts of events so horrific that they could not be adequately described, explained, or comprehended. Survival had frequently depended on the assistance of Catholic neighbors, and many Catholics themselves feared being mistaken for Protestants, thereby blurring the distinction between Protestants as victims and Catholics as perpetrators.[87] The various survivors who fled to Geneva brought eyewitness accounts limited by the narrow perspective of individual experience, and thus laced with gaps and contradictions. It took the Calvinist leadership considerable time to record and correlate the various accounts they received.[88] Although a large number of publications, whether poems, hymns, or pamphlets, appeared in the wake of the massacres, these were almost all Catholic celebrations of a royal triumph over conspirators and a popular triumph over heretics in which "the visions of horror became

murky."[89] In other words, Huguenots found it very difficult to obtain accurate, detailed, and coherent accounts of events in the first weeks and months following Saint Bartholomew's Day. In fact, there is very little remaining evidence of what precisely happened during the massacres of 1572 that has not been at least somewhat adulterated by Protestant propagandists intent on constructing a "myth-making metahistory."[90] The first significant published account from a Huguenot perspective appeared more than six months after "the day of treason," as the publisher described 24 August 1572, and this framed the violence with a narrative of royal treachery and cruelty.[91] The other major publications on the massacres, including those based on eyewitness accounts, appeared years after the massacres.[92]

Before Protestants could develop an explanatory narrative of the massacres of 1572, they responded to survivors with empathy and solidarity. In seeing themselves as God's elect, the Huguenots identified their persecution with calamities suffered by the Israelites. The Old Testament not only taught that God permitted afflictions as a means of correction, but that he also responded to the sufferings of his people with pity and compassion. It was natural, therefore, for Huguenots to model such responses themselves. For example, the pastor at Troyes, Nicolas Pithou, wrote in his memoir, "Finally, our good God, looking with pity on the poor churches of France, having compassion for their miseries and calamities, for all of his desolated people, gave them relief from so much misfortune by a peace," which ended the third religious war in August 1570.[93] In other words, despite the emphasis Calvinism placed on stoicism, it could also accommodate empathy for coreligionists in distant congregations. One of the first coordinated responses to the Saint Bartholomew's Day massacres took place at Geneva where Theodore Beza gathered together a score of refugee pastors. According to the official account of the meeting, he first "showed them the compassion that we had for their calamities, *which are ours*" (emphasis added), asked them to share "familiarly" their resources and needs, and offered financial support.[94] Although it came in a face-to-face setting, this was an expression of nonvictims sharing in the suffering of strangers, thereby tightening bonds between Huguenot communities across France.

The earliest Protestant responses to the events of 1572 not only emphasized the cruelty and horror of the massacres, they also insisted on the innocence, piety, and virtue of the victims. Underscoring these latter characteristics served to rebut royalist propaganda, which presented Huguenot leaders as conspirators. Also important in shaping immediate responses were the already published Huguenot versions of earlier massacres. These created an apparent continuity of violence that made Saint Bartholomew's

the culmination of a trajectory of violence that now appeared planned and executed with royal support, despite the official peace that had reigned since 1570.[95] In short, the scale of the massacres combined with the earliest Protestant efforts to comprehend their purpose and meaning turned them into a kingdom-wide collective trauma that well exceeded any previous experiences of religious violence.

The lack of published texts or images that described or depicted in detail the massacres of 1572 in their immediate aftermath suggests that Tortorel and Perrissin's graphic images of earlier massacres helped to intensify the personal responses and thus collective trauma that struck Huguenots at the time. None of the contemporary pamphlets conveyed so vividly the visceral cruelty of the most recent massacres as did these prints of earlier events. Moreover, the fact that they formed a new medium for reporting recent events would have greatly increased their emotional impact. At the very least, the variety of massacres depicted in the collection made it easier to imagine the dozen or more urban massacres of 1572 without having to witness them directly. There is little doubt that the spoken word was the most important means to disseminate the actual horrors and suffering experienced during the massacres. Contemporary pamphlets reflected this oral culture, while also giving it greater consistency. Some earlier pamphlets had clearly sought to arouse the emotions of their fellow Protestants, just as sermons did. The stated purpose of one such pamphlet was to record the persecution and "execrable murder" of followers of the gospel, which will "help us to be more emotionally stirred (*nous sert pour estre plus esmues*)" as well as to combine prayer with vigilance.[96] Another recent author had worried that the events of 1568–70 were "so lamentable" that recounting them would "only multiply the horror and misery," but justified his publication as a way to give eyewitness accounts precedence over hearsay.[97] Most pointedly, in 1569, Antoine de Chandieu published his "Ode on the Miseries of the French Churches." This was a highly emotional and deeply personal response to the violence inflicted on the "true church" in France. The central stanza describes the poem as a boat that carries its author on rivers of his own tears, spreading the news of his fellow Protestants' suffering in France to distant lands. This major poem by an important Huguenot leader and publicist marked a new level of spiritual anxiety and emotional introspection published in response to three wars of religion in order to share such feelings with coreligionists.[98]

The dramatic new medium of printed images of religious massacres reflected and extended the eyewitness accounts, sermons, and pamphlets of the day. Many of Tortorel and Perrissin's sources were clearly oral, although the contents were generally confirmed by later printed sources.[99]

This relationship to other sources enhanced the effectiveness of these images in communicating the distant suffering of the victims of the Saint Bartholomew's Day massacres. Thus, their images provide more than mere proxies for the sort of descriptions contained in pamphlets, or even in private correspondence and Protestant sermons, most of which have long disappeared. These images significantly enriched a corpus of materials that provided the basis for increasing affinities between various Huguenot congregations. "Not only did the good Huguenot household possess a family Bible in French, it usually had a range of other texts, including a prayer book, a psalter, and Crespin's *Book of Martyrs*."[100] A copy of *Quarante tableaux* would have been an ideal addition to even modest collections of Protestant literature. Moreover, Le Mans was surely not the only church where deacons shared "responsibility for reading Crespin's martyrology before the minister's sermon."[101] This practice suggests the importance of communal participation in identifying with the sufferings of others. Given that many congregations met in private homes, and thus in small groups, owners of such homes would likely have shared their copies of *Wars, Massacres, and Troubles* with their fellow believers.

Although the *Quarante tableaux* did not include depictions of the Saint Bartholomew's Day massacres, they did provide powerful support for a Protestant interpretation of the horrors of 1572. In response to Catholic propagandists who presented the massacres as both divinely inspired (to stamp out heresy) and royally authorized (to preempt conspiracy), Protestant publicists countered with an explanation that combined four elements: the treachery of the monarchy, the barbarism of the perpetrators, the innocence of the victims, and the continuity of violence directed against God's elect. All of the massacres directed against Huguenots over the previous decade, therefore, automatically became part of a compelling history of the present. In short, the dramatic images of Tortorel and Perrissin not only illustrated past events, they confirmed and enriched the Protestant discourse about the "inhuman cruelties" and "papist barbarities" of the Saint Bartholomew's Day massacres.[102]

It is not possible to describe with real precision the impact the images disseminated by Tortorel and Perrissin had on individuals and communities; nevertheless, some tentative conclusions are possible. These are based on following the lead of modern art historians who, having moved from connoisseurship to visual culture, infer meaning from pictorial techniques, and thereby interpret the responses artists intended to provoke in viewers.[103] Furthermore, David Freedberg and Vittorio Gallese argue that visual representations of emotion-laden gestures provoke sensorimotor activity

that is the neurological basis for emotion and empathy from viewers.[104] They conclude unsurprisingly that the more realistically an artist depicts an emotional gesture, the more readily the beholder identifies with it. Such claims are made explicitly in terms of emotional responses such as grief and fear. The massacres of 1572 "provoked a veritable trauma—the word does not seem too strong—in those who experienced them directly or indirectly (*ceux qui de près ou de loin, les ont vécus*)," notes Janine Estèbe. "We are not surprised, therefore, that certain individuals who strongly felt the tragedy in their hearts and souls translated their emotions into very violent images."[105] But there was more to this relationship between images, both visual and verbal, and the experience of trauma, for it was the communication of mass violence and personal suffering to others that helped to produce the indirect trauma mentioned by Estèbe. In short, the images and explanatory playlets contained in the *Wars, Massacres, and Troubles* made these prints, whether viewed individually or as part of a series, a potent medium that helped to generate the collective trauma experienced by Huguenots in the wake of the Saint Bartholomew's Day massacres of 1572. This collective trauma served to crystallize Calvinist religious identities as victims of Catholic violence and God's chosen people at the same time.

As noted earlier, Tortorel and Perrissin's prints had been immediately reproduced in a smaller format—and adulterated form—by Franz Hogenberg, a prolific Protestant printmaker based at Cologne. Although his series had fewer scenes, he did include all six massacres from the original series. Financial insolvency ended publication of *Wars, Massacres, and Troubles* in 1572. This left Hogenberg to generate his own depiction of the Saint Bartholomew's Day massacre in Paris, which he did very quickly. This is another diachronous image that combines several stages in the assassination of Admiral Coligny with a general slaughter of Protestants. Hogenberg depicts many defenestrations, bodies being aggressively stabbed and dragged, and numerous naked corpses left strewn about the streets. Although the original explanatory text is in German, some early copies had a French translation mounted above the image.[106] The caption is most noteworthy for claiming that some three thousand "gentlemen and servitors" of Coligny had been killed, as well as another five thousand Protestant men, women, and children. The significance of Hogenberg's print lies less in the size of its audience in France, which was probably small given the royal crackdown at the time, and more in how it conveys the earliest consensus on the massive scale, extreme brutality, and indiscriminate nature of the slaughter (see plate 4).

The bloody events of 1572 solidified the shift that Calvinists had been making away from an earlier emphasis on stoic martyrs and toward a more

emotional emphasis on innocent victims killed for their faith. The wide availability of Tortorel and Perrissin's printed images of previous massacres offered a ready-made interpretive framework for understanding the events of that year. Together with the purification and consolidation of the Huguenot church in France during the years of conflict since 1561, the new psychological framework together with the graphic quality of the images served to turn what otherwise may have been largely pity into a stronger emotional investment in fellow believers, one characterized by empathy and compassion. Simon Goulart's hugely influential, multivolume work, *Mémoirs on the State of France under Charles IX*, first published in 1576, reinforced the trend. This lengthy compendium and narrative commentary contained detailed descriptions of many of the massacres that had taken place four years earlier. Goulart's work was unusual in trying to identify as many ordinary victims as possible. Such an approach fit with his insistence that such victims deserved the status of martyrs, a position that he reinforced when he published the expanded final edition of Crespin's martyrology in 1582. Goulart's approach, with its emphasis on the suffering of God's elect, provided the narrative interpretation and emotional fuel that would galvanize remaining Huguenots into not simply dying for, but rather fighting for, their faith.[107]

CATHOLIC RESPONSE

According to Denis Crouzet, the massacres of 1572 also had a major psychological impact on French Catholics, one that may appear surprising given that the perpetrators had been militant Catholics whose extreme violence had been quickly legitimized by royal authority. Though many Catholics were clearly sickened by the slaughter, even more of them saw it as providential. The spate of Catholic pamphlets and poems that followed the massacres made no attempt to downplay the popular violence that had been unleashed, but rather reveled in it. Their common theme was that God had intended the massacres to punish heretics, to save the kingdom, and to glorify "the Most Christian King."[108] Over time, however, many Catholics became profoundly disturbed by the survival of the Huguenots. The Saint Bartholomew's Day massacres may have been a form of divine intervention in the world, but it proved to be a *miracle manqué* because it failed to extirpate heresy throughout the kingdom. This failure had a distressing explanation: Catholics themselves had thwarted God's purpose through their sins and wickedness. Far from relieving good Catholics of their eschatological anxiety, therefore, the massacres heightened their sense of sinfulness and increased the perceived need for collective penitence. Such responses would prepare true believers

for a return to God's soteriological violence. This need for collective penitence and preparation for sacral violence constituted the religious foundation of the Catholic League that took shape in the 1580s.[109]

Considering the violent rhetoric of Catholic polemic, it is remarkable that contemporary printed images of Huguenots committing massacres are almost completely absent from the wars of religion in France until very late—the only prominent printed one being that of the *Michelade* at Nîmes depicted in *Wars, Massacres, and Troubles*, which was published by Protestants. What Catholic depictions of Huguenot violence may have looked like, had they been printed for wider distribution, is suggested by the watercolor drawings in the manuscript volume "De Tristibus Galliae," composed in the mid-1580s.[110] Here the destruction of sacred images and religious artifacts is especially significant (see plate 3). The manuscript also contains images of Protestants killing Catholics but mainly in the context of sieges. One unique image shows Huguenots dragging a corpse and desecrating graves. Blood miraculously spurts from the stabbed skeleton of a disinterred saint while a priest's body is stuffed with communion wafers (see plate 5). Here God's immanence in the world through the Eucharist (the blood and body of Christ) matters more than depicting an actual event. Thus, not even this image attempts to historicize a veritable massacre.

Rather than publishing depictions of massacres,[111] Catholic polemicists published texts and images intended to provoke massacres. As early as the 1550s, the priest and prolific publicist Artus Désiré denounced Protestants in France as "priapic prophets of Antichrist who would be eliminated in the coming cosmic battle that heralded the End Time."[112] Publications of this sort added to their message of eradication by representing Huguenots as iconoclastic monkeys.[113] Today's viewer, familiar with the Nazis' labeling of Jews as *Untermenschen* and the Hutus' description of Tutsis as cockroaches, can hardly avoid being unsettled by depictions of Huguenots as monkeys—the dehumanization of victims being an essential element of most massacres.[114] Equally important is the religious idiom of the sixteenth century. First, the cult of images played a key role in the construction of shared identities, whether social, professional, religious, or political, through the social media of processions, confraternities, dedications, and public oaths. The sudden abolition of such images profoundly changed how individuals understood their relationship to a community. Destroying images of patron saints, scattering relics, burning vestments, melting chasubles, smashing altars, and tearing down rood screens all sundered the ties between the living, the dead, and the celestial protectors that had constituted an enduring collectivity.[115] Thus, what may appear mainly as property

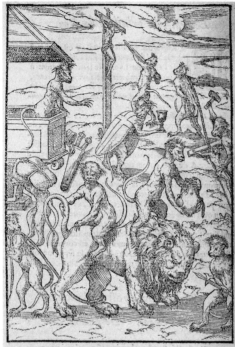

APOCAL. XIII.

Puiſſance a eſté donnee à la beſte de blaſphemer con-
tre Dieu & ſon tabernacle, & ceux qui habitent au
ciel. Et luy a eſté permis faire guerre contre les
Sainᴄts & les vaincre.

Figure 3. Catholic polemic:
Huguenots as iconoclastic monkeys
subjugating a lion that represents
both Lyon and France.

Printed in Gabriel de Saconay, *Discours des
premiers troubles advenues à Lyon*
(Lyon: Michel Jove, 1569). Special
Collections, University of Virginia,
Charlottesville, VA.

damage today was experienced by sixteenth-century Catholics as the massa-
cre of communities founded on the immanence of God in the world.

Second, the link to the Apocalypse is made explicit in a printed frontis-
piece that quotes the book of Revelation: "Power was given to the beast to
blaspheme against God and his tabernacle, and those who dwell in heaven.
And he was permitted to make war on the Saints and to defeat them" (see
figure 3).[116] According to scripture, the period of the beast's power would
be limited and would end with the beast's destruction in the final battle of
Armageddon, the essential precursor to God's reign on earth. The obvious
conclusion for Catholics to draw was that Huguenots were themselves a
sign of the end times, and therefore the true faithful needed to prepare for
another great bloodbath. Thus, what may seem to be almost playful, even
farfetched, images of iconoclasm are, in fact, once understood in a biblical
and eschatological context, visceral provocations to religious massacre.[117]

Instead of trying to communicate suffering through print media, Catholic leaders mobilized the faithful through devotional confraternities and their attendant public processions, especially in the mid-1580s.[118] Devotional confraternities made greater spiritual demands on their members than did intercessional confraternities. The latter had a long history as basically social bodies organized under the auspices of a patron saint, whereas devotional confraternities cultivated more intense forms of lay piety, especially as expressed through overt action. They also expanded to admit less socially elevated members. The processions held by devotional confraternities were penitential in nature, serving as collective expressions of expiation and pleading for divine mercy. These processions were especially effective rituals of religious purification because they worked to fuse the individual and the community. Penitents effaced their social status and individual identities by wearing hooded tunics, but also accepted individual suffering through long marches barefoot, often combined with self-flagellation, in order to invoke God's immanence in their communities. Such processions could become instruments of religious aggression, at times turning into veritable pogroms. Some ecclesiastical authorities worried that such popular fervor had escaped their control and that a rift was opening between the faithful and the institutional church.[119]

The role of processions as an alternative means to communicate suffering has not been fully appreciated. In short, the ability to share in the suffering of others depended on the theological notion of belonging to the mystical body of Christ in which the union of the baptized produces a commerce of prayers and in which "everything received in holiness by each, belongs somehow to all."[120] The role of the church in mediating individual salvation was, therefore, paramount. As the vehicle of the sacred, it deployed an institutional rejection of the profane life through clerical celibacy and monasticism, on one hand, while on the other, it made available the sacraments to all. Thus the institutional church both denigrated the lives of lay individuals and provided the means of spiritual rescue for them at the same time. Naturally, therefore, lay Catholics were not ordinarily expected to share the same level of dedication to the faith as clerics; however, in a time of widespread "eschatological anxiety," processions offered laymen an opportunity to become instruments of their own salvation, as well as that of their communities, in advance of the Final Judgment.

CONCLUSION

The different responses to the massacres of 1572 reflected not only differences in theology and religious practice, but also different experiences of

individual suffering and the means by which it was communicated to others. As Charles Taylor notes, the Protestant doctrine of the priesthood of all believers provided a stimulus to the emergence of the modern self. But too much emphasis on a fundamentally Lutheran concept of individual salvation misses the significance of Calvinist teachings about predestination, especially in the context of severe persecution. Here the survival of God's first chosen people, the Israelites of the Old Testament, provided powerful inspiration and a unifying solace. The many editions of Crespin's martyrology, with their shift after 1570 toward including victims of massacres, added more immediate examples for Huguenots to admire and possibly emulate. The ways in which Calvinism encouraged a more clearly articulated sense of self interacted reflexively with the new ways of communicating the suffering of those involved in a religious massacre to those who had no direct experience of it. As Tortorel and Perrissin's scenes of massacre demonstrate—and remember, they are both proxies for and heighten the intensity of the abundant Protestant pamphlets of the day—representations of others' tragedies could only provoke compassion in fellow believers if they (1) contained details that could be substantiated, (2) were easily understood without elaborate explanations, and (3) captured the intensity of mass brutality and individual suffering, all at the same time. Furthermore, the series of prints by Tortorel and Perrissin reflected a Protestant version of the causes and course of the wars of religion. The inclusion near the beginning of two prints showing the arrest and execution of Anne du Bourg created a clear trajectory from martyrdom to massacre in the years 1559–62. The clustering of prints showing massacres from 1561 and 1562 (Cahors, Vassy, Sens, and Tours), while also omitting various others, reinforced the contrast between a brief period of attempted political conciliation and a new season of Catholic violence.[121] The inclusion of these early massacres in particular also indicates the process by which they became "chosen traumas"[122] that helped to consolidate the collective religious identity of French Huguenots. Thus, whenever Protestant leaders negotiated peace terms with the crown, they argued for compensation for these massacres in particular.

Moreover, disseminating the series throughout France in 1570–72 had the unintended consequence of adding to the psychological shock of the Saint Bartholomew's Day massacres. The intense pathos of the images stood out in the media landscape of the period, and they were readily available in 1572 well before coherent Protestant accounts of the events that year could be published. In this case, historicizing massacre had the effect of magnifying it. Tens of thousands of abjurations, together with

widespread Nicodemism, revealed the extent to which emotional shock and self-doubt endangered French Calvinism. Those who chose to remain avowedly Huguenot became convinced that armed resistance to the monarchy, based on a fusion of religious organization and martial power, was both acceptable and essential to their survival, and thereby the propagation of true religion.[123] Once the Protestant Union formed across southern France in 1572–73, however, Huguenots became more prone to perpetrate killings that did not fit the analysis of Natalie Davis. It would be easy to dismiss these as part of a cycle of vendetta,[124] but that would suggest that they lacked religious content. Such an analysis soon becomes tautological: only when Protestants engage in iconoclasm and lynch priests are they truly engaged in religious rioting; the rest is merely murder.

Much the same can be said of Denis Crouzet's analysis of Catholic responses to the massacres of 1572. He is alert to the psychological impact of what we have dubbed the *miracle manqué* of that year, though his description makes it appear even more traumatic for Catholics than for Protestants. The more than ten years that elapsed between 1572 and the full flowering of the penitential movement, however, suggests that this latter had more to do with a growing willingness to implement reforms adopted by the Council of Trent. At the very least, the two were complementary, fostering increased personal piety and, thus, a burgeoning self. Furthermore, the popular and clerical trends clearly gave the militant Catholic League a base of support that vastly inflated the political ambitions of the Guise family. It is a mistake, however, to see this all channeled into a form of mystical politics in which Catholic zealots of all ranks would find individual and collective salvation in the assassination of Henri III. The evidence suggests, on the contrary, that the religious purity of their local community mattered as much in 1588, when the Sixteen locked down Paris in the "day of the barricades," as it had in 1572. Just because they were not massacring supposed heretics—partly because there were so few available to massacre—did not make this any less religiously inspired violence.

There is plenty of evidence, therefore, that the events of 1572 constituted a collective trauma for Huguenots as well as a catalyst for Catholic piety. Moreover, the resulting intensification of religious experience in both religions provided a stimulus for the self. This is most notable in terms of increased self-reflection and interiority that came with greater piety. It is easy to appreciate the psychological strains that resulted from being forced to decide whether to make outward actions reflect inner beliefs. In this context, communicating the suffering of coreligionists to those not directly impacted by events could only have added to the strain. The process of

confessionalization in the sixteenth century eroded various traditional social structures that had been powerful determinants of personal identity. The emergence of religious choices frayed the crosshatched networks of kinship, confraternity, and local community, and thereby forced individuals to engage more psychologically in defining themselves. By the late sixteenth century, once confessional divisions had become clearly articulated almost everywhere, local religious leaders (especially pastors and priests) became far more influential in maintaining a sense of community. They did so through collective religious rituals that emphasized both the internal state of the believer and social conformity. David Sabean has suggested that the new dynamic of confessionalism created a tension between individuals who largely constituted their personal identities in concert with others and clerical leaders who employed disciplinary methods intended "to relocate the constituting matrix from without to within."[125] Regardless of the differences in how the various confessions handled this issue, its commonality points to the increased prominence of reflexive self-consciousness that resulted from the breakdown of Christendom into rival religions. Visual and textual representations of the suffering caused by sectarian violence made it increasingly possible to identify with, and feel empathy toward, individuals from distant communities who were unknown and even unidentified, other than by an increasingly reified religious identity.

The Fronde and the Crisis of 1652

Long before Victor Hugo's poem of 1872, 1652 was "l'année terrible" for Paris. This year brought the climax of the Fronde to the capital. Widespread violence by marauding troops, a rush of refugees to the city, and a terrifying disintegration of social and political order traumatized the social elite of the city. The sheer complexity of the Fronde, with its sudden and confusing shifts in alliances among a bewildering array of learned magistrates and atavistic aristocrats, has been enough to discourage scholars. Even the eminent Pierre Goubert wondered how best to distill the significance of the Fronde; faced with how much there is to recount, he remarked, "it is acceptable to hesitate: a roiling ocean of intrigues, despicable acts, chaos, and armed revolts of all sorts . . . dearths, epidemics, perhaps plagues, certainly soldierly rabble. What then is the essential?" In trying "to think" the whole thick stew, he drew his conclusion: "We will solidly affirm, that almost all the elements of the Fronde . . . were connected to the past, which they prolonged, exalted, then terminated, or almost."[1] Likewise, one of the most insightful histories of these events concluded that "the Fronde lacked a quality that, more than any other, can make a historical phenomenon significant: it had no creative value. The Fronde added nothing to history, neither a new idea capable of spreading, nor a new rhythm."[2]

With hesitation, condemnation, and scorn characterizing even the best histories of the period, there is little wonder that historians have generally missed an important cultural development that arose from emotional and psychological reactions to the troubling events of the time. Using the concepts of collective trauma and the modern self to analyze the cultural impact of the violence generated by the Fronde, especially at its height around Paris in 1652, focuses attention on the interaction between two elements of the crisis: contemporary representations of violence and suffering, on one hand, and the practice of religion, both personal and collective, on the other. These topics are not obviously complementary. All the same, an examination of their interaction suggests that many members of the

Parisian elite experienced both a sense of collective trauma during the summer of 1652 and an intensification of self-reflection. More specifically the interplay of religious change and civil war led to the sudden emergence of collective compassion expressed as a serious effort to relieve the suffering of those most afflicted by the widespread devastation and violence.[3]

This new charitable imperative, which became a feature of baroque piety, was rooted in religious developments of the early seventeenth century. These changes helped to inspire a greater inwardness and personal piety among those who sought salvation through the Catholic Church. In addition, the birth of Jansenism and its incubation near Paris, the influence of the secretive social network known as the Company of the Holy Sacrament, and the foundation of various charitable religious organizations operated by lay women as well as men, all contributed significantly to shaping social and cultural responses to the violence and upheaval of the Fronde. These responses included a novel form of compassionate witnessing that combined with a more intensely interiorized piety to produce an early form of Christian humanitarianism. This more socially engaged form of charity reflected an emerging sense of self and a collective response to the suffering of others.

RELIGIOUS TRENDS

Major religious trends linked to the Counter-Reformation in France did much to shape responses to the widespread suffering caused by the Fronde. These trends encompassed a variety of ideological, spiritual, and social elements.[4] Catholic attitudes toward the role of the individual in securing spiritual well-being changed considerably between the 1580s and the 1640s. As we have seen, this shift began as part of the church's response to the Protestant Reformation, but it had developed its own internal dynamic by the early seventeenth century. Therefore, like the Protestant Reformation, the Catholic Revival dramatically added to the pressures and expectations placed on individual believers. Even within mainstream Catholicism, salvation became increasingly a matter of personal religious practices in addition to collective worship.

Making religion more intensely personal required individuals to interiorize the church's religious teachings by learning how to pray and meditate in private, rather than simply to participate in public prayers and liturgical routines. France experienced a steady shift toward private devotional practices in the early decades of the seventeenth century. This cultural revolution toward a more silent spirituality required secular clergy to be both

better trained and more influential in religious affairs. Edmond Richer's major treatise of 1611 argued that parish priests should have a decisive voice in the affairs of the church because they were the ones who performed its essential function, the cure of souls. That same year, the enormously influential Pierre de Bérulle founded the Oratorians as a noncloistered order devoted to the training of ordinary priests. The Oratorians believed that only the proper performance of priestly functions would enable lay believers to receive the sacraments and the spiritual guidance needed to attain God's grace. This simultaneous emergence of *richérisme* and the Oratorians accelerated the trend toward greater personal piety.

The novelty of these developments is hard to appreciate without a sense of just how little spirituality even priests displayed at the end of the sixteenth century. In fact, at the time, most people doubted if the secular clergy, let alone ordinary lay men and women, could live a life of genuine spirituality; such a life was reserved for those who took vows and entered a cloister. Lay Catholics, however, craved more direct access to God and sought it through active devotional experiences. Popular religion, especially in areas largely devoid of Protestants, did not put much emphasis on the Mass, especially in comparison to repeated processions, confraternal feasting, and regional pilgrimages to the shrines of healing saints. Whatever rudiments of Catholic doctrine most believers acquired came from the liturgy rather than catechism.[5] A flowering of confraternities for both sexes underscored the continued importance of sociability in developing religiosity and personal piety. At the same time, private devotional works became increasingly popular among the literate. The result was something of a paradox in which a group of educated women might meet as members of a devotional association whose sociability also fostered more private and interiorized forms of spirituality.[6]

At the heart of personal salvation lay private confession, which Tridentine Catholicism had made "the most daunting of all the sacraments for the mass of the population."[7] By requiring the believer to offer a private confession before taking communion, the church created a psychological drama focused on each individual's conscience. Furthermore, the church also encouraged more frequent communion, thereby making confession a more common practice. The development and spread of confessional boxes sheltered sinners from their nosy neighbors and so increased pressure on believers to engage in serious self-accusation. This move toward examining one's own conscience more thoroughly and more often encouraged a broadly based interiorization of spirituality. And yet the growth of religious and spiritual individualism among ordinary French men and women should

not be overstated. Confession and communion at Easter became nearly universal in the late seventeenth century only because it remained largely annual and communal.

More personalized forms of spirituality tended to develop among the urban elite. François de Sales's wildly popular book *Introduction to the Devout Life*, first published in 1608, had a major impact. Rather than write for cloistered men and women for whom religion was a vocation, De Sales addressed himself to lay people, starting with those who possessed social power and influence. This masterpiece of spirituality and psychology taught that true piety could be attained even by individuals who wished to continue enjoying worldly pleasures. Such piety would merely require daily devotions, a regular search of one's conscience, and acts of benevolence toward the less fortunate in life. Thus, personal prayer and private meditation were needed to supplement attendance at Mass and the seven sacraments. Moreover, one's way of performing spirituality was to be explicitly individualized. "Devotion must be exercised differently by the gentleman, the artisan, the servant, the prince, the widow, the daughter, the wife; and what is more, devotional practices must be tailored to fit the strength, the vocation, and the duties of each individual."[8] Thus, genuine spirituality became available to ordinary Catholics, rather than being restricted to individuals who had taken religious vows and, in doing so, engaged in an "annihilation of the self."[9] This laicization of piety discreetly incorporated elements of the Protestants' priesthood of believers without theologically compromising Roman Catholic orthodoxy. Men and women who did not want to abandon their engagement with society could still achieve true piety, notably through acts of charity, thereby accruing spiritual benefits for the individual while also alleviating suffering in others.[10]

The emergence of Jansenism also fostered the personalization and interiorization of piety in France. The foundational text, Cornelius Jansen's monumental *Augustinus*, appeared posthumously in 1640. Most theologians viewed this as an extreme interpretation of Augustine's arguments regarding humankind's total depravity and consequent total dependence on God's salvific grace to overcome sin and eternal damnation. The resulting controversies over dogma played little part in most conversions to Jansenism, however.[11] The motive for making such a life change came from the psychological appeal of playing an intensely personal role in responding to God's grace. Jansen's fellow traveler, the abbot of Saint-Cyran, gave the movement a practical twist. He started with the assertion that "God has reduced all religion to a simple interior worship done in spirit and truth."[12] He also instructed the nuns of Port Royal to adopt extreme spiritual asceticism in

response to the innate depravity of all humans. Saint-Cyran insisted that God's grace could not be secured through penitence alone, but required sincere contrition, which could only come from intense self-reflection.[13]

Saint-Cyran's teachings reached an audience well beyond Port Royal thanks to Antoine Arnauld. His treatise *On Frequent Communion* took the French religious world by storm on the eve of the Fronde, running through six editions from 1643 to 1648.[14] Despite its flamboyant show of patristic learning, Arnauld wrote his masterwork in an elegant French rather than scholastic Latin, which enabled lay readers to judge theological issues for themselves, even while being subjected to an almost irresistible logic. Just as important to the book's success was the psychological appeal of its central argument. *On Frequent Communion* advocated an unusually stern morality, especially when individuals prepared themselves for communion. Moral rigor, like asceticism, has always appealed to a significant portion of the population, and this was especially true in seventeenth-century Paris. In contrast to the Jesuits' support for frequent, even daily, communion (a position supported by the Council of Trent), Arnauld argued that practices of the early church showed that communion should be taken infrequently, and only after an arduous cleansing of the soul through confession and penitence. Arnauld exhorted his readers to "pray often, confess often, do penitence often, fast often, weep often, and give alms often—but take Communion infrequently, only when the heart and soul have been carefully prepared."[15] Thus, Arnauld moved well beyond abstract controversies over grace and predestination by addressing immediate issues of ordinary religious practice.

The teachings of Saint-Cyran and Arnauld required believers to reflect much more intensely on their motives and actions. Determining the actions necessary to purify one's soul involved far more introspection than was required of those who took frequent communion. However, the profound "soul searching" that accompanied such practices was not limited to Jansenists. Despite loud hectoring from the Jesuits, the papacy refused to condemn Arnauld's book. On the contrary, an impressive array of sensors, papal nuncios, and bishops formally and publicly approved it. Arnauld's arguments fit well with the "psychology of reverence" developed earlier by Pierre de Bérulle, and thus became a logical extension of one strand of the Counter-Reformation.[16] The immense popularity of *On Frequent Communion* helped to transform the general practices of Catholicism in France. The number of Catholics taking weekly Communion in Paris dropped sharply after the 1640s. Even the Society of Jesus eventually modified some of its teachings on Communion and absolution.[17] Many people had obviously

come to believe that receiving God's grace required a great deal more intro-spection than had previously been the case. As a consequence, the experi-ence of religion became notably more personal and more interiorized, at least among the urban elite.

The various theological and doctrinal impulses that encouraged a more interiorized spirituality in the seventeenth century also provided the cul-tural seedbed for the flowering of collective compassion that accompanied the Fronde. The crusading mentality of the Holy League in the 1580s had produced a "penitential piety" that expressed itself mainly through "com-munal rites of penitence and an ecstatic and apocalyptic spirituality." Once the League collapsed, "collective gestures of atonement" were replaced by "penitential asceticism" in which cloistered religious orders (both male and female) hoped to save lost souls, such as the heretical Huguenots, through self-denial and prayer.[18] However, the generation born after the wars of reli-gion developed new sensibilities. These were not always harmonious, of course. Early in the seventeenth century, Christian stoicism, as developed by Pierre Charron, a theologian at Bordeaux, and Guillaume Du Vair, the bishop of Lisieux, deemed compassion toward the poor a sign of weakness, "a foolish and feminine pity," to be distinguished from a willed and ratio-nal mercy, in which the believer assisted the suffering, but without being emotionally moved or sympathizing with them. Such attitudes contrasted sharply with those of François de Sales and Vincent de Paul, who did not disdain the poor in this way.[19] By midcentury, it was the latter who prevailed. Thus, the penitential spirituality of the late sixteenth century faded as a more charitable spirituality took institutional form. Pious women in par-ticular became increasingly sensitive to the plight of impoverished peasants and the suffering of the urban poor. Visits to hospitals, prisons, and poor houses had long been a laudable feature of the lives of devout lay women of elite status. However, turning such activities into a vocation marked a major social innovation. Thus, by the 1630s, the search for greater spiritual fulfillment had led to another shift in religious values, one that worked to promote charitable service over self-mortification. Devout men and women came to see the desperate and destitute as more than objects of pity, but as lost souls who could not be saved by prayer alone. In short, a thoroughly internalized devotion to God inspired a concern for the plight of the needy. Interiorized piety was directed outward in compassion and apostolic service. This led to a new determination to provide both spiritual and material aid to the poor. Thus, the Catholic Revival in France included the creation of a growing number of lay confraternities (known as *charités*) devoted to serv-ing the sick, the poor, the decrepit. These enabled the devout to lead a deeply

religious life without meeting the restrictions of religious cloistering. Some of these *charités* developed into major religious organizations, most notably the Congregation of the Mission, the Ladies of Charity, and its activist sisterhood, the Daughters of Charity. Such organizations were typical in drawing upon the wealthy for their leadership and financial support, but unusual in being based on local parishes where they devoted themselves to saving the souls of ordinary people through preaching, catechism, and charity.

The women and men who engaged in such charitable activities believed that apostolic service to the poor played a part in their own spiritual well-being. For example, at the height of the Fronde in 1652, the abbess of Port-Royal, Mère Angélique, counseled that personally identifying with the sufferings of the poor would be the premise for God's grace: "It is very good for you to be busy with the poor, of whom there is such a large number," she wrote; "it is together both an action of piety and of justice to feel their misery and to weep with those who weep and suffer excessively. We live in a time when it is necessary to have a heart of mercy toward others if we want God to show mercy to us."[20] (This is especially striking coming from a woman who had been forced by the armies of the Fronde to flee her abbey on the outskirts of Paris in the winter of 1648–49, who deprecated her own capacity to empathize, and who advised others to suffer in silence ["de fair mourir tout cela en soi"].)[21] Thus, despite her own stoicism, Mère Angélique believed that an intensely emotional engagement with the suffering of others would have personal, social, and spiritual benefits.

These increases in personal piety as well as in charitable works became mutually reinforcing responses to the disruptions of the Fronde. In particular, Arnauld's *On Frequent Communion* treated the giving of alms as a critical aspect of spiritual life. More than being merely an appropriate complement to prayer and fasting, giving alms offered a powerful means to secure spiritual absolution. Some of Arnauld's contemporaries thought that this operated as a rather crude exchange in which giving alms would purchase deliverance from the just penalties of sin, even while continuing to sin.[22] However, Arnauld taught that obtaining the spiritual benefits of charity required a change of heart. As he saw it, the "admirable economy of grace" ensures that by undertaking good works, such as giving alms, the sinner prepares himself for God's grace, which then provides the inner inspiration for yet greater faith and more good works. According to Arnauld, giving alms was "very useful to those who seriously think about changing their lives, and to those who, through a liberal distribution of their goods, strive to engage God to grant them the grace of a perfect conversion."[23] Although Arnauld's *On Frequent Communion* was not explicitly devoted to questions of

poor relief, its enormous popularity fostered the great surge of charity that accompanied the Fronde.

The combined impact of the new practical theology on penitential piety and the crisis of the Fronde encouraged Catholics to turn their individual spiritual concerns into collective action on behalf of thousands of peasants left destitute by military and economic crisis. For example, *On Frequent Communion* persuaded Charles Maignard de Bernières, one of the leading philanthropists during the Fronde, to become a lay follower of the doctrines of Port-Royal in December 1643.[24] In 1647, he also joined the Company of the Holy Sacrament, an association of laymen as secretive as it was elitist. The all-male Company embodied the activist side of the wealthy and influential *dévots*. Though often portrayed in a rather sinister light due to their support for incarcerating marginal members of society, the surviving records of the Company show that they made considerable effort to redress the problems of poverty and displacement during the Fronde. They did this by raising money, gathering clothes and food, distributing relief supplies, and generally supplementing the meager "out-of-doors" relief available to the poor at the time. The Company also supported the formation of the elitist Ladies of Charity, which Vincent de Paul and Louise de Marillac organized to provide assistance to the sick at hospitals around France.[25] Moreover, the involvement of someone like Bernières in both Jansenism and the charitable activities of the Company reminds us that their differences did not really harden into strident animosities until after the Fronde when, in 1653, the papacy condemned five propositions distilled from Jansen's *Augustinus*.[26] Bernières also cooperated with Vincent de Paul in his efforts to provide charity to the war-torn countryside, their theological differences notwithstanding. Monsieur Vincent, as he was generally known, objected to Arnauld's position on frequent Communion, fearing that it demanded too much of ordinary believers. Nonetheless, he, too, believed in the importance of interiorized piety. Famous for his dictum "action is our entire task," Vincent de Paul also recommended prayer and meditation before action in order to discern the divine will. "You must have an inner life, everything must tend in that direction," he wrote; "if you lack this, you lack everything."[27] He also told an annual assembly of the Ladies of Charity, "The first means [to sustain your charitable activities] is to have an affection, internal and continuous, for working at your spiritual improvement . . . to have the lamp lit inside of you."[28] Thus, many strands of French Catholicism contributed to the trend toward greater personal piety, which proved a critical factor in "the national awakening to the problem of poverty and the solutions to advocate" at the time of the Fronde.[29]

INFORMATION AND REPRESENTATION

The little-known relationship between midcentury trends in Catholic piety and responses to the violence and destruction of the Fronde is made especially evident by a peculiarly powerful series of pamphlets later known as the *Relations*. The distinctiveness and cultural impact of these particular pamphlets emerges clearly only once they have been situated in the contemporary approaches to reporting current events in print. Despite the sophistication and success of Tortorel and Perrissin's *Wars, Massacres, and Troubles*, nothing quite like it again appeared in France until the French Revolution. In fact, even basic reporting on current events did not become a part of French print culture until the 1630s. Nonetheless, by the time of the Fronde, members of the Parisian elite could count on regularly delivered reports on contemporary events: the printed word had become their daily bread, though it was a loaf unleavened by images.

The first newspaper in France, the weekly periodical *La Gazette*, began when Théophraste Renaudot received an official monopoly in 1631. *La Gazette* achieved rapid success thanks to its regular reporting of current events: battles in Italy, diplomacy in Vienna, profits in Amsterdam, and plays in Paris, all appeared side by side. Supplements called *Extraordinaires* soon appeared to provide detailed accounts of the Dutch siege of Curaçao or the lavish funeral of the king of Denmark. When criticized for printing factual errors, Renaudot justified his publication by making a distinction between history and journalism: "History is the narrative of things that have happened; the *Gazette* [is] only the rumors about them. . . . It does not lie even when it reports some false news which it was given as true."[30] This sophisticated understanding of journalistic truth largely eschewed the sensationalist stories that dominated the ephemeral press.[31] The *Gazette*'s main strength—relatively accurate news—owed much to its main weakness: dependence on the government, which Renaudot confirmed through a published endorsement of Mazarin in January 1645.[32]

The *Gazette*'s serious tone, access to official sources, and large distribution network in provincial cities made it exceptionally influential. Collective readings of the periodical occurred in many places, from churches and confraternities to workshops and barracks.[33] With such an important instrument of potential propaganda at the government's disposal, it is not surprising that Renaudot was forced to follow the regency when it abandoned Paris for Saint-Germain in January 1649. According to a contemporary wag, during the blockade and siege that followed, the Parisian elite "suffered less from the dearth of bread than the lack of news."[34] This

lacuna was briefly filled by the publication in Paris of another weekly periodical, the *Courrier françois*, a dozen issues of which appeared during the first three months of 1649. Its reporting style contrasted sharply with that of the *Gazette*. As a government instrument, albeit a fairly discrete one, the *Gazette* did not dwell on the misery caused by the siege and blockade of Paris. In contrast, the *Courrier françois*, being favorable to the rebellious magistrates and largely restricted to local news, carried a number of stories about "the unmatched cruelties and violence" committed by "the troops, most of them foreign, in the environs of Paris." According to the paper, the "evil plans [Mazarin] had developed to ruin the city" went beyond military matters and possibly included sending "incendiaries" to burn it down.[35] The immediate commercial success of the *Courrier françois* inspired an irregular imitation written in burlesque verse. This too provided abundant and occasionally picturesque details on life in the capital that summer.[36] However, both of these alternative papers were short-lived publications. Attempts to replicate them when Paris was again threatened during the spring of 1652 failed miserably.[37]

Once reestablished in Paris, the *Gazette* provided a steady diet of narrative news, including regular reports on the fortunes and misfortunes of war. The perspective blended the chivalric ethos of personal glory won in combat with dispassionate descriptions of the devastation wrought in the countryside. Once in a while, such accounts could be highly evocative, such as following the Spanish defeat at Guise on 1 July 1650: "you could not take ten strides without trodding on the corpses of men and animals; not having had the spare time to bury them [there was] an intolerable odor that you can only imagine. It was a hideous spectacle . . . to see a large share of the bodies still languishing and only asking that someone finally kill them off."[38] But descriptions of this sort were very rare. A pioneer in journalism as the first version of history, Renaudot strove to avoid sensationalism. As a result, the *Gazette* reflected a baroque sensibility in which the panegyrics of victory associated with Louis XIV replaced the emphasis on massacres and atrocities common during the wars of religion.

But the Fronde did not lack lively and evocative publishing; on the contrary, it marked an outpouring of pamphlets. Rather than compete directly with a rather stodgy newspaper backed by a royal privilege, *frondeurs* of one stripe or another, as well as printers whose motives were wholly pecuniary, preferred to publish individual pamphlets. Parisians daily awoke to the bellowing of peddlers hawking the latest printed ephemera (see figure 4). These publications were also displayed in bookshops and stalls that dotted the bridges and quays of the Seine. Moreover, every print shop

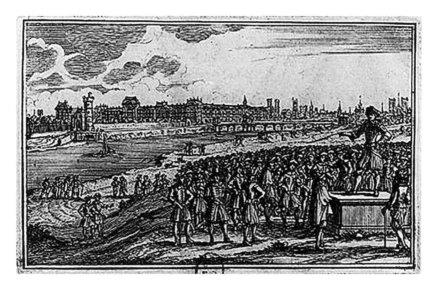

Figure 4. A supporter of the Fronde exhorting Parisians to revolt against Cardinal Mazarin. Anonymous woodcut engraving (Paris, 1649). Bibliothèque Nationale de France.

had its own boutique. Thus, during the Fronde, headline versions of the latest events saturated Parisian society on a quotidian basis. This was especially the case during the most dramatic periods of civil conflict such as the siege of the capital in 1649 when several dozen new pamphlets appeared every day and the spring of 1652 when the princely rebellion reached its height. During the five years of the Fronde, Paris was inundated with ephemeral publications, at least fifty-two hundred in all. Over half were four or eight pages; most of the rest had no more than sixteen pages. An eight-page pamphlet cost one sou, or two-thirds as much as a one-pound loaf of bread.[39] Their contents ranged from popular songs and private letters to news bulletins and battle narratives. This tsunami of print was characterized by virulent—and frequently scurrilous—pamphlets attacking the first minister, Jules Mazarin. Such pamphlets ranged from fake reportage to ribald libel. Despite being collectively known as *mazarinades*, however, most pamphlets that appeared during the Fronde bore no mention of the much-mocked Italian and instead took aim at rival *frondeurs*. Many even supported the regency government against various opponents. In contrast to the propaganda generated by the wars of religion, however, the pamphlets of the Fronde did not contribute to great political debates. What is more, for obvious reasons, authors rarely put their names on the pamphlets they penned.

The polemical style of *mazarinades* make them problematic sources for the study of contemporary attitudes: exaggeration, satire, ridicule, defamation, and misinformation characterized most of them. As a result, using *mazarinades* as a barometer of public opinion would be deeply misleading. Rather the writing, publication, and distribution of such pamphlets is best understood as a mode of politics intended to influence the attitudes of particular audiences, some of which could be very small. In short, *mazarinades* constituted civil war conducted by printed means. All the same, the sheer proliferation of pamphlets during the Fronde marked a sharp increase in the influence of printed matter on public attitudes. This was especially so in Paris where the vast majority of them were published, including most of those focused on events elsewhere in the kingdom. Even if *mazarinades* do not reveal the waxing or waning of support for the regency government, the influence of these pamphlets clearly eroded the power of social corps to determine the attitudes and political alignments of their members.

It is remarkable, even astonishing, that only a handful of pamphlets published during the Fronde contained images (see plate 6). This surely reflects the social exclusivity of the intended audience. The bourgeois of Paris apparently did not need crude wood-cut images to inform them or stimulate their reading pleasure. Moreover, commercial impediments associated with the nature of publishing at the time may have limited the desire to add illustrations to ephemeral texts. First, by 1630, the production of printed visual images in Paris had shifted almost entirely from relatively inexpensive wood-block prints to notably more refined, and hence more expensive, intaglio prints made either by engraving or etching copper plates. Second, the publication of books and prints was kept quite separate from one another. This made it hard to combine substantial text and sophisticated images other than as frontispieces. Third, the copper plates used to print refined images usually needed to be retouched after a thousand copies due to simple wear.[40] This would have required the sustained involvement of highly skilled artists, which was not likely at a time when pamphlets were published cheaply and with dizzying rapidity in order to respond to changing events or other pamphlets. Some *mazarinades* became famous for their salacious vulgarity, but this was not intended to appeal to the lower social orders: they could not read them anyway. The polemical, derogatory, and scatological elements of many *mazarinades* would seem to have invited illustration with visual satire, but this was not the case either. The reasons for the absence of caricature in the *mazarinades* are not obvious, but probably also derive from the practical aspects of production.

Even though the Fronde did not generate many images of violence, the cruelties and suffering that accompanied the Thirty Years War (1618–48) had become the subject of some remarkable visual representations, notably in Germany by Hans Ulrich Franck and in France by Jacques Callot. The vogue for the intaglio prints that had replaced wood-block printing in Paris had been significantly stimulated by Jacques Callot, one of the most innovative and prolific print artists of the baroque era. Near the end of his career, Callot had used his craftsmanship and artistic genius to turn the horrors of seventeenth-century warfare into high art. However, his famous series entitled *Les Misères et les Malheurs de la Guerre* was published in Paris in 1633, a full fifteen years before the Fronde. Scholars have not determined how well the series sold in the intervening years; however, it was recognized as a masterwork by an already well-known artist with a large oeuvre—fourteen hundred pieces—available from most important print dealers in mid-seventeenth-century Paris.[41] Furthermore, Callot remained emblematic of artistic success in the world of printmaking a full half century after his premature death in 1635. It is reasonable to assume, therefore, that his greatest work had an unusually wide distribution, even if it fell short of mass production.[42]

The seventeen individual scenes plus title page that constituted *The Miseries and Misfortunes of War* (to give its title in English) were published in three distinctly different editions as well as widely copied.[43] The most common of these included three rhyming couplets each. These short verses helped viewers to interpret the series as a sustained discourse on the dangers of an undisciplined soldiery. These dangers were shown to be multifaceted. They included plundering farms, burning villages, looting churches, devastating convents, holding up stage coaches, torturing farmers, and raping servants. The verses that accompany the image of a village being pillaged include emotional responses to such ravages: "Those whom Mars nourishes with his evil deeds, treat in this manner the poor country people. They take them prisoner, burn their villages and even wreak havoc on their livestock. Neither fear of the law, nor sense of duty, *nor tears and cries can move them*" (emphasis added) (see plate 7).[44] Indiscipline led to the suffering of soldiers as well. Callot depicts them being ambushed, butchered, and hanged by peasants determined to wreak revenge. Elsewhere soldiers are shown being captured, tortured by strappado, and executed by military provosts (either hanged, broken on the wheel, or shot by firing squad) for their marauding. Yet other images depict soldiers as crippled and bedraggled paupers, passing their final years in hospices or as roadside beggars. The final scene is of soldiers receiving financial reward for honorable and virtuous service.

The graphic, pervasive, and strikingly realistic violence depicted by Callot have made *The Miseries and Misfortunes of War* a landmark in the history of visual representations of warfare, often cited alongside Goya's *Disasters of War* and Picasso's *Guernica*. Although we lack contemporary commentary on Callot's *Miseries*, we know that they were considered among his masterpieces. This was not for technical reasons alone, even though the composition, finesse, and remarkable detail incorporated in these modestly sized images continues to astonish. Rather, these images are too graphic not to have elicited strong responses from viewers. They clearly fit with other invocations of pity at the time, even when limited by the application of reason. Mid-seventeenth-century viewers could not help but reflect on the extreme suffering and moral depravity illustrated in these scenes. Moreover, would an affective response not have been more likely in an age when most artistic production glorified war? Artistic connoisseurship, moral outrage, and simple pity were certainly not incompatible.

Despite their potential to move viewers then and now, we need to note key features of Callot's *Miseries and Misfortunes of War* and the period in which they were made. Callot was not engaged in journalistic reportage. In fact, he may not have directly witnessed the violence in his native Lorraine that the series is assumed to represent. More important, his series was an artistic and humanistic statement about uncontrolled violence. By not taking sides between peasants and soldiers, but rather by depicting both as sometimes ruthless perpetrators and sometimes agonizing victims, Callot exposed the cruelties of the style of warfare that characterized the early seventeenth century.[45] Whether his approach to war increased sales in Paris during the Fronde, or even resonated more strongly given the added immediacy of the civil conflict by 1652, remains unknown. Nonetheless, reporting in *La Gazette* would have persuaded Parisians of the realism of Callot's engravings, even though the laconic and very sporadic accounts of burned villages and fleeing peasants included in Renaudot's weekly paper could not have generated anything like the same emotional impact.[46] Careful scrutiny of Callot's series reveals various techniques that went beyond reality in order to magnify the horrors he depicts. These include isolating particular figures, multiplying the number and variety of participants, and including numerous acts of violence in every scene. Given the immediacy of Callot's images, with their distinctively baroque appeal to emotions, it is surprising that the civil strife in France from 1648 to 1653 generated almost no similar images of violence. Instead, the pamphleteers of the Fronde devoted themselves to verbal imagery, both scurrilous and serious.

The Fronde may not have generated images of violence to compare with those of Jacques Callot or Hans Ulrich Franck,[47] or even of Tortorel and Perrissin, but some of the pamphlets that appeared at the time did pack an emotional punch, one capable of inspiring compassion in response to the sufferings of others. A particular series of *mazarinades*, generally known as the *Relations* following their republication as a collection in 1655, provides evidence that the printed word could inspire a new level of social action. The scope of the charitable movement that emerged during the Fronde owed much to this series of pamphlets. These so-called *Relations*, the first of which appeared in late 1650, were the work of Charles Maignard de Bernières, the son of a senior magistrate in the Parlement of Paris who, inspired by his turn to Jansenism, had recently sold his venal office as a royal magistrate (*maître des requêtes*) in order to devote himself entirely to charity.[48] Bernières's newfound piety led to social action in response to news of the devastation inflicted on Champagne by foreign mercenaries, notably those units employed to defend the frontier from the Spanish. Pamphlets such as *La Champagne désolée par l'armée d'Erlach* (Paris, May 1649) told horrific tales of "women and girls of all ages, and even gentlemen in the care of their parents, forced and violated. . . . Dead bodies and decaying carcasses thrown in wells to infect them with plague, which causes the poor peasants to die when they pull them out," etc.[49] Acts of sacrilege—butchering a priest and defecating on the Eucharist—added to the atrocities. The following year, devastation in Picardy and Champagne, this time caused by the invading forces of Charles IV, Duke of Lorraine, sent refugees fleeing westward.[50] Bernières reacted to the renewed crisis by organizing a charitable association. Having learned from the emotional impact of graphic texts on himself and his friends, he soon began publishing the *Relations* as a means to raise money for emergency relief operations.

The surge in poor relief that developed during the Fronde resembles modern philanthropy in that it combined making public appeals with developing personal relationships to major donors. The public appeals came from some twenty-nine pamphlets published anonymously by Bernières over several years. These pamphlets had print runs of three to four thousand copies each, which made them some of the most widely circulated pamphlets of the day. Unlike many other *mazarinades*, the *Relations* were not simply distributed in the streets of the capital. The success of the publicity campaign depended on mobilizing influential social networks; therefore, many of the pamphlets were delivered directly to influential urban notables by members of charitable organizations.[51] Consequently, at least a few of these pamphlets could be found in most cities in France. In Paris, they

mobilized magistrates of the Parlement and especially their well-heeled wives, who gathered in "charitable assemblies" to organize the solicitation and collection of contributions. By the autumn of 1650, these women had already raised "large donations for the poor folk of Champagne ruined by the archduke's army."[52]

Such impressive results demonstrate the effectiveness of the *Relations* in linking graphic descriptions of poverty and violence with the new place of charity in personal salvation. The first of the *Relations*, which appeared in September 1650, contained vivid accounts of the horrors of war in Picardy in order to "stir the innards" of readers and inspire them to contribute to emergency relief. The pamphlet directed Parisians "devout enough to donate" to contact their parish priest or the wives of presidents of the Parlement, Lamoignon and Herse.[53] In early 1651, Bernières expanded the scope of his publicity campaign to include devastation wrought by marauding soldiers in Champagne. The *Relations* and the relief effort they supported continued to focus on the regions east of Paris until the spring of 1652, by which time the crisis had reached the suburbs of Paris. The pamphlets' title pages often explained that their descriptions of rural devastation were "extracted from letters written by ecclesiastics sent expressly from Paris to aid" the populace. These extracts differed markedly from the grandiloquent rhetoric of general immiserization that characterized most *mazarinades*. Other pamphleteers of the Fronde invoked the hardships of the common people in order to caste blame on opponents. In contrast, the *Relations* aimed to rouse the Parisian elite from its collective apathy through compassionate witnessing.[54]

Such testimonial reporting combined specific locations with precise details of human suffering. The specificity of these accounts made them all the more compelling,[55] as the following extracts illustrate:

Basoches, Fismes, Brennes [October 1650]—Armies have camped in all the towns; churches have been profaned and ransacked; inhabitants have been living in the woods and caves where some were massacred and others smoked out like foxes; thus entire families have been suffocated and others carried off by the armies to satisfy their brutality.[56]

Thierasche [May 1651]—. . . and in order to draw a ransom from the said Gerard, [they] roasted his feet, burning his shoes and knee socks on his legs, [and] hanged others by the chin and did diverse other cruelties.[57]

S. Quentin and adjacent villages, 6 & 29 January [1652]—The entry of the Burgundians into our territories last month, and the passage of our own troops this month has reduced things to the utmost extremity.

Whatever remained of houses has been demolished to the foundations; trees have been cut, men beaten and crippled; women dishonored, some of whom, to avoid this misfortune, saved themselves in the waters and had their legs frozen, which had to be cut off.[58]

Lagny [September (?) 1652]—The inhumanity of the enemy armies has reached the point that in the village of Nully a live child was thrown into a burning oven, and a husband and wife were whipped so badly with thorn branches that they died from the beating; that in the village of Daumat, a poor church warden had all his limbs broken, his stomach opened, and his entrails pulled out in order to force him to reveal the location of the church's sacred ornaments; not to mention the raping of women.[59]

Each of the almost thirty pamphlets later collected under the heading of *Relations* contained several such accounts. These were succinct pieces of reportage based on a limited vocabulary and a sometimes tangled syntax. Rather than describing at length their experiences, the authors of the extracts repeatedly emphasized both the shock of what they had seen and their inability to describe it. "You cannot imagine the misery without seeing it," writes one; "there is no tongue that could tell, no pen that could express, no ear that dares hear what we have seen," notes another.[60] And yet even these expressions of linguistic helplessness made the *Relations* effective at communicating the suffering of the rural populace. Several themes recur regularly. Both torturing men and violating women appear repeatedly. These are the quintessential brutalities of marauding, invading armies; including them underscored the social marginalization of the victims and the damage done to their personal and sexual honor.[61] The *Relations* also repeatedly mention the ransacking of churches and the loss of priests. The absence of priests deprived thousands of villagers of the Mass and, most frighteningly, burial without last rites. (After all, the charitable movement of the mid-seventeenth century was as concerned about saving souls as it was about alleviating suffering.) Corpses left lying in streets and fields, whether at battle sites or in areas afflicted by plague and starvation, also formed a leitmotif of the *Relations*, one made more gruesome by descriptions of wolves feeding on decaying flesh.[62]

The most frequent theme of the *Relations* was that of starving peasants reduced to eating almost anything.

In the Tierrache, most of the inhabitants have died of hunger; for the past two months, the better off have been reduced to eating bread made of barley bran; others feed on lizards, frogs and weeds.[63]

From Rheims and the villages around Boult on the river Suippe, 12, 27, and 28 February [1652]. No day passes without two hundred people starving to death in these two provinces. . . . We assure you that we have seen with our own eyes, between Reims and Rhétel, herds, not of animals, but of men and women, rooting around in the fields like pigs looking for roots.[64]

In and around Rethel is the height of calamity, it is such there that one hears talk only of murders, ransackings, sacrileges, fires, rapes, diseases and famine. Most inhabitants eat only the flesh of dead animals and the chaff of the little grain that has been sown.[65]

So horrifying were the extracts contained in the *Relations* that it became necessary to counter incredulity and claims of exaggeration. In a pamphlet published in early 1652, Bernières (anonymously) insisted that he only reproduced "written testimony from village priests, officers of royal justice, town councilors, and priests of the mission."[66] Such witnesses were individuals "worthy of trust," as the subtitles of several pamphlets pointedly added. He returned to the issue of credibility later that spring, writing angrily that even skeptics could not deny the desperate plight of the mass of refugees now living in the suburbs of Paris. They cannot ignore, he wrote,

the poor in our faubourgs who have been wasting away from hunger for several months; this infinite number of refugees who, driven from the countryside by the approach of the armies, strike our eyes, and whose voices echo in our ears. . . . The desolation of our villages is public enough that it no longer needs to be announced; it is time to wake up, for God batters our gates with a flood of warriors. We must prepare for the same scourges that have afflicted other provinces.[67]

Whoever republished the *Relations* as a collection in 1655 also noted, "If in this history unusual things stand out that surpass ordinary credulity, we have on hand the originals to show the truth of it (*pour en faire voir la vérité*)."[68] Here, in short, was the purpose of larding these pamphlets with epistolary extracts, namely, to expose the true misery that afflicted the victims of the civil war in Champagne and Picardy, and thereby emotionally move readers to action.

THE CHARITABLE IMPERATIVE

The tension between the appalling suffering that the letter writers had witnessed and the willingness of readers to believe them was directly related

to the imperative of charity. As one wrote, "I dare not further empha-
size the misfortune [around Rheims] out of fear that those who will hear
these grievous stories, and who will not provide relief for them, which the
authority they hold obliges them to provide, will only believe that these are
more a colorful discourse than a true account. Nevertheless, I am obligated
to reiterate to you that the disorder is infinitely greater than that which can
be said and written."[69] The challenge of communicating effectively enough
to move others emotionally, that is, "to give them an understanding of
the public desolation, and the effective determination to remedy it," was
overtly acknowledged. "I am fully aware that they have heard enough from
the frequent accounts given to them, but that what comes only through
the ear does not strike the heart like what comes through the eyes." In
order to close this gap between reality and credulity, the authors invoked
their own emotional responses—"the miserable cloth rags that had been
given to him to cover his nudity drew tears from me"—and included official
records (*procès-verbaux*) of pillaging and murder. That Bernières published
the highly personal and emotional responses of witnesses, rather than any
legally certified accounts that would have lacked the same intensity, under-
scores the originality of his enterprise. Presenting images of humans eating
grass in the fields, women gang raped by soldiers, or men hung from hooks
by their chins was more than sensationalism and more than tragedy; it was
an attempt to use printed testimony to provoke horror and compassion.

The phrase "to show the truth of it" used by the editor of the *Recueil de
relations* and the reference to seeing, not just hearing about, devastation and
suffering suggest that the graphic nature of the *Relations* sought to invoke
visual images in the minds of readers. In his important treatise, *Christian
Alms, or The Tradition of the Church Regarding Charity toward the Poor* (Paris,
1651), Antoine Le Maistre described the *Relations* as "vivid and eloquent
paintings depicting the truth of the matter to the eyes of an infinite number
of readers."[70] Given the almost total lack of images in the *mazarinades*, the
Relations became the most detailed and emotionally disturbing representa-
tions of the violence and suffering generated by the Fronde. According to
Le Maistre, not only did these "very true and very exact" accounts play a
vital role in informing people about distant conditions, "which they could
only vaguely learn about from public rumors, which are always uncertain
and partly false," they "moved those who had appeared insensitive" and
"warmed those who had seemed colder than marble."[71] While other pam-
phleteers conformed to a long tradition of expressing pity for the plight of
the abject poor, the *Relations* added a more positive tone. As we have seen,
other pamphlets also provided vivid accounts of violence and suffering,

but Bernières's almost thirty pamphlets shared a clear purpose: to generate charitable donations by inspiring compassion. In this they were immensely successful, so much so that the period appears as a watershed in public responses to suffering. Though he does not mention the *Relations* in particular, the great Dutch historian of the Fronde, Ernst Kossman, noted that by deploying the "ancient theme of taking pity on the misery of the lowest folk," the *mazarinades* fit into a long literary tradition that ran from the Middle Ages to the Enlightenment. Nonetheless, not only was the misery "horribly real," but "during the Fronde we see at times a veritable revolutionary sentiment that made use of compassion, which until then had remained negative."[72] Thus, as Kossman sensed, but did not explore, the *Relations* had briefly transformed attitudes toward the sufferings of the impoverished and displaced from condescending pity to affirmative compassion, with all the implications that had for self-reflection and personal action.

Though largely overlooked by historians,[73] contemporaries were well aware that the unprecedented surge of charity during the Fronde owed much to the publication of the *Relations*. These pamphlets tapped directly and explicitly into the new forms of religiosity that had emerged in the previous decades. As the series developed, individual pamphlets became increasingly inclined to overt exhortation in spiritual terms.[74] The impact of the *Relations* was immediate in both emotional and material terms. Thanks to these pamphlets, hundreds of "pious folk" contributed money to the cause. In the first six months, eighty thousand livres were given for poor relief along the frontier. Another thirty-two thousand followed in the spring of 1651, as well as twenty thousand livres to purchase seed grain. By the end of the year, Parisian elites had contributed two hundred thousand livres to relieve suffering in Picardy and Champagne. Even individuals who were short on cash found ways to contribute. Some brought a notary to Bernières's home and legally committed themselves to pay sizable sums in installments. Aristocratic ladies sold jewelry and silverware in order to fulfill their duty as Christians. Anne of Austria set an example. The devout queen, made aware of "the extreme sorrows in the provinces" by *Relations* delivered to her privately, donated earrings worth sixteen thousand livres.[75] Thanks to Bernières's publications, charity toward victims of the civil war had become fashionable.

In addition to sparking an unprecedented surge of charitable donations, the *Relations* inspired a new attitude toward the sufferings of common folk. The rich and powerful in seventeenth-century Paris could not avoid seeing the poor and destitute around the city, and not just in isolated pockets. The growing number of beggars and vagabonds in the capital had come to be seen as the principal source of disorder and thus the subject of novel attempts

to discipline and Christianize them.[76] This quotidian familiarity with abject poverty makes it all the more remarkable that Parisian elites could be moved to compassion for the rural victims of war. It took religious inspiration to transcend the social and physical distances of the day. By the summer of 1651, the central message of the *Relations*, namely, that good Catholics could not simply ignore the misery of nearby provinces, began to receive significant support from other religious publications. In July, a leading member of the Jansenist circle, Antoine Le Maistre, published his important work (mentioned earlier) entitled *Christian Alms*. This two-volume work began by invoking the marauding foreign armies northeast of Paris, which it dubbed "this new evil incomparably more violent than the others," and then elaborated on the origins and influence of the *Relations*. In Le Maistre's view "it was truly only the Spirit of God that could produce such a rare marvel in our century, that is, to see officers of royal justice and other highly virtuous individuals unite their hearts and their property in order to distribute alms, to abandon all the civil affairs of men in order to take charge of this affair of God."[77] He then spent five hundred pages presenting a general doctrine of Catholic charity. This vast compendium of writings and examples from ecclesiastical history may have been rather more than most people were willing to read; nonetheless, it was written in French and thus provided a deep well from which lay and clerical leaders alike could draw inspiration.

Even those who resisted the rigorism of Port-Royal found it important to expound on the spiritual implications of charity in the midst of the prevailing social crisis. In his *Exhortation to Parisians on Aid for the Poor* of December 1651, the renowned poet and biblical exegete Bishop Antoine Godeau preached a sermon (soon published) in which he argued that the calamitous conditions in nearby provinces raised the giving of alms to the level of a precept, rather than merely a counsel of the church.[78] This meant that such charity became a personal obligation to remain in good standing with God. Godeau even argued that for wealthy Parisians to disobey his precept would be a mortal sin and, therefore, could jeopardize their personal salvation. Godeau proceeded to pull every lever available to persuade members of his audience: scripture, church teachings, reason, and compassion. First, he elaborated on the suffering in the region: naked and homeless peasants reduced to eating grass, mice, and dogs; babies dying at desiccated breasts; young women daily tempted to sell their honor to stay alive. He then thundered, "Pitiless rich, how can you [*vous*] not be moved when such horrible calamities are recounted to you? If you [*tu*] ignore the voices of the Apostles, the Holy Fathers, the Doctors, of Reason, how can you [*tu*] stifle the voice of Nature, which speaks to you [*tu*] in your heart?" He drove home the message

by insisting that personal salvation came before politics. This section had a telling sidebar summary: "Everyone must reflect on the disorders of his conscience rather than those of the State."[79] Godeau's episcopal precept, his well-timed switch to the singular, familiar *tu*, and his veiled rebuke of *frondeur* factionalism all helped to emphasize that each of his readers had to make a personal response to the calamities of the Fronde: the fate of their individual souls as well as the fate of the kingdom depended on it.

Many members of Godeau's intended audience made a personal response to his admonition by giving generously to organizations that provided emergency relief. During the first half of 1651, the *Relations* reported that the network it supported was spending sixteen thousand livres a month on the basic necessities of life. Good weather that year promised widespread relief in the form of a bountiful harvest, but ill-supplied and undisciplined troops dashed those hopes. Soldiers cut crops for fodder, emptied storehouses of seed grain, and slaughtered livestock at will. Matters deteriorated steadily during the winter and spring of 1651–52. Flour became even more expensive than during the siege of 1649. Disease increased and murders multiplied as desperate refugees began pouring into the suburbs of Paris.[80] By May 1652, they numbered ten to twelve thousand and had utterly overwhelmed all institutional charities.[81] In this atmosphere of impending anarchy, the authorities of Paris turned to a collective religious ritual to preserve the city, and even the kingdom, from further devastation.

RELIGIOUS PROCESSION

The growth in self-reflection inspired by rigorist thinking about confession and Communion encouraged the interiorization of religion, but it did not preclude participation in collective rituals. The growing crisis in the spring of 1652 brought Parisians to the brink of despair. The diarist Jean Vallier, a royalist official in Paris at the time, recorded the sense of desperation sweeping the city: "The fire of civil war was breaking out in almost every province with such violence that it was beyond human wisdom to extinguish it. . . . We were left with only tears and oaths in the surfeit of our suffering."[82] Such growing desperation inspired a major display of collective action: a procession of the reliquary of Sainte Geneviève. The impetus came from the canons of the abbey of Sainte-Geneviève. One of them captured the spirit of the moment in a pamphlet, written as a supplication on behalf of the city's population, by drawing a parallel between the events of his day and those of 451, when, according to ancient tradition, the prayers of a young maiden named Geneviève had persuaded God to spare Paris from being ravaged by Attila the Hun.[83] Twelve hundred years later, in early June 1652, the approach

of the Duke of Lorraine's ill-disciplined army created a similar anxiety in Paris.[84] In fact, it bordered on open panic. Parisians were terrified of both the mercenary army and the mass of desperate refugees fleeing before it. As Omer Talon, the advocate general of the Parlement of Paris, put it to his fellow magistrates, "we fear that the country folk, being totally devastated, will rush and fall upon the great towns as they did to several of our neighbors."[85] A contemporary print describes the purpose of the procession of Sainte Geneviève's relics in almost apocalyptic terms: to stop the wrath of God and thereby prevent the iron and fire of civil war from turning the great city into a desert through famine and plague.[86] Clearly much was at stake in the procession, politically and psychologically (see plate 8).

The grand procession, held on 11 June 1652, was the greatest display of relics Paris had seen since the wars of religion—and it would never be matched again. Twenty-seven years had passed since the gilded and bejeweled reliquary of Sainte Geneviève had last been processed through the city's streets. This time it was joined by the reliquaries of nine other saints and the four "daughters of Notre Dame," each accompanied by monks and canons from the relevant churches and abbeys, as well as a panoply of officials representing the entire civic and corporate structure of the city. The great procession both mirrored and magnified the fear and anxiety gripping the capital. An astonishing number of people lined the streets, forcing the solemn procession to wend its way through a human corridor barely four feet wide. Viewing stands holding up to fifteen rows of spectators choked the main squares. Houses and shops all along the route had their facades obscured by scaffolding built for viewing, and windows and rooftops overflowed with people eager to see the passing pageantry.[87] The great procession of relics of 11 June 1652 became the largest public gathering in Paris during the entire seventeenth century.

The Parisian elite also watched the grand procession, though they did not all see it in the same light. Those familiar with the history of the League in the 1580s recognized the procession as another bold and even cynical attempt to harness the civic Catholicism of the capital for political ends. In contrast, those who believed in divine miracles and the efficacy of intercessory prayer undertook a prescribed fast before the procession, while also worrying about their many neighbors who ignored such admonitions.[88] Accounts given by contemporaries such as Madame Françoise Bertaut de Motteville tended to emphasize how rival *frondeurs* (notably Gaston d'Orléans, the cardinal de Retz, and the Prince de Condé) each sought to use the procession to mobilize popular support for his own ends. Popular cries of "Saint Condé" had an especially ominous ring.[89] However, whether they believed in the stated purpose of the procession—to implore God to

bring peace to the kingdom—or regarded it as a largely political maneuver, a peaceful attempt to overcome internal divisions and unify the capital, Parisians who experienced the procession would have been even more psychologically distressed by subsequent events.

Far from abating following the great procession, the crisis soared to new heights. Armed conflict flared up, both around Paris and at Bordeaux, and famine ravaged the countryside. Public authority in the capital began to crumble and soon threatened to collapse entirely. At first, some pamphlets took the withdrawal of Charles IV, Duke of Lorraine's army toward the Spanish Netherlands as evidence that the sacred procession of Sainte Geneviève had produced results.[90] And yet, the marauding, rape, and pillage that accompanied the retreat marked 1652 as "the year of the Lorrainers" in the collective memory of Picardy.[91] As far as Parisians were concerned, no sooner had the duke's forces departed than the royal army under Marshal Henri de la Tour d'Auvergne, Viscount of Turenne, arrived, taking up a position at nearby Saint-Denis. The Prince de Condé tried to maneuver his forces around Paris, but Turenne's army trapped the rebel force of at least six thousand men on the eastern edge of the city. A fierce battle in the faubourg of Saint-Antoine ensued on 2 July (see plate 9). Despite being able to use the trenches and barricades prepared as defenses against the Lorrainers, the rebel forces took increasingly heavy casualties.[92] The mounting slaughter stirred "the Grande Mademoiselle" to her famous action of opening the eastern gates to Condé's men and turning the guns of the Bastille on the royal forces. This extraordinary intervention allowed the remnants of Condé's army to stream into the city. Residents of the capital who witnessed the carnage that day must have shared the fitful sleep of Mademoiselle that night, her mind "full of the faces of the poor dead."[93] Instead of the peace and unity sought by the procession of Sainte Geneviève, political divisions had brought the civil war into the heart of the capital itself.

The apogee of popular violence in Paris followed two days later with a chaotic attack on the palatial Hôtel de Ville. Paris had experienced a series of sporadic disturbances since early April. These started with assaults on grandees and escalated to noisy protests and eventually murderous riots in June.[94] Matters deteriorated so much that city leaders twice ordered bourgeois to arm themselves and chains to be stretched across streets to prevent mobs from circulating.[95] The growing unrest jangled the nerves of the bourgeois. These respectable denizens of the city, men who neither held judicial offices nor labored with their hands, staffed the civic institutions of Paris, including the urban militia. Their various internal divisions and institutional rivalries formed the social substance of local politics. On 4 July, an ad hoc assembly

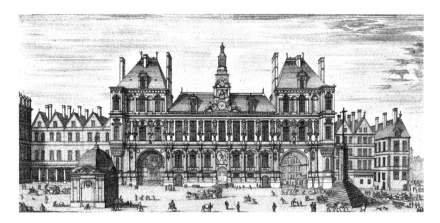

Figure 5. The Hôtel de Ville in Paris during the Fronde.

Etching designed by Israel Silvestre and engraved by Jean Marot and Stefano della Bella (Paris, 1640s). Metropolitan Museum of Art.

of city notables met at the Hôtel de Ville to discuss urgent matters of public order and poor relief. The leaders of the princely Fronde in Paris at the time hoped to exploit this opportunity to compel civic leaders to join them in opposing the royal government. Rabble-rousing troops and militiamen bullied Parisians into wearing knots of straw as a symbol of unity against Mazarin, then began agitating the swelling crowd outside the Hôtel de Ville (see figure 5). When the crowd learned from departing *frondeurs* that the assembly inside was unwilling to declare support for the princes, preferring instead to deliberate further, the demonstrators exploded in anger. They promptly set fire to the main doors, eventually fought their way inside, and by nightfall had begun killing notables almost at random. Once the rampage ended, numerous corpses littered the chambers and courtyards. In addition to a dozen senior dignitaries, the victims included "a quantity of *bons bourgeois*" (apparently twenty-five to thirty) from the assembly.[96] Those who survived had either disguised themselves or paid for their lives in cash. A reliable death toll could never be established, but the social prominence of the principal victims clearly shocked contemporaries.[97] One of them noted that the emotional impact of the attack grew in the recounting of it: "This horrible riot forced the entire city to remain under arms throughout the night because people feared that these enraged men would attack houses and were not reassured until the next day, even though by then the horror of these events was more pronounced on the faces of those who had learned the details from accounts given by others who had escaped."[98] Fear and panic had become highly communicable, and quickly infected the entire city.

Although the battle of Saint-Antoine on 2 July had killed some two thousand men, the slaughter of two to three dozen civic notables at the Hôtel de Ville two days later provoked an even greater trauma in the life of the city. The massacre was the fruit of popular violence unleashed by internecine strife within the social and political elite. Ever since the Day of the Barricades in 1648, Parisian society had been riven by deep tensions. Its elaborate hierarchical structure of corporate and professional bodies threatened to come tumbling down. Opposing the regime greatly strained the internal cohesiveness of many such groups. Members of the most influential corporations in Parisian society, such as the Parlement, the *échevins*, and the six great merchant guilds, as well as those in lesser guilds, militia companies, and district assemblies, all found themselves forced to decide if and when to oppose the royal government, and, by doing so, risk undermining the social order that defined them as individuals. Those who refused to join the *frondeurs* and instead supported the court were hounded by their neighbors and corporate brothers as "mazarins." Political choices divided families, altered alliances, disrupted patron–client networks, destroyed old ties, and created new ones. The events of 1652 in particular created profound divisions in Parisian society: the Fronde had pitted "father against son, husband against wife, neighbor against neighbor, and servants against their masters."[99] Corporate identities became altered and even supplanted by personal loyalties and political commitments.[100]

Having to make these difficult and consequential choices exacerbated divisions within the socially disparate *bons bourgeois de Paris*. The frequency with which pamphleteers referred to these men highlighted their importance in the political struggles of the Fronde, but it did not make them any more coherent as a social group. Only in the final months of the prolonged civil war did the bourgeois of Paris coalesce into a more united, and hence more effective, political force, and thereby helped to end the Fronde. In late September, the bourgeois of Paris openly broke with both the princes and the parlementary rump still in the capital. As much as historians focus on the political interplay between elites, however, it was the relationship between the bourgeois of Paris and the restless populace of the city that shaped the final act of the drama. The preeminent historian of early modern Paris, Robert Descimon, has strikingly described the massacre at the Hôtel de Ville as a "traumatic event that disrupted the historical landscape" of the capital. He explains that "after the massacre, the bourgeois community was never able to resume the form it had before the troubles, and the fracture of Parisian society set the frightened dominant classes against the 'dangerous classes.'" This created a new "mental structure" that

periodically reappeared all the way to the Paris Commune.[101] During the Fronde, discourses of discontent had combined with increasingly complex factional alignments to generate new social cleavages and unexpected collective identities. Such a distinctive realignment of the social order fits well with Jeffrey Alexander's understanding of the characteristic societal consequences of a collective trauma.

What explains the rapid and enduring realignment of 1652? The attack on the Hôtel de Ville would have been less shocking and, therefore, less socially traumatic without a number of important ancillary factors. First, it took place in the midst of a prolonged civil war that had ravaged the countryside around Paris in 1651 and again in 1652. By April, devastation in the region had driven the price of grain up to levels not seen since Henri IV's siege of Paris in 1590. The soaring cost of bread and new taxes on wine provoked popular unrest and frantic efforts to obtain firearms.[102] Refugees flooded the faubourgs and beggars filled the streets. Second, various *frondeurs* now sponsored hyperbolic pamphlets that called openly for mass violence.[103] Such incendiary pamphleteering gave the attack on the Hôtel de Ville the air of a revolutionary movement.[104] The *Gazette* in particular, contributed to bourgeois fears of the common people by attributing the violence at the Hôtel de Ville entirely to the "populace," without mentioning either the soldiers of Condé's army, who had clearly instigated the incident, or the petty bourgeois supporters of the *frondeur* magistrate Pierre Broussel.[105] Third, the fear of social revolution gained credibility when the mob failed to differentiate *mazarinistes* from the other notables inside, thereby amalgamating them all into men worthy of murder, beatings, and ransom. Such circumstances made it easy for the confused and vacillating bourgeois of Paris to see the agitated populace as a growing threat to the city and their place in its social order.

Finally, published accounts of events at Bordeaux, written in Paris with the intention of stirring trouble in the capital, also helped to make the massacre at the Hôtel de Ville a source of collective trauma. Several such pamphlets described in lurid detail the events that led to the triumph of the Ormée, a populist movement that had taken control of Bordeaux's town hall on 25 June 1652, then mounted an assault on the wealthy quarter of Château Rouge. These pamphlets depicted scenes of extreme violence, including street battles, barricades, blasting down doors, and rampant pillaging. The title of one pamphlet announced a pitched street battle involving hundreds of men on either side, with *ormistes*, described as "a populace drunk on wine," battling "the city's bourgeois" using "two cannons and six fauconneaux [smaller guns] taken from the Arsenal." The lurid description

of events concluded that "burning, carnage, robbery, blasphemy, and disdain for religion triumph."[106] Although scores of *ormistes* died in the attack,[107] readers in Paris were most shocked by the handful of deaths among the elite, as well as the destruction of property. Another pamphlet changed the dates of events in Bordeaux to correspond more closely to the massacre at the Hôtel de Ville in Paris, thereby suggesting a plot to synchronize the massacre of municipal elites in both cities. The purpose may have been to tie together the princely *frondeur* brothers, Armand de Bourbon, Prince de Conti, and Louis de Bourbon, Prince de Condé, but it was the violence of popular elements that raised the greatest alarm.[108] Events in Bordeaux also inspired two of the most revolutionary pamphlets published during the Fronde. These pamphlets called overtly for popular insurrection in order to overcome "the injustice, violence and cruelty" of both parties, the Mazarinists and the princes.[109]

Such radical language terrified the *bons bourgeois de Paris*. However, even though certain units of the Parisian urban militia had declined to perform their duties, popular agitation in Paris did not mirror developments at Bordeaux. The Ormée, composed of middling sorts with the support of artisans and shopkeepers, had been forming for months. The increasingly organized movement finally gained control of Bordeaux in late June 1652, thereby temporarily supplanting the traditional judicial elite. As an urban social movement, the Ormée bore similarities to both the Paris Sixteen of the 1580s and the *sans-culottes* of the 1790s; however, nothing resembling these three movements emerged in Paris during the Fronde.[110] Thus, without the graphic and alarmist reporting on the events in Bordeaux, the violence of early July in Paris would not have had the same psychological impact on the capital's elite. Moreover, given the confused reporting about both events, what had begun as eyewitness accounts of the violence at the Hôtel de Ville quickly became distorted and magnified in the retelling by being mixed with the more extreme accounts being published about events in Bordeaux.

The shock caused by the massacre at the Hôtel de Ville sparked a political and social realignment of the bourgeois of Paris. The judicial and commercial elites had always been internally divided, with strong royalist sentiments sprinkled throughout both groups.[111] The resulting confusion made political choices largely personal ones. Individuals could not simply adopt the position of their *corps*. It took a shocking act of violence, followed by a calculated as well as coincidental exaggeration of its social significance, to convince many Parisian bourgeois that the time had come to embrace royal authority. Therefore, despite Condé's grip on the city, *frondeur* spirit began to flag in late July. Mazarin's voluntary exile fostered this

growing change of heart. Moreover, his departure was soon followed by a royal amnesty in late August, which was reiterated a month later. By late September, the troubles provoked by Condé's forces camped in the faubourgs, as well as the havoc wrought by another appearance of the Duke of Lorraine's rapacious forces in the Paris region, made the return of the teenaged king to his capital a matter of urgency for men of property in the city. As a consequence, the *bon bourgeois de Paris* steadily coalesced against *frondeurs* of all stripes. This was a newly constructed unity, forged during the crisis, and sustained by greater alienation from the general populace as well as growing loyalty to the monarchy. Thus, political and social realignment paved the way for Louis's definitive return to Paris on 21 October.[112]

Historians usually recount these events without paying much attention to their psychological impact. In addition to a sudden change in the political climate and the emergence of a profound social fracture in Paris, the events of early July 1652 had spiritual—and, therefore, psychological—implications for many of the city's residents. For those who believed in saintly intercession, the total failure of the great procession of relics on 11 June to bring either peace or relief to the region had to be understood in religious terms. Bishop Antoine Godeau explained in a pamphlet published on the eve of the procession that if Sainte Geneviève did not move God to restore peace to the kingdom, it would be the fault of Parisians themselves. Not only did Sainte Geneviève disapprove of their disloyalty to the king, she loved God more than Paris; therefore, unless Parisians appealed to her "through a true penitence, through a sincere life conversion," she would ignore their pleas for relief and instead ask God to punish them. Godeau then made charitable donations central to a proper change of heart. "Buy back your sins; buy back those of the kingdom, with the alms which God's wrath cannot resist."[113] Thus, Godeau explicitly applied the recently emphasized relationship between individual contrition and Christian charity to the growing violence and disorder of 1652. He advised Parisians to search their individual consciences before they could hope for any relief from the social and political crisis.[114] In other words, intense introspection, a primordial element of the self, became a religiously prescribed response to suffering and civil strife. After a search of one's conscience, and for the sake of salvation (both personal and political), specific action must follow: Christian charity. Such an admonition was not forgotten amid the rush of events; on the contrary, it was strengthened by them.

The intertwining of the spiritual and political implications of the crisis of 1652 are made strikingly clear in one of the most important pamphlets printed during the Fronde, *The Fully Naked Truth, or Sincere and Disinterested Opinion on*

the Real Causes of the State's Ills and the Means to Provide the Remedy for Them.[115] Although written in late June, this pamphlet first appeared anonymously a month after the dramatic events of July. *The Fully Naked Truth* has generally been deemed one of the most astute and persuasive of all *mazarinades* thanks to its search for deeper causes of the Fronde and its evenhandedness in attributing blame for the breakdown of order. For our purposes, it is the relationship in this important pamphlet between three elements—religion, civil strife, and personal suffering—that deserves particular attention. The author, now known to have been Robert Arnauld d'Andilly, explains that a failure to offer his opinion in the midst of the "extreme hardship" produced by France's "domestic divisions" would be to renounce "all feeling for humanity." Before offering political analysis, however, the pamphlet provides a Jansenist explanation of the crisis: "the basic cause [of our ills] is our sins, for which we have not known how to ask God's forgiveness with enough sighs, moans, and tears, nor to do enough severe penitence." Experts on weeping in the context of religion at this time note that it was associated with consolation and especially with repentance; thus, weeping "was regarded positively as evidence of the believer's piety and God's grace."[116]

It is especially significant that d'Andilly wrote from a position of personal suffering over the calamities of his time. He states, "I would only be able to speak with sighs mixed with tears," and refers to "the pain that presses on me." He even finds it difficult to describe the suffering caused by the civil war: "words fail me. . . . One would have to be a Demon to be able to turn a charcoal drawn from Hell into a pencil in order to trace all the horrors, all the inhumanities, all the murders, all the rapes, all the impieties, and all the sacrileges" committed by the marauding armies. Having repeatedly invoked his anonymous self throughout, d'Andilly ends by basing his main advice on "the assurance that the testimony of my own conscience offers me." This autonomous, individual conscience is exercised before the Almighty alone. And yet, d'Andilly does not separate himself from society, nor put himself above others. He closes with a supplication asking God to "ease *our* suffering, dry *our* tears, and soften in some way the memory of *our* past ills." He also expresses a hope that God's mercy would supplant his justice "by arresting the course of *our* punishment, which, however terrible it is, is a lot less than *our* sins" (emphasis added). Readers of this moving and influential pamphlet could sense the pain felt by its author: the collective trauma of the Fronde had become his own personal suffering. Both by remaining anonymous and by counting himself among the many others caught up in the tragedy afflicting France, the author brilliantly challenged every reader to make a search of his own conscience the basis for political action.[117]

The Fully Naked Truth also dispensed timely political advice. It told readers to submit to the king even if, despite all supplication, he refused to banish Mazarin. This message received support from other pamphlets, notably one that framed the issue in terms of the failure of the grand procession in June. Here a canon of the abbey of Sainte-Geneviève begins by insisting on the spiritual sincerity of all the preparations for the procession. He then claims to have received a visit from his patroness, "clothed in light and carrying a torch," during which she explains that the bourgeois of Paris are the stumbling block to peace, and thus the source of so many calamities (all described by the author in considerable emotional detail). Their actions, which culminated in turning artillery against the king and failing to prevent the massacre at their "Autel de Ville," had tied her hands. In short, God wanted a complete subordination to the powers he had established on earth, that is, submission to the king.[118] In contrast, other pamphlets put their faith in the *frondeurs*. Processing the relics of Sainte Geneviève had never before failed to produce a miracle, stated another *mazarinade*, before proceeding to assure readers that the princes would not abandon the city to its troubles.[119] How were the bourgeois of Paris, its true citizens, to respond to the disasters that had befallen them? What would inspire them finally to act? One pamphleteer reduced it to a matter of personal suffering: "I see plenty of other bourgeois more melancholic than I; but, since everyone feels his own pain, I must be satisfied with complaining alone, leaving every individual to judge whether he is as anguished as I am."[120] The message was clear enough: any decent citizen of the city who experienced its collective suffering as personal anguish—and it was obvious that many did—would be moved to put an end to that suffering by supporting royal authority. In short, if the suffering was personal, the response should be political.

Thus, political issues were interwoven with religious, personal, emotional, and, indeed, psychological responses to the crisis of July 1652. At the same time as the bourgeois of Paris were being challenged to brave the power of rebellious magistrates and magnates and support the king as the only way to restore order to the kingdom, they were also being challenged to confront their own consciences and thereby to conclude that they personally needed to provide charity in order to alleviate the social suffering provoked by the civil war. In short, the humanitarian crisis that unfolded in and around Paris during the summer and autumn of 1652 increased pressure on the individual bourgeois of Paris to do something to help restore order, and that meant Christian charity as much as political action. The *Relations* had fostered an unprecedented surge in charitable activity in the areas east of Paris devastated by war and famine in 1650–51. The prolonged

crisis of 1652, brought home to individual consciences by preaching and pamphlets alike, inspired another equally if not more impressive effort.

Although usually omitted from political histories of the Fronde, the civic leaders of Paris held special assemblies in late June to organize a response to the surge of poverty in the city and the rising tide of refugees from the countryside. Despite the desperate misery evident in the streets and faubourgs, the city's leaders, including the Parlement, had rejected proposals to impose a temporary tax on all bourgeois in order to provide poor relief. Rather than assume collective responsibility, the city's leaders had merely called for additional generosity on the part of individuals—and inspired a violent protest in the process.[121] Talk of alternative solutions, however, actually led to a drop in donations to existing charities, even as conditions worsened. By July, the number of refugees in the faubourgs reduced "to the last extremity" had soared to fifteen or sixteen thousand, not including actual beggars. The *Relations* responded by calling on the faithful to donate anything they could—a second coat or spare bread—in order to clothe and "nourish Jesus Christ in the person of the poor." At the same time, Bernières describes soup kitchens established in the war zone around Étampes, sixty kilometers south of Paris, where villagers now "appeared more dead than alive."[122] Destitute peasants in Picardy and Champagne, as well as nobles and burghers bereft of resources but reluctant to seek charity (the "genteel poor"), also continued to receive aid.

Such operations depended on an extensive network of charity driven by extraordinary social and religious zealotry. The greatest name in seventeenth-century charity, Vincent de Paul, played a leading role in organizing the charitable efforts publicized by the *Relations*, though he was never named in them. In early 1650, Anne of Austria had granted him official protection for the charitable activities that he directed along the northeastern frontier, and his efforts had expanded dramatically following the siege of Guise by the Spanish in June 1650. "Monsieur Vincent" relied on the Ladies of Charity, which he and Louise de Marillac had founded years earlier, to generate donations. Women of the upper bourgeoisie, notably those associated with the Parisian magistracy, soon outnumbered their aristocratic counterparts in the organization as it swelled to some three hundred members.[123] Vincent de Paul also sent members of his Congregation of the Mission into the war-ravaged regions to identify needs and manage relief operations. Their letters supplied many of the extracts published in the *Relations*. Working in conjunction with both organizations were the Daughters of Charity, also overseen by the energetic and demanding Louise de Marillac. She chose modest young women from small towns because they proved more willing than their social superiors to perform menial tasks

amid foul odors and squalid conditions. Rather than take the public and per-
manent vows that characterized nuns, women admitted to the Daughters
of Charity took private vows once a year to serve the poor.[124] This made
them all the more admirable in times of extreme distress. As Vincent de
Paul noted in late June 1652, "the poor Daughters of Charity are doing
more than we are as far as the corporal works of mercy are concerned."[125]
Whether drawn from Parisian high society or village obscurity, the hun-
dreds of women and men involved in emergency poor relief provided living
examples of how individuals inspired by a more interiorized form of piety
could become instrumental in redressing the crisis of 1652.

It is particularly noteworthy that the massive surge in charity in 1652 took
the place of a more predictable response, to wit, an extensive crackdown on
popular violence. This is only partially explained by the fracturing of state
power. That the social elite of Paris chose not to engage in repression, but
to deploy private charity instead, strongly suggests the influence of recent
religious teachings that made both sincere repentance and the giving of alms
essential elements of personal salvation. Individuals responded to the suffer-
ing caused by the prolonged civil war with an outpouring of charity. Religious
organizations took the lead, but many laymen joined the effort financially and
spiritually. The bishop of Paris sent missionaries throughout the diocese to
"compel individuals to look within themselves" and to reflect on God's final
judgment if they did not "endeavor to give alms."[126] In October, the bishop
published the results of a general inquiry into the "miseries of the country-
side and the needs of the poor around Paris," which he followed with a sim-
ilar pamphlet a few weeks later.[127] Like the *Relations*, these reports combined
harrowing descriptions of death and destruction with explicit appeals for
charity. The response began with a mass mobilization of religious orders and
confraternities in Paris, each assigned to different clusters of war-ravaged vil-
lages around the capital. Lay men and women supported the movement with
impressive enthusiasm, either as guild members or as individuals. "All Paris
contributed," wrote Vincent de Paul. Butchers donated almost six thousand
pounds of meat; hosiers gave money and clothing; the rich offered jewelry
and silver serving ware. One woman personally delivered her entire ward-
robe, including her shoes, and returned home barefoot.[128]

This massive surge of charitable activity in the autumn of 1652, though
known to a few specialists, has not been included in the basic narrative of
the Fronde. Moreover, these developments have not been well explained,
especially in political and psychological terms. This new outburst of charity
clearly had roots in longer-term developments. These necessary precondi-
tions, however, do not explain the role of precipitating factors. The surge

of charity in 1652 would not have happened without the *Relations* or the previous years of both preaching and practicing charity in response to the calamities of the civil war. Basic social and economic concerns no doubt also influenced responses. Many members of the Parisian elite owned property in the surrounding countryside and would have been eager for a return to normalcy in these localities. In such cases, however, their actions would likely have been more focused on specific villages. In contrast, the deputation sent by the six great merchant guilds of Paris that met with the young king on 29 September 1652 put the tragic state of the poor in the capital at the center of their tearful appeal for his return. According to the *Gazette*, in describing the suffering of the most desperate in the city, the weeping deputies "also drew tears from the assembly." "And these good bourgeois, who were able to display more heart than tongue [i.e., more emotion than eloquence], nonetheless expressed themselves so effectively that their majesties [Anne of Austria and Louis XIV] were very moved."[129] Thus, the remarkable charitable response that accompanied the king's return to Paris certainly appears to have been a psychological and spiritual response to the mass violence and emotional suffering of that summer.

To be clear, the sheer extent of suffering does not alone explain the charitable response. In fact, even as appalling hardships continued throughout the winter, a palpable "donor fatigue" quickly set in. It seems, therefore, that having used charitable giving to pay their spiritual dues for resisting the monarchy's authority, by 1653, Parisian bourgeois no longer felt compelled to make additional sacrifices. As the political crisis of the Fronde came to a close, enthusiasm for charity also waned. Louis XIV made a triumphal return to his capital on 21 October 1652 (see figure 6), and the reviled Mazarin soon followed on 3 February 1653. Despite the ongoing humanitarian crisis, the scope of charitable activities began to contract almost immediately thereafter. Bernières published only a handful of pamphlets over the following two years. By 1655, he had come to the conclusion that the *Relations* risked the disdain and insignificance associated with ordinary pamphlets, which is a sign of their extraordinary influence previously.[130] These graphic accounts of suffering and the massive effort at emergency relief for victims of the civil war had helped to raise some six hundred thousand livres in charitable donations, most of it in 1651 and 1652.[131] Such sums far surpassed any previous mobilizations of charitable relief and constituted one of the most astonishing features of the Fronde. Moreover, it marked the first time that a deliberate campaign of publicity had been used to alter public consciousness and shape a movement that resembled Christian humanitarianism, a new alternative to the Christian fatalism that had long prevailed.

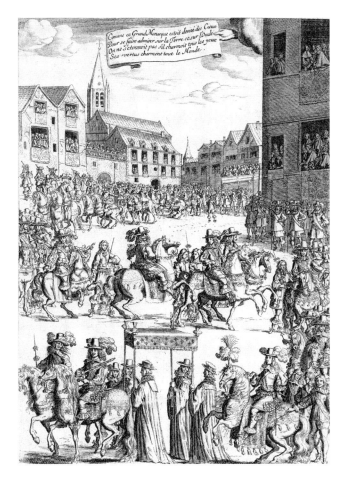

Figure 6. The entry of Louis XIV to Paris, 21 October 1652.

Anonymous etching (1652). Bibliothèque Nationale de France / Gallica.

The impressive mobilization of charity during the late Fronde is evidence that the bourgeois of Paris, at least, experienced a sense of collective trauma in the summer of 1652 and that many of them responded in the manner prescribed by a new, more rigorist theology and an increased interiorization of piety. That so many turned this increased inwardness into outward action points toward the development of a more salient self. In other words, the interiorization of piety in the first half of the seventeenth century is not sufficient to explain the level of charity attained in Paris during the Fronde. Rather, the representations of suffering contained in the *Relations* helped to stimulate individual and collective compassion among the Parisian bourgeois, which reflects increased inward thinking.

The descent into greater violence in July 1652, despite the procession of the relics of Sainte Geneviève only a few weeks earlier, together with the fears of social revolution provoked both by misleading pamphlets about events in Bordeaux and by exaggerated retellings of events in Paris, induced a widely shared reaction among the *bons bourgeois de Paris*. The social realignment that made them more fearful of the lower orders of the urban populace, which they increasingly viewed as lumpen elements who threatened the social order, is evidence of a collective trauma. This shared response, and the resulting change in perspective that it produced, proved critical to ending the Fronde. Thus, the decline in support for *frondeurs* among Parisian bourgeois and the growing unity generated by shifting support toward the monarchy in the autumn of 1652 provide evidence of the extent to which responses to widespread poverty and dislocation had interacted reflexively with responses to the political crisis. The sudden decline in charity in early 1653, once both Louis XIV and Mazarin had returned to Paris, confirms that the crisis had linked *frondeur* politics and personal conscience in particularly intense ways.

The Thermidorians' Terror

Scholars have a strong, but rather vague, sense that the French Revolution deeply impacted the development of the self. Prior to the Revolution, natural philosophy and Enlightenment aesthetics took on the vocabulary of sentiment and sympathy, thereby cultivating human beings' natural capacity for "fellow feeling."[1] The new bourgeois culture of *sensibilité* encouraged discussion and exploration of intimacy and the interior life of the individual. Inner truths and personal feelings were to be reflected in unabashed tears, whether shed alone when reading a novel or a private letter, or in the company others, such as at the theater.[2] These new cultural and emotional mores also determined responses to acts of violence. It became inappropriate, for example, for ladies and gentlemen to be spectators at public executions.[3] The new modes of conduct also reflected a marked increase in concerns about self-representation.

The democratic aspects of the French Revolution greatly magnified issues of sensibility and self-representation. The social and cultural upheaval that began in 1789 forced French men and women to reimagine and reconstruct many of their most important social ties. It is not difficult to see how a revolution based on individual rights and bent on destroying the existing corporative order became a great catalyst to Western-style individualism, which is fundamental to the modern self. And yet it is difficult to identify just how various stimuli generated by the French Revolution directly promoted the combination of increased interiority, self-reflection, empathy, and the sense of authenticity and continuity between an interior life and exterior persona that characterize the self. Dror Wahrman has—rather controversially—argued that England saw an *"ancien régime* of identity" replaced late in the eighteenth century by a sense of self in which "identity became personal, interiorized, essential, even innate."[4] Then, on the basis of various shards of cultural evidence from across the channel, Wahrman concludes that France experienced the same shift in the late 1790s. His focus for this almost Foucauldian rupture is on "subjectivities" associated with

race, class, and gender, which he argues became more fixed as a result of revolution. Such an interpretation pays little attention, however, to the considerably greater psychological work required to develop new identities in a rapidly changing and still volatile society. Thus, it is not the supposed rigidity of certain categories of identity that should be emphasized, but rather their increased mutability, and even malleability, at the level of the individual.

The French Revolution wrought truly sweeping changes in terms of collective and individual identities. These included such profound transformations as abolishing seigneurialism (in the course of which peasants, *paysans*, officially became country dwellers, *habitants de campagne*, and, in some regions, serfs or vassals became tenants or proprietors), destroying the entire corporative social order based on guilds, parishes, and noble lineage (which led to social mobility, both upward and downward, more than it did to sudden class consciousness), replacing a kingdom of subjects with a nation of citizens each possessed of individual rights (thereby making adults equal before the law, if not equal in choosing lawmakers), introducing no-fault divorce (thus opening the possibility of a new economy of personal emotional fulfillment for both women and men), and valorizing military service as the duty of citizen-soldiers (in the process, turning socially marginal soldiers, *soldats*, into heroic defenders of the fatherland, *défenseurs de la patrie*). These sweeping reforms in the structures that underpinned society contributed enormously to valorizing the individual, regardless of the extent to which individuals' material circumstances improved or not.

Less obvious, perhaps, was the impact of revolutionary violence on the psychological work of identity formation. This is particularly the case with feelings of victimization. Psychological responses to the violence of the Revolution remain difficult to assess, although some original and creative approaches have been taken. Peter Fritzsche has explored the longer-term reactions embodied in a postrevolutionary "sense of loss" and the emergence of feelings of "nostalgia." As he notes, "the interplay between grand narrative and the individual evidence of experience produced a compelling interior voice that was characteristic of the nineteenth and twentieth centuries."[5] In a different vein, William Reddy has argued that the sweeping shift from the externalized emotions of eighteenth-century sentimentalism to the introspective intensity of nineteenth-century Romanticism began in the immediate aftermath of 9 Thermidor II (27 July 1794).[6] Such approaches put particular emphasis on developments in the first five years of the French Revolution, especially the period known as the "Reign of Terror" in 1793–94, but largely overlooks the immediate post-Thermidorian period.

These histories fail to appreciate the extent to which the Reign of Terror as a distinct period of the French Revolution was largely determined by those who took the reins of government after the overthrow of Maximilien Robespierre and his closest allies. The more one examines the Thermidorians' construction of the Terror, the more it becomes evident that its psychological effects on the French populace were inextricably entwined with the subsequent period. Furthermore, many of these cultural and psychological effects acted as catalysts for a more developed self.

Such an approach starts with the recognition that not everything attributed to the so-called Reign of Terror as a trauma actually occurred during the months between March 1793 and July 1794, the most extended time frame usually given for this period. There is no doubt that the repression, coercion, and state-authorized violence perpetrated in France during this time directly impacted a large number of French men and women, but it was far from the majority of the population. Equally important, it was during the year *following* the parliamentary coup d'état of 9–10 Thermidor II (27–28 July 1794) that an exceptionally effective communication of suffering through text and image compelled the French to see the preceding period as a coherent phenomenon based on intense and ubiquitous fear. It was during the so-called Thermidorian period that French men and women saw the interplay between atrocities and tragedies, the difficulty of distinguishing victims from perpetrators, and the deployment of a sentimentalist idiom in order to politicize pathos all reach their height during the French Revolution. Furthermore, these cultural and political forces combined to require individuals to develop self-representations, and, therefore, to engage in self-reflection, far more than has been generally recognized. This combination of developments during the post-Thermidor period made the Terror into a collective trauma, one that gave French men and women a greater sense of personally sharing in the larger fate of the nation. In many ways, it was the version of the Terror constructed by the Thermidorians[7] that France as a nation continued to "work through" for decades to come.

To be clear, we owe the concept of a reign of terror to Thermidorian politicians who sought to establish the legitimacy of their rule by repudiating aspects of the state-authorized violence of 1793–94. And yet just what forms of violence and coercion counted as unacceptable and what as necessary under the circumstances of Year II proved deeply contentious in Year III. Rather than rewrite the history of these debates, which is largely the history of Thermidorian politics, we need to explore the cultural and psychological implications of the trajectory from the summer of 1794 to the autumn of 1795, and even to 1797. It is during this period that a massive

dissemination of pamphlets, newspapers, and pictorial prints exposed and framed events before the death of Robespierre as a "reign of terror" in ways that carried the emotional consequences of the original violence to a vastly larger number of people, many of whom had lived at relatively safe distance from extreme political violence. This broader collective trauma interacted in complicated ways with the many changes in individual identity already fueled by the French Revolution.[8] The Thermidorians' struggle to determine who was culpable for the events of 1793–94, and especially how to define and deal with the victims, brought these elements together in a particularly forceful way, thereby making the Thermidorian period especially fertile in fostering the self.

"The Reign of Terror"

Some scholars who study trauma are convinced that "the recollective reconstruction of an event" is more important in generating its traumatic effects than is the initial experience alone.[9] Responses to the so-called Reign of Terror support this claim. Despite the general pall of repression that hung over France in 1793–94, it was not until months after the overthrow of Robespierre that most Frenchmen learned details about the full range of injustices and atrocities committed in Year II. Thus, it was after Thermidor that images and discourses of violence had the greatest psychological impact on the general population of France. This was certainly not the case in Paris, the region of the Vendée civil war, the principal cities of southern France, or departments along the frontiers. Most residents in these areas had enough personal experience of local incidents of bloody resistance and repression to be directly affected emotionally if not materially. However, it took the Thermidorian period to turn the various episodes of repression and coercion deployed in 1793–94 into a truly national trauma known as the Terror, a period during which the entire country of France was victimized by a sanguinary dictatorship supposedly unprecedented in history.

There is no doubt that a great number of people experienced real and profound fear under the revolutionary government of 1793–94, as the Montagnards and their allies around the country intended. The discourse of terror as a necessary tool of government emerged during the crisis of 1793 when the National Convention faced a massive revolt in the Vendée, the threat of foreign invasion in the northeast and southwest, and the so-called Federalist revolt in key cities around the country, especially across the south. The *sans-culottes* insurgency of 4–5 September 1793 in Paris may not have led the Convention officially to put "terror on the daily agenda" (*terreur à*

l'ordre du jour), as historians long believed, but many agents of the revolutionary government talked and acted as if it had.[10] The frequent use of this phrase by those actively engaged in repression during Year II gave Thermidorians the basis to turn it into a caricature of that year. This retrospective discourse on terror was so pervasive that it even became a way for individuals to describe their personal experience of the regime.[11]

Between early June 1793 and late July 1794, France lived through a period in which fear was an exceptionally important instrument of rule. The revolutionary government needed fear to compensate for its inherent lack of authority and therefore trumpeted the summary justice it meted out to its enemies. As a result, the guillotine became an omnipresent symbol, a synecdoche of the fledgling republican regime. Moreover, the arbitrary exercise of revolutionary authority ensured that many French men and women experienced fear simply because of who they were, not what they had done. Even those who did not belong to the most proscribed groups, such as priests, nobles, financiers, wholesale merchants, and tax collectors, ran the risk of being arrested as "suspects" under the elastic law of 17 September 1793. In addition, the massive mobilization of men and matériel for war, including imposing the Maximum (fixed price ceilings on numerous basic commodities) and requisitioning a wide range of supplies for the war effort, put almost anyone who engaged in the market economy, from fishmongers, bakers, and shoemakers to cartwrights, bankers, and horse breeders, at risk of denunciation and persecution. Personal wealth, passing challenges to authority, and even political passivity could all turn individuals into "suspects."[12]

All the same, it is easy to exaggerate the threat posed to most French men and women by the revolutionary government of Year II. Even many specialists, usually eager to describe the cruelties and civil strife of 1793–94, seem to forget that most parts of the country did not experience much violence at the time: in fact, fully half of France's eighty-four departments (averaging 350,000 persons each) had twelve or fewer citizens executed by revolutionary justice.[13] Moreover, despite the official publicity that accompanied various coercive features of the revolutionary government of 1793–94, historians have not paid much attention to the differences between what the population of France knew was happening during the so-called Reign of Terror and what they were told about it thereafter.[14] To be sure, some of the *"grandes mesures"* of Year II had been made public as they unfolded. For example, several newspapers published a letter sent to the Commune that praised the extreme violence being used to subdue rebels in the Vendée. However, the brutality of such repression was often obscured by vague rhetorical language, such as describing the Loire River as a "revolutionary

torrent" carrying away the detritus of the Vendée.[15] Despite the Jacobins' endless discourse on "enemies of the people," constant search for "conspirators," and harping on the need to punish "moderationism," the actual measures being taken in certain parts of the country were only vaguely known, if at all. Augustin Cochin, in his study of Jacobinism, noted how little was said in this vein. "The silence maintained about these enormous actions is not the least curious feature of this strange period. France was suffering from the Terror—one could say that she was unaware of it—and Thermidor was at first a deliverance, but then a discovery: people went from surprise to surprise for months and months."[16] Jules Michelet also recognized the extent to which the Thermidorians discovered the horrors of Year II. "It was an immense Dantesque poem that, from circle to circle, led France down into this hell, still little known even to those who had traversed it."[17] Charlotte Biggs, an English woman who lived in France and maintained a private correspondence throughout the Convention, confirmed this impression. She remarked a few weeks after 9 Thermidor that her earlier letters had only provided "some faint sketch of the situation of the country, and the sufferings of its inhabitants—I say a *faint sketch*, because a thousand horrors and iniquities, which are now daily disclosing, were then confined to the scenes where they were perpetrated; and we know little more of them than what we collected from the reports of the Convention, where they excited a laugh as pleasantries, or applause as acts of patriotism. France had become one vast prison, executions were daily multiplied, and a minute and comprehensive oppression seemed to have placed the lives, liberty, and fortune of all within the grasp of the single Committee."[18]

This description of the all-encompassing reach of the Committee of Public Safety was a quintessentially post-Thermidor caricature. Despite the growing administrative centralization prepared by the law of 14 Frimaire II (4 December 1793), an official rhetoric that justified terror, notably Robespierre's speech of 4 February 1794 on virtue and terror, and the concentration of exceptional justice at Paris following the law of 22 Prairial II (10 June 1794), the so-called Reign of Terror was neither consistent nor coherent. In short, those features of the regime that constituted "the Terror" were largely experienced at the local level as the arbitrary actions of representatives on mission and revolutionary militants who acted with little or no accountability, rather than being understood at the time as a system of government.[19] After all, it was Robespierre's attack on various former representatives on mission, supposedly for having sullied the republic through their independence in implementing extremist measures, that finally precipitated his overthrow.

It was the deputies who defeated Robespierre and his acolytes who first presented the improvised government of Year II as a "system of terror" operated by "terrorists" (both neologisms at the time) with supposedly devastating emotional consequences for the entire population. A month after 9 Thermidor, the deputy Jean-Lambert Tallien gave a famous speech explaining what he described as the "system of terror" that developed in 1793–94. At first he blamed the nature of the regime on Robespierre: "he is the one who put it into effect with the help of some subordinates." But Tallien soon expanded his explanation by claiming that the logic of terror had surpassed individuals. Those who put it into effect found themselves trapped in an escalating spiral of fear and violence. The "system of terror" divided "the republic into two classes: those who caused fear and those who felt fear." He painted the elevation of fear into a "system of terror" in terms that amount to an almost clinical, even if prepsychiatric, definition of trauma: "Terror is a habitual and general trembling, an exterior trembling that affects the most hidden fibers, which degrades man and likens him to a beast; it is the perturbation of all physical forces, the shocking of all moral faculties, the derangement of all ideas, the reversal of all affections; it is a real disorganization of the soul, which leaves it nothing but the ability to suffer and the resources of despair."[20] According to Tallien, this was the experience Robespierre's regime had inflicted on men and women throughout France. Tallien's interpretation became woven into the fabric of politics over the following year. For example, Jacques-Charles Bailleul, in a speech to the Convention on 19 March 1795, provided a similar, if less psychologically precise, description of life under the previous government: "Terror dominated all minds, oppressed all hearts—it was the government's strength. . . . The human self [*moi*] no longer existed; every individual was nothing but a machine, coming, going, thinking or not thinking, according to how the tyranny pushed him or animated him."[21]

Historians have largely rejected the Thermidorian's self-serving explanation of the "system of terror," but a great many of them have retained a similar general framework, thereby treating the government that emerged in Year II as a far more pervasive and systematic exploitation of fear than it actually was.[22] Being subject to the coercive regime of 1793–94 was not the same as being traumatized by terror. It took a return to freedom of the press and a growing demand for retribution truly to define "the Terror," thereby making it into a more distinct phase of the Revolution. More precisely, it took a series of shocking revelations during Year III to give full meaning to the discourse of terror, the "law of suspects," and the fetishization of the guillotine. Revelations about the extent to which the fledgling

republican government had deviated from judicial and military norms came from a combination of debates in the National Convention, trials before the Revolutionary Tribunal, and, above all, an outpouring of anti-Jacobin publications.

The ascendancy of radical republicanism in Year II had severely curtailed the expression of opinion, especially in print. Conformity in dress, speech, and, above all, publication had been the order of the day. The events of 9 Thermidor soon reversed this trend, thereby allowing an increasingly free press once again to play the Enlightenment game of mirrors in which publicists sought to shape public opinion by claiming to speak on its behalf. Separating the rhetorical strategy of publicists from the actual influence that pamphlets and newspapers had on the population is not possible. That the press played a far greater role in society during the 1790s than ever before is not in doubt, however.

THE REVOLUTION IN PRINT

Print culture in France had expanded dramatically between the Fronde and the French Revolution. The *frondeurs* had produced fifty-two hundred pamphlets in five years—an astonishing outpouring for the seventeenth century—whereas the French Revolution produced over fifty-five thousand pamphlets in a decade, an equally astonishing outpouring a century and a half later.[23] The increase is even greater than these numbers suggest, for the pamphlets produced during the French Revolution tended to be many times longer than those published during the Fronde and published in much larger print runs. The population of France had grown by about 50 percent during this time, and rates of literacy had increased even faster. Moreover, typical reading practices had evolved considerably as intensive reading of a few texts became complicated by journalism and the extensive reading of a variety of texts.[24]

The French Revolution greatly aided the trend toward extensive reading, as one can tell from the explosion of pamphlets and newspapers. Prior to the crisis of 1788, France had only a few national newspapers, led by the venerable *Gazette de France*. However, these were greatly supplemented by at least a dozen foreign periodicals written in French and dependent on subscriptions in France. There were also about eighty provincial publications, most of which were largely devoted to commerce and culture and only a few of which contained significant political news.[25] Prerevolutionary papers that covered political events were tailored to a "sophisticated audience of cultured men and women . . . and kept them abreast of what was new . . .

but these periodicals were not meant to stir them to action."[26] The fall of the Bastille provoked a radical transformation in the nature and influence of the popular press. Thereafter, in addition to thousands of pamphlets, came hundreds of newspapers. Paris alone saw 130 new titles appear in 1789.[27] Most of these did not last long, but the sudden change was clear. For the next decade, French readers would be inundated with an unprecedented and often overwhelming variety of perspectives on current events. Extensive reading took wing and soared throughout the 1790s. Reading the news aloud became commonplace in political clubs, cafes, and town squares alike, thereby multiplying the power of the printed word several times over.

More often than not, reporting on current events included editorial efforts to explain and interpret them. Such editorial intervention turned many newspapers into instruments of action, especially in the hands of radicals such as Camille Desmoulins, Jacques Pierre Brissot, Robespierre, and Jean-Paul Marat. As revolutionary newspapers joined pamphlets in seeking to shape public opinion, they broadened the potential audience. Moreover, as the political stakes rose, so too did the intensity of journalistic rhetoric. Few restraints remained by 1793. The *sans-culottes* movement stimulated fierce competition to attract readers among the common people. More than a dozen journalists tried to impersonate "Père Duchesne," a cantankerous folk figure who spewed invectives against *"aristos," "calotins,"* and *"tripoteurs."* Crude obscenities embellished conspiracy theories and angry denunciations to alarm readers into joining the revolutionary struggle.[28] Such emotive rhetoric fueled support for the politics of resentment and repression.

While the *sans-culottes* movement battened on invective-laced radicalism, other forms of journalism grew increasingly scarce. The royalist press all but disappeared in the autumn of 1792 following the overthrow of the monarchy and the September Massacres. In the spring of 1793, the Girondin press was also attacked and then finally shut down by the forceful assertion of a Jacobin orthodoxy. A new quasi-official journalism, in which newspapers received subsidies from political clubs, government ministers, local authorities, and deputies on mission, soon came to dominate the public arena. Even without a censorship law, Jacobins throughout the country successfully imposed considerable conformity on the press. Reporting contemporary events did not end, but most news now came heavily cloaked in a republican and populist ideology. Any remaining diversity of opinion in the press mainly reflected factional divisions within the Jacobins themselves, and even those largely disappeared during the spring of 1794. Although the revolutionary government never asserted complete control of the press,[29]

it did silence expressions of empathy for individuals targeted by the repression of 1794. Private thoughts had to be closely guarded; otherwise they could lead to public executions.[30]

The parliamentary coup of 9–10 Thermidor was neither an attack on revolutionary government per se nor a blow struck for greater freedom of expression. Nonetheless, publicists recognized the change in atmosphere, and a massive surge of pamphleteering quickly followed, especially in Paris. Public squares and street corners again rang with the repetitive calling of sensational titles and headlines. Dozens of pamphlets openly attacked the men in power, most of whom were still Jacobins. Revolutionary newspapers that were revived and given a new political slant, notably Louis-Marie Stanislas Fréron's *L'Orateur du peuple* and Tallien's *L'Ami des citoyens*, proved astonishingly successful despite their editors' personal histories as extremist Montagnards. Such overtly "reactionary" newspapers systematically discredited the regime that existed before the "happy revolution" of 9 Thermidor.[31] Parodies, fictional dialogues, and classical parallels, all common fare already, enriched the emerging Thermidorian discourse. Most importantly, the press gave voice to the public's mounting hostility to the policies of repression,[32] made redundant by military victories over the republic's foreign and domestic enemies. At first, Thermidorians relied more on hyperbole than on precise accusations. Jacobin journalists hit back in defense of the revolutionary government—past and present—but they had lost their monopoly on public rhetoric. In a few short weeks, detailed accounts of the collective atrocities and personal tragedies of Year II turned the tide against Jacobin justifications for revolutionary government.

ATROCITIES IN THE NEWS

Public revelations of atrocities and published accounts of tragedy played central roles in how the Thermidorians came retrospectively to define the revolutionary government of Year II as the Terror. Such revelations and publications began in late August 1794 and may have been coordinated with Tallien's speech on the "system of terror." First, the deputy Laurent Lecointre tried to have former members of the Committees of Public Safety and General Security indicted for the excessive repression and political violence of Year II. However, the Convention repudiated his vague claims, and the Jacobins expelled him from their club. Second, an anonymous pamphlet entitled *Queue de Robespierre, ou les Dangers de la liberté de la presse* portrayed Jacobins as dangerous men bent on continuing the tyranny of Robespierre. It proved one of the great publishing successes of the French Revolution.

Within a week, an astonishing seventy thousand copies had been printed and distributed throughout France. *Queue de Robespierre* (*Robespierre's Tail*, i.e., his remaining acolytes) claimed that those who opposed a free press were afraid of being exposed for having ruined trade, monopolized government positions, and murdered more than a million persons (!). Despite also lacking much tangible evidence, the *Queue de Robespierre* carried the day through verve and wit. It quickly inspired a wave of Thermidorian pamphleteering: at least twenty-five other pamphlets borrowed from its title or responded directly to it.[33] Despite their heady rhetoric, the imprecision of the attacks by Lecointre and the *Queue de Robespierre* reveal just how little even well-placed politicians and publicists knew about events that would soon become hallmarks of the Terror and yet how powerful even a modicum of evidence could be when artfully exploited.

Revelations about the excesses of Year II accelerated with the trial of ninety-four members of the elite at Nantes sent before the Revolutionary Tribunal in Paris on charges of "federalism," an accusation often levied against refractory moderates in the provinces who resisted Montagnard domination. The trial in mid-September 1794 inspired another massive spate of publicity. Pamphlets and newspapers reported breathlessly on the sordid practices of revolutionary repression that had accompanied the fight against the royalist rebels in the Vendée. The appalling suffering of the accused—37 of the original 132 city notables had died on route or in prison before the trial had even begun—had become national news. Even that was quickly surpassed by tales of the mass drowning of thousands of prisoners in the Loire, often conducted at night and with elaborate rituals of humiliation. Mass shootings without trial, sexual abuse of female prisoners, and plundering corpses all became central features of the reporting.[34] Even newspapers distributed to the peasants of Alsace reported these details "in the local idiom" (German) despite the distance from Paris, let alone the Vendée.[35]

The trial of the Nantais inexorably led to the impeachment and trial of Jean-Baptiste Carrier, accused along with the Revolutionary Committee at Nantes of perpetrating atrocities in the Vendée. The revelations at this trial further fueled the national obsession with the emerging narrative of atrocities. The official indictment was published as a pamphlet and excerpted in leading newspapers. It described "the horrors committed by the accused" as almost unmatched in history, and described the Loire as "flowing with bloody water," its "banks covered with the bones of victims slaughtered by barbarism, and vomited ashore by indignant waves."[36] Weeks of extensive press coverage followed, revealing to the entire country lurid details of arbitrariness, corruption, sexual predation, and wholesale slaughter. Descriptions of the

systematic drowning of thousands of prisoners produced the greatest shock. A lively contemporary engraving by Jean Duplessis-Bertaux captures many elements of the testimony given at trial (see figure 7). It shows well-armed men loading victims into flat-bottomed skiffs and barges, then either sinking the boats or simply throwing victims overboard. Both the brutality and the suffering that accompanied such sinister activities is amply depicted. Men strike struggling victims with swords, cudgels, and poles; women and children in a boat near the bank extend imploring arms toward the perpetrators; and dogs devour corpses that have already washed ashore. The horrifying "facts" of the matter—that there had been twenty-three separate *noyades*, that men and women had been stripped naked and tied together in "republican marriages," etc.—were quickly fixed in synthetic accounts and early histories, too many of which are still repeated today.[37]

The publicity that arose from the trials regarding repression at Nantes put, in the words of Bronislaw Baczko, "l'horreur à l'ordre du jour."[38] At the time, deputies also rose in the Convention to denounce both army generals and fellow deputies who had directed the brutal military repression in the west. According to the national newspaper of record, the *Moniteur*, when a deputy read aloud General Louis-Marie Turreau's orders to one of his column commanders to "disarm and slaughter everything in his path, without distinction of age or sex," "the entire assembly responded with an expression of horror."[39] Descriptions of other atrocities further darkened the mood. Leading citizens from Bédoin in the Rhône valley appeared in the Convention to describe the total destruction of their town, including the burning of five hundred houses, in retaliation for a liberty tree having been chopped down. Deputy P.-C.-A. Goupilleau followed them to the podium, adding that when he arrived at nearby Orange in August 1794, he found a trench full of five hundred corpses that had to be covered over, as well as six other trenches and a large quantity of quicklime intended to accommodate another twelve thousand bodies. Moreover, the Popular Commission there had sent men as old as eighty-seven and boys as young as six to the guillotine. Unaware that they had just heard gross exaggerations—the Commission of Orange sentenced "only" 332 individuals to death—the deputies in the National Convention rose as one to swear that they had had nothing to do with such "atrocities."[40]

The term "atrocities" became a leitmotif of the ensuing debate about culpability. If members of the governing committees of Year II were not held accountable, argued deputy F.-P. Legendre, then the National Convention itself would be blamed. His litany of atrocities, which highlighted the *noyades* at Nantes, the *mitraillades* at Lyon, and the excesses of Joseph

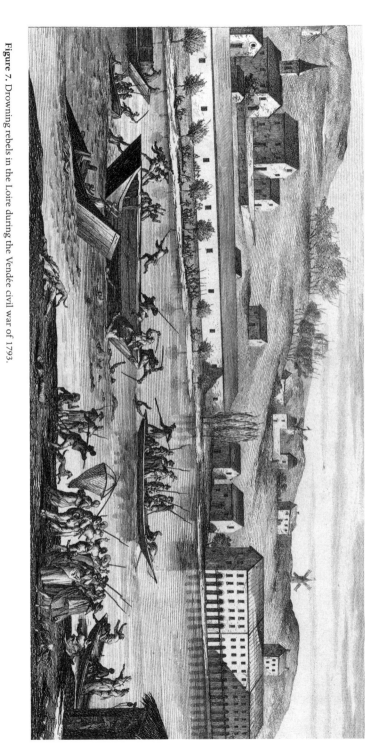

Figure 7. Drowning rebels in the Loire during the Vendée civil war of 1793. Detail of etching by Jean Duplessis-Bertaux (Paris, 1797). Bibliothèque Nationale de France.

Le Bon at Arras, has come to characterize the Terror ever since. However, this was the Thermidorians' Terror, expertly crafted to focus responsibility on select members of the revolutionary government during Year II, especially Robespierre.[41] This interpretation of the Terror as the fruit of a narrow tyranny was fortified by two lengthy reports developed by investigative committees of the Convention. Innumerable historians have mined these reports, especially their documentary appendices, for evidence on the inner workings of the revolutionary government of Year II. This familiarity, along with the archival research done thereafter, has obscured the national impact both reports had at the time they were published. The blatant bias and interpretive hyperbole of these reports were effectively masked by the mass of sensational, unpublished documents they included as supporting evidence. The first report, based on Robespierre's private papers and over four hundred pages long, developed the thesis of a bloody tyranny, "a reign by terror," constructed through acolytes and place seekers. The second report, 250 pages long, focused on other key members of the two "great committees." The opening paragraph of this second report crystallized the Thermidorians' version of the Terror: "the land of liberty covered in prisons, giving way under the weight of scaffolds, soaked in the blood that watered it every day; terror hung over all heads; desperation inundated all souls; mourning spread to all families; dismay in all cities; revolutionary armies roaming the departments, preceded by fear, accompanied by devastation, and followed by death."[42] In short, according to the most thorough investigations undertaken to date, the tyranny of a handful of men had produced emotional suffering in every person, family, city, and department in France. Both reports received massive publicity throughout the country.

These official reports led directly to the indictment of four former members of the governing committees of Year II, already known as the "great guilty."[43] One of these, Jean-Marie Collot d'Herbois, illustrates the central role of specific atrocities in the post facto image of 1793–94. Events at Lyon held a special place in the Thermidorians' construction of the Terror at the national level. Collot d'Herbois had been added to the Committee of Public Safety in direct response to demands that the Convention make "terror the order of the day." He thus embodied an obvious link between the tyranny of the "great guilty" on the committees of government and bloody atrocities in the provinces. The government had intended the repression at Lyon to be especially exemplary, and Collot d'Herbois had not disappointed. He even justified using cannons to perform mass executions as humane because the condemned did not have to watch dozens of others die before they faced death themselves. By late 1794, however, the gruesome details of the

mitraillades at Lyon were becoming increasingly widely known thanks to an early history of the siege published in Switzerland and then Paris.[44] Here readers learned how victims, some tied together in groups, others attached to trees on the plane of Brotteaux, had been shot en masse, at times using cannons filled with grapeshot, with hussars then sabering survivors to death. The *Journal de Lyon* embroidered on these events. Its inaugural issue of 17 February 1795 was devoted to a single article, "Collot-d'Herbois. Cris de Vengeance." The editor, Alexandre-Michel Pelzin, maximized the emotional impact of the atrocities: "Come close," he beseeches his readers," their groaning will inform you that, after the impact of the fatal blow, they hung for a long time suspended between life and death, that their cries of suffering echoed beyond the river, and that later their bodies were chopped to pieces by steel and the palpitating limbs thrown in the Rhône." The origins of such brutality are expressed in a print depicting a massacre committed the day that Lyon fell to revolutionary forces in December 1793 (see plate 10). Here *sans-culottes*, clearly marked by long trousers and red liberty caps, engage in systematic killing. National guardsmen abet the slaughter, and a mounted cavalryman appears ready to join the fray.[45] The artist has included two severed heads—the one in the foreground resembles a head displayed to a crowd after an execution by guillotine, whereas the head in the background is on a pike being promenaded, one might say, Parisian style—thereby capturing both forms of "revolutionary justice," official and popular. Equally important, the title of the image makes Collot d'Herbois responsible for the massacre. All of these elements typified the Thermidorian caricature. Collot d'Herbois was held singularly responsible for the atrocities at Lyon, even though several other representatives on mission also directed the repression there. By focusing on Collot d'Herbois (and not the equally culpable Joseph Fouché),[46] the Thermidorians were painting a picture of the Reign of Terror that began as a small, rather improvised, group portrait. A large number of figures were only added to the background after the *sans-culottes* uprisings in Paris in the spring of 1795.

Before those epochal uprisings, however, two other men had become part of the selective group portrait of those responsible for the Terror: Antoine Quentin Fouquier-Tinville, the malleable prosecutor of the Revolutionary Tribunal in Paris, and Joseph Le Bon, an aggressive representative on mission to the armies of northern France, both of whom became proxies for the abuses of revolutionary justice. The atrocities committed by the Revolutionary Tribunal in Paris had quickly become common knowledge in the wake of Thermidor. Eight months of pamphleteering and judicial investigation preceded the trial of Fouquier-Tinville and twenty-three other members of

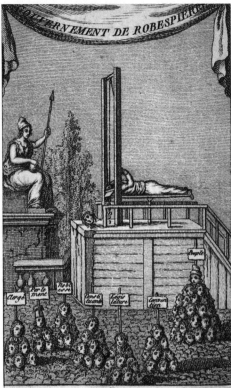

Figure 8. "Government of Robespierre." Samson the executioner, having already guillotined various groups of people, cuts off his own head.

Frontispiece from Philippe-Edmé Coittant, *Almanach des prisons* (Paris, 1794). Carl A. Kroch Library, Cornell University.

the Revolutionary Tribunal. This abundance of publicity fully discredited the inner workings of revolutionary justice in Paris. This included fixing the number of victims in advance of trials and concocting prison conspiracies in order to judge and execute batches of prisoners at a time.[47] A contemporary print captures this escalating pursuit of victims by depicting the executioner as so enthusiastic about his work that, once he had run out of victims, he could not resist decapitating himself (see figure 8). Such mockery synthesized some of the shocking statistics revealed in the spring of 1795. At the time, avid readers could even subscribe to a serialized report that provided extensive details on 2,786 individuals executed by guillotine in Paris between August 1792 and October 1794.[48] Neither souvenir nor memorial, such a serial publication could only prolong the agony of discovery.

It soon became the turn of Joseph Le Bon to be put on trial for "excesses." His crass and deadly methods while on mission had initially been excused by Bertrand Barère on behalf of the Committee of Public Safety as merely "a bit harsh" ("formes un peu acerbes"). By the spring of 1795, however, the public had been well informed of the large number of victims—said at the time to exceed 550—guillotined during Le Bon's mission.[49] Two men who had been imprisoned at Arras (but escaped the guillotine), Louis-Eugène Poirier and Montgey, published a series of sensational pamphlets charging Le Bon and his acolytes with numerous abuses of power, including public humiliation, sexual degradation, and personal enrichment.[50] Their publicity campaign included the most notorious print of the Thermidorian period, "Les Formes Acerbes" or "Harsh Means" (see plate 12). The elaborate engraving appeared in May 1795 and helped to make Le Bon the Thermidorians' totemic figure of terror, a cannibalistic drinker of blood who joined with tigers in devouring the bodies, male and female alike, piled up beneath two guillotines representing the revolutionary tribunals at Arras and Cambrai. "Drinkers of blood," "cannibals," and "tigers" were among the most common epithets applied to the Jacobins of Year II. The accompanying text explains these allegorical allusions, as well as elucidating the female nude standing in the cloud: she represents Truth holding Poirier's pamphlets, which led to freeing the prisoners shown in the background. The interplay between text, image, and action during the Thermidorian period is nowhere better illustrated than in this one engraving. Moreover, its depiction of distraught survivors on the edge of an abyss of death gave it emotional impact as well. Not only would it have especially struck viewers who had been arrested the previous year, almost anyone who had escaped the direct consequences of repression could easily read the fear and desperation on the faces of the survivors. In addition to its emotional content, the allegorical density of "Les Formes Acerbes" allowed it to embody almost all of the main tropes that accompanied the revelation of atrocities committed during 1793–94. In fact, as a visual statement of the Terror as a multi-faceted atrocity, and Thermidor as sudden relief, it remains unsurpassed. Furthermore, the origins and content of "Les Formes Acerbes" suggest that the influence of the Thermidorian press, even more than factional struggles in the Convention, turned the bloody repression of Year II, which had largely been a regional phenomenon, into a national trauma known as "the Terror."

During Year III, perhaps more than at any other time during the French Revolution, pamphlets and newspapers shaped public opinion and political action alike. The impulse came from Paris, but the provincial press also

gave local meaning to the Thermidorian definition of the Terror.[51] Despite
the hardships and economic chaos that accompanied the harsh winter of
1794–95, a surprising number of newspapers sprang up in provincial cit-
ies around the country. Almost all of these were vehemently anti-Jacobin.
Moreover, a number of provincial papers that had managed to continue
publishing despite the censorship of Year II, usually by remaining almost
apolitical, began in late 1794 to adopt the rhetoric of horror and culpabil-
ity associated with Thermidorian propaganda. And yet other papers that
had backed the revolutionary government of Year II experienced a sudden
reorientation in Year III as their editors underwent a conversion experience
similar to that of Tallien.[52] As a result, by the summer of 1795, all major
cities in France had anti-Jacobin newspapers.[53] The regional readership for
such papers meant that their Thermidorian diatribes spread like so many oil
stains, each with a certain local color, into surrounding areas.

The surge in newspaper publishing in 1795 also embroidered on the tap-
estry of terror in various smaller cities and towns, places such as Arras,
Calais, Dijon, Grenoble, Nice, and Reims. Even such modest backwaters as
Figeac, Montargis, and Vesoul spawned local newspapers steeped in Ther-
midorian vitriol.[54] These provincial papers regularly reprinted articles from
the moderate or right-wing press in Paris, such as the *Journal de Perlet*, and
added moving anecdotes about victims of revolutionary justice. Above all,
they specialized in denouncing local "terrorists" in language that reflected
a clear nationalization of Thermidorian rhetoric. The obscure *Le Décadaire
du Cantal* wrote about "the tyrants and *Vandals*," "these monsters whose
fury still floats on waves of blood," "these cannibals with claw-like hands,"
"these venomous reptiles," before demanding the punishment of a handful
of local agents of the former Jacobin regime. Even the old *Affiches de Sens*
suddenly became intensely political, publishing the speech of a Girondin
reintegrated into the Convention, "which, it is said, brought soft tears of
pity." It also excoriated the former representative on mission, a moderate
Montagnard named N.-S. Maure, as a "cannibal" and a "monster" who told a
prisoner's children that he would give them "the head of their father to play
boules with!!!" *Le Reveil-Matin*, published for a few months at Châlon-sur-
Saône, insisted on the ubiquity of fear under the previous regime: "Take a
look at the thousands of jails that existed in France. . . . Ask yourself about
the constant fear under which you lived during that frightening reign, and,
if you respond that you were never afraid of being arrested and taken away
from your home at night, if you never trembled for your property (even
if a worker), then I would say that you are a terrorist or their agent."[55]
Thus, the full range of the periodical press, from regionally influential

papers published daily in major cities to local papers produced three times a month in provincial towns, served to propagate a Thermidorian version of the Reign of Terror as a series of horrific atrocities and injustices that were ubiquitous in France and unprecedented in history.

The extent to which this rhetoric came to define the previous regime, even in areas of general tranquility, is apparent from a placard addressed to "the villains who temporarily constituted the Revolutionary Committee of Louviers," a modest market town in Normandy. The placard described these men—no doubt neighbors well known to the authors—as "monsters" and "cannibals" who "wanted the agrarian law" and "craved blood." Such language would seem to suggest that the Eure had seen some truly bloody repression; in fact, however, it experienced no more than the internment of a few hundred suspects (including thirty-two at Louviers) and a mere four executions.[56] Here is a prime example of the Thermidorians' Terror at work where there had been very little "terror" in the first place. How many French men and women like those imprisoned at Louviers experienced an even greater sense of fear once the Thermidorian imaginary persuaded them that they had only narrowly escaped the guillotine? Arbitrary arrests, house searches, administrative purges, requisitions, and dechristianization, even in areas that did not experience significant physical violence, provided the basis for a sense of psychological violence that became all the more powerful after the fact. The fear that such milder forms of coercion may have induced helps to explain the effectiveness of Thermidorian claims about the pervasiveness of the so-called Reign of Terror. Having seen a prominent citizen locked up because a son had emigrated, or a widow punished with a crippling fine for being "religious and an aristocrat," made it easier for citizens to believe that they had barely avoided a bloodbath in their own region, that by some quirk of fate, they had not seen a guillotine decapitating neighbors in the local town square. Only by a "miracle" had some departments not been ravaged "by the men of blood."[57] Moreover, the sense of having been part of a pervasive oppression helped to extend the language of atrocity to all verdicts rendered using revolutionary procedures. Victims described verdicts as "atrocities" or "rendered atrociously," even when they only imposed fines.[58]

AN ABUNDANCE OF TRAGEDIES

Along with massive reporting on the atrocities of Year II came a flood of personal accounts of the tragedies wrought that year. Whereas the two concepts—atrocity and tragedy—sit comfortably together, their contrasting

moral resonances tend to evoke different emotional responses. Reporting atrocities provoked anger and demands for retribution; revealing tragedies elicited empathy and fellow feeling. Although the two are not mutually exclusive, invoking atrocities emphasizes perpetrators whereas describing tragedies puts the focus on victims. Scholars have been far more concerned with describing and explaining the actions of perpetrators of the Terror than they have in understanding the experiences of those subjected to the repression.[59] When victims did become the focus of study, it was either to obtain a head count and social breakdown or to dwell on the suffering of particular victims, especially the most famous ones, in order to enrich the black legend. This latter approach began, of course, during the Thermidorian period itself.

By late 1794, prison memoirs had become a wildly popular new genre of revolutionary literature.[60] Many of these appeared as individual accounts published by survivors determined to describe their suffering, as well as to clear their names and demand retribution. Equally popular were collections of anecdotes gathered from former prisoners. These elaborated on the squalid physical conditions of prison life—overcrowding, damp cells, fetid mattresses, putrid latrines, rotten food, etc.—as well as the psychological effects of imprisonment under an arbitrary regime. The manifold sources of fear stand out: cruel and arbitrary jailors, betrayal by police spies or fellow prisoners, trial by a revolutionary tribunal, and possibly death by guillotine. These were often conveyed by describing how other prisoners responded to the torments and anxieties of prison life. In this new genre, concrete quotidian concerns make the suffering easy to grasp and an inspiration for empathy. Such concerns took precedence over attempts to explain the causes of the suffering. Instead, they relied on simple caricatures of the larger context, such as calling the Robespierrist regime "the bloodiest tyranny that has ever desolated the world."[61] One of the most successful examples of prison memoir, the *Almanach des prisons, ou Anecdotes sur le régime intérieur de la Concièrgerie, du Luxembourg, etc., sous le tyrannie de Robespierre* (Paris, 1794), opens with the following line: "During the reign of Maximilien the First, all the atrocities, all the horrors that the most industriously ferocious imagination could invent, were on the daily agenda."[62] The editor merely adds that he has included only the experiences of known patriots while excluding those of counterrevolutionaries who received their just punishment. In other words, his tragedies reconstituted the Terror largely in terms of victims alone. So successful was his first volume on the prisons of Paris that it quickly reached a fourth edition, then spawned another three whole volumes of similar stories.[63] Clearly there was a large and avid readership for such publications.

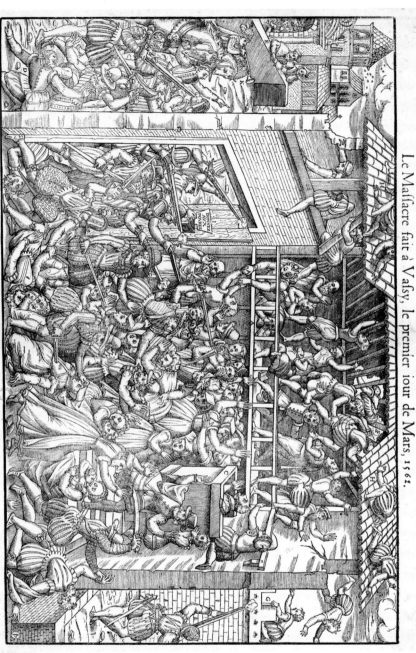

Le Maſſacre fait à Vaſſy, le premier iour de Mars, 1562.

A. La Gauge ou lou prêchoir ou citoyen enuiron 1200. perſonne.
B. Monſieur de Guiſe qui commandoit.
C. Le Miniſtre dedans la chaire priant Dieu.
D. Le Miniſtre ſe cuydant ſauuer, eſt bleſſé en pluſieurs lieux & euſt eſté tué, n'euſt eſté que le cuir rompu en deux.
E. Le Cardinal de Guiſe appuyé ſur le cimetiere de la paroiſſe.
F. Le tronc ou pouſſa arrache.
G. Pluſieurs qui ſe gettans ſur la muraille de la ville ſe ſauuent aux eſchamps.
H. Pluſieurs qui ſe cuydas ſauuer ſur le toſt & ſe harquebouſés.
I. Le tronc ou pouſſa arrache.
K. Le trompe qui te ſauuent par deux diuers s'en fout.

Plate 1. "The Massacre at Vassy the first of March 1562." Woodcut by Jacques Tortorel and Jean Perrissin, plate 11 from *Wars, Massacres, and Troubles* (Geneva, 1569–70). Bibliothèque Nationale de France.

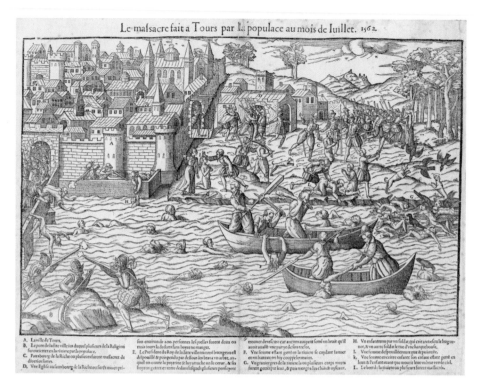

Le massacre fait a Tours par la populace au mois de Iuillet. 1562.

A. La ville de Tours.
B. Le pont de ladite ville où duquel plusieurs de la Religion furent iettez en la riuiere par la populace.
C. Fauxbourg de la Riche ou plusieurs furent massacrez de diuerses sortes.
D. Vne Eglise au fauxbourg de la Riche ou furet tuez en pri- son enuiron de 200. personnes lesquelles furent deux ou trois iours la dedans sans boyre ne manger.
E. Le President du Roy de ladite ville nommé bourgeau est despouillé & puis pendu par dessous les bras à vn arbre, auquel on ouure la poytrine & luy arrache on le cœur, & les foyans iettez en terre dedans lesquels plusieurs perseyont
trouuer de secours: car aucuns auoyent semé vn bruit qu'il auoit assailé vne partye de son tresor.
F. Vne femme estant iettee en la riuiere se cuydant sauuer en vn bateau on luy couppe les mains.
G. Vingtaine prés de la riuiere la ou plusieurs corps morts furent iettez par haut, & puis mangez des chiés & oyseaux.
H. Vn enfant tenu par vn soldat, qui crie à vn escu le higue- not, & vn autre soldat le tue, & vn harquebousse.
I. Vne femme despouillée toute nue & puis tuée.
k. Vne femme enceinte enfante son enfant estant iettee en l'eau: & l'enfant auant que mourir leue vn bras vers le ciel.
L. Le bord, la riuiere ou plusieurs furent massacrez.

Plate 2. "The Massacre at Tours done by the populace in the month of July 1562." Woodcut and etching by Jacques Tortorel and Jean Perrissin, plate 14 from *Wars, Massacres, and Troubles* (Geneva, 1569–70). Bibliothèque Nationale de France.

Plate 3. Protestant iconoclasm at Lyon. Watercolor drawing in "De Tristibus Galliae" (Lyon, ca. 1584). Bibliothèque municipale de Lyon, MS 156.

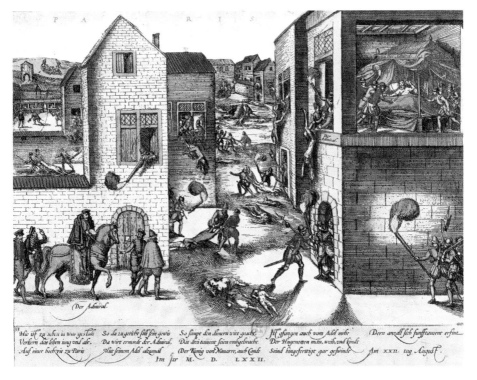

Plate 4. Assassination of Admiral Coligny and massacre of Saint-Bartholomew's Day. Engraving by Franz Hogenberg (Cologne, 1572). Bibliothèque Nationale de France / Gallica.

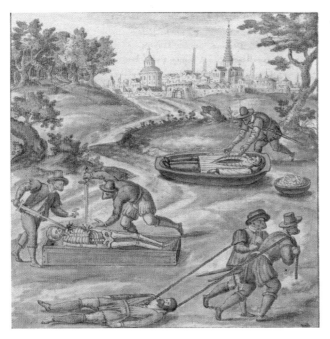

Plate 5. Desecration of graves by Protestants. Watercolor drawing in "De Tristibus Galliae" (Lyon, ca. 1584). Bibliothèque municipale de Lyon, MS 156.

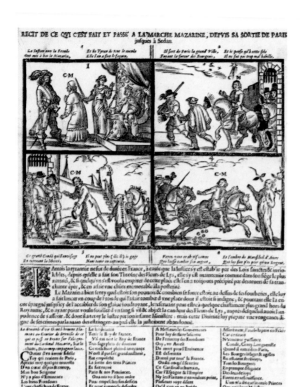

Plate 6. An extremely rare *mazarinade* with images: "Narrative of Mazarin being forced into exile at Sedan." Anonymous woodcut engraving (Paris, 1651). Bibliothèque Nationale de France / Gallica.

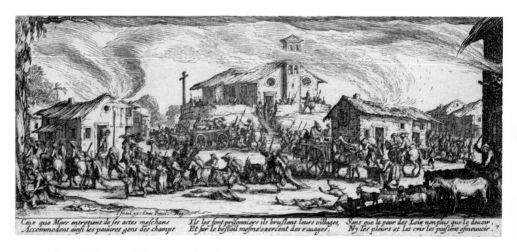

Plate 7. "Pillaging and Burning a Village." Etching by Jacques Callot, plate 7 from *The Miseries and Misfortunes of War* (Paris, 1633). Acquired through the Museum Associates Purchase Fund. Photography courtesy of the Herbert F. Johnson Museum of Art, Cornell University.

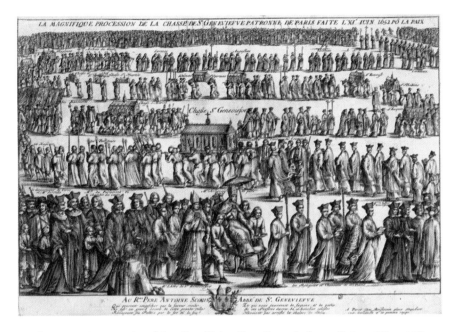

Plate 8. Massive procession of the relics of Sainte Geneviève and others at Paris on 11 June 1652. Etching by Nicolas Cochin (Paris, 1652). Bibliothèque de l'Institut national d'histoire de l'art (Paris), OC 59.

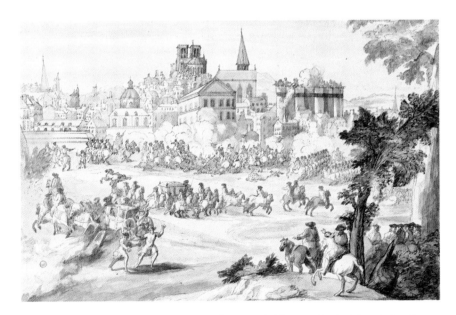

Plate 9. Battle in the faubourg Saint-Antoine between rebel forces under the Prince de Condé and royalist forces under Marshal Turenne, 2 July 1652, with the Bastille in the background. Anonymous watercolor drawing (Paris, 1652). Bibliothèque Nationale de France.

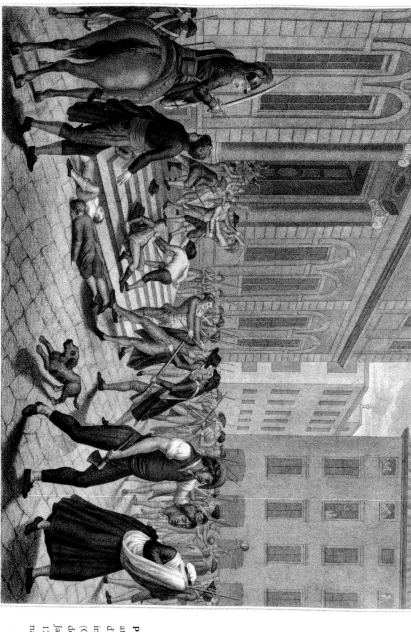

The massacre at Lyon ordered by **COLLOT D'HERBOIS** at the head

Massacre de Lyon ordonné par **COLLOT D'HERBOIS** (continued from previous page)

Plate 10. "The Massacre at Lyon ordered by Collot d'Herbois in 1793." Engraving by James Idnarpila (Giacomo Aliprandi) (London, 1804) after original by Jacques Bertaux (Paris, ca. 1795). Bibliothèque Nationale de France.

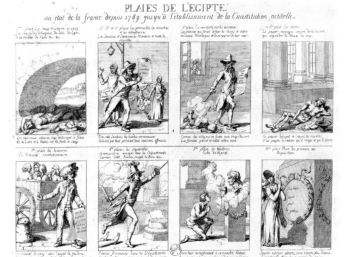

Plate 11. "Plagues of Egypt or the state of France from 1789 to the establishment of the current constitution." Anonymous etching (Paris, 1795). Bibliothèque Nationale de France.

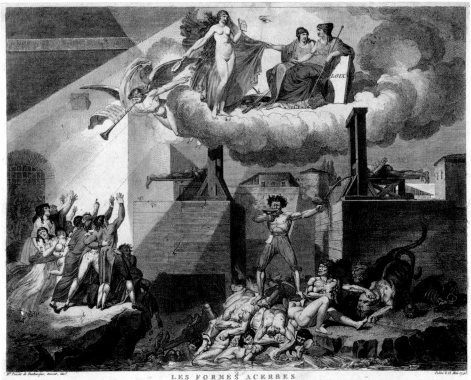

Plate 12. "The Harsh Means of Joseph Le Bon." Hand-colored etching by Charles Normand after drawing by Louis Lafitte (Paris, 13 May 1795). Bibliothèque Nationale de France.

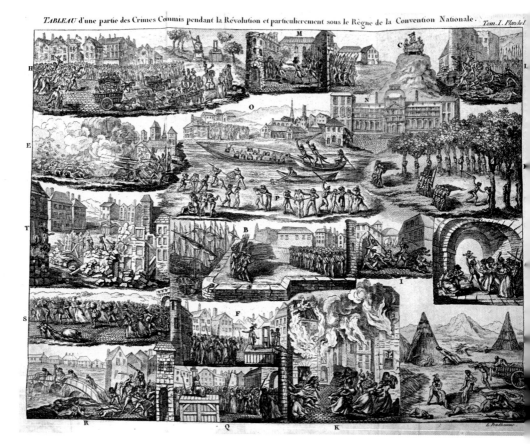

Plate 13. "Tableau of some of the crimes committed during the Revolution and especially under the National Convention." Anonymous engraving from Louis-Marie Prudhomme, *Histoire générale et impartiale des erreurs, des fautes et des crimes commis pendant la Révolution française*, 6 vols. (Paris, 1797), vol. 1 frontispiece. Carl A. Kroch Library, Cornell University.

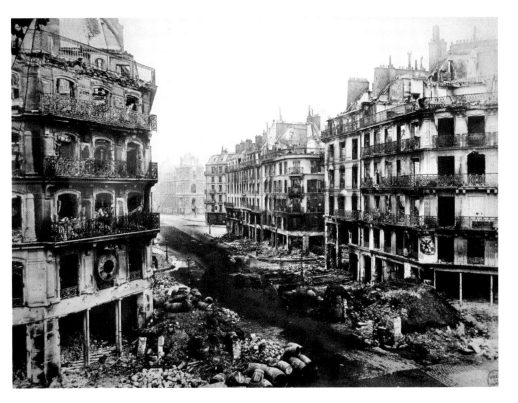

Plate 14. Destruction on the rue de Rivoli in Paris, May 1871. Photograph by Bruno Braquehais. National Library of Brazil.

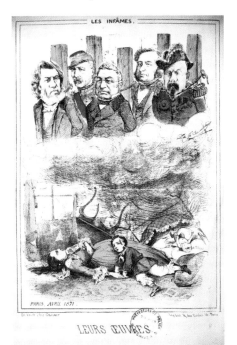

Plate 15. "Their Works." Five "infamous" civilian and military leaders of the Versailles government led by Adolphe Thiers held responsible for the bombardment of Paris that killed innocent bourgeois women and children in their homes. Lithograph (Paris, April 1871). Archives de la Préfecture de Police, Paris. Author's photo.

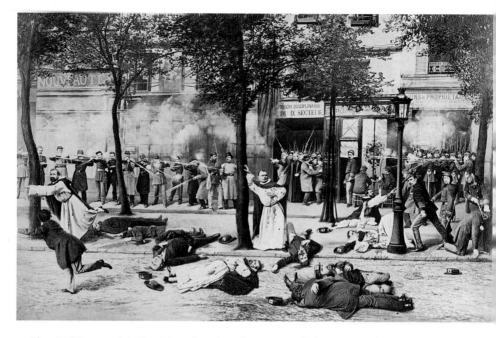

Plate 16. *"Massacre of the Dominicans from Arcueil, 25 May 1871."* Photo-montage by Eugène Appert (Paris, 1871). Metropolitan Museum of Art.

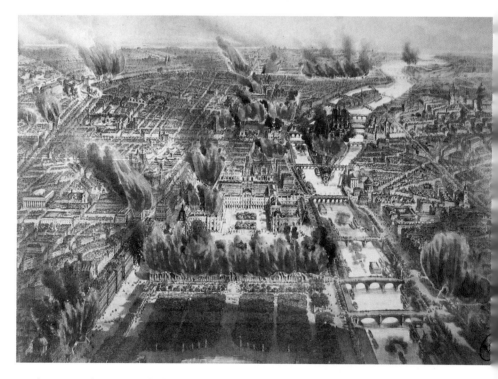

Plate 17. Paris burning. Hand-colored photograph of a lithograph in Bibliothèque historique de la Ville de Paris, Paris Album 8o 21. Author's photo.

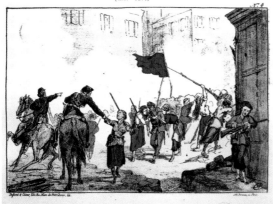

LA PRISE DE PARIS.
(MAI 1871)

La barricade de la place Blanche défendue par des Femmes.

Plate 18. "Women defending the barricade at the place Blanche." Depicts several women with muskets, one in a National Guard uniform, and women assisting a wounded fighter. Lithograph by Léonce Schérer (Paris, 1871). Archives de la Préfecture de Police. Author's photo.

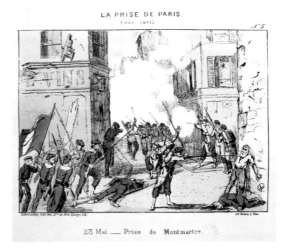

LA PRISE DE PARIS.
(MAI 1871)

23 Mai — Prise de Montmartre.

Plate 19. "Capturing Montmartre on 23 May." Depicts the summary execution of an elderly man, perhaps simply because he was old enough to have fought in 1848, and two bodies oozing blood in the streets. Lithograph by Léonce Schérer (Paris, 1871). Archives de la Préfecture de Police. Author's photo.

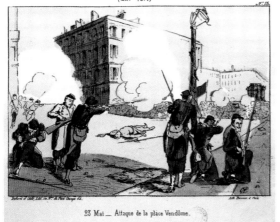

LA PRISE DE PARIS.
(MAI 1871)

23 Mai — Attaque de la place Vendôme.

Plate 20. "Attack on the place Vendôme on 23 May." Depicts a sinister-looking soldier and a bleeding corpse in the square. Lithograph by Léonce Schérer (Paris, 1871). Archives de la Préfecture de Police. Author's photo.

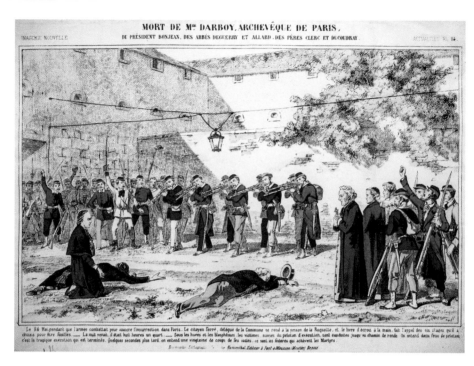

Plate 21. "Death of M. Darboy, Archbishop of Paris." Depicts the execution of six hostages, called martyrs in the accompanying text, at La Roquette prison on 24 May. Lithograph with gilding published by *Imagerie Nouvelle* (Pont-au-Mousson, 1871). Archives de la Préfecture de Police. Author's photo.

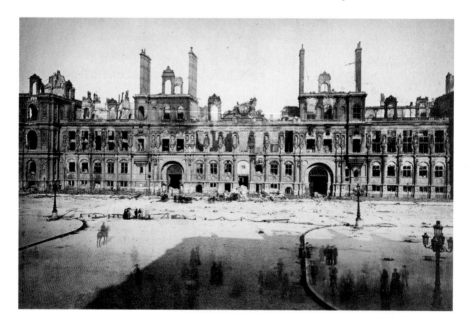

Plate 22. Burned ruins of the Hôtel de Ville. Photograph no. 1 in Alfred d'Aunay, *Les ruines de Paris et ses environs, 1870–1871: Cent photographies par A. Liébert*, 2 vols. (Paris, 1871), folio edition. Bibliothèque Historique de la Ville de Paris. Author's photo.

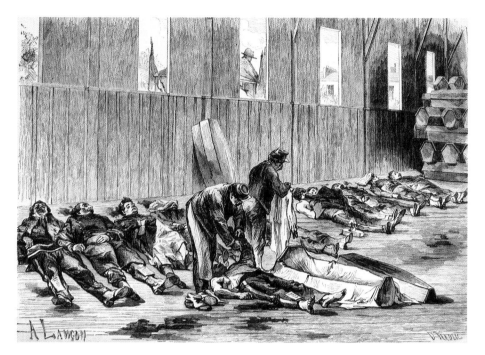

Plate 23. *"Shrouding the dead at the Ambulances de la Presse: harvest of one day's combat."* Wood engraving by Auguste Lançon in *L'Événement illustré* (Paris, 1871).

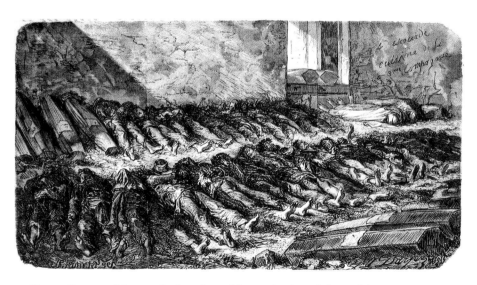

Plate 24. *"A corner of the room for those shot and deposited at the Ambulances de la Presse, rue Oudinot."* Wood engraving in *L'Événement illustré* (Paris, 1871).

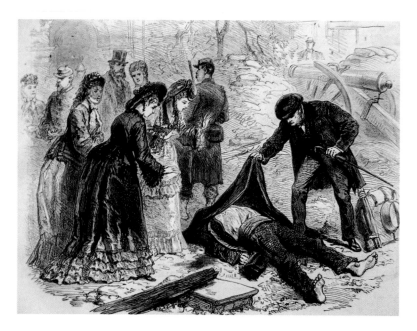

Plate 25. Identifying a dead body after the taking of a barricade. Wood engraving in *L'Univers illustré* (Paris, 1871).

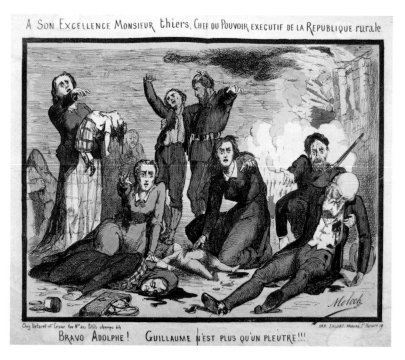

Plate 26. "To his excellence Monsieur Thiers, head of the executive power of the rural Republic. Bravo Adolphe! William is just a coward!!!" Color lithograph by Moloch (Alphonse Hector Colomb) (Paris, 1871).

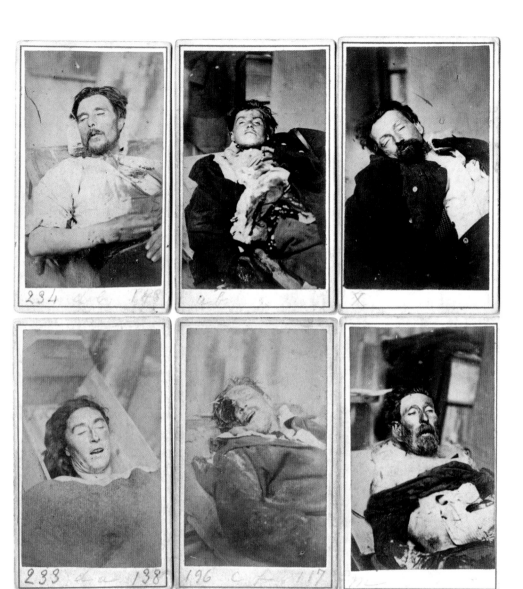

Plate 27. Corpses photographed during May 1871 for the purpose of identification:
(1) man with gun-shot would in chest, probably from being executed;
(2) adolescent boy wearing a National Guard uniform;
(3) bourgeois man wearing a frock coat;
(4) woman in a simple coffin;
(5) man killed by disfiguring head wound;
(6) older man missing his shoulder.
Collection of the Musée d'histoire vivante, Montreuil.

Plate 28. Self-commissioned photographs of members of the Commune Pilotell and Gambon in a photograph album assembled by the police. Archives de la Préfecture de Police. Author's photo.

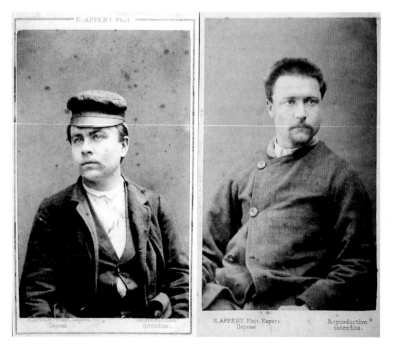

Plate 29. Communards photographed by Eugène Appert in the prisons of Versailles. Archives de la Préfecture de Police. Author's photo.

The genre of prison memoirs tapped into a deep cultural proclivity for works imbued with pathos. The last third of the eighteenth century witnessed a flowering of pathos in plays, novels, autobiographies, and even in private correspondence. Pathos stirs tender, melancholy emotions that lead to pity and empathy. Thus, creating pathos meant putting suffering on display as a privileged means to make compassion contagious.[64] When P.-J.-B. Nougaret published *Histoire des prisons de Paris et des départements* as a four-volume set in June 1797, he assured readers that he had no intention of inciting hatred or undermining the current regime. Rather his introduction explained that he had "read avidly, and with the most painful pleasure, the harrowing accounts of the sufferings that innumerable victims of Robespierre experienced in their cells. [His] tears had flowed, like those of all France, when reading the writings which, to be highly engaging, had only to describe naively these unprecedented horrors."[65] In short, the effectiveness of these simple narratives in communicating suffering to others, thereby generating tears of sympathy, was one of their principal merits.[66] Moreover, most of the narratives, anecdotes, and verses that filled Nougaret's volumes had first appeared in Year III. Even though the editor added a few explanatory notes about his sources, he did not always identify the original victims by name. The resulting ambiguity could add to the potential universality of the experience. Whether or not the reader had suffered serious persecution during Year II, the lack of precise political context and the anonymity of particular sufferers made it easy for others to identify with these victims of terror and tyranny. Furthermore, Nougaret's title page officially dedicated the four-volume collection "to all those who had been detained as suspects" during a period when, as he put it, "millions of Frenchmen" had been killed for their wealth. Clearly his republication of Thermidorian prison narratives was based on their effectiveness in generating a sense of shared suffering among far more Frenchmen than had actually been imprisoned by the revolutionary government of Year II.

Nougaret was far from being the only author to exaggerate the human devastation wrought by the "system of terror." Various claims were made about the extent of the repression, sometimes on the basis of specious, though perhaps persuasive, calculations. Armand Guffroy, in his book-length pamphlet, *The Secrets of Joseph Le Bon and His Accomplices*, wrote that there had been "fifty thousand [surveillance] committees of the most tyrannical dictatorship. Each committee had twelve members chosen from among the most ignorant, the most turbulent, and the most corrupt men. . . . Well then, supposing that each member committed only one error and one injustice, there would be one million, two hundred thousand victims of

the most appalling proscription on the surface of a country that we sought to regenerate with liberty."[67] (Recent historians put the combined total of deliberate executions—with or without verdicts—and deaths in prisons at thirty-five thousand to forty thousand.)[68] Other Thermidorians provided no basis for their statistics and simply folded them into speeches and pamphlets denouncing various aspects of the now defunct dictatorship. One of the most influential and impassioned statements on the human toll was undoubtedly that published by the deputy Maximin Isnard, the central portion of which was reproduced in the *Moniteur*, the leading newspaper of the period.

> Civil war ignited; Robespierre elevated to a dictatorial throne; the Convention mutilated, powerless, subjugated; the reign of terror established; the proconsulate introduced; all sentiments of nature stifled; freedom of action, words, and the press in chains; honesty, virtue, and philosophy proscribed; commerce, the sciences, and the arts destroyed; vandalism and banditry crowned; defamation and denunciation remunerated; maratism deified; public funds squandered; the agrarian system proclaimed; human morality corrupted, the national trust violated; properties invaded; numerous tribunals of blood instituted, the right of life and death given to the most ferocious beings; thousands of scaffolds erected; *fifty thousand bastilles stuffed with so-called prisoners of state*; the plague ravaging prisons in the west; the Vendée kept alive; *one hundred thousand victims executed, struck down or submerged; three hundred thousand defenders of the Convention's unity proclaimed outlaws at the stroke of a pen; six hundred thousand true republicans forced to emigrate; millions of families, of widows, of orphans, drowned in their tears*; entire departments put to the sword and consumed by flames, vast regions providing no harvest other than bones and brambles; the elderly massacred and burned in their beds of pain; children slaughtered at the maternal breast; virginity violated even in the arms of death; monsters of the ocean fattened on human flesh; the Loire rolling more corpses than stones; the Rhône and Saône changed to rivers of blood; the Vaucluse a fountain of tears; Nantes a tomb; Paris, Arras, Bordeaux, and Strasbourg become butcheries; Lyon in ruins, the Midi a desert, and all of France a vast theater of horrors, pillage, and murder. (emphasis added)[69]

Isnard's statistics were utterly impossible to verify, but the French Revolution was helping to propagate a statistical way of thinking, therefore his inflated rhetoric may not have discredited his inflated totals. Embedded

as they were in one of the most vivid and comprehensive Thermidorian descriptions of the Terror, such numbers would have been particularly compelling.

Other publicists took advantage of the atmosphere of recrimination in Year III to depict the entire Revolution, not just the Terror, as the source of nearly universal suffering across France. This sort of amalgamation became especially powerful when presented in pictorial form. A broadside entitled the "Plagues of Egypt" is typical of this general trend toward amalgamation and undifferentiated victimization (see plate 11). Purporting to show "the state of France between 1789 and the current constitution" (of 1795), this popular broadside uses the ten plagues called down upon Egypt by Moses as a means to summarize the sufferings inflicted on France by the Revolution. In the first frame, a range of incidents stretching from 1791 to 1794, all of which involved dumping bodies into the Rhône or Loire Rivers, are amalgamated into the plague of turning water into blood. In another frame, the work of the Revolutionary Tribunal is linked to the plague of hailstorms. The accompanying doggerel claims that the "tribunal of blood" strikes nobles, the wealthy, and the learned alike, obviously without discrimination. The final frame presents the military levies of 1793 as the ultimate plague that killed all of Egypt's firstborn males. Here a young virgin both cries over the lack of husbands and represents France mourning its future. Thus, a single sheet, using ten crude pictures and a minimum of words, presents the Revolution as a series of massacres, executions, and other scourges and, thus, as a vast collective trauma for all French men and women.

Even if contemporary publicists overstated the human toll exacted in 1793–94, Thermidorian efforts to define and disavow the "system of terror" conferred the status of victim on a very large number of people. As we noted in the introduction, Jeffrey Alexander has made the ability to identify the perpetrators of mass violence and respond to the needs of its victims important components of his definition of a collective trauma. The Thermidorian Convention's struggles to determine culpability for the excesses of Year II and its clumsy efforts to identify and punish perpetrators are well known and central to the political narrative of the period. Interwoven with this struggle, however, was another, largely unexplored, narrative about the Thermidorians' handling of victims.[70] The flood of publications that revealed atrocities and recounted tragedies forced the government to respond to the suffering of victims. This proved particularly difficult in the circumstances of Year III. Just who counted as true victims of the Robespierrist regime was not easy to determine. Many of those subjected

to harsh measures had helped to precipitate the crisis of 1793 by openly resisting the republic (refractory priests, counterrevolutionary royalists, and Vendéans); others manifestly declined to support the fledgling republic in its time of greatest need (constitutional royalists and émigrés); and yet others hoped to establish a revolutionary republic, but disagreed—sometimes violently—over who should do it or how it should be done (Girondins, Hébertists, Dantonists). The distinctions that needed to be made between these groups, though often difficult, appeared in danger of disappearing during the first six months of 1795, especially during debates over annulling verdicts, restoring property, and rehabilitating reputations.

A major contribution to the debate over how to deal with victims of the Terror came from the abbé André Morellet, a well-known philosophe, when he published *Le cri des familles* in late 1794. This wildly successful pamphlet began with a rather expansive definition of victims, one that arose from a typically Thermidorian version of the Terror. He claimed that "Frenchmen had shuddered under an oppression for which history offered no parallel" and went on to describe "the shooters and drowners of Lyon and Nantes, the crazed and ferocious men, the Robespierres, the Carriers, etc., who for so long had made France a prison and a tomb."[71] Morellet's pamphlet implied that almost anyone who had been punished during this terrible period was perforce a victim of injustice. Therefore, the Convention needed to rectify the wrongs of the previous regime by restoring seized property, especially to families whose heads of household had been executed during the tyranny of the previous year. As one would expect from an aging philosophe, Morellet made his case logically and rationally, referencing in passing the notorious judicial travesties of Calas and Sirven during the Enlightenment. But more than reason and precedent were needed to convince the Convention to act. The case for compensating victims required a particularly Thermidorian blend of politics, justice, and emotions.

This combination emerged in full force in March 1795 when a moderate deputy named François-Antoine de Boissy d'Anglas, a rising paragon of Thermidorian morality, gave one of the most impassioned speeches ever given in the National Convention. Although Boissy d'Anglas based his speech on Morellet's arguments,[72] he added four noteworthy issues of his own: personal responsibility, moral conscience, social reputation, and empathy for others.[73] These novel aspects of his speech reflect the ways in which the Thermidorian period acted as a catalyst for the development of the self.

Unlike the publicist Morellet, Boissy d'Anglas was a member of the National Convention who had never been excluded from his seat,[74] and

therefore was almost obliged to make personal responsibility a key feature of his speech. As a deputy, Boissy d'Anglas could adopt a more forceful rhetorical style, one in which he included himself as a member of his audience. This perspective allowed him to heighten the personal implications of his message while still retaining the logic of Morellet's arguments. His speech rested on two interlocking claims, one inculpatory—that most of the violence perpetrated by organs of the revolutionary government during 1793–94 had been criminal—and the other exculpatory: that the bulk of deputies in the Convention, like himself, had acquiesced to these extreme measures due to a constant threat of violence hanging over them. But times had changed. He and his fellow deputies may not have been able to prevent "the imprisonments, the despoliations, the massacres without number and all the injustices of which we were the witnesses and the victims," but since 9 Thermidor, "our responsibility has become total." Boissy d'Anglas made this new moral responsibility especially personal by calling on deputies to confront their individual consciences. "Let each of us descend to the depths of his conscience and he will see [a powerful, terrible truth] engraved there: it weighs on my heart, and I discharge a sacred duty by delivering it into your bosom." This exploration of the individual conscience, this penetrating self-reflection, would make each deputy more keenly aware of his moral obligations.

To complement internal examination, Boissy d'Anglas dwelt on external judgment. He put special emphasis on reputation. Unless he and his fellow deputies acted to rectify the injustices of Year II, they would be held responsible for them; therefore, their reputations hung in the balance. "France, Europe, and posterity will demand a most rigorous account of all the bad we did not prevent and the good we did not do." Even the dead were present in the chamber, judging them and asking for recompense for lost loved ones. "Legislators, let us do our duty: we cannot revive those struck down by crime, but let us at least console their spirits, which, at this very moment, follow us, surround us, beseech us, and float about this place." Consoling the spirits of the dead meant returning property to their families, an act that would restore the reputation of the *conventionnels*.

Individual reputation also meant personal character, which, in the late eighteenth century especially, emphasized virtue and sensibility. Therefore, Boissy d'Anglas combined the ethics of justice and the duty of character with the emotions of compassion. According to him, the deputies agreed that the verdicts of the Revolutionary Tribunal were "judicial murders" and that concurrent seizures of property were "thefts [that] plunged one hundred thousand innocent families into misery." "The cry of these families

strikes our ears, their mourning saddens our faces, their tears pierce our hearts." The "painful suffering" and "mortal anxieties" that the deputies had themselves felt during the previous regime ought to make them all the more sensitive and virtuous. "Can we allow to stand verdicts rendered by cannibals against women, virtuous, old, weak, and absurdly accused of conspiracy, whose sex, age, and ailments were insulted by ferocious scoffing from headsmen-judges?" Worse, perhaps, was the fate of families who had lost their heads of household. If deputies were truly sensitive, they would be moved by the suffering of victims and act to alleviate it. "What! Their wives, their children watched them die, and for a year they have been bathed in tears, plunged into the worst misery—their pain should disarm us! Or do you claim that liberty is like those barbarous gods that wanted no other burnt offering than a holocaust of human victims?" Put in this light, compassion for the human suffering caused by the Terror ought to overcome any political arguments against annulling verdicts and compensating victims.

Contemporaries who heard or read Boissy d'Anglas's speech would have recognized his appeal to empathy and compassion as a return to the moral aesthetics of Enlightenment sensibility and public expressions of fellow feeling. This was a striking repudiation of 1793–94 when true patriots were repeatedly called upon to overcome their natural feelings. Various scholars have explored the revolutionaries' efforts to manipulate the grammar of sensibility or sentimentalism,[75] the vocabulary of which was suffering, innocence, virtue, pity, and sympathy, contrasted with persecution, villainy, cruelty, and callousness.[76] The most obvious manifestation of sensibility was the unabashed shedding of tears, especially by men in public. Several such events marked the Revolution, notably at moments of tension when revolutionaries hoped to overcome factional conflict.[77] Such events did not, however, occur during the prolonged crisis of 1793–94, when the factions were more likely to shed blood than tears. Nonetheless, it is a mistake to conclude that the Terror did irreparable harm to the moral aesthetics of sensibility or the power of sentimentalism.[78] Rather, it was the complicated developments of the Thermidorian Convention, especially its responses to the atrocities and tragedies of 1793–94, that ultimately most blunted the affective power of sentimentalism.

Jacobins frequently used the sentimental rhetoric of intense feelings, often referring to the heart as a natural source of truth and virtue. During the years of growing strength prior to the overthrow of the monarchy in 1792, leading Jacobins used the sentimentalist idiom to depict certain groups, such as mutineers at Nancy and patriots at Avignon, as martyrs to counterrevolutionary conspiracy. Furthermore, sentimentalist rhetoric

enabled Robespierre to turn the people into a "collective individual" and himself into a "heroic victim," thereby creating a melodramatic basis for fusing himself (or better his revolutionary "self") with the people and its suffering.[79] These common rhetorical flourishes have led scholars to conclude that sentimentalism achieved a form of apotheosis during the Terror.[80] However, the Jacobins' use of sentimental language can be misleading. What appear as obvious efforts to evoke strong emotion, as was common in the idiom of *sensibilité*, were either attempts to foster indignation and inspire revolutionary élan or, rather ironically, part of Jacobin efforts actually to subvert the sentimentalist emphasis on human fellow feeling.

As a regime that relied on high levels of fear in order to govern effectively, the revolutionary government of 1793–94 faced severe challenges in overcoming the prevailing emotional regime of the late eighteenth century in which the pathos of sentimentalism played such a large role. William Reddy has explored this challenge with great aplomb, but not without adding some confusion as well. He describes the "quasi-official Jacobin brand of sentimentalism" as an attempt "to transform a series of sudden, intense emotions . . . into a veritable system of government." Once they attained power, however, Jacobin efforts to manipulate the central logic of sensibility required asserting the superior woes of "the people," or even better, the needs of all "humanity," over the suffering of actual individuals.[81] As a result, Jacobin rhetoric turned away from pity, sympathy, and compassion, which were the very heart of sentimentalism.[82] In fact, as Reddy himself notes, Jacobins struggled against "false pity," the sort of feeling that would spare the life of a convicted aristocrat, nonjuring priest, or even wayward fellow revolutionary. For example, when contemplating the fate of Louis XVI during his trial, Robespierre argued that the duty of lawmakers was "to sacrifice the first impulses of their natural sensibility to the salvation of a great people and oppressed humanity," thereby avoiding the "barbarous deal with tyranny" that clemency for the king would constitute. Such logic sought to transform natural sensibility into passionate love and courageous self-sacrifice for the causes of liberty, equality, and the revolutionary fatherland. However, Jacobins claimed that these objectives could only be secured by ruthlessly destroying the enemies of the republic. Thus, representatives on mission and other agents of the revolutionary government repeatedly asserted the need to overcome impulses toward compassion. "We are in defiance against the tears of repentance; nothing can disarm our severity," wrote Collot d'Herbois and Fouché, in defense of the *mitraillades* at Lyon.[83]

Therefore, far from truly rooting their actions in the sentimentalism of the age, the Jacobins found it better to cultivate stoicism and the civic virtue

of antique republicanism. In doing so, they simply borrowed a few elements of the prevailing sentimentalist idiom as a means to shift away from genuine emotional sensitivity and toward a severe secular ideology. A more accurate summary of the Jacobins' attitudes toward sentimentalism, therefore, would be this: "it is necessary to banish sensitivity, because, in times of revolution, it pushes the soul into spinelessness; to banish pity, because it saps courage; to banish philanthropy, because it hinders action." Fouché put the Jacobins' view even more succinctly: "pity and sensitivity are crimes of *lèse-liberté*."[84] Madame de Staël, too, had a way of identifying the heart of a matter: she later described the Terror as "a continual system—and consequently calculated—not to acknowledge pity."[85] In short, the essence of the Terror included elements of melodrama, with its basis in villains and victims, but its emotional priorities contradicted the essence of sensibility.

It is important to be clear about the Jacobins' relationship to sensibility as it pertained to the coercion and repression that constituted the Reign of Terror, because this relationship tended to intensify introspection among self-proclaimed patriots. The Jacobin perspective raised a troubling question: How could a good patriot be an *homme sensible* without committing treason against liberty? Almost any answer provoked a psychological drama. Whereas the cult of sensibility sought both to foster empathy and to attack the supposed hypocrisy of hiding one's emotions, openly sympathizing with individuals condemned to death, or even their widows and orphans, was a betrayal of the revolution. In his analysis of the diary of Jacques-Louis Ménétra, a glazier active in the political life of Paris during 1793–94, Reddy notes that Ménétra had to mask his feelings of loss after personal friends were sent to the guillotine, otherwise he would have become suspect in the eyes of his fellow *sans-culottes*, and thus risk being executed himself. Ménétra's successful effort at emotional insincerity gave him the appearance of Jacobin orthodoxy, but it was antithetical to the dictates of eighteenth-century sensibility. The only way to manage the tension between the two was for uncertain agents of the revolutionary government to reflect more intensely on their personal character, motives, and commitment, and then, if necessary, to draw a distinction in their own minds between their true selves and the patriotic personae they created for public consumption. The tension was often between timeless emotional demands imposed by love or friendship and the supposed necessities of founding a new social and political order. The psychomachy that many revolutionaries experienced between affective ties and civic virtue, between personal compassion and political violence, heightened the challenge of reconciling their interior lives with their public lives.[86] In many cases, this proved

impossible and resulted in the eighteenth-century political equivalent of sixteenth-century religious Nicodemites.

Jacobins may have faced greater self-doubt and psychological dissonance than the individuals they persecuted, but the emotional experiences of perpetrators did not equal those of victims. Of course, given the changing tides of the French Revolution, the categories of perpetrator and victim were neither clear nor mutually exclusive.[87] Nonetheless, too many lines are blurred if we equate the psychological struggle faced by men who gained positions and prestige by asserting their ardent patriotism, and then found themselves betraying the norms inculcated by the culture of sensibility, on one hand, with the more obvious emotional suffering experienced by individuals who remained faithful to their friends and family and consistent to their principles,[88] or who simply could not change their social identities and, therefore, became officially proscribed "enemies of the people." These latter victims may not have been innocent, nor did their experiences necessarily entail any less introspection or even dissembling;[89] however, their deployment of the sentimental idiom was far more straightforward and compelling. For that reason, the rhetoric of sensibility and sentimentalism experienced an especially rich flowering during Year III. Thus, Reddy's claim that the sentimentalist idiom had begun to be erased "almost immediately after Thermidor" is clearly incorrect.[90]

In fact, as the speech by Boissy d'Anglas in March 1795 illustrates, sensibility continued to shape France's political culture well after Thermidor. Boissy d'Anglas's virtuoso performance had wrapped Morellet's carefully reasoned arguments in his own brilliant rhetoric that emphasized personal responsibility, moral conscience, reputation, and empathy for victims. And he was not alone in blending these issues with the rhetoric of sensibility. They had already appeared together in skeletal form when a group of widows and orphans stood at the podium of the Convention asking for a law to protect the property of the guillotined husbands and fathers from continuous official peculation.[91] They also appeared together in the many petitions asking the Convention to rectify judicial errors and excesses committed since the spring of 1793. Narrative texts had been especially influential in generating the culture of sensibility and sentimentalism during the late eighteenth century. In the process, they provided a secularized and materialist basis for empathy and social justice. Therefore, it is not surprising that petitioners who sought to rectify what they claimed to be gross injustices turned to the themes and rhetoric of sentimentalism to make their cases. In so doing, they found themselves formulating their accounts in ways that mirrored fictional texts that had been designed to "represent,

repeat, and celebrate the act of being moved."[92] Thus, by 1795, first-person narratives inundated France with stories of personal suffering as well as calls for pity and compassionate action. Pathos again took the stage, only it was now no longer fiction, but a powerful reality.

The Thermidorian Convention responded to the rising tide of petitions by authorizing its Legislation Committee to revise verdicts, release people, and restore property in cases where revolutionary justice had punished individuals for offenses that were neither "ordinary crimes" nor "acts of royalism." This inspired even more petitions and led to scores of overturned verdicts each month.[93] The process of appealing verdicts to the Convention involved much more than judicial procedures or legal technicalities. Petitioners invoked an array of personal, emotional, moral, and reputational considerations that went far beyond matters of law. These other issues corresponded well to those parts of Boissy d'Anglas's speech that resonated with the culture of sensibility, or more specifically, of sentimental pathos. These other considerations highlighted the interplay of personal circumstances and public reputation that stimulated self-reflection in both authors and readers.

PUBLIC REPUTATION AND PRIVATE REFLECTION

The Revolution had given millions of Frenchmen the opportunity to participate in politics. In doing so, it compelled them to develop more fully articulated and more public narratives of personal identity. In order to vote, for example, new citizens had to make statements about income and property that had never been so public before. Many eyebrows rose and tongues wagged when certain neighbors either appeared or failed to appear on lists of eligible voters. Later, eligibility to vote or to hold public office required obtaining a "certificate of civic conduct." Being granted such certificates depended on being able to explain, often in extraordinary detail and to the satisfaction of capricious local authorities, one's conduct in the Revolution thus far.[94] In much the same manner, though perhaps with even more intensity, men who wanted to join a popular society had to answer similar questions. By the time of the Convention, such questions were often posed in raucous public meetings.[95] As the number of popular societies soared and political factionalism intensified, clubs went through divisive purification rituals. Members who lacked the obvious credentials of revolutionary militants might make claims—such as participating in certain armed demonstrations—that they would later regret, especially once the wheel of political fortune turned and another round of purification followed. Legion

are the clubs that added the term "regenerated" to their names in late 1794 and 1795.

The fifteen months of the Thermidorian Convention prolonged and complicated the need for individuals to provide public explanations for past conduct. Personal trajectories through the Revolution required repeated self-representation. Representations of one's self were constituted first through political conduct and then through claims made about that conduct. The unprecedented opportunities and threats created by the Revolution encouraged self-reflection as individuals made what could be life-changing choices. As the Revolution grew more radical, both private matters of conscience and public explanations of conduct took on greater significance. So too did claims made about earlier choices, thereby intensifying the need for continuous self-reflection. Political principles and private interests, *patrie* and *paterfamilias*, consistency of action and intensity of commitment, integrity and hypocrisy—these terms reflect only some of the many tensions that individuals had to blend and balance throughout the prolonged upheaval.

The "law of suspects" adopted in September 1793 had made it possible to arrest an exceptionally wide array of individuals as "suspects," including anyone who had been denied a certificate of civic conduct. Being arrested as a suspect defined someone as a threat to the community and, therefore, a potential subject of revolutionary justice. Individuals targeted by this law for their actions (rather than simply for being a former noble, priest, *parlementaire*, etc.) produced a spate of petitions and memoirs designed to defend themselves against various charges—specified or not—that could push them to the social margins of the community, if not eliminate them from it altogether. These *mémoires justificatifs* (or autodefenses, as they have been dubbed)[96] often included carefully edited versions of the author's lives to date. Circulating such narratives in printed form was not unusual,[97] and reflects the importance of constructing a particular identity in the eyes of the public, as well as those of civil and judicial authorities.

As we have noted, efforts to present a suitable public persona stimulated self-reflection. It did so as much when developed in print as it did when acted out in person. Individuals arrested for political conduct often found themselves forced to question their motives and deeper convictions, sometimes to assess their true character or social worth, or to determine what would be worth living for—or dying for—should circumstances change. Those who made such thoughts part of their public narratives—à la Rousseau's *Confessions*—sought to evoke greater empathy from their readers.

Such narratives also underscored the universality of risk created by living through a revolution. When a society suddenly tore itself apart, remarked General J.-V.-M. Moreau in his published justification, "there is nobody who can be sure that one day he won't appear in the position of an accused. Therefore, let everyone do some self-reflection."[98] Such advice was intended to limit the excesses of partisanship; it also suggested the importance of modeling introspective behavior for others to emulate.

Producing a memoir of autodefense may have stimulated self-reflection, but it was self-presentation that mattered most. *Mémoires justificatifs*, including those that remained in manuscript, were obviously intended to influence people who had little knowledge of the author. This called for various rhetorical strategies. Learned authors drew on the shared stock of classical education among the elite by making comparisons and parallels with figures from antiquity. Personal justifications also deployed a rhetoric of transparency, describing private as well as public conduct as evidence of the personal virtue, and thus innocence, of the accused. One woman convicted of supporting royalism naively believed that it might help her petition to insist that she had always paid the taille (a tax on peasants during the ancien régime). Many *mémoires justificatifs* borrowed the language and tropes found in the sentimental dramas of the age. This approach had already been incorporated into some legal briefs that lawyers had published on behalf of their clients in order to influence public opinion during the late eighteenth century.[99]

Above all, presenting evidence of patriotism was the most common theme. A son in the army, donations to the war effort, service in the National Guard, election to local office—anything that showed support for the Revolution, especially in its republican phase, was useful to establish an author's revolutionary bona fides. But autodefenses elaborated on more than their authors' actions during the Revolution. Turning inward for the sake of outward appearances was tried as well.[100] Many authors made claims about their personal character, motives, and states of mind. To make these more than merely rhetorical exercises, however, autodefenses often included evidence of the author's reputation in the local community. This was usually done by adding supporting attestations that ended with a gaggle of signatures. The petition sent by Jean Gauzan of Réole offers a model. He had been sentenced by the Military Commission at Bordeaux to a huge fine of one hundred thousand livres, as well as imprisonment until peace, on the shallow grounds that he had given no proof of patriotism and daily spent time with aristocrats. Once released in late 1794, he asked for the fine to

be revoked by claiming that he had regularly attended primary assemblies, assiduously served in the National Guard, and always enjoyed the esteem of his fellow citizens, who elected him a municipal official. He also sketched a brief moral portrait of himself. This might have been dismissed out of hand had he not also provided a supporting document, signed by fifteen public officials and self-declared "notables" from Réole, that corroborated his claims by noting that "he was always regarded as a good citizen, simple, peaceful, without ambition, seizing the opportunity to oblige, but timid and tranquil by nature."[101]

The addition of signed attestations, sometimes included in printed memoirs as well, highlights the socially embedded nature of individual identities as they were elaborated during the turmoil of revolutionary upheaval. Above all, autodefenses that included signed attestations sought to demonstrate that the would-be suspect was not, in fact, a threat to the community, but rather an integral part of it.[102] The authors of autodefenses, fully aware that they were engaged in public self-representation, had to consider carefully what aspects of their identities and actions they would present, especially when an official inquiry might soon follow. Such inquiries could be surprisingly thorough, whether in Year II or Year III, and whether taken for the purpose of prosecution or judicial revision. For example, the petition from Laurent Melloni, the former revolutionary mayor of Bagneux (Indre), successfully deployed a sentimental rhetoric about the extent of his misery. The ensuing inquiry confirmed his advanced years, physical infirmities, dependent children, property holdings, political principles, zeal and personal integrity in office, ignorance of his sons' emigration, and the devastating impact that the seizure of his grain and livestock had had on him and his family.[103]

Memoirs of autodefense and petitions seeking relief from revolutionary repression proliferated most during the Thermidorian period. Naturally, therefore, individuals once targeted as suspects wove prevailing Thermidorian themes into their personal histories. This usually meant asserting that they were victims of the "appalling system of terror," or the "tyranny of Robespierre," or, equally common, of his local "henchmen" or "our tyrants." Furthermore, authors commonly emphasized the profound emotional impact of being a suspect or spending time in prison. A former *parlementaire* remarked that the law that proscribed him "caused the birth of despair in my heart," which was only later replaced by "joy at escaping the decemviral inquisition."[104] The elaborate expressions of emotional suffering included in many petitions invoked the *sensibilité* that was expected of

readers at the time. Note the lengthy petition written on behalf of relatives of those condemned at Bordeaux, dozens of whom signed explicitly as widows or orphans: "Oh, citizens, forgive our excessive pain, our despair; return us to our fatherland, return us to ourselves, in the name of humanity, in the name of justice, for the glory of the French nation, for your glory . . . authorize the revision of verdicts for Frenchmen unjustly condemned."[105] The censorious tone of the rest of this petition derived from a powerful and widely shared sense that the victims of the Terror were more than suffering supplicants; they occupied the moral high ground, could expect lawmakers to be moved by their situation, and demanded to be treated appropriately. It is in such circumstances that pathos made its greatest demands on politics.

The significance of the Thermidorian discourse on the Terror in the construction of personal identities, and especially the role of printed publicity in this process, is made strikingly apparent by periodicals produced in the small town of Montargis south of Paris. In late 1794, Charles Claude François Blondet-Lablossière, a prosperous and pugnacious landowner from the village of Saint-Firmin, published a lengthy autodefense in which he described his personal trajectory through the Revolution, which included being elected a departmental administrator of the Loiret from 1790 to 1792, enrolling his only two sons in the army in 1792, and heading his local surveillance committee in 1793–94, in short, not only a proven revolutionary, but a genuine republican. However, after Blondet-Lablossière resisted the requisition of his grain reserve—in order to supply local farmers with spring seed, he explained—local "terrorists" denounced him as a "royalist" and "speculator." Six months in prison, only to be released in August 1794, turned him into an ardent Thermidorian determined to restore his reputation. Thus, his autodefense prepared the ground for his *Journal des acteurs célèbres du théâtre tragique du district de Montargis*.[106] This irregular periodical published over the first six months of 1795 served exclusively to disparage man by man, and in elaborate detail, the reputations of the leading "terrorists" of the local area. Blondet-Lablossière repeatedly likened events in the district of Montargis, thirteen of whose residents were guillotined in Paris, to the worst excesses committed at Nantes, Lyon, Marseilles, and Bordeaux, naturally doing so with sentimentalist rhetoric ("recounting atrocities that rip apart your hearts") and violent excoriations ("filling dungeons with innocent victims that you daily murdered . . . in order to sustain this insatiable thirst for carnage and blood"). Moreover, he asserted that if the local "drinkers of blood" had been able to perform in a "larger theater,"

they would have "exceeded Fouquier-Tinville, Carrier, and Robespierre." By including intimate details about each of the local "terrorists," such as being asked by the father of one to help rescue him from a dissolute life in Paris, and by having his accusatory profiles reprinted in the *Journal du district de Montargis*, Blondet-Lablossière effectively destroyed their public standing in the region. Despite publishing their own autodefenses and character assassinations, several local "terrorists" were publicly burned in effigy. By summer 1795, most of them had either been arrested or fled the district.

The effectiveness of Blondet-Lablossière's publicity campaign in defining both himself and his opponents became especially clear when he published a letter of response from one of the "small fry" he had denounced in passing. The young clerk Jean-Baptiste Martin admitted that he had participated (under duress) in falsifying papers that sent the village mayor to the guillotine, but claimed that he was "seized with horror when reflecting on the atrocious means used by these wicked beings to destroy the poor Lefebvre." Blondet-Lablossière followed this self-justifying confession with a statement of understanding and forgiveness: henceforth you "will know how to resist crime in order to follow the laws of humanity. As for me personally, whatever the post providence assigns to me, I promise you my sentiments of esteem and friendship." Thus, Martin's pathetic self-justification helped a modestly wealthy landowner, who had consistently framed local events as part of a vast national trauma, to highlight differences in personal responsibility among "perpetrators." The obvious efficacy of doing so forced many individuals to engage in an unprecedentedly public encounter with their consciences and their reputations. If the autobiographical "I" is central to developing the modern self, as scholars generally acknowledge, then the Thermidorians' Terror proved an especially powerful catalyst because it forced many thousands of Frenchmen to engage intensively, and often publicly, with the tensions between inner motives and outer actions, between private fears and public emotions, in order to establish their personal identities.

THE HAZARDS OF POLITICIZED PATHOS

Despite the rising tide of petitions and autodefenses, the debate about annulling verdicts and compensating victims dragged on for months. Government action depended on distinguishing between counterrevolutionary conspirators rightly condemned and innocent victims of a horrible tyranny.

Boissy d'Anglas had claimed that among "the innumerable mass of dead . . . very few are guilty." Therefore, adopting a policy of restitution toward the "unprecedented mass of innocent victims" was simply expiation for a criminal regime, even if it inevitably restored fortunes to "some families of the guilty."[107] This position was too extreme for most lawmakers at the time. It took a further shift in the political climate to compel them to act decisively on matters of rehabilitation and restitution.

Two failed *sans-culottes* insurrections in Paris in the spring of 1795 encouraged the Convention to take legal action against individuals implicated in the "system of terror." These revolts provided the inspiration and justification to expand greatly the range of men to be held responsible for the tyranny of 1793–94. The Convention had recently ordered every public official, whether civilian or military, who had been sacked or suspended since the overthrow of Robespierre to return to his native commune and there be put under surveillance. This effectively made every former public official into an official "suspect" in Thermidorian terms. Following the insurrection of 12–13 Germinal (1–2 April 1795), the Convention ordered a general disarmament of "terrorists," that is, men known "to have participated in the horrors committed under the tyranny that preceded [9 Thermidor]."[108] This exceptionally vague language provided legal cover for a general settling of scores at the local level. The Convention went even further following the insurrection of 1–4 Prairial III (20–23 May 1795) by ordering the arrest and imprisonment of servitors of the former regime, especially targeting members of surveillance committees and revolutionary commissions. This led to the arrest of some thirty thousand would-be "terrorists."[109] Such an approach made individuals politically, morally, and even juridically responsible for actions that had usually been taken collectively. It also automatically cast a pall of presumed guilt over their actions during Year II, thereby further justifying vigilante violence against erstwhile patriots now dubbed "terrorists."

Taking these major steps toward defining the supposed perpetrators of the Terror was matched by a gradual expansion of the Convention's efforts to delineate and then compensate their victims. Various laws adopted in the first half of 1795 rehabilitated tens of thousands of people who had emigrated or been subjected to revolutionary justice during 1793–94, notably everyone who participated in the Federalist revolts. Tens of thousands of émigrés, many of them avowed royalists, and all of them now officially recognized as victims of the Terror, rushed back to France. On 9 June 1795, "considering the abuse that has been made of revolutionary laws [and] the impossibility of distinguishing through revisions the innocent from the

guilty," the Convention also decided that property confiscated as part of verdicts rendered using "revolutionary procedures" would be returned to victims or their families. Important exceptions covered individuals condemned as conspirators, émigrés, or armed rebels; however, even refractory priests received their property back.[110] Continuing its work of defining both perpetrators and victims, the Convention decided in mid-August to nullify all convictions achieved through "revolutionary procedures" against persons who were still alive. Such a law could not bring anyone back from the dead, but it did free a large number of people who had been sentenced to lesser punishments.[111] Equally important, such a decree essentially criminalized all forms of exceptional justice during 1793 and 1794. This new decree fixed in republican law the idea, so often repeated by surviving family members, that their loved ones had been the victims of "judicial murder."[112]

It has been important to sketch the Convention's handling of the complex issues of judicial revision and property restitution because this set the official Thermidorian parameters of victimhood during the Terror. The laws that rehabilitated tens of thousands of people who had emigrated or been subjected to revolutionary justice during 1793–94 complemented the laws that invigorated and expanded legal action against men who had been actively engaged in applying the repressive measures of 1793 and 1794. This combination of laws adopted during the spring and summer months of 1795 served to crystallize a semiofficial Thermidorian distinction between who should be classed as victims and who should be classed as perpetrators of the Reign of Terror. Such distinctions were hardly crystal clear, however. Above all, it became extraordinarily difficult to apply retributive justice in a way that could effectively pardon error and punish crime.[113]

The process of parsing victims and perpetrators took place in a thickening atmosphere of politicized pathos in which public mourning and commemoration of the dead also began to flourish. For example, a major festival was held at Lyon to celebrate the erection of a large cenotaph dedicated to the victims of the siege there in 1793. Whereas the inscription on the monument remained strictly funereal, the dedication ceremony mixed collective grief and public mourning with the Thermidorian politics of personal revenge.[114] A contemporary engraving conveyed this unhealthy mix of emotions to audiences well beyond Lyon (see figure 9). The visitor at the center of the scene has his hat off and head down, apparently in sadness; however, the more prominent title pointedly refers to "victims immolated at Lyon by the terrorists." Such a label could not help but inspire anger and a desire for revenge.

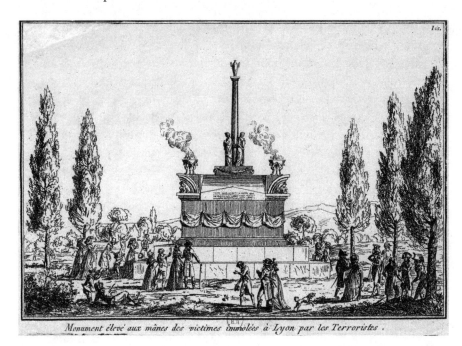

Figure 9. "Monument raised to the spirits of victims immolated at Lyon by the terrorists." Anonymous etching (1795). Bibliothèque Nationale de France.

The reactionary anthem, the *Reveil du Peuple*, introduced in January 1795 as an alternative to the *Marseillaise*, made an even more explicit link between victims and vengeance. By far the most popular song of 1795, the *Reveil du Peuple*, or *People's Awakening*, contained all the major tropes of Thermidorian extremism—"murder," "carnage," "butchery," "assassins," "frightening cannibals," "anthropophagic horde," "drinkers of human blood," etc. One verse was quite literally pathetic: "Plaintive spirits of innocence / Rest calmly in your graves / The belated day of vengeance / Finally turns your killers pale." The extent to which the popular cry for vengeance supplanted grief and mourning is evident from the Convention's abject weakness in having both the *Reveil du Peuple* and the *Marseillaise* played during the ceremonies commemorating the first anniversary of 9 Thermidor on 27 July 1795.

As this single symbolic act of cowardice and confusion suggests, the Convention's efforts to identify and deal with both perpetrators and victims of the Terror also served to legitimize the growing trend toward vengeance in the provinces. As the revelations of atrocities grew more grizzly, as the number of prison accounts multiplied, and as the tidal wave of petitions and autodefenses rose, public attitudes moved beyond pity and compassion

to embrace vigilante violence. Thus, during the spring and summer of 1795, it became increasingly difficult to distinguish between the execution of avowed counterrevolutionaries who had resisted the republic in the name of God and king, and largely innocent victims condemned merely for being aristocrats, tax farmers, or priests—or somehow inappropriately revolutionary. Speeches in the Convention and before local assemblies, newspapers and pamphlets circulated nationally and regionally, and handbills and broadsides plastered on walls around the country repeatedly amalgamated various episodes of 1793–94 into a single Terror, all of whose victims appeared increasingly innocent.

As the Thermidorians struggled to turn their version of the Terror into a set of laws that would deal with both perpetrators and victims, they soon became aware that the republic itself was increasingly at risk. A general collapse of state authority at the national level and intense factional struggles at the local level fueled renewed political violence. As officials of the Jacobin regime around the country began to lose their grip on the populace, their opponents and surviving victims dubbed them "terrorists" and began hunting them down. The political trends and propaganda efforts of 1795 served to justify a wave of revenge killings in areas where revolt and repression had been worst in 1793.[115] A series of spectacular prison massacres and prisoner ambushes, as well as hundreds of individual lynchings and isolated murders, swept the Rhône valley and the Mediterranean coast. Some two thousand individuals associated with the Reign of Terror in the region died in this prolonged surge of vengeance.[116] At the same time, in western France, a widespread guerrilla struggle known as *chouannerie* emerged in the wake of the depredations of the Vendée civil war. Numerous small *chouan* bands used surprise assaults, kidnappings, and assassination to retaliate against agents of the republic who had assisted with the repression of Year II. In both the south and west, the popular violence of 1795 and beyond was highly local in purpose and content. Most of the attacks on Jacobins came from people who knew them personally and who sought revenge on behalf of their family or community.[117] Local authorities with a Thermidorian perspective justified revenge killings as the natural fruit of grief and emotional trauma. After a mob broke into the prisons at Lyon and massacred a hundred Jacobins, the municipal authorities composed an address to "the French people and the National Convention" in which they explained the slaughter as a spontaneous outburst of popular fury. The address is a model of Thermidorian pathos that both insulted the recently murdered and almost sympathized with the killers: "It will not be the smallest crime of these monsters [the dead Jacobins] to have forced virtue to appear cruel for a moment. . . . The

nation and the law were powerless against nature's impetuous fervor, and it was by giving itself over to sobs of despair and tears of sorrow that a people, misguided by its excessive misfortunes and its own sensibility, committed these fearsome acts of vengeance."[118] Clearly the magistrates believed that retributive justice, even if promptly and efficiently delivered, was insufficient balm to heal the emotional wounds of their fellow *lyonnnais*.

As the prison massacres of the Midi demonstrate, the Convention's orders first to discredit through surveillance, then to disarm, and finally to arrest former agents of the revolutionary government exacerbated the vigilante violence directed against them. As a result, whole new categories of victim emerged from the turmoil of Year III. A sense of profound victimization now spread to include perpetrators of the revolutionary violence of 1793–94, men who had acted out of "an excessive zeal and blind rage for liberty," as it was later put.[119] With thousands of Jacobin functionaries languishing in local jails around the country, it is not surprising that the Legislation Committee began to receive petitions from documented "perpetrators" who provided autodefenses in which they too claimed to be victims of injustice. The petition from Henry Maury, a battalion commander in the Army of the Pyrenees, illustrates the continued use of the sentimental idiom by an official "terrorist" to describe his predicament. Maury explains that after having been arrested and imprisoned on the orders of a Thermidorian representative on mission, he was left *"to groan in irons* for four months for mistakes in which *my heart took no part*; my ordeal comes from having been a member of an Extraordinary [Military] Commission, and this ordeal, *I say with all the sincerity in my soul*, has as its cause the *happiness of humanity*, because in *the terrible functions* that I performed during a period of two months, I had the satisfaction of having contributed to saving *a host of innocents*, whom personal hatred and vengeance had sent before us with all the appearance of the greatest crimes" (emphasis added).[120] Other petitioners adopted similar language. They also sought to distinguish themselves from true villains of the Terror. Pierre Dalbarade, who boasted of having led the army to victory in Spain through his expertise as a mountain guide, asserted that had done nothing "for which he could reproach himself" while serving on a military commission during Year II. On the contrary, like Maury, he claimed to have helped free many innocent people and insisted that his extraordinary commission should not be compared to the one at Orange and several others "that had committed horrors unworthy of republicans."[121] For our purposes, it does not matter whether either Maury or Dalbarade, both successful officers in the republic's armies, deserved to be punished for their part in the domestic repression carried out in southern France in Year II. Rather, it is

worth emphasizing that they, too, had spent months in prison treated as suspects who endangered the republic and, therefore, whose fate—as well as personal reputations—hung in the balance. Moreover, they too framed their experiences in sentimentalist terms: despite their patriotic service, pure hearts, virtuous intentions, and services to humanity and the innocent, they had suffered personal misfortune that they did not deserve.

It should be clear by now that the Terror had hardly exhausted the sentimentalist idiom. On the contrary, it was a powerful structuring force in the most quintessentially Thermidorian discourses of Year III. The proliferation of pathos in the accounts of atrocities and tragedies that poured off the presses helped to turn largely localized experiences of violence and repression into a more intense collective trauma that brought France together as a nation. Such accounts also turned the political tide against the Jacobins. By the summer of 1795, the category of "innocent victims of the Terror" had expanded massively, encompassing most people who had been subjected to revolutionary judicial procedures and all manner of émigrés who had fled France as part of the "Federalist" revolts. Thanks to the renewed power of sentimentalist rhetoric, such as Boissy d'Anglas employed in his speech of March 1795, the Thermidorian Convention committed itself to restoring victims' property and, in broad terms, rehabilitating their reputations.

Identifying victims and defining their rights was one side of a coin; the other side was identifying perpetrators and prescribing their punishment. This proved more difficult. The trials and executions of high-profile agents of the revolutionary government, such as Carrier, Fouquier-Tinville, and Le Bon, the deportation of a few "great guilty," and the summary hearing and execution of leading Montagnards held responsible for the Prairial insurrection set the tone for yet more retributive justice. The Convention, through a series of laws passed between November 1794 and July 1795, had come to define tens of thousands of former servitors of the revolutionary government as "terrorists," many of whom found themselves in prison by the summer of 1795. Such laws seemed to encourage, if not to legitimize, forms of "popular justice" undertaken by vigilantes, especially in the south and west. The sweeping nature of the antiterrorist laws, as well as the sporadic violence and outright massacres they encouraged, combined to turn erstwhile perpetrators into new kinds of victims. Not surprisingly, they, too, deployed the sentimentalist idiom to restore their reputations, regain their freedom, and gain the protection of the law.

In order to appreciate the significance of this reversal of fortunes during the summer of 1795, it is best to recap the influence of sentimentalism on political culture during the Convention. The Thermidorian print media helped

to make the Terror into a more national trauma by repeatedly deploying a sentimentalist idiom based on pathos and sensibility. This idiom encouraged the development of the self by fostering both empathy and self-reflection, in which the demands of sensibility confronted the demands of citizenship (or self-interest). Thus, the Terror was not the apotheosis of sentimentalism. Rather, it was a period of confusion and open assault on the central aspects of sensibility, such as pity and compassion for others. These sentiments returned in the Thermidorian period (literally with a vengeance), which led to a further expansion of categories of victim. The Convention made various legal provisions for victims that restored property to them or their families and in the process served to rehabilitate victims' reputations. Petitions to the Convention, often overlapping in style and content with published autodefenses, illustrate the extent to which the Thermidorian discourse on the atrocities and tragedies of the Terror and the sentimentalist idiom that accompanied them had become framing devices for personal narratives of victimization. Autodefenses often shared the same rhetorical strategies as petitions. Furthermore, they reveal the importance of public reputations both before and after Thermidor. Being able to combine self-representation with attestations about character and civic conduct required reflecting carefully on potential tensions between internal and external images of one's personal identity.

However, former servitors of the revolutionary government also became adept at deploying the sentimentalist idiom associated with victims because the Convention's legislation directed at perpetrators (generally dubbed "terrorists") was too broad (that is, it provided no mechanism to distinguish errors from crime) and because it encouraged would-be popular justice in the form of lynchings and massacres. The Convention failed to establish an effective form of retributive justice for the Terror and so, threatened with a rising tide of royalism, it ended its legislative existence on 4 Brumaire IV (26 October 1795) with an amnesty for all "acts related to the revolution." The amnesty put paid to its prolonged efforts to create a clear distinction between victims and perpetrators. In fact, a law adopted the previous day effectively excluded substantial numbers of would-be victims of the Terror (émigrés and refractory priests) from the category of true victims (so to speak). Moreover, neither the Directory nor the populace fully accepted the amnesty and continued to ostracize and persecute many former "terrorists."[122]

By the time of the amnesty in October 1795, so many people, with such a wide range of experiences and attitudes toward the Revolution, had turned to the sentimentalist idiom that its political potential had become largely exhausted. Some of this resulted from the near banality of accounts of human suffering by this point in the Revolution. Charlotte Biggs, an English lady who had spent more than a year in prison at Amiens, noted in

mid-June 1795, "Nothing since our arrival at Paris has seemed more strange than the eagerness with which every one recounts some atrocity, either committed or suffered by his fellow-citizens; and all seem to conclude, that the guilt or shame of these scenes is so divided by being general, that no share of either attaches to any individual."[123] By adopting the amnesty, the Convention had abandoned any effort to choose between actual crimes and circumstantial errors of judgment, and thereby prolonged the difficulty of working through the collective trauma known as the Terror.

It is important to note that the amnesty was not founded on assuming collective responsibility for the events of 1792 to 1795. On the contrary, it simply left individuals legally free to navigate the new regime of the Directory, encumbered only by the reputations they had created in the harrowing three years since the overthrow of the monarchy. Throughout the years 1792 to 1795, political success and personal survival had both put a premium on creating a public persona, one which often depended on attestations from officials, notables, and neighbors. To be able to coordinate this public persona with an inner sense of identity, especially if these were notably at odds, required considerable psychological effort in order to maintain a coherent sense of personal identity. Living with the tension between interior and exterior, and having to reflect on one's conduct both before and after Thermidor (taking note of this extended time frame is vital), helped to foster the interiority that became so central to the development of individualism and the Romantic movement.

Naming: Individuals, Tropes, and Trauma

The amnesty of 4 Brumaire IV may have blunted the political force of the sentimentalist idiom, but it did not end the reckoning with revolutionary violence committed during the Convention. In fact, the experience of violence during the French Revolution was documented in unprecedented ways that paid particular attention to the fate of individuals as part of trying to capture the full trauma of the period. In 1796, Louis-Marie Prudhomme published his *Dictionnaire des individus envoyés à la mort . . . pendant la Révolution*, which contained the individual names, occupations, and dates of death of 13,863 judicial victims of the French Revolution. This was not a wildly inaccurate tally, that is until he added greatly inflated estimates of the number killed in civil strife (900,000) and foreign war (over one million), as well as the number of people the Revolution had terrorized into committing suicide (4,700), the number of women it killed by inducing premature childbirth (3,400), and the number of people driven insane out of fear and grief (1,500)—that is, severe psychological trauma. When Prudhomme republished the *Dictionnaire* as

part of his six-volume *Histoire générale et impartiale des erreurs, des fautes et des crimes commis pendant la Révolution française* in 1797, he highlighted the personal experiences of revolutionary victims by including hundreds of vividly written anecdotes, many hastily adapted from sources printed in Year III. Some of his claims were clearly exaggerated—such as the tanning of human skin for use as clothing—but readers did not know better and would have been captivated by his powerfully emotive writing. Furthermore, a number of tables and printed images formally organized the many atrocities and acts of injustice into a compendium of individual tragedies that again appeared as a great collective trauma.[124]

Prudhomme's overall approach is captured well in the crowded foldout print and its accompanying key in volume 1 (see plate 13). As this image shows, Prudhomme knew how to combine individual suffering with mass slaughter to obtain maximum emotional impact. Compare the image of the breastfeeding baby being ripped from its mother's bosom before she was sent to the guillotine with the mass of people in tumbrels on the way to be executed. But Prudhomme was not an antirevolutionary. In fact, he had been a successful revolutionary journalist before the Terror and was reviving his career by denouncing the obvious dangers of political violence. As a result, Prudhomme's collection of verbal and pictorial representations of atrocities was moderately ecumenical.

The attention Prudhomme paid to identifying individual victims of revolutionary violence, and not just quantifying them, emphasizes the need to reflect on changing notions of identity in relationship to revolutionary violence and collective trauma. His pictorial montage reveals how victimization had spread to include many of those who had perpetrated the revolutionary violence of 1793–94. Most of Prudhomme's print is devoted to aspects of the Terror, including all of the most famous atrocities of 1793–94: the drownings at Nantes (marked O), the burning of Bédoin (K), the mass executions by cannons at Lyon (E), the stream of tumbrels to the guillotine in Paris (H), and the firing squads at Toulon (B). However, Prudhomme's montage also includes massacres of Jacobins committed by opponents of the Revolution in 1795 (I and R). This reminds us that political massacres did not end with the overthrow of Robespierre. In fact, an image emerged of organized murder gangs ravaging the Midi. Though at least as much Jacobin fantasy as royalist reality, these were famously dubbed *compagnies du Soleil* in Provence and *compagnies de Jésus* in the Lyonnais (see figure 10). The popular notion that such murderous organizations operated at the behest of royalist émigrés illustrates the breakdown of community and interpersonal trust that typically characterize collective trauma. The result was a further multiplication

Figure 10. Royalist cutthroat with an assault on a Jacobin in the background.

Anonymous engraving (1797). Bibliothèque Nationale de France.

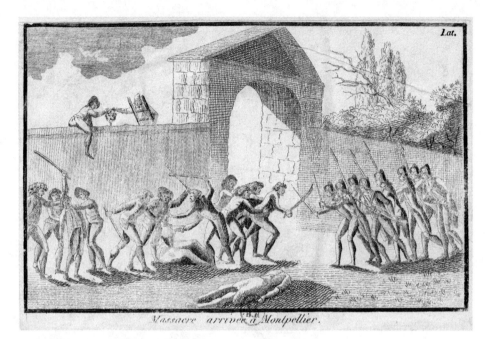

Figure 11. "Massacre that happened at Montpellier" (fictional).

Anonymous etching (ca. 1798). Bibliothèque Nationale de France.

of myths about massacres. For example, the newspaper published at Le Mans in western France reported on a battle that supposedly took place near Marseilles between republicans and "égorgeurs" (cutthroats)—the epithet of choice for the antirepublican vigilantes—after which three hundred finely worked knives had been collected from the (entirely fictional) battle site near Marseilles.[125] Newspapers were not alone in perpetrating false massacres. Printmakers, too, invented massacres that have no basis in the historical record. Such is the case with the print "Massacre that happened at Montpellier,"[126] which does not correspond to any event that took place in the years after the overthrow of Robespierre (see figure 11).

In these same years, discursive formulas based on rhetorical inflation could heighten both fear and the sense of trauma experienced by those who had not yet suffered directly, and thereby alter their actual experience of future violence. The bloody civil war of the Vendée, for example, became a ubiquitous metaphor. Wherever reactionaries uprooted a few liberty trees or assaulted purchasers of national properties, local officials would describe it as "une petite Vendée" or even "une seconde Vendée"; Saint-Domingue became "une Vendée coloniale"; resistance in the hills north of Nîmes became the "Vendée

cévenole," etc. Opponents of the regime used similar rhetorical tropes to associate violence committed in the later 1790s with earlier excesses. Individuals also took on greatly magnified identities: village Jacobins were labeled "robespierrots"; a radical journalist and later justice of the peace in the southern town of Gignac became locally known as the "Marat of Lyon"; former colonists from Saint-Domingue tagged the Directory's principal agent there the "Carrier of the Antillies"; there was no place in the country, no matter how obscure, that did not "have its victims and its Collots."[127] Such associations served obvious political purposes, but they could also have deleterious psychological consequences. Knowledge about the consequences of arbitrary arrest or expedited justice, prison massacre or gang lynching, caused later experiences of politicized violence to resonate with the injustices and atrocities of earlier years, thereby increasing fear and a sense of trauma.

To summarize then, in the years 1794 to 1797, a massive outpouring of printed descriptions and images of violence, and especially of hitherto little-known atrocities, combined with exaggerations, an array of new discursive tropes, and a reinvigoration of sentimentalist rhetoric to magnify the psychological impact of the violence of 1793–94, as well as to stretch that impact well into 1795 and beyond. On one hand, seeing the amalgamation of various sorts of "victims" into a barely differentiated mass and, on the other hand, seeing the repeated inflation of the significance of various acts of violence suggest a clear association between individual suffering and collective trauma. The organizing strategies, images, and tropes used to represent violence, whether that violence was criminal or political, collective or individual, revolutionary or antirevolutionary, suggest that the suffering of individuals was being successfully communicated—and systematically exploited—to create a wider collective trauma experienced by many more French men and women than actually suffered serious persecution under the revolutionary government of 1793–94.

Furthermore, the profound social and political changes wrought by the Revolution, especially replacing a corporative social order with a polity based on citizens imbued with individual rights, accelerated the emergence of the modern self. This more mutable and more psychologically constituted sense of identity made French men and women both more susceptible to fear and more inclined to empathy. Whether individuals managed to keep their distance from revolutionary turbulence or found themselves caught up in it, they witnessed an "explosion of sensibility," often experienced collectively.[128] Under these circumstances, individuals who had been victimized by violence came to experience it differently, that is, their cognitive phenomenology of violence changed. The result was to leave people convinced that they had

been through a collective trauma, which in turn made them feel vulnerable and unwilling to put their trust in the institutions of the fledgling republican regime. Thus, the Thermidorians' Terror as a "recollective reconstruction" of events became a collective trauma experienced at the full range of levels, from the individual, to the community, to the region, to the nation. Paradoxically, it may well be that by turning the experiences of the Terror into a collective trauma the Thermidorians helped to create a stronger sense of national identity, based not so much on citizenship as on suffering. In that sense, the Thermidorians' Terror helped to turn "peasants into Frenchmen" in ways that Eugen Weber never explored.[129]

CHAPTER FOUR

The Paris Commune and the "Bloody Week" of 1871

The Paris Commune of 1871 lasted a mere ten weeks. The final week of the revolutionary insurrection, quickly dubbed *la semaine sanglante*, or Bloody Week, destroyed more lives and property than Paris, or any other city in Europe, had experienced throughout the century. Assigning blame for the catastrophe has been a charged issue ever since. In fact, both sides bore enormous responsibility. The French army did most of the killing; the Communards caused most of the property damage. The excesses of the repression became immediately apparent, as did the futility of setting fire to monumental buildings. With so much blame to go around, it can be difficult to discern the psychological responses experienced by Parisians in the aftermath of such cataclysmic events. At the least, hundreds of thousands of individuals were profoundly shocked by the intense violence and human suffering. Bloody Week forced them to navigate, individually and collectively, the intense emotions of vengeance or pity, of random death or heroic sacrifice, even if they had not personally experienced the vicious street fighting.

Too often responses to the violence of the Commune have been ascribed to the social status or, more specifically, the social class to which individuals belonged. This supposed class-based response is illustrated for the bourgeoisie by the expiatory construction of the basilica of Sacré-Coeur on Montmartre, and for the working class by the socialism of the "red belt" of peripheral neighborhoods around the city. Such a dichotomous understanding overlooks the complexity of initial representations and the responses they provoked from most Parisians. Living in a fast-growing and rapidly modernizing metropolis had encouraged Parisians of all social backgrounds to reflect more on their personal identities, thereby stimulating their individualistic selves. It is not surprising to discover evidence, therefore, that responses to the violence of Bloody Week were less determined by social status than by personal experience. Expressions of pity, empathy, and shared suffering, as well as fear, antipathy, and alienation, very often did not conform to the demands of "class consciousness." Rather, responses to the

violence of the Paris Commune, especially the cataclysm of Bloody Week, both intensified self-reflection and stimulated a greater sense of shared identity. In short, a massive outpouring of representations of the extreme violence, many in relatively new media, produced a collective trauma that helped to consolidate emerging collective identities along class lines; however, this was a belated response based on subsequent developments. In short, working-class consciousness was at least as much a consequence as a cause of the Commune. Furthermore, the long tradition of focusing on class formation has obscured the importance of individualism and the formation of the self even beyond the bourgeoisie.

COLLECTIVE IDENTITIES

Many historians have viewed the Paris Commune as a working-class uprising, an interpretation that originated with socialists in the 1870s.[1] This is not so much wrong as too simplistic, because it tends to equate social status with class consciousness. There is no doubt that by the middle of the nineteenth century, Paris had become fraught with tensions between wealthy property owners and the educated elite, on one hand, and struggling artisans and impoverished laborers, on the other. The bloody uprising known as the June Days of 1848 had consolidated an image of the laboring classes as the dangerous classes. Thereafter, the terms "bourgeois" and "proletarian" became well established and were even associated with "class conflict" by the 1860s. Nevertheless, the concept of the "working class" as a coherent social formation was used almost exclusively by socialists. Almost everyone else preferred the plural form "working classes" and usually meant this as a synonym for "the poor."[2] Such lexical considerations point to a relatively weak sense of class consciousness among workers prior to 1871. Moreover, most historians now view the support that many workers gave to the Commune less in terms of a class struggle to end their exploitation, and more in terms of a quasi-utopian hope to establish a participatory democracy founded on individual liberty and social welfare, a hope shared by many shopkeepers and office clerks, teachers and students. There is no doubt that workers of various sorts, ranging from craftsmen making luxury goods to unskilled day laborers, made up the bulk of those who supported the Commune. However, what Jacques Rougerie, the leading twentieth-century historian of the Commune, once described as a "quasi-totality" has become, on the basis of his own research, no more than three-quarters—and probably closer to two-thirds—of supporters being properly described as workers.[3] Moreover, most of those who labored for a living did so as skilled artisans

employed in small, specialized workshops. Labor strikes were limited to specific and largely isolated groups, such as typesetters or bronze smiths. As a result, there was no significant solidarity across the multitude of skilled trades and low-skill occupations. Such workers' organizations as existed at the time remained weak and fragmented. In fact, workers were reluctant to support these organizations, whether initiated by employers, the church, or workers themselves, mainly because they were seen as too restrictive. In contrast, informal limits on such issues as piece rates, hiring and firing, or employee mobility remained the norm because they allowed workers to preserve higher levels of personal pride, independence, and self-regard. In other words, perhaps as many as three-quarters of all the inhabitants of Paris could be described as belonging to the laboring classes, but their great diversity and lack of worker organizations hindered them from developing a sense of class consciousness.[4]

Robert Gildea has argued that it was neither urbanization nor industrialization, but the "myth" of the Commune that really made the French working class, that is, gave individual workers a sense of belonging to a larger collective identity simply because they were workers. Some years after the Commune, explains Gildea, French socialists began systematically to commemorate Bloody Week in order "to project accusations of violence normally leveled against the workers onto the bourgeoisie." Such commemorations served to legitimize "the proletariat as victims and martyrs," and thereby "to develop the solidarity and class-consciousness of the workers and hopes for future redemption by underlining the collective suffering they had endured."[5] This approach did not fully emerge until the amnesty debates of the late 1870s. Gildea's explanation implies that the socialists' version of the Commune has long obscured the actual response of most Parisians, the laboring classes included, to the massive death and destruction wrought during the Commune.[6] To explain more precisely, the extreme fragmentation and stratification of the laboring classes of Paris at the time meant that most people on the lower rungs of the social order did not immediately experience the bloody defeat and massive repression that ended the Commune in May 1871 as a collective trauma for workers as workers. Rather, it took years of reinterpreting the events of the Commune to create a "recollective reconstruction," or "memory," of collective trauma that helped workers to identify themselves as members of a broader social class.

If workers who became Communards had only a vague sense of themselves as representatives of a broad social class, then what mobilized them to join the Parisian revolution of 1871? The historical sociologist Roger

Gould has developed a sophisticated explanation for support for the Commune based on social network analysis. Whereas he acknowledges that most of those who fought for the Commune were artisan wage earners, he argues that they were mobilized more by neighborhood solidarities than by social status or class identity. Moreover, various social networks stimulated by the crises of 1870–71 rapidly knit these neighborhood solidarities into a citywide movement based on a sense of belonging to "the people of Paris."[7] Gould's analysis adds valuable insight, but it does not explore what such a shared identity might have meant to the self-perception of individuals.

The size and rapid growth of nineteenth-century Paris offered both individual anonymity and social anomie. The city's population had tripled since the French Revolution, reaching almost two million inhabitants by 1870. Paris remained a congeries of neighborhoods with a surprising ability to create face-to-face communities. However, the overlapping networks of sociability were not nearly as tightly knit as those of sixteenth-century villages or even eighteenth-century bourgs. The differences lay, of course, in the high levels of social autarky in early modern communities, on one hand, and the massive influx of residents from the countryside into Paris during the nineteenth century, on the other. These immigrants to Paris may have retained ties to former villages and bourgs, but above all they needed to build new relationships, ones that permitted a rare degree of self-fashioning. The ability to shed key elements of one's personal identity in the countryside and to shape a new one in the city appeared most obvious in individuals who had the talent, drive, and good fortune to climb the social ladder. These new personal identities and the urban relationships that sustained them made neighborhood networks of sociability a critical source of mobilization in support of the Commune, especially in the recently annexed areas of northern and western Paris.[8]

During the 1850s and 1860s, a massive redesign of Paris under the direction of George-Eugène, Baron Haussman had destroyed significant sections of old Paris in order to cut wide boulevards and open urban squares. This so-called *haussmanisation* helped to gentrify central Paris and to push workers out of the center and toward the periphery, or *banlieue*. These peripheral areas were officially incorporated into Paris in 1860, an administrative change that more than doubled the city's surface area. By this time, the *banlieue* had become home to most new immigrants to the city.[9] These newly incorporated and rapidly populated neighborhoods became the basis for reconstituting the sense of community that had been lost by so many Parisians, either by their move from provincial towns and rural villages or by their displacement from the center of Paris.

New forms of social integration also developed through the impressive array of political associations that flourished in the years 1868–71. These various neighborhood clubs fostered greater social and political equality. They were far from exclusively working class and included disproportionately large numbers of shopkeepers, journalists, and bourgeois professionals. Together they forged a common revolutionary spirit based on a combination of urban citizenship, anticlericalism, and a willingness to use violence.[10] Moreover, an explosive expansion of the National Guard in response to the Franco-Prussian War of 1870–71 further encouraged social integration for political ends. Above all, where a national guardsman lived in Paris, rather than his occupation, had the most influence in determining whether he sided with the Commune.[11] And yet a surprising number of national guardsmen enlisted in units based in neighborhoods where they did not actually live.[12] This was especially common in peripheral districts where workers displaced from central Paris and recent immigrants from the countryside constituted the bulk of inhabitants at the bottom of the social order. Such cross-neighborhood enlistment suggests a certain degree of citywide integration, but one limited by both social status and neighborhood residency. The Prussian siege of Paris during the winter of 1870–71 also served both to unite and to divide Parisians. The common enemy provided a basis for municipal unity and a sense of social solidarity in the early stages of the siege. The longer the siege lasted, however, the more its appalling hardships fell disproportionately on the poor, who began actually to starve to death. Eating dogs, cats, and even rats became a common trope of the siege.[13] Bitter cold and lack of fuel further eroded a sense of solidarity and stoked resentment at the more prosperous Parisians who had been able to flee the city.

The Commune was the first citywide government Paris had seen since the French Revolution. As such, it channeled aspirations for municipal independence and inspired political participation. The "people of Paris" became constituted, rhetorically at least, as a truly collective political actor for the first time.[14] As a concept, the "people of Paris" embodied all the oppositional qualities that the term *peuple* had acquired since 1789; however, despite a multitude of references thereafter, the "people of Paris" had yet to be established as a distinct and meaningful social identity.[15] It was certainly not the entire population of inhabitants. The Commune was inspired by hostility toward the national government at Versailles, especially its handling of the war effort and the brutal winter siege. The rhetorical "people of Paris" also shared a hatred of the power elite, which included the Catholic Church as well as the plutocracy of bankers, industrialists, and old

aristocrats, but that was rather abstract: the most immediate enemies of the individuals who constituted "the people" were more often well-known individuals, notably landlords, *concierges*, police agents, and priests.[16] And yet none of these antipathies provoked sufficient social cohesion to generate a shared consciousness based on social identities. In short, as a social identity, belonging to the "people of Paris" was inspirational rhetoric seeking an aspirational reality.[17]

The Commune worked assiduously to forge the "people of Paris." A series of lavish populist balls gave Paris a festive atmosphere during the spring of 1871. Inviting the populace to help destroy President Adolphe Thiers's house, burn the guillotine, and topple the Vendôme Column also fostered symbolic unity. But the reality of the Commune's reign was a rapid alienation of the bulk of the population in only a few weeks. Jacques Rougerie has acknowledged that his early work significantly overstated the extent of support for the Commune.[18] Drunkenness and looting by national guardsmen, disastrous military engagements with the Army of Versailles, increasingly coercive recruitment, the pillaging of churches, and the arrest of numerous priests, as well as widespread administrative chaos, led most Parisians to rejoice at the appearance of the Versaillais in late May.[19] In other words, the actual people of Paris, in contrast to the rhetorical "people of Paris," did not share a unifying social identity based on notions of social class or even shared residency in the capital, but rather responded to events more as self-conscious individuals and members of more loosely knit neighborhoods than has generally been appreciated.

INDIVIDUALISM AND MODERNISM

Rather than juxtapose alternative forms of *collective consciousness*, either exploited proletarian or Parisian populist, it is more enlightening to examine the growing significance of *individual self-consciousness* and how it interacted with the many personal tragedies that resulted from the Commune. When we speak of "individualism" today, we tend to think in moral and psychological terms. However, the word "individualism" arose in early nineteenth-century France as part of the lexicon of conservative opposition to the French Revolution and then of early political economists who generally juxtaposed it to "socialism."[20] Later, the liberal values of an unfettered economy seemed to give individualism an ethical justification. Nonetheless, individualism was even more widely decried as a solipsistic solvent of the social obligations that underpinned family, religion, and community. The tension between these two perspectives on individualism was perhaps no

more evident than in Paris during the Second Empire. There, new forms of urbanism, consumerism, and secularism rapidly altered the relationship between individuals and their sense of community.

Napoleon III had pushed for the *haussmanisation* of the capital in order to make it the most modern city in the world.[21] Here urban life would become a more elegant and leisurely experience, one that included strolling along broad boulevards, seeing and being seen. This meant performing the roles of actors and spectators at the same time. More or less prosperous residents of Paris during the Second Empire also acquired new habits of consumerism, learning to shop in covered arcades populated by boutiques and at new department stores where an unprecedented variety of products were sold at fixed prices. Sales of this sort avoided the interpersonal engagement that came with haggling over merchandise.[22] Such changes dramatically altered the character of neighborhoods and relationships within them. Projecting public identities to unknown strangers through acquiring the latest fashions blended with established networks of sociability based on profession, residence, and place of employment.

The massive changes wrought in the city between 1850 and 1870 did not leave old Paris devoid of working poor, but it did make the western neighborhoods more evidently bourgeois. Equally important, incorporating the *banlieue* in 1860 meant adding a number of important former villages, each of which had its own independent character, whether it was Auteuil, Passy, and Vaugirard in the west, or Montmartre, La Villette, Belleville, and Charonne in the north and east. But the massive influx of immigrants into these communities added many layers of complexity. They became neighborhoods where authentically Parisian artisans, those who had been forced from the heart of Paris by urban redesign and the resulting rise in rents, encountered and mixed with newly arrived provincials attracted to the city by opportunities for employment.

Thus, the "Parisianness" of support for the Commune is difficult to appreciate. Certain facts challenged general assumptions. At the time of the uprising, only one-third of the residents of the capital had been born in Paris.[23] And yet almost half of the residents of Belleville, the most ardently pro-Commune part of the city, had been born in Paris. This reflected the relocation of skilled craftsmen making refined products (known as *articles de Paris*) from the city center to the *banlieue*. In contrast, provincials generally obtained work in the newer enterprises, industries, and commercial ventures of the capital. The building boom also absorbed a disproportionate number. Thus, the population of Belleville, the quintessential "working-class" neighborhood, included a significant proportion of residents who worked

in old Paris, but who had become more fully integrated into their neigh-
borhood on the eastern heights of the city, where their children were born
and raised. In such areas, no clear social boundaries separated artisans and
laborers from shopkeepers, clerks, or independent proprietors.[24] In contrast,
physical and social separation from the more gentrified neighborhoods of
western Paris greatly exacerbated the latent social tensions that exploded in
the Commune.

The rapidly changing social geography of Paris required individuals to
adapt psychologically. For example, those who left rural villages to move to
the big city rarely moved back home again. Therefore, their experience of
urban life included the opportunity to redefine themselves largely free from
the expectations and constraints of the family, town, or village from which
they had come. From the perspective of historians writing in the late twen-
tieth century, Paris in 1871 preserved many of the vestiges of a premodern
city where neighborhoods could feel like villages. Viewed from the perspec-
tive of the French Revolution, however, Paris had become almost unimag-
inably heterogeneous, as well as far more physically and socially polarized.
Historians of the Commune rightly emphasize the appalling poverty, squa-
lor, and misery that blighted many parts of the *banlieue*. And yet rates of
indigence had actually declined between 1848 and 1871. At the same time,
the wealth of better off members of society had multiplied several fold.
This enrichment of the already secure, many of whom were also not born
in Paris, made social disparities all the more glaring. The resentments of
the disadvantaged are easy to imagine. Less obvious are the opportunities
for self-actualization available to those Parisians who could truly enjoy their
city as the emerging capital of modernity.[25]

Being able to determine one's personal lifestyle was not a common expe-
rience before the nineteenth century. By the end of the Second Empire,
however, hundreds of thousands of Parisians were in a position to choose
where to live, what occupation to take up, whether to pursue postsecondary
education, whom to marry (or not), how to dress, where to dine, whether
to attend opera or steeplechase, where to travel on holidays, etc. Having
these choices meant having influence over one's life plan as well as one's
style of living (a phrase coined by Max Weber). Being able to choose within
a plurality of possibilities some of the most important features and routines
of one's own life is central to the construction of the modern self.[26] The
increase in affluence and social mobility in Paris removed many traditional
restraints and thereby contributed directly to elements of self-awareness.
Moreover, at the opposite end of the social spectrum, the conditions of
poverty in Paris also eroded the power of tradition to shape life plans and

lifestyles alike. Peasants who migrated to Paris due to a lack of work in the countryside found themselves in a competitive and unstable environment. Their new life plans reflected sheer desperation more than purposeful self-actualization. Moreover, once in the teaming city, free of familiar faces and timeless routines, many of them adopted novel modes of activity, including in such identity-shaping realms as friendships, sexual relations, and children. Doing heavy manual labor with limited leisure time led to high rates of alcoholism; residing in tenement housing increased sociability and promiscuity; and being without property and prospects encouraged concubinage and "illegitimacy."[27] Rampant disrespect for the authority of the church emancipated many among the Parisian laboring classes from the forced conformity of religious practices.[28] Thus, it is clear that across the entire spectrum of society, the rapid growth and modernization of Paris during the middle decades of the nineteenth century greatly stimulated psychological processes associated with the modern self, even when these bore little resemblance to the Hegelian ideals of self-mastery.

The rise in literacy during the nineteenth century also stimulated self-reflection and a greater understanding of how others experienced life. By midcentury, literature, especially serialized novels, had become a powerful cultural force. The prevailing literary spirit for decades had been Romanticism. What the French Revolution did for individualism in the realm of rights, the Romantic movement did for individualism in the realm of the self. And just as revolutionary rights were based in reason, the Romantic self was based in emotions. The Romantic movement "finally entrenched the independence of the individual in an unassailable way."[29] Romantic heroes flouted the conventions of society, traded passion for stoicism, placed creative originality above ordinary morality, and above all, had inner lives with depth and texture. *La Presse* summarized the trend in early 1862: "The novel has been transformed in our century: it has become more intimate; that is to say, it has become more imbued with those passions that stir deep in the heart of man and of societies."[30] This statement received powerful confirmation from Victor Hugo's monumental novel *Les Misérables* published a few months later.

Les Misérables was the greatest publishing sensation of the nineteenth century. It moved readers like few novels before or since. It also provoked intense debate.[31] Writers such as Gustave Flaubert and the Goncourt brothers, whose new forms of realism explored the inner turmoil and sensationalist experiences of otherwise ordinary individuals, criticized Hugo's latest work for its artificiality, digressions, and heavy-handed politics. One key to the novel's success, however, was its contemporary relevance. Although the

story culminates with the failed Parisian uprising of 1832, its focus on the plight of the laboring poor and the injustices perpetrated by an oppressive social order resonated with the 1860s. As one enthusiastic commentator noted, "its moving narrative summarizes the errors of the present. . . . It is history, but also prophecy." He also observed that Hugo included a vast array of characters that "appear, disappear, and reappear again" just like in "this enormous and changing milieu that is called Paris."[32] Even though it was one of the earliest novels to focus on the lives of common people,[33] many of Hugo's most admirable characters either came from the elite or managed to overcome injustice and hardship to attain a place among the elite. Furthermore, Hugo used his characters both to induce empathy for the suffering of the poor and to explore the operations of the individual conscience. Even critics praised the psychological insight of Hugo's chapter "A Tempest in a Skull" in which Monsieur Madeleine, a wealthy capitalist and town mayor, weighs the consequences of admitting his true identity as the ex-convict Jean Valjean. Thus, Hugo's approach compelled his readers to put themselves in the minds of others and to reflect on how they would respond to similar circumstances.[34]

The intensity of response that *Les Misérables* provoked in readers is well summarized by an early review: "The miseries of our social state [are] stripped bare with frankness, but with equity, and judged with a compassion that is inseparable from true justice. . . . It is the human heart plumbed, the depths of conscience revealed by a light both implacable and forgiving; it is the eternal struggles of the soul, its baseness and its nobility. . . . We were not only moved, but we felt better; the soul affirmed itself and ascended."[35] Thus, by exploring both the plight of the poor and the inner life of his characters, Hugo offered readers the emotional rewards of empathy. Whereas his contemporaries were writing novels that went even further in exploring the inner psyche, no other novel combined such potent contemporary issues with such broad appeal. The fellow feeling toward the poor generated by *Les Misérables* among the better educated in Paris, however transient these feelings may have been, helped to sow the seeds of empathy in the wake of the Commune.

Although the hardship of ordinary life for much of the French population in the nineteenth century inured them to the suffering of others, exceptionally harrowing circumstances had the potential to elicit more widespread empathy and even compassion. The mass violence of the Commune created such circumstances. Furthermore, an unprecedented combination of textual and visual means to communicate the suffering of others developed this empathy and thereby acted as a catalyst for a more developed self.

The impact was no doubt greatest among social groups already encouraged by religious teachings and education to engage in introspection and self-realization. Despite the proliferation of autobiography after the French Revolution and Napoleonic era, it was still extremely rare for ordinary people to record their thoughts and emotions. Illiteracy was a declining obstacle, but France's education system employed a concept of the self considered largely exclusive to bourgeois men.[36] Such exclusionary thinking made it highly unlikely that a French artisan would write anything like Samuel Pepys's diary, even two centuries later.[37] How then can we understand the emotional and psychological responses of those who suffered from the events of the Commune?

The military courts that prosecuted thousands of supposed Communards have left a substantial body of evidence on their sex, age, occupation, birthplace, residence, past entanglements with the law, etc. Historians are fully aware of this information, thanks to the great summary report delivered by General Félix Antoine Appert to the National Assembly in 1875.[38] However, such records make no effort to assess the emotional or psychological consequences of the Commune. When the authorities inquired about mindset, it was to determine motives and little else. A great many participants claimed that either financial need (the National Guard paid 1.5 francs a day) or coercion (many guardsmen were forcibly enrolled) had induced them into uniforms and onto barricades. Plenty of independent evidence supports such claims, even when not true in individual cases.[39] Moreover, few participants showed the courage of J. Trohel, who boldly averred his devotion to the Commune and, if that was a crime, offered to turn himself in to the police.[40] In short, the authorities created no archive on how Parisians may have suffered, physically or emotionally, during and after Bloody Week.[41] Nonetheless, careful reading of contemporary accounts does reveal expressions of pity, empathy, and compassion toward fellow Parisians even when they took opposing positions on the Commune. These acted as both a stimulant for *and* a sign of a more salient self.

MIXED RESPONSES

The conservative response of hostility to the Commune is too often reduced to simple class antagonisms, to fear of the laboring classes as dangerous classes.[42] However, the surge of animosity in the wake of the Commune was a natural response to the immensity of the tragedy, and it was not confined to the bourgeoisie. By the end of May 1871, much of the city had become a confused tangle of home and battleground, of victory and defeat,

a landscape of destruction that affected all levels of society, from ragpickers to *rentiers*. Heaping scorn on Communards was born of much more than bourgeois disgust with the banausic beings who populated the city: many of the deaths and most of the damage occurred in the most prosperous neighborhoods of Paris. These included the boulevard des Italiens, the rue de Rivoli, and the porte de Maillot (see plate 14). The outbreak of massive fires on 23 May provoked widespread terror. They also inspired its natural corollary, a desire for revenge, in this case against an imagined horde of female incendiaries. Panicked Parisians, regardless of their wealth, quickly boarded up every coal chute and cellar opening as a prophylactic against indiscriminate destruction.[43] Several conservative dailies reappeared at the same time, immediately turning rumors into reported "facts." Few readers, whatever their sympathies, could question this "reality," which quickly became consolidated through realistic images that were more convincing than the propaganda caricatures usually reproduced by historians (see figure 12).

Nor were social relationships across disparities in income always and essentially antagonistic. The deaths of thousands of workers meant much more than a potential shortage of labor. Correspondence between various members of the Vignon family, both inside and outside of Paris, and their domestic servants shows deep mutual concern. Hierarchy in the household is not in doubt, but neither is the affection that masters and servants felt for one another, especially in times of peril.[44] The overwhelming majority of self-described bosses employed only a few people and so knew each of them personally. Such workers later counted on bosses to secure their release from prison. For one example among thousands, a prisoner named Chassny wrote to his mother asking her to send his birth certificate and to ask "la patronne" to get him released from La Roquette.[45] Neighbors, shopkeepers, servants, clients—all of these implied personal relationships that softened the harsh outlines of class distinction. The social fabric of the city had many layers, but, like a bandage wrapped around a wound, it absorbed and spread suffering through the layers as well as along them. The upper layers may have soaked up less blood, but the stain was no less red. For example, the hand-colored lithograph entitled "Their Works" depicts five national civilian and military leaders as infamous criminals tied to stakes and separated from the scene of a bloody woman and two children, evidently killed by shells that struck their bourgeois residence (see plate 15). In short, too much has been made of class-based animosity in the wake of the Commune,[46] and not enough of the shock of the entire disaster and the fellow feeling it could produce.

Figure 12. "Incendiaries: pétroleuses and their accomplices."

Wood engraving in *Le Monde illustré* (Paris, 1871).

In this light, historians need to be cautious about seeing the flood of publications denouncing the "crimes of the Commune" as representative of all bourgeois opinion. There is no doubt that the concept was widespread. In fact, the phrase became a popular title for a variety of works.[47] The most famous of them, at least subsequently, was a series of eight crude photo-montages by Eugène Appert that appeared between August 1871 and October 1872. These included reconstructions of various atrocities committed by supporters of the Commune, including the shooting of General Claude Lecomte and General J. L. Clément-Thomas on the first day, and the massacre of almost ninety hostages, notably the archbishop of Paris, as well as a group of Dominican priests, during Bloody Week (see plate 16). These photo-montages combined the latest and most sophisticated photographic techniques with an utterly rudimentary composition obviously based on disparate elements, including hired actors. The composite nature of these images made them discernibly false, even at the time. All the same, photo-montages by Appert, as well as others, were disseminated in all sizes from large plates to pocket format, and were probably the most popular photographic images of the Commune put into circulation. These emphasized the violence of the Commune, often substituting "massacre" or "assassination" for the more neutral term "execution." Representations of this sort clearly served to dramatize the suffering inflicted by the Commune. Rarely noted, however, is that these series of photo-montages ended with images depicting the government repression as well. Looking closely at these latter images reveals a sensitivity to the fate of Communards whose individual punishment was supposed to serve as a collective expiation.[48] To categorize such series in ideological terms as either simply pro- or anti-Communard is to obscure the full range of affective responses that they could generate.

In contrast to what one might expect from reading most historians' accounts of the aftermath of Bloody Week, many early narratives, even those fundamentally hostile to the Commune, showed empathy toward supporters and their loved ones. For example, Malevina Blanchecotte's diary, published in early 1872, contains a vitriolic gem worthy of the arch-conservative Maxime Du Camp: "these criminals, these incendiaries, these assassins. These wild, savage, furious beings . . . do not belong to humankind: they are monsters who require a zoological classification." And yet she is deeply moved when she sees workingmen killed on the barricades or bedraggled prisoners escorted through the streets. More than that, she is disgusted by the spectators who snigger at the prisoners' misfortune or sneer at their filthy faces, black hands, and haggard looks. And she was not alone. A month after hostilities, she writes of meeting "respectable folk who, even

while condemning and execrating the supreme atrocities of recent days, did not include the whole world of poverty in their disdain, [rather] pitying those unfortunates who were swept up, misled, unawares or stupid." She also laments the "innocents shot in the fighting."[49] The journalist and historian Étienne Coquerel, who disparaged the Commune, nonetheless described a similar reaction in his contemporary account. Angered by the abuse hurled at disheveled and pitiful prisoners by a well-appointed Parisian crowd, he and others cried out "Quiet!" and tried to restore the spectators' "feelings of dignity and respect for suffering, even that of criminals." This attitude fits with his earlier comment that "we felt more compassion than anger for the misled who devoted themselves."[50] Even Edmond de Goncourt, an epitome of aristocratic disdain for the Parisian underclass, found it difficult to sustain his harsh posture. He famously wrote on 31 May, "It is good that there was neither conciliation nor bargaining [because the scale of repression] defers the next revolution by a whole generation." However, he also found "the sight of the lugubrious procession" of prisoners to be personally "painful." Moreover, "for the rest of his life he expressed sympathy with all the suffering" that followed from the Commune.[51] Thus, an honest reading of all but the most extreme early accounts reveals many concerns over the cascade of executions without trials, sympathetic reflections on the plight of prisoners, and anxiety about the possibility of obtaining proper justice after the holocaust of May (see plate 17).

These sympathetic responses from people who otherwise deplored the Commune came quickly and without any obvious political calculation. Note how the renowned journalist Catulle Mendès moved rapidly from shock and condemnation to uncertainty and sadness: "So many emotions and ordeals have exhausted this voluptuous [city], and then all this blood, so much blood! Corpses in the streets, corpses in doorways, corpses everywhere! Oh! These men who were caught, who were killed, were certainly guilty; these women who poured liquor in bottles and kerosene in houses were criminals! But, aren't people often duped in the first moments of enthusiasm? Were they guilty, all those killed? What's more, such punishments, whether merited or not, are always a cruel sight. The innocent fall sad while justice is done."[52]

Many Parisians found it extremely troubling to take sides in the conflict. Despite being wealthy and well connected, Geneviève Bréton steadfastly refused to support either the Commune or Versailles, as we learn from her profoundly introspective journal, which she wrote to explore this "new person as she defined it 'who lived inside of me without me knowing it.'"[53] She disparages fellow bourgeois for fleeing Paris, then goes to work in an aid station caring for wounded *fédérés* (Communard national guardsmen). Bréton pities them

as "poor idiots" duped by leaders whom she hates and would "gladly kill." The sight of a few dead *fédérés* in the street "wrung [her] heart with horror and pity." Her sporadic entries express compassion for the convoys of prisoners, which included some "truly respectable men . . . coupled with rabble and treated as such," as well as searing denunciations of impromptu executions, bourgeois hypocrisy, and unseemly gloating. With a mix of anger and exhaustion, she takes personal stock of it all: "What I have seen in the past month revolts my heart, insults reason, and creates an intolerable disgust for everything I see, hear, and know!" Thus, the tragedies of Bloody Week had combined with personal grief and intense self-reflection to leave Bréton, young, rich, and beautiful, in an emotional stupor—and desperate to enter a convent.[54]

As already noted, most Parisians welcomed the arrival of the Versaillais. Even on the slopes of Montmartre, the feared redoubt of the rebels, soldiers met with much popular relief. But the scale of the repression quickly turned the tide of popular concern. As an expert on the repression has noted, "following Bloody Week and the internment at Versailles, opinion and the press became upset by all the bloodletting."[55] Recent histories, especially those that pay attention to contemporary accounts, recognize that Paris did not divide into bourgeois reactionaries and revolutionary workers; that "the most ordinary human beings could tip toward accepting the worst" in response to the Commune, but that the repression also "revolted the hearts of witnesses and inspired expressions of compassion from them."[56] Thus, concern for those who were duped, for innocent victims, and even for the fate of the guilty provided the basis for empathy beyond personal encounters and across social strata alike.

MIXING MEDIA

Parisians had never experienced anything like the Commune. Nor had they ever experienced the combined extent of textual and visual reporting on it. Despite how familiar the media climate of 1871 may appear, we must remember that both the abundance and the convergence of sources were quite new. Moreover, the widespread and almost immediate availability of precise details on the events was critical to how Parisians experienced the death and destruction visited upon them and their city. Given the scale of the violence in 1871, it is easy to miss an obvious fact: most residents did not directly witness the armed struggle to retake Paris. Not only had over six hundred thousand of them, or almost a third of the population, left by the time the army entered the city's western gates, but most of those who remained either lived in neighborhoods that saw little fighting or wisely

took shelter indoors, often underground.[57] Hearing cannons, gatling guns, and rifle fire, smelling smoke, gunpowder, and kerosene,[58] even seeing raging fires and floating ash, did not tell the full story. Nor did the incessant rumors. It was rapid and detailed reporting that informed Parisians of the human and material carnage inflicted across the capital, and they soon learned of it in graphic detail. In fact, the vibrant print media of 1871 gave Parisians an unprecedented grasp of the cataclysmic events that devastated their city. This outpouring of images and texts, in the form of lithographic prints, illustrated newspapers, affordable photography, and a tsunami of immediate histories and first-person accounts, made it possible for Parisians across the social spectrum to appreciate in detail and in highly personal terms the extensive suffering provoked by the events of the Commune. The relative novelty of several of these media added to their impact.

Both visual and textual sources of information about contemporary events grew considerably more sophisticated between the French Revolution and the Paris Commune. Lithography appeared in France during the Bourbon Restoration. It had the advantage over traditional printmaking of bypassing the laborious and highly specialized task of engraving on a copper plate. Lithography allowed prints to be made simply by drawing on limestone, then using acid to etch the stone before inking it. This process made it much easier to represent visual nuances. Using limestone templates also vastly increased the number of copies that could be printed before the quality of reproductions began to deteriorate. As a medium for reporting news, the lithograph came of age with the Revolution of July 1830 when a mere three days of street fighting in Paris overthrew the Bourbon regime. Numerous lithographs were soon published to report these shockingly sudden events. One depicted an attack on a barricade on rue St Honoré; another showed a gunfight in front of a well-known café.[59] Less than a generation later, lithography again served to provide quick, and increasingly sophisticated, images of revolutionary events, this time representing another quick change of regime in February 1848 and the brutal repression of the workers' uprising later in June that year. It is hardly surprising, therefore, that lithography proved an important medium for representing the dramatic events of the Paris Commune.

Even more important to the production and dissemination of images of contemporary political violence was the illustrated newspaper. The first of these was *L'Illustration*, a Paris-based weekly launched in 1843. The inaugural editorial explained that the purpose of combining text and images was to convey contemporary events to its readers "so effectively that they could imagine being there."[60] The turn to illustrating

contemporary events truly came of age with the revolutions of 1848, when circulation soared.[61] The quality of engravings in illustrated newspapers was remarkable, especially given the short time between an event and illustrated reports of it. Under these tumultuous circumstances, illustrated newspapers extended their staff by dividing tasks between sketch artists who drafted images on site and a team of engravers who quickly turned them into fully detailed prints. Rather than taking the time to perfect a detailed drawing, visual reporters sent in hastily composed sketches accompanied by verbal descriptions. It fell to draftsmen and engravers at the print shop to elaborate the final image. Moreover, using bundled ends of boxwood, rather than copper, for engraving made it easier to combine text and images on the same page. Artists drew directly on the boxwood, which had been coated with white zinc oxide to give it the texture of paper, before sending it to the engravers' workshop. Once the composite wood block had been engraved using a burin, a cast copy was made from steel in order to sustain large print runs. Thus, it took a team of specialists to create a realistic—though partially imagined—image: one that combined proper perspective, depicted precise details, had a naturalistic quality, and yet could also be reproduced in tens of thousands of crisp, clear copies. These improvements on the older technology of wood engravings allowed illustrated newspapers to produce images that neither lithography nor photography had yet made possible.[62]

Thanks to the techniques of lithography and the illustrated newspaper, images of fighting on barricades, bodies graphically splayed over heaps of rubble, or corpses lying contorted in the street all became part of the visual lexicon of Parisian print shops. The ease of producing such images on a mass scale combined with their exceptional realism and kinetic energy to transform the coverage of contemporary events. The proliferation of images via lithographic printing and illustrated weeklies intensified the effect of timeliness and thereby enhanced the impact of images on contemporary society. The results powerfully shaped individual and collective memories and thereby rapidly altered how recent events became contemporary history.[63] Théophile Gautier, editor of L'Univers illustré (founded in 1858), remarked on the appeal of images at the time. "Our century does not have the time to read, but it always has the time to look; where an article takes a half an hour, a drawing takes only a minute. A rapid glance is enough to appropriate the information it contains, and the simplest sketch is always more comprehensible and more explicit than a page of descriptions," but then concluded, "we want our columns to say as much to the mind as our engravings do to the eyes."[64] Thus, by the time of the Commune, illustrated newspapers had

become sufficiently widespread, sophisticated, and affordable that much of the population of Paris was able to consume contemporary events through images as well as texts. This new "economy of representation"[65] interacted with profound social changes in ways that anticipated the later, but perhaps no greater, shock of photography.

The significant cost of the original illustrated weeklies such as *L'Illustration*, *Le Monde illustré*, and *L'Univers illustré* limited their circulation through the 1850s. In the early 1860s, however, publishers began to market the news to the masses, selling daily issues for as little as five centimes.[66] By 1866, the most popular illustrated weekly printed in Paris, *Le Journal illustré*, cost only ten centimes per eight-page issue and had a circulation of over one hundred thousand copies. Thus, by the end of the Second Empire, even artisans and laborers could afford illustrated newspapers with their sophisticated and highly realistic wood engravings. Although the four most affordable illustrated periodicals published in Paris in 1870 (*Le Journal illustré*, *La Presse illustrée*, *L'Univers illustré*, *Le Magazin pittoresque*) did not appear during the Commune, *L'Illustration* and *Le Monde illustré* continued to be available. Moreover, both papers produced cheaper spin-off publications that combined the quick reporting of current events with a sense of history. For example, *L'Illustration* produced an eight-page weekly, *La Guerre illustré* (renamed *L'Événement illustré* during the Commune); each issue cost a mere fifteen centimes, or one-tenth of the daily pay of a national guardsman.[67]

The illustrated papers that appeared during the Commune strained and sometimes clearly broke the ethical rules that governed war reporting at the time. The outbreak of war in 1870, and especially the slaughter at Sedan on 17 September, had led to a new willingness to depict mass death in French and foreign newspapers alike.[68] The Prussian siege of Paris during the following winter prompted yet more intimate depictions of wartime carnage and human suffering. But it took the events of Bloody Week to sweep aside editorial scruples about depicting death. Battles over barricades, bodies in the streets, insurgents summarily executed, corpses heaped up pell-mell, or neatly arrayed in makeshift morgues: every gory aspect was depicted and described in shocking detail (see figures 13, 14, and 15). Contemporaries were struck by the explicit nature of contemporary reporting as well as the role that images played in it. One observer contrasted the lack of press reporting on the firing squads of June 1848 with the extensive coverage of 1871. He claimed that in 1848 "the newspapers of the day constantly denied" the executions by firing squad of the June Days, whereas for a full two weeks in 1871, "the newspapers obligingly described these appalling executions, which only some . . . found 'excessive'!" Several conservative

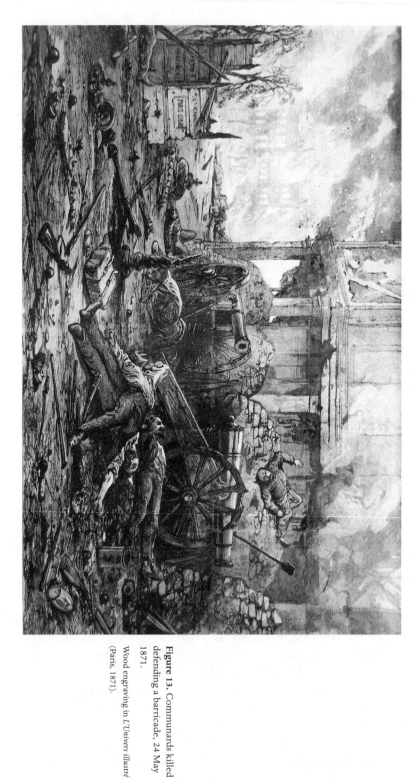

Figure 13. Communards killed defending a barricade, 24 May 1871.

Wood engraving in *L'Univers illustré* (Paris, 1871).

Figure 14. "Paris—Summary execution of insurgents, agents of the Commune, rue Saint-Germain-L'Auxerrois, 25 May at 6:30."

Wood engraving in *L'Événement illustré* (Paris, 1871).

papers, such as the *Gaulois, Figaro*, and *Paris-Journal*, "shamelessly" reported the killings in detail because they thought them insufficient.[69] The same contemporary commentator noted the extensive use of images and their added emotional impact: "And, as if the text of these newspapers had been insufficient to depict them, all the illustrated reviews continued for several months to contain engravings recounting the massacres." Moreover, he recalled vividly one particular published drawing: it "showed a poor woman, a female incendiary, half naked, back against a wall, at whom were pointed several revolvers. The woman is crushed with pain and fear at the same time. The effect of this engraving is grippingly frightful" (see figure 16).[70] Numerous other images packed a similar emotional punch and in doing so defined the events they depicted. Contemporaries took note of the special power of images. In late 1871, Francisque Sarcey asserted that reading pamphlets left only ideas, soon replaced by others, whereas seeing a caricature engraved images on the mind "whose forms and colors floated in the memory long after they were viewed."[71] The Communard historian Prosper-Olivier Lissagaray also noted that the illustrated press "speaks more vividly to the imagination."[72]

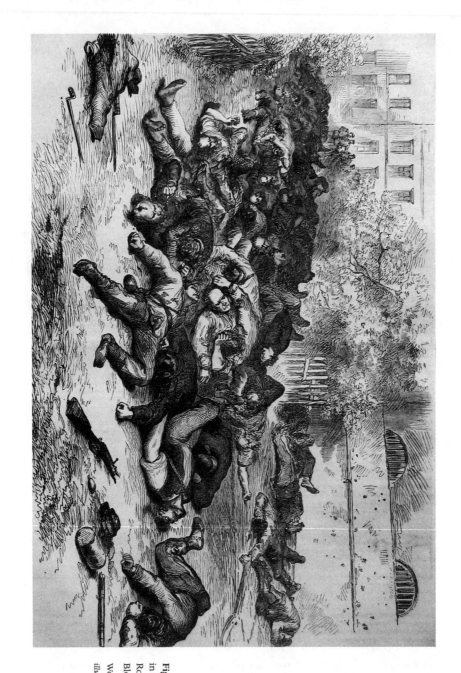

Figure 15. Rebels killed in the fighting at La Roquette prison during Bloody Week.
Wood engraving in *L'Univers illustré* (Paris, 1871).

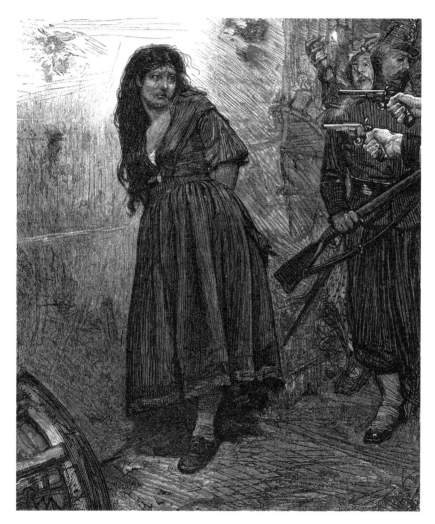

Figure 16. "The end of the Commune. The execution of a pétroleuse."

Wood engraving in *The Graphic* (London, 1871). iStock.

The ability to include a range of specific emotional responses from different individuals in the same image exceeded that of all but the most fortunate photographer even today. The wet-plate collodion process used at the time—known as ambrotype—required at least five seconds of exposure. This prolonged exposure time made it impossible to capture photographically any kind of movement, let alone dramatic action. Furthermore, technological limitations also did not allow newspapers to print photographs until almost a decade after the Commune. These factors did not prevent journalists from conveying the reality of events as much as might be supposed. First, photographs regularly served as the basis for the wood-block engravings that appeared in newspapers. This was especially true of individual portraits and urban architecture. Second, artists who designed depictions of action for the illustrated press continued to use compositional techniques that heightened both action and emotion beyond what even later photographs could achieve. For example, an engraving could show figures simultaneously marching toward the viewer, turning a corner, and marching away, a set of actions that only moving pictures could render more realistically.[73]

Thus, the technology used by the illustrated press, which allowed it to combine extensive text and graphic images, gave it a unique power to establish the "reality" of events, such as the summary executions in the otherwise idyllic setting of the Luxembourg Gardens (see figure 17).[74] Of course, the illustrated press also created other forms of "reality" that were not, in fact, real. Although not without precedent in earlier insurrections, the sight of women fighting alongside men on the barricades of the Commune elicited great media attention. Even though female supporters of the Commune largely conformed to prevailing gender norms by serving in auxiliary roles, such as canteen women and nurses, the fact that some women did bear arms generated a myth of numerous ferocious Amazons, and even entire units of female *fédérés*, defending barricades to the death.[75] Women becoming warriors greatly alarmed conservatives, who considered it consummate evidence of the Commune's pervasive threat to social order. The general fear that anarchy would triumph over patriarchy inspired the most famous invention of the contemporary press: female incendiaries. An outpouring of hair-raising stories and lurid images created a stereotype of *pétroleuses* stealthily setting fire to the city. However, the generally realistic images offered by illustrated newspapers were no doubt considerably more convincing than the histrionic caricatures of deranged furies often reproduced since (see figure 18). Despite the insistent discourses on danger and dishevelment, both physical and moral, the military courts found

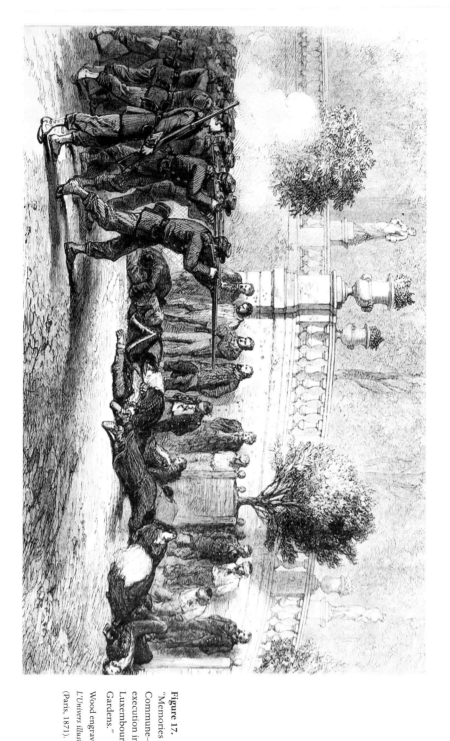

Figure 17.
"Memories of the
Commune—an
execution in the
Luxembourg
Gardens."

Wood engraving in
L'Univers illustré
(Paris, 1871).

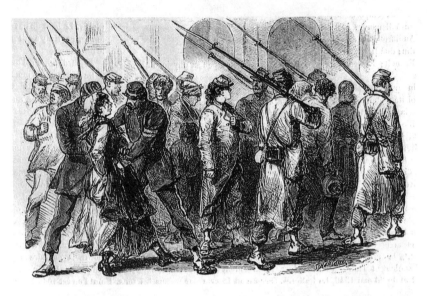

Figure 18. "Arresting women, one in a National Guard uniform, accused of shooting an officer." The other woman is an incendiary: she is dressed in ordinary clothing, not the uniform of a canteen woman or nurse, and is clearly agitated.

Engraving in *L'Événement illustré* (Paris, 1871).

scant evidence of actual female incendiaries and convicted no women of the crime. In fact, over 80 percent of women taken prisoner were not even prosecuted. Moreover, of those women who did stand trial, only twenty were convicted of serious insurrectionary crimes, such as bearing arms. In short, even though the Commune provided some self-consciously political women with opportunities, the media response helped to ensure that their experiences did not constitute a major turning point on the road to full participation in politics.[76]

Those people unlikely to buy or read an illustrated newspaper still encountered plenty of vivid images of events thanks to the proliferation of cheap prints. These color lithographs were sold both as single sheets and in collectible sets. Although some were innocuous images of individuals and events, a large share of the overall production took a partisan position. The bulk of these used satire and caricature to ridicule the Commune and its supporters. For example, G. de Marcilly's series of sixteen prints entitled *Agonie de la Commune* consistently portrayed Communard national guardsman as incompetent drunkards. A series of thirty caricatures by Léonce Schérer entitled *Souvenirs de la Commune* also relentlessly mocked the Commune and its defenders as boozers and buffoons. Likewise, *Communardiana*

by Nix is a series of fifteen hand-colored lithographs, each one a caricature depicting grotesque faces assembled into a supposed family portrait.[77] The first of these, titled "Le Major Pétrolowick et Mme. Pétrolinska, les petites pétrolettes," illustrates the stereotypical association of foreigners with the Commune and its desperate strategy of widespread arson. Such lampooning suggests a distinct lack of pity or sympathy for anyone tied to the Commune, whether leaders or ordinary *fédérés*.

And yet even these artists expressed concern about the level of repression. Print no. 29 of Schérer's *Souvenirs de la Commune* shows Versaillais soldiers routing panic-stricken *fédérés* with a caption calling the repression "a bit staggering!" followed by many ellipses to suggest that more, perhaps much more, could be said. Schérer was also among several artists who contributed to a narrative series of prints entitled *La Prise de Paris (Mai 1871)* that depicted nineteen episodes from *la semaine sanglante* in an unusually dynamic and vivid style. Whereas the series is vaguely pro-Versailles and the captions lack commentary, the images do nothing to obscure the army's brutality. In fact, many scenes contain highly charged elements that could easily have aroused compassion for the Communards. One print shows women both assisting a wounded man and fighting heroically on the barricade at place Blanche (see plate 18); another depicts an old man, without weapon or uniform, being shot point blank against a wall while a national guardsman lies in a pool of blood at his feet (see plate 19); yet another depicts an insurgent face down in blood and a soldier reloading his rifle while directing a sinister look at the viewer (see plate 20). An image of the Commune's execution of priests at the prison of La Roquette, as well as several other images in which dead Versaillais ooze copious amounts of blood, combine to give the series an unusual balance. Thus, in addition to being cheap, colorful, exceptionally violent, and available as single prints, this series impacted an unusually diverse audience by providing a simple visual summary of the sufferings of Bloody Week. As John Milner notes, images of this sort, "with their strangely awkward rhythms, flat colors and stylized drawing sometimes had more visual impact, a wider circulation and offered a more succinct analysis of events than either wood-engraving, canvas or steel-engraved images ever achieved."[78] Seeing them in shop windows, or posted in cafés and taverns, multiplied the message for free.

In addition to the proliferation of simple colored prints in the style of *images d'Épinal*, Parisians could have gazed upon, and purchased if they had the means, an array of larger and more expensive lithographic prints devoted to events of the Commune. These contained greater detail, more

careful hand-coloring, and even reflective gold paint.[79] Such collectible images were clearly intended to be mounted and displayed in bourgeois homes. Given their cost, it is not surprising that prints of this nature tended to reflect anti-Communard sentiments. But these were not merely allegorical. Included among such elaborately produced prints were various depictions of the Commune's executing its hostages, especially Archbishop Georges Darboy, whose iconographical centrality to the story of the Commune offers a parallel to that of Admiral Gaspard de Coligny three centuries earlier (see plate 21).

Shop windows also filled with photographs. The macabre curiosity of tourists rushing to Paris to gawk at smoldering buildings in June 1871, and then seeking souvenirs of their visit, helps to explain the sudden spate of photographs depicting the ruins there.[80] These were available to tourists and locals alike in a wide variety of formats that ranged from individual, pocket-sized pictures to luxurious two-volume folio editions (see plate 22).[81] Whether sold individually or in collections, such photographs implicitly condemned the Commune. It would be a mistake, however, to flatten the response to these images to a tourist's callous curiosity, or even a Parisian's moral outrage. Sometimes the text accompanying images of ruins drew attention to the human consequences of the physical destruction. One of Appert's famous photographs, "Bondy burned—church square," was accompanied by the text, "Look at the house opposite the church and say whether war has ever offered a scene more likely to make the heart ache!"[82] Text could also add such heart-rending details as the fact that all the tenants in the shattered buildings beside the Porte St.-Martin had been killed.[83] A few photographs of devastated neighborhoods even included people stoically posing in the foreground. As a rule, however, the smaller the collection in either number or size of reproduction, the rarer were photographs that included people or depicted private houses.[84] Capturing the gothic beauty of monumental ruins apparently did not fit well with the pathos of actual human suffering.

Seeing so many parts of the city in ruins extended the sense of loss to the experience of living itself. A bourgeois Parisian, Francisque Sarcey, lamented, "A profound melancholy seized us all when looking at these sites where we had loved, where we had suffered, where we had endured life such as it is, a mix of good and bad. . . . What devastations! What ruins! . . . A monetary wound is not deadly. But so many memories gone, wiped out! Oh, let's not talk about that any more! I feel myself dying!"[85] The destruction of many important places and communal spaces profoundly disturbed Sarcey's personal arc of life experience, so much so that he felt the need to turn away from the subject in order to save himself. The loss of such important parts

of his own past seemed to threaten his personal identity, and hence sense of self. But such feelings were not experienced in isolation. The earliest newspaper account of the devastation conveyed an intrepid journalist's emotional shock: "Forgive me, all you French who are reading me, if I give only informed notes. My heart is profoundly distressed. I cried upon seeing Paris ruined, lost, dishonored. I reproduce only some notes. I am deranged with suffering."[86] Such published expressions of emotional anguish invited readers to empathize with the reporter as well as the immediate victims of the almost undescribable devastation.

Of all the monumental buildings and prominent streets ravaged by the conflict, none had a greater impact on Parisians' sense of shared identity than the destruction of the Hôtel de Ville. The fire that ravaged the palatial structure not only destroyed some of Paris's own memories as vast quantities of historical records went up in smoke; it ruined the preeminent symbol of the city's illustrious history. Seeing a photograph of it in ruins would have given almost any long-term resident of the city a sense of personal loss, regardless of his or her political views. Whatever else may have inspired the Commune, it was clearly made possible by a widely shared Parisian hostility toward the national government. The Hôtel de Ville had long been a physical embodiment of this sentiment and had naturally served as the municipal seat for the Commune itself. Thus, its destruction seemed particularly senseless and distressing to supporters as well as opponents of the short-lived revolutionary regime.

That responses to the Commune could be rather mixed should also be noted. The many personal tragedies of those few months certainly involved emotions that extended well beyond trauma or mourning. Suffering and deprivation could also be turned into memories of generosity and survival. In December 1871, a middle-class family received a deluxe album labeled "La Guerre et la Commune." In it was a variety of drawings, allegorical prints, and panoramic scenes, as well as a series of twenty-one mounted photographs of ruins in and around Paris. The handwritten inscription reveals that this was a gift to a sister in whose empty house the donor's family had found refuge during the Commune. "We give you the sad picture of our suffering, of our disasters, I would add, of our shame, so that you might form an idea of them, you who were so lucky to have remained far away."[87] Here was a memento of tragedy inspired by personal suffering, chagrin at the actions of fellow Parisians, and gratitude for the good fortune that had spared them the worst. All of this had been felt personally as well as *en famille*. Such emotions were much more than mere addenda to bourgeois triumphalism over proletarian depravities; they were characteristic of how

images of destruction carried profound meaning for so many Parisians. The complex emotional associations of this particular album cautions us against being simplistic in interpreting collections of photographs as evidence of unfeeling detachment or moral distancing.[88]

Illustrations of the ruins wrought by the conflict could become all the more meaningful when accompanied by a narrative account. The writer Édouard Moreau collaborated with the photographer Pierre Petit to produce such an album. They intended their collaboration "to show to citizens who cannot come to Paris, the cruel ravages inflicted on our unfortunate city in these nefarious days of civil war."[89] One of the earliest and most personal accounts of the final days of the Commune, that of Louis Énault, *Paris brulé par la Commune* (signed 15 June 1871), included a dozen engravings based on photographs.[90] Énault introduced his account as a "simple narrative of the things I saw," which he composed at his wife's request. Though safely away from Paris, she had "followed the events of the tragedy that we were witnessing, waiting for us to become its victims." As her husband put it, this was a narrative "of the sufferings that we would wish to forget. I renew mine in recounting them; but you wanted to know about them. You will see how great they were." The immediate publication of Énault's account is evidence that producing it for his wife was largely a literary conceit. All the same, this device allowed him literally (and visually) to satisfy popular demand. Any reader who had not been in Paris during the Commune, especially the six hundred thousand Parisians who had left before the second siege, could now more easily and vividly share in the suffering of neighbors, friends, or relatives who had lived through it.

The quick publication of personal accounts such as that of Énault also offered those who had remained in the city throughout the spring a means to situate and complete their experiences during the Commune. Blanchecotte explicitly justified her hastily published day-by-day, eyewitness account, *Tablettes d'une femme*, as a service to those who had not experienced much of Bloody Week because they were in hiding or on the run. The famous memoir by Catulle Mendès, signed 31 May 1871, likewise used a diary-style format. This approach created a visceral sense of living through the events of the Commune without knowing the outcome. Several features of Mendès's account served to stir vicarious emotions in his readers. Including some of the many rumors he heard led him to remark on the distress caused by asking others about what was happening while knowing full well that whatever they said would be unreliable.[91] At one point Mendès asks, "In the midst of so many horrible events that affect the entire country, should I give space to suffering that broke only one heart?" He answers, "Yes, the smallest

detail is not without importance in the largest painting" and proceeds to describe a mother overwrought by having to bury her dead toddler without the blessing of a priest.[92] By concluding that the suffering of individuals matters, whatever the scale of the larger tragedy, Mendès made it possible for every reader directly or indirectly impacted by the violence of May to feel that his or her own sense of personal suffering was valid and formed part of the larger tragedy provoked by Bloody Week.

The literary qualities of Mendès's account, together with his balanced reporting, which is not done with a false objectivity but with moral engagement and sensitivity to the plight of others, made his memoir exceptionally effective in framing the experience of even those who had actually lived through the Commune. His experiences may have recalled their own, and no doubt even fused with their own. Such is the power of compelling prose. For example, Henri Rochefort dashed about the casemates of the Fort Boyard reciting to his fellow prisoners passages from the manuscript of Victor Hugo's *L'Année terrible*. "You'll never have any idea of the effect that you produced on these men," he later reported to his friend Hugo, "most of whom saw and suffered what you remind them of so admirably. They were crying buckets, and yet these are frighteningly tough chaps."[93] Just as the epistolary novels of the eighteenth century encouraged readers to identify strongly with such characters as Richardson's Clarissa and Rousseau's Julie, and thereby "to empathize across class, sex and national lines,"[94] the literary power of certain accounts of the Commune, such as Mendès's diary, Blanchecotte's memoir, and Hugo's epic poem, made it possible for hundreds of thousands of people to experience vicariously many of the tragedies of the Commune. Such narratives led readers to compare their own fate to that of other Parisians, to ask themselves about who deserved their suffering, and, in some cases, to ask why they had lived while others had died.

Newspapers and magazines also rushed to print personal accounts of suffering: the more intimate, the better. For example, from 8 to 26 July 1871, the *Moniteur* published a series of letters that Louis Bonjean, the president of France's highest court, had written to his wife from prison before being executed as a hostage. Alongside these were graphic extracts from a parallel correspondence between Bonjean's secretary and his brother.[95] Historians have frequently used such sources to convey a sense of immediacy in their own narratives, but without asking how these early accounts served to inform others at the time. It is one thing to be aware of mass suffering and quite another to see it in highly personal, individualistic terms. The flood of deeply personal accounts that so quickly followed the end of the fighting provided an unprecedented sense of what Parisians had experienced both

physically and emotionally. Never before in France had there been such detailed, graphic, and personal accounts of suffering as accompanied the destruction of the Commune.

The textual descriptions of firsthand accounts had the advantage over illustrations of being able to fuse sights, sounds, and smells into a single moving description. Benoît Malon, an actual member of the Commune, vividly parsed the cacophony of street fighting: "Paris offered one of these spectacles of splendid horror that make epochs. The continuous thunder of battle; the whistling, exploding shells and canister shot, crisscrossing in the flaming air, delivering fire and death all over Paris; the sinister stutter of gatling guns and the piercing bursts of gunfire, interrupted only by the clang of bayonets, lugubrious cries of agony, and dull moans from the dying; all of that in an atmosphere of fire, under a crimson sky, divided by billowing flames that rise above the burning palaces, reducing even the strongest men to a strange stupor."[96] Foreigners have often remarked on the seasonal delights of Paris in the springtime, but the English reporter Henry Vizetelly found it far less charming in 1871. "In vain did the scent of lilac-bushes strive to contend with the smell of powder. It was the latter which the mild April breezes wafted incessantly hither and thither, whilst clouds of smoke enveloped each budding plant like deadly blight."[97] All the sounds and smells came together in the singular atmosphere of urban combat: "The crackling of firing squads, the explosion of bombs, and the noise of gatling guns filled the air, while the odor of powder began choking the throats of local residents. Then horrible cries arose from the most badly injured, and the whistling of projectiles, from the batteries on Montmartre, passed rapidly over the rooftops of all the surrounding streets."[98] The extensive detail and exceptionally vivid quality of such accounts made it unusually easy for readers to imagine the full sensory experience of those who had lived through the dramatic events themselves. Narratives of this quality obviously brought readers closer to the presumed emotional experiences of participants as well.

Memoirs and diaries were also complemented by a remarkable variety of early histories. These relied heavily on the abundant coverage of events provided by newspapers but had the virtue of arranging it all in a coherent narrative. These "immediate histories" came in a wide range of formats. A mere three weeks after the fighting ended, the "Bibliothèque populaire" came out with a pocket-sized book of 127 pages entitled *Histoire de la Commune de Paris (18 mars – 31 mai 1871) avec plan*. Though published by ardent republicans and aimed at a popular audience, this short history unequivocally condemned the Commune. A fairly simple prose style combined

narrative drive, graphic detail, and moral outrage. "The public voice, in its thirst for savage justice, demands summary executions, and their number ceaselessly increases. Posterity will wonder how Frenchmen could plan and prepare this enormous crime, and it will shudder, as we do, in thinking about the appalling cataclysm which was the inevitable result."[99] The *Histoire de la Révolution du 18 mars* by Paul Lanjalley and Paul Corriez was another republican history of the Commune that appeared within a month of events. This impressive account ran to 570 quarto-sized pages and was replete with documents that, together with the tone of the text, emphasized a positivist form of historical objectivity.[100] Nonetheless, Lanjalley and Corriez also occasionally resorted to emotional and pejorative explanations for the violence: "It seems that both parties returned to the barbarism of antiquity. And an inexpressible anxiety took hold of all those whom an inhuman rage—rage from defeat or rage from triumph—had not rendered completely insane, all those who believed in more civilization among us."[101] Here was an unusual emphasis on the attitudes of the uncommitted, those whose principal emotion was fear rather than hatred. Such men and women surely represented the great majority of Parisians of all classes. In short, the ever-expanding worlds of news reporting and literary history made vicarious experiences and, therefore, fellow feeling and even empathy easier and more compelling than ever before in French history.

MASS DEATH AND ANONYMOUS BURIAL

Despite the unprecedented visual and textual coverage of the Paris Commune, some of its greatest affective consequences came from the great uncertainty that surrounded death during Bloody Week. This uncertainty arose from the nature and extent of the killing, which took place both randomly and systematically. Several other factors heightened the emotional impact of this uncertainty. These included the far greater attention that French officials paid to identifying and tracking individuals among the population thanks to long-standing anxiety about the laboring classes as dangerous classes. This increasingly sophisticated bureaucratic oversight increased expectations that individuals could, should, and would be accounted for, even in cases of mass violence. It had been understandably difficult for the ramshackle revolutionary state of 1793–94 to be very precise about the overall death toll during the Terror, especially in provincial areas of prolonged conflict. The growth in bureaucratic record keeping and police surveillance since then, however, was expected to eliminate such gross uncertainties by 1871. And yet they did not. Not knowing even approximately how many

persons died, let alone who exactly was among the dead or how they had been killed, resulted not only from the nature of the fighting, but also from the deliberate desire on the part of the regime based at Versailles not to know. Officers systematically put prisoners before firing squads, often without attempting to identify them formally. The process did not, however, resemble being "disappeared" by a South American dictatorship in the twentieth century. Rather, identification remained largely haphazard. For example, a certain *femme* Grossman was informed by a lieutenant that she should appear at the "abattoirs" of La Villette where "her husband and brother-in-law, alas, had been shot."[102] However, being a foreigner, having a criminal mien, or simply having grey hair (and thus appearing old enough to have fought in the June Days of 1848) could lead to immediate execution against the nearest wall or in one of several human killing centers, such as the Lobau Barracks near the Hôtel de Ville.[103]

The army's common disregard for recording the identities of those it killed during the reconquest of Paris contrasted sharply with the Commune's efforts to identify and properly bury each of its own fighters who had been killed in the six weeks of fighting before the final slaughter. This concern served to increase the value of every life lost for the cause of the Commune, as well as to stoke anger at Thiers's government. Moreover, from early April onward, the army of Versailles executed a number of captured *fédérés*, especially those known to have deserted the regular armed forces. The Commune responded with vociferous cries for vengeance and an ill-prepared sortie against Versailles. The resulting clashes began a string of lopsided defeats for the Commune. Thereafter, posting serialized lists, each containing many hundreds of *fédérés* identified by name and unit who had been taken prisoner, magnified the anxiety and loathing felt by their friends and family.[104] Each of these names were individuals who, according to the Commune, could be executed at any time. Moreover, even though atrocities were rare in the early weeks, fears that the army of Versailles would brutally massacre prisoners had some basis in fact. After approximately three hundred *fédérés* were killed in the fighting at the Moulin Saquet on 3 May, for example, reports circulated that many of the dead had been mutilated. Burial certificates later confirmed these reports.[105] Thus, as fighting intensified, Parisians became increasingly aware of the deadly cost of supporting the Commune and the stakes attached to the loss of each and every *fédéré*. However, once the army entered Paris itself and the wholesale slaughter began, the affective consequences of capturing or killing *fédérés* shifted dramatically.

Even before the final week of reckoning, heavy losses among the *fédérés* began to change both the means used to identify the dead and the emotional

stakes associated with their deaths. The Commune's fighting forces lacked the kind of clear hierarchy and logistical capacity that characterize modern armies. As a result, it proved increasingly difficult to keep track of *fédérés* killed in action. Many *fédérés* failed to carry any form of identification, thereby leaving them potentially anonymous corpses. The most informed estimate of losses among the *fédérés* between 2 April and 21 May, that is, before the army of Versailles actually entered Paris, puts casualties at between six thousand and eight thousand men; an official source from the period indicates that the Versaillais took about thirty-five hundred prisoners during the same seven weeks.[106] However, soaring desertion rates, which prompted the Commune to issue threats of immediate execution as well as to adopt a blanket requisition of all able-bodied men between the ages of seventeen and thirty-five (later forty), added to the enormous difficulty of determining the identities of individual *fédérés* fighting and dying for the Commune. It is not surprising, therefore, that who died during *la semaine sanglante* and precisely how they died proved difficult to determine, especially because neither the government nor the army, both much criticized for the excesses and arbitrariness of the repression, conducted an inquiry. This left room for great speculation on the number of people killed. Historians usually cite a figure of between twenty thousand and thirty thousand, but this is certainly too high.[107] Even the widely cited "minimum" figure of seventeen thousand "killed" during Bloody Week, was a tentative figure that was simply accepted as credible by the French Army commander, General Patrice de MacMahon, and only if applied to the number of individuals "killed *and wounded*" throughout the siege, that is, over the course of seven *weeks* of fighting, not the final seven *days* of Bloody Week.[108]

Determining the number of individuals who died during Bloody Week is important because it reveals not only continuing uncertainty, but aspects of the emotional consequences of that uncertainty. The government gave precise figures for casualties in the Army of Versailles,[109] but did not even estimate the number of deaths on the side of the Commune because unit commanders had not kept tallies.[110] An army cover-up has been suspected ever since.[111] However, other sources are available, and they are not suspect. Municipal records indicate that 6,650 bodies of those killed on the streets or shot by military authorities were buried in Parisian cemeteries without applying for the usual official permit during the last ten days of May 1871. This figure did not include almost eight hundred bodies known to have been dumped in a quarry in Belleville, up to a thousand bodies not exhumed from the Bois de Boulogne, or a few dozen bodies discovered haphazardly over the years. Adding these other bodies to the ones officially buried in

cemeteries brings the tentative total to about eighty-five hundred corpses. However, this figure does not apply exclusively to "Communards" killed; it includes hundreds of civilians either caught in the cross fire or mistakenly shot as suspects, as well as some regular soldiers killed in the fighting. This total of eighty-five hundred dead is moderately higher than the upper estimate given by Robert Tombs, the first historian to do a serious study of the available evidence. However, this more certain figure is still well below the most commonly cited totals for Parisians killed during Bloody Week.[112]

Adjusting the number of individuals who died during Bloody Week down from thirty thousand, or even twenty thousand, to eighty-five hundred means that fewer people were on intimate terms with someone who died that week than has been commonly claimed. In fact, if we assume that each person killed had a strong emotional attachment to a dozen other individuals living in Paris, the lower figure indicates that about 5 percent of inhabitants lost a close friend or loved one that week. This was still genuinely shocking, of course, but scale matters. Moreover, most Parisians did not see the slaughter in person, and even those who did witness death directly likely saw only a few bodies at most. Even as we recognize the lower incidence of direct contact with death, however, we need also to recognize that the new media of the day, such as illustrated newspapers and photographs, made the carnage astonishingly immediate for many Parisians otherwise only indirectly impacted by it. Evidence of mass killing abounded, especially in the newspapers and prints that poured off the presses. Moreover, in order to grasp the immediate social impact of the slaughter of Bloody Week, we need to examine cultural practices and representations that magnified the number of deaths into an even greater trauma.

The fact that a large number of the corpses from *la semaine sanglante* were buried without identification greatly reduced the number of funerals in Paris. This paradox of more deaths and fewer funerals had important cultural consequences. The comparative paucity of funerals in late May contrasted with the plethora of processions that had preceded Bloody Week. The Commune stoked animosity toward the Army of Versailles by developing a cult of funerals for fallen *fédérés*. All of these funerals were conducted strictly as civil affairs, without any participation of the Catholic Church. The first great funeral for fallen *fédérés* came on 6 April, when hundreds of thousands of Parisians witnessed a huge procession along the grand boulevards.[113] Such processions, accompanied by solemn music, weeping mourners, and distraught widows, soon became commonplace.[114] On 19 May, for example, the boulevards from the Champs-Élysées to the place de la Bastille filled with funeral wagons, which all took a turn around the Bastille before heading to Père Lachaise

where the dead from the "guerre sociale" were interred. As one dyspeptic republican noted in his diary, this daily procession was designed to "strike the populace through a certain display of death. Public routes now belong almost exclusively to funeral processions. They are the triumphal marches of the ham actors in the Hôtel de Ville."[115] The Commune's concern to identify its heroes and honor them in death soon came to highlight the lack of respect and failure to identify so many of those killed the very next week.

Just how all the corpses were handled during and after Bloody Week contributed to both the collective trauma of the experience and the myth generated by events. Contemporaries saw or heard plenty of wagons, coaches, and carts bearing cadavers across the city for disposal, either at the time or within a few weeks.[116] Descriptions and depictions of these events abounded as well. Newspapers graphically reported the hasty burials in the cemeteries of Montmartre and Père Lachaise. A macabre contemporary lithograph also shows men with shovels and pickaxes laboring in a cemetery at night with a large dome, possibly of the Panthéon, visible in the background.[117] However, such images could only begin to account for what had happened to most of the bodies. Where they were all put was not made public at the time, nor has it become fully known since. At first, many of the bodies found lying in the streets were hastily buried in public squares, along quays and boulevards, in courtyards and cellars. Later, over that summer, more than thirteen hundred such bodies were exhumed and reburied in regular cemeteries. However, an unknown number of bodies, estimated by the police at one thousand, were also buried in the Bois de Boulogne and never relocated. On 16 June 1871, the newspaper *Le Temps* published an article on the interment of bodies in the Bois de Boulogne, the continuing exhumation of *fédérés* buried in the city, and the incineration of corpses found in defensive fortifications. In particular, the author notes "the cadaverous odor [that] presented real dangers" along the southwestern edge of the city, where heavy smoke was seen during the day and low flames became visible at night, and mentions the use of "quicklime, tar, and carbolic acid to destroy the corpses of Prussians, *fédérés*, and French soldiers that had accumulated" in the forts of Issy and Vanves. According to the eyewitness reporter, all of this was being done "with great care and precaution."[118] The authorities may have been able to protect the population of Paris from pestilence associated with putrefying corpses, but they could not shield loved ones from the pain of not knowing who had died and whether they had been properly buried. Large numbers of unidentified corpses in the Bois de Boulogne, the quarries of Belleville, or the heavily damaged fortifications of Issy and Vanves meant that Parisians would have found it extremely difficult to learn just who among their friends, neighbors,

and relatives had died, let alone when and where. Such uncertainties also made it easy to exaggerate the number of victims of the Versaillais.

Further confusion over the fate of relatives and neighbors resulted from the arrest of some thirty-six thousand individuals during the repression or shortly thereafter. Most memoirs describe convoys of haggard prisoners, often including women and children, being escorted by soldiers through the streets and on their way to prisons at Versailles. As a photographer noted in his diary, "After so much suffering, sadness, and horror, here's what remained for me to see and hear, in the very center of Paris . . . marching interminably four by four, in the middle of the road, an uncountable number of men, prisoners gathered individually or rounded up together, sometimes for their expressions, for the look of their shoes, for nothing: by the chance of capricious election."[119] Thus, just as Paris was being flooded with images of death and destruction, newspapers began to print stories about the plight of thousands of prisoners. The accompanying images devoted considerable attention to the physical and facial demeanor of the supposed Communards. Given the circumstances, it is remarkable that some of these images actually included elements of pity and tragedy (see figure 19). The degrading treatment, the appalling prison conditions, and the difficulty mothers and wives had in locating and visiting their menfolk became the subject of extensive publicity. Moreover, the wide range of social types hastily seized by the police helped to stimulate empathy. That almost anyone could have been arrested, rightly or wrongly, became obvious by the fact that over seven thousand individuals were released after preliminary questioning and without further investigation. Many of the rest had played a minimal role in support of the Commune, leading to another 21,600 being released without trial within the first year.[120] During that same period, almost a thousand prisoners died before being properly judged. As Gustave Maroteau wrote from the military hospital at Versailles on 25 September 1871, "I saw everything, suffered everything. . . . Finally, I left the prison of St. Pierre, a tomb, not revived like Lazarus, but dying."[121] Such experiences only added to the agonizing mix of mass death and pervasive uncertainty.

In the meantime, how was one to know whether a brother was dead and buried, or alive and in prison? Because she dressed better than a laundress did not mean a sister was not being held at Versailles charged with arson, or been shot out of suspicion and buried without identification. Moreover, thousands of supporters of the Commune fled the country, thereby adding to the uncertainty, at least for a time. Like most newspapers, *L'Événement illustré* published detailed articles on the desperate scenes at Versailles and the nearby military camp of Satory where a horde of claimants went

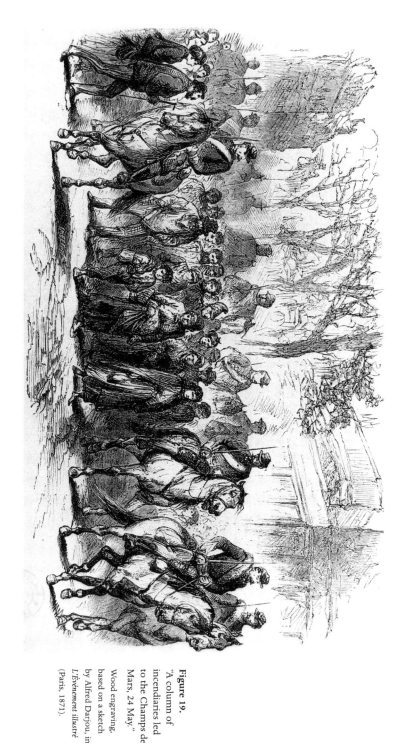

Figure 19.
"A column of
incendiaries led
to the Champs de
Mars, 24 May."

Wood engraving,
based on a sketch
by Alfred Darjou, in
L'Événement illustré
(Paris, 1871).

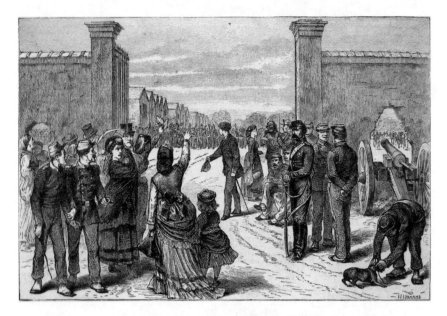

Figure 20. Visitors leaving accused Communards imprisoned at the military camp of Satory near Versailles.

Wood engraving in *L'Univers illustré* (Paris, 1871).

looking for individual prisoners: as Jules Claretie put it, "all classes are represented. Silk dress brushes cotton dress; cap bumps hat; smock rubs cardigan" (see figure 20). In another article on his visits to Versailles, Claretie reported, "you experience, alas, a horrible tightening of the heart, an inner suffering that twists your guts when listening to the interrogations of these people, some of whom don't even comprehend their actions."[122] It is this sort of text, combined with graphic images of ill-kempt and despondent prisoners, that strongly suggests the possibility of widespread empathy, even among those who wholeheartedly rejected the Commune.

Failed revolutions act as a powerful social solvent, however, and the *après* Commune was no different. The arrival of the Army of Versailles immediately unleashed a torrent of recriminations. "And now that we're not dead, we accuse one another," wrote Blanchecotte on 29 May.[123] The authorities received almost four hundred thousand denunciations, most of them anonymous.[124] Such actions severely frayed any sense of community that survived the fighting. The repression encouraged the settling of scores at all levels, from neighborhoods to families. *Concierges* were notorious for reporting on their building's tenants. Abused wives gave the police precise details of when their husbands were away, supposedly mounting

barricades. Daughters turned in tyrannical fathers.[125] The police soon realized that their zealous pursuit of Communards made them pawns in personal quarrels, especially when they saw many released detainees returning to terrorize neighbors who had turned them in.[126] Individuals in prison awaiting trial by military courts were the subject of grave concern on the part of family members and even widespread compassion in their communities. But that was not enough to overcome intense mistrust and antipathy. After all, it had been diehard militants, everywhere a minority, who had brought infantry battalions, gatling guns, and field cannons into their streets. They may have fought bravely, but they did not all die heroes to their neighborhood or to others who labored for a living. Thus, what measure of animosity and what measure of empathy conditioned relationships in the wake of the Commune are exceptionally difficult to discern. It is best simply to recognize that considerable tension existed between the two, rather than succumbing to caricatures of bourgeois hostility or working-class solidarity.

There was no socially or culturally prescribed way for Parisians to respond to mass death. Social distinctions certainly made a difference in determining the rituals of death for individuals. Only a few Parisians could afford to provide family mausoleums in the city's crowded cemeteries. However, the scale of the killing in May 1871 and the hasty disposal of thousands of unidentified corpses ensured that the vast majority of those killed that month were treated no better than paupers in death, whatever their social status in life. The prompt burial of these many cadavers (sometimes followed by exhumation and reburial) made it extremely difficult to identify many, if not most, of the victims of the fighting. Moreover, the politics of the moment inhibited those who survived the carnage from coming forward to identify those who had fought and died for the Commune. The resulting disposal of a large number of unidentified bodies inevitably had its own traumatizing effects.

Dying and being buried unidentified, whether on battlefields or in big cities, had largely ended in France by 1871. Ever since the eighteenth century, the growing dignity of every individual had been accompanied by an expanding capacity to keep track of each of them both in life and in death. The municipal administration of Paris had been surprisingly successful at recording individuals who died during the Prussian siege of the city. The city also managed to provide them with the official funerals and burials required by local statute. Starting in 1850, impoverished residents of Paris had the right to a free funeral and burial in a municipal cemetery. Their bodies were interred in a *fosse commune*. This "common grave" was not simply

a pit full of bodies, but rather a trench in which coffins had to be spaced a minimum of 20 centimeters apart, covered by 1.5 meters of soil, and topped with identifying crosses. If demand required, corpses that had been buried in a *fosse commune* for at least five years, by which time they had been reduced to skeletons, could be dug up and replaced by new ones.[127] This system was no doubt strained during the Prussian siege. Almost twenty thousand registered burials—four times the monthly average—took place in Paris during January 1871.[128] During the last weeks of the Commune, however, the system of recording deaths and burying bodies broke down. As a result, Parisians came to see and experience death in novel ways that heightened their sense of loss.

The random vagaries and emotional consequences of trying to identify those who died violently during the Commune are revealed by the sketches of a hospital worker and artist named Alfred Auteroche.[129] One of his sketches shows a newsboy killed by an exploding shell. He was already in a coffin when his mother identified him, recounted the last time she saw him, and explained that he had become their primary source of income after her husband lost his job as a stonemason. In contrast to such positive identifications, made by loved ones and replete with individual stories, were those people who died abandoned and unidentified. Auteroche's sketches depict just such a case: the corpse of a woman, about thirty-five years old, who had also been killed by an exploding shell. Her naked body had been left with a street address pinned to the bare shoulder, and yet no one came to claim her. Both the beloved boy and the naked woman would have been hastily buried in a common grave, but only the boy could have had an iden-tifying marker above. Like so many others killed during Bloody Week, the anonymous burial of this naked woman constituted a threat to personal identity and the moral fabric of the community. Each body is the repository of selfhood, a platform for the identity that constitutes a particular human being. The secularism of the Commune's official funeral ceremonies not-withstanding, most Parisians at the time also considered the body an incar-nation of the essence of humankind, one that held the potential for eternal life, thereby separating humans from animals. As a result, the inability to identity a body and to bury it with the appropriate rituals undercut the moral fabric of human community.[130]

REGARDING THE DEAD

The Commune broke new ground in the ways in which victims were iden-tified and depicted. The increased expectations that came with nineteenth-

century notions of citizenship, especially in an era of universal manhood suffrage, inspired the Commune to make a concerted effort to identify every fallen *fédéré*. On April 3, the day that the Commune launched its abortive offensive against Versailles, it created a bureau of information at the Hôtel de Ville dedicated to processing *fédérés* killed in combat. The new office adopted the practice of taking photographs of unidentified corpses in order to enable family or friends to identify them even after they had been buried. This practice began with the battle of Buzenval on 19 January 1871. The day after the battle, 250 corpses were delivered to the morgue, where officials inventoried their effects and then transported the bodies to Père Lachaise cemetery. There a police official named Gustave Macé had a photographer take pictures of them as individuals and in groups before they were interred.[131] This addition of photography to official burial requirements in Paris explains one of the most famous images generated by the Commune: a photograph of twelve male corpses in crude coffins. This image has been frequently reproduced as evidence of the mass slaughter of Communards during *la semaine sanglante*.[132] In fact, however, this image dates from early April when the information bureau first began processing the corpses of unidentified *fédérés*. This new interpretation is proved by the copy preserved at the Musée de l'art et d'histoire de Saint-Denis. Here the photograph is in a period frame stamped by the well-known photographer André-Adolphe-Eugène Disdéri and labeled "Victimes des 3, 4, et 5 avril 71."[133] It is important to note, however, that this oft-reproduced photograph did not become an iconic (mis)representation of Bloody Week until decades later;[134] therefore, it played no part in shaping immediate responses to the slaughter.

Other images of corpses, however, did become part of many contemporaries' visual experience of the Commune. As combat casualties mounted, the Commune created a new Inspectorate General charged with collecting daily reports from the provisional hospitals scattered throughout Paris. This process facilitated the identification of *fédérés* killed in battle, which required the presence of relatives whenever possible, and thereby expedited the burial of corpses before they decomposed.[135] Although the bureau for gathering information about *fédérés* killed in action was transferred to the Ministry of War on 22 April, officials at the Hôtel de Ville continued to maintain their own information, including photographs, on unidentified individuals buried in municipal cemeteries.[136] The Paris morgue had long had viewing windows that enabled visitors to identify corpses; however, the scale of killing during the Commune required the addition of many more such sites.[137] Makeshift morgues quickly sprang up as appendages

to various provisional hospitals and soon became well known to ordinary Parisians looking for missing loved ones.[138] Thanks to the illustrated press, even those who were not compelled to make the rounds of the morgues of Paris gained a basic understanding of how they worked. *L'Événement illustré* printed an image of dead Communards stretched out at the Ambulances de la Presse at 27 rue Oudinot (see plate 23). The artist Auguste Lançon alludes to the process of identification by including both a departing civilian in one of the windows and two orderlies covering corpses with shrouds.[139] Another newspaper image of a similar scene suggests some of the emotional impact of such a sight by showing several corpses with agonizing grimaces on their faces (see plate 24). Little explanation was needed: Communards had died violently, then been spread out in rows like fish in a market for public viewing. Depicting the faces of the dead with unusual detail reflected disdain for the rebels who defended the Commune, as opposed to the patriots who defended France. Nonetheless, such detailed depictions also served to highlight their suffering and their individuality. We must not forget either that the graphic intimacy of such images was unprecedented in the contemporary press.[140]

Of course, most of those killed during the Commune were not put on public display because their identities had been established in situ. There are numerous accounts of people, mostly neighborhood women, searching among bodies left splayed over shattered barricades or strewn in the street in the hopes of finding a missing husband or son. Too often peering at bodies in the street, perhaps covered by a coat or blanket, has been interpreted as mere bourgeois curiosity when, in fact, contemporaries remember it as a desperate search for loved ones (see plate 25). Very quickly, however, such obvious searching risked arrest and indictment for having aided the insurgents. As a result, the number of bodies that were buried without ever being identified must have been very substantial.

In this respect alone, the experience of death during and after the Commune contrasted sharply with experiences during the Prussian siege. In both cases, artillery shells had rained death and destruction on the city without discriminating between social strata. During the repression of May, however, the Versaillais far exceeded the Prussians, a point highlighted by a vivid propaganda poster produced by the caricaturist Moloch (see plate 26). Above all, the Versailles army summarily shot thousands of Communards without worrying about formal identification, let alone proper disposal of the bodies. Over twenty military tribunals conducted summary trials, and yet most kept no records of the prisoners they executed. As a result, trying to identify and bury victims of the fighting, whether they had been

incidentally killed by shelling or deliberately executed by firing squad, became exceptionally difficult in the chaos of May 1871.[141] The hasty burial of thousands of unidentified corpses became central to the tragedy of the Commune, as well as to its later interpretation, and yet little effort has been made to understand the cultural consequences of the high level of anonymity among the dead.

As has been mentioned, in order to reduce the number of "heroes" who went to their graves unidentified, the Commune's information bureau on *fédérés* killed in action employed photographers for the first time. This became possible thanks to a relatively new technique that enabled commercial photographers to provide the more respectable members of society with *cartes de visite*. The process used for generating these personal cards of self-presentation made it possible for photographers to take relatively inexpensive photographs of many of the unidentified *fédérés* killed in combat. Each pocket-sized photograph received two numbers, apparently one to indicate which morgue had handled the corpse and the other to indicate where it was buried. Several commercial photographers participated in this process, at both the Hôtel-Dieu and various temporary morgues.[142] Together they produced a large number of shockingly violent photographs. These macabre images showed the torsos of individual corpses, many with their clothes torn and faces mutilated, all in pocket-sized format (see plate 27). Thousands of people in search of loved ones would have been shown these gruesome portraits in the hope of being able to identify them. Such grizzly photos of unnamed dead inevitably passed into private hands where they were soon used to discredit the violence of the Versaillais.[143] Archives around Paris contain scores of these photographically preserved cadavers. That they do not contain hundreds, even thousands, of such photographs suggests that the purpose of identification for which the photographs were originally taken was largely fulfilled. The missing photographs were probably either destroyed once a positive identification had been made or given to family members who had convincingly identified their loved ones. Thus, most of today's archival photographs depict individuals who went unidentified at the time.

In order to appreciate the emotional punch of these photographs we must remember that images of individual working men and women had been extremely rare before they were photographed as dead and mutilated Communards.[144] Furthermore, photographic portraits taken in the late nineteenth century registered an idealized identity by combining individualism with bourgeois conformity. Commercial photographers began to thrive in the mid-1850s once they developed a technique to use a single collodion negative to take several smaller pictures. This sharply reduced the

price of photography and made it possible even for clerks and accountants to possess a photograph of themselves, albeit only the size of a playing card. Having such portraits made into *cartes de visite* was an important marker of social respectability. The inevitable result was a collusion between photographers and subjects that yielded a remarkable consistency of image: formal poses, bourgeois apparel, and solemn expressions predominated. By using backdrops, fancy furniture, and a few props, photographers could give a successful shop owner dressed in his Sunday finest the appearance of a solicitor.

Photographic portraits, especially when turned into *cartes de visite*, contributed directly to the emergence of the modern self. The invention of photography came at a time when the demands of individualism ran alongside new feelings of collective belonging generated by urbanization, industrialization, and consumerism, to mention only the most sweeping of changes. Photography was one of these changes. Once turned to making personal portraits, photography contributed to the emergence of the socially distinctive individual in the modern sense of the term. The need for "auto-affirmation" inspired both recognition of the individual and the cohesive force of diverse social groups. The portrait, once restricted to those who could afford paintings but now made possible on a mass scale by photography, became "one of the means to constitute this necessary *social consciousness of self*."[145] Photography allowed each person to see himself and to construct himself as a subject at once both unique and socially conformist, as a person and a persona, as legitimately having the prerogatives of an individual while also being recognized as part of a group. Presenting pocket-sized portraits as *cartes de visite* for social purposes made them photographic identity cards in which the human being in the image fused an individual person, a subjective self, and an objective social status.

By the time of the Commune, such technological aids to combining social aspiration with individual identity had penetrated the middle classes; however, they had not yet reached the majority of French men and women, those who labored for a living. It would take another two decades and more before peasant proprietors, respected shopkeepers, and skilled craftsmen could emulate their social superiors by having personal photographs taken at weddings or baptisms. Before that happened, however, the French laboring classes had their first significant encounter with photography in the context of war and revolution. At first these were group photographs: soldiers posing alongside cannons or a mix of national guardsmen and laborers manning the fortress-like barricades in the place de la Concorde or standing alongside the toppled Napoleonic column in the place Vendôme.[146] In such

photographs, the identity of working Parisians was still largely established in social and relational terms rather than in individual ones.

In this context, not having already possessed photographic portraits of family members as individuals surely heightened the emotion of seeing a son, husband, or brother fixed photographically for the first and only time as a disheveled and bullet-riddled corpse. The initial psychological impact came from seeing graphic and irrefutable proof of the person's violent death; the sustained impact came from an image that overlay and partly supplanted other memories of the living person. The loved one clearly no longer existed in life, and yet he or she persisted in death. Thus, photographs of unidentified *fédérés* massacred by the Versaillais possessed a unique power to generate feelings of empathy and social association. The circulation of such images after Bloody Week surely enraged many in urban milieus favorable to the Commune. The photographs of mutilated female corpses seem to have been especially disturbing, so much so that General Jules Bourelly remarked upon them thirty years later.[147] The sheer carnal brutality of these images also elicited empathy for the anonymous victims and their families, even among Parisians who had not supported the Commune. Those who lived in the poorest districts such as Belleville and Montmartre would have been most inclined to identify with the victims, but they were not uniquely susceptible. Survivors knew that the street fighting had been exceptionally brutal in places and that the army had carried out hasty and arbitrary executions across the city. Moreover, the nature of these photographs made it impossible to tell whether the carefully framed corpse had once been a carpenter or a jeweler, literate or illiterate, Parisian or provincial. Viewing photographs of individual but often nameless corpses made it very easy for Parisians to imagine themselves or their loved ones also lying dead, unidentified and unclaimed, following the chaos of Bloody Week.

The best-known and most widely circulated portraits were not of corpses, however, but of living Communards. The Commune was the first revolutionary movement in history whose leaders became easily recognizable to the general public. Many of these principal figures had portraits of themselves taken by professional photographers, either before or during the Commune. These images followed contemporary norms of photographic portraiture by emphasizing sober, bourgeois respectability, such as that of the Communard Charles Ferdinand Gambon. Only the caricaturist Georges Pilotell, representative of the Commune for the Fine Arts, chose to give himself a revolutionary air. Pilotell's studio portrait shows his hair rakishly swept back, a pistol in his belt, and a menacing glare in his eyes, looking much like a French Garibaldi (see plate 28). By its very idiosyncrasy,

Pilotell's posturing reminds us of the role sitters played in fashioning their own photographic images. Even if the other leading Communards chose to have themselves photographed in a rather conformist manner, having personal photographic portraits made them more distinctive as individuals in the public eye.

The spring of 1871 also saw photographs play a role in repression for the first time. This too had its psychological import. The government at Versailles first used photography to identify rebel leaders it sought to arrest, then to document those who had been arrested. Just as the army penetrated into Paris, the Prefecture of Police at Versailles ordered between 120 and 170 copies of photographs of each of forty Communard leaders. This led to the distribution of three batches totaling 8,775 commercial photographs of the "most wanted" men from the insurrection.[148] These individual photographs soon became the basis for albums indicating the fate of many of the Commune's leaders and assisting in the search for others. In subsequent weeks, military authorities authorized the commercial photographer Eugène Appert to make individual portraits of hundreds of prisoners, including women and children, awaiting trial at Versailles (see plate 29). These were sold both to the prisoners themselves (and so would have been, like *cartes de visites*, self-portraits of a sort) and to the military authorities for use in identification and prosecution.[149]

Photographic portraits of Communards, whether they had posed for them before being arrested or later as prisoners, were widely sold in France and even abroad. They also provided the basis for newspapers to engrave and print individual portraits and even two-page arrays of members of the Commune.[150] Commercial photographers themselves sold hundreds of thousands of portraits of leading Communards.[151] These photographs became collectibles, reverently assembled into personal albums or tacked to bedroom walls.[152] Despite strenuous efforts by the government and police to control the distribution of images related to the Commune, citing concern that they would disturb public peace, feverish demand led even barbers and haberdashers to display them for sale. By the end of the year, the growing crackdown had led to a strict ban on portraits of individuals who were either "under prosecution or convicted for their participation in the insurrection."[153] The level of popular demand for such images—and the commensurate government anxiety it created—is revealed by the prosecution and conviction of a Parisian grocer simply for carrying a brand of tapioca that included Appert's photographs of Communards inside the packaging as a marketing ploy to increase sales.[154] The police also targeted images of barricades in particular. In one case they claimed that a small oil painting

was "an apology of the insurrection"; in another case, they argued that an engraving inspired "pity for the fate of dead or imprisoned insurgents."[155] Clearly the authorities believed that images related to the Commune had a special power to generate sympathy, especially in the midst of continuing repression.

If contemporaries believed in the power of representations to shape attitudes and emotional responses, then we should too. In other words, it is reasonable to conclude that the events of Bloody Week broke new ground in how representations of mass violence could provide an impetus to a more developed self. Illustrated newspapers, colored lithographs, portrait-style photographs, instant memoirs, and immediate histories combined to communicate with unprecedented effectiveness the death and destruction of Bloody Week to all Parisians, even those who experienced little of it directly. The wide availability of these diverse representations together with their explicit purpose of conveying personal tragedies with as much emotional impact as possible stimulated empathy across social strata and beyond face-to-face encounters. Such empathy encouraged inner reflection. Hundreds of thousands of people were further stimulated to ruminate on their personal choices, commitments, and experiences, all put into a comparative framework. Simply surviving the Commune required explanations and justifications; these then became personal narratives that increased the salience of the self.

INDIVIDUALS IN CLASS FORMATION

The ferocity and desperation of the resistance in May 1871 raised concern about the plight of the laboring classes. This concern was reflected even in the most expensive illustrated newspapers. Shortly after the Commune, *L'Univers illustré* published an image entitled "Families of workers fleeing the fires started by the insurgents." The accompanying text explaining that "they had lost, in the immensity of the disaster, all they owned in the way of bedding, possessions, and furniture," and concluded, "This spectacle gripped our hearts," thereby prompting an appropriate response from readers to the manifest pathos in the image.[156] In a similar fashion, *L'Événement illustré* published a series of images and stories over the summer of 1871 entitled "Les bas-fonds de Paris" ("The slums of Paris") that sympathetically depicted ragpickers, soup kitchens, and other aspects of urban poverty. A year after the Commune, the National Assembly launched an inquiry into the state of workers in France.[157] The initial responses generated by the eighty neighborhood commissariats of the capital provide rare

insights into contemporary responses to the conditions facing workers a year after the Commune. The police commissioner in charge of the neighborhood of Père Lachaise responded to the enquiry by saying that "the recent events that bloodied the year 1871 have, in my opinion, only dug the ditch between [workers and bosses] deeper than it already was before." This might appear unremarkable, even predictable. However, it is one of only two commissioners' reports that mention the events of the Commune the year before, even though all of the responses were required to address relations between workers and bosses.[158] These highly detailed reports contain a surprisingly wide range of responses. A considerable number of neighborhood commissioners describe the relationship between workers and bosses as "rather cold" or "quite tense"; however, just as many neighborhood reports described relations as "good" or "agreeable." More significant, perhaps, these reports mention few workers' organizations, while also emphasizing the difficult lives of most workers, especially women. None notes a shortage of workers. In other words, this extensive corpus of neighborhood-based reports reveals frequent expressions of concern for workers, but almost no evidence that the events of the Commune had made the workers of Paris more hostile to employers.

The neighborhood commissioners' reports on workers tended to take a longer view of labor issues, one that stretched over a decade or more. This longer perspective directs us to appreciate the impact that the catastrophic episode of the Commune may have had on workers as individuals, rather than as members of a nascent proletariat. In fact, the extent to which they had been profoundly traumatized as a class is challenged by contemporary evidence. A summary police report on "working milieus" in Paris a full year after Bloody Week claimed that workers had silently accepted the necessity of the repression up until that time. Only then did they begin to become agitated due to "tearful articles published in favor of the detainees of the insurrection, those condemned to hard labor or deportation, or those condemned to death, whether executed or not."[159] Such a perception provides support for the notion that it took time and the press to turn the events of the Paris Commune from a trauma shared by individuals of many diverse backgrounds into a trauma that had a distinctly more powerful impact on workers as workers.

The many representations of violence and suffering that we have considered in this chapter should be understood as seeds cast over soil made increasingly fertile for an experience of shared suffering by the growing value of the individual worker in nineteenth-century France. A variety of forces in play during the decades since the French Revolution had promoted

an increasing emphasis on personal dignity. The French Revolution's leg-
acy of individual rights, followed by universal manhood suffrage in 1848,
provided the political foundations of individualism. The Second Republic
raised social expectations, especially for those who labored for a living. As
Adolphe Blanqui put it in 1849, given the "moral malaise" of the working
classes, "it will be necessary for us to act together in order to make the house
livable for tenants who have become more demanding."[160] These demands
only grew during the Second Empire. Although earnings increased more
than the cost of living, they fell short of the expectations created by residing
in the world's capital of luxury. As one of the neighborhood commission-
ers observed in 1872, "The taste for well-being, the satisfaction of mate-
rial appetites, and the almost universal lack of saving, contributes equally
to keeping workers in a precarious state, despite the rise in salaries."[161] As
a result, a variety of labor sectors became subject to chronic discontent.
As another commissioner put it, "The demands of workers and the resis-
tance of bosses are becoming a source of permanent antagonism."[162] These
demands related as much to personal independence as they did to better
pay. And even if aggregate data showed signs of improvement, a great
many workers led desperate lives of extreme poverty. "It is impossible for
the worker to save money. His life is a long torment; being unable to cheer
himself with any pleasure, he lives without purpose until the awaited day
when out of anger he throws himself into revolutions with the hope of a
better future," commented a neighborhood commissioner, almost fatalis-
tically.[163] Moreover, the Romantic movement in literature and the arts had
put emotional flesh on the political bones of French individualism. The
unprecedented success of Victor Hugo's *Les Misérables* helped to arouse
interest in and concern for the individual fates of even the most marginal
members of society. In short, a variety of forces had converged to increase
individual self-regard and the value of daily life, thereby making poverty
and precarious employment more difficult to bear, and revolutionary action
more tempting.

The Commune had promised more personal freedom and social justice
than most Parisians had known or even expected. And yet only a minority
of the population did anything to support the cause. The catastrophic fail-
ure of the Commune as a revolutionary movement threw its supporters
back on themselves. Their various tragic fates, as revealed in detail by the
press and photography, encouraged others to empathize with them, as well
as to contemplate their own prospects in society. As we have noted, suffer-
ing during *la semaine sanglante* extended well beyond those who labored
for a living to include Parisians from all social strata. And yet, however

emotionally disturbing the events may have been, Parisians were not united by either a common enemy or a common suffering.

There can be no doubt that the events of the Commune produced widespread trauma in the population of Paris. However, the social sources and implications of this emotional suffering have often been oversimplified, largely due to assumptions about social class and collective identity. "The issues were diverse and class did play a part," notes Bertrand Taithe, who then adds, "But it was class in the city, class in the neighborhood, class embedded in the historical discourse of national identity, class as a constitutive element of identity, but *neither the most important nor the most vibrant dimension of the revolutionary self*" (emphasis added).[164] In other words, when it came to commitment to the Commune, social status was relevant but not determinant. Individuals staked their positions as part of intense psychological processes of reflecting on who they were and what they were prepared to sacrifice. Judging by newspapers, personal memoirs, lithographic prints, immediate histories, and even police reports on labor relations, attitudes toward the events of Bloody Week were distinctly individualized and often defied later notions of shared class identities. In the end, most Parisians blamed the leaders of the Commune for fomenting a violent revolution that brought death and destruction to their city, while also deploring the excesses of the repression and empathizing with many of the people targeted by it.

The commonly held image of unrelenting bourgeois hostility to the Communards needs to be tempered by the fact that the regime, generally viewed as the epitome of bourgeois reaction, made an effort to ameliorate the plight of survivors of all social stations. Early in 1872, the neighborhood police commissioners of Paris distributed one hundred thousand francs to alleviate the distress of wives and children of men arrested following the Commune.[165] This financial relief may have been repeated several times, though it seems to have gone unremarked by historians. Furthermore, by July 1872, 2.6 million francs (of the 6 million francs allocated by the National Assembly to indemnify loss of property during the "second siege" of Paris) had been paid out. It is notable that this money was paid on a prorated and socially progressive basis ranging from 100 percent for losses evaluated at less than one hundred francs to 30 percent for losses over one thousand francs.[166] Together these programs showed considerable concern to ameliorate the conditions of a very wide range of Parisians who had suffered from the Commune and its repression, including the families of Communards in prison.

If working-class consciousness was more a product of the Commune than the Commune was a product of working-class consciousness, as

suggested earlier, then it is logical to explore how workers suffered as individuals rather than assuming that they suffered collectively *as workers*. Neighborhood sociability, political associations, and the National Guard Federation underpinned the rhetorical "people of Paris," but that too remained a rather amorphous, even aspirational, social identity, especially considering the extent of immigration into the city and the sharp differences between neighborhoods. Thus, it was not clear at first that the experience of mass violence generated a consensus that clearly identified the victims and helped to redefine their place in the social order, as Jeffrey Alexander's model of a collective trauma requires. Mass trauma there certainly was. However, it was only as a carefully constructed *collective memory of trauma* that socialist leaders were later able to turn the last days of the Commune into the basis for a widely shared class identity and a new, more radical voice in the politics of the Third Republic.

As we have seen, the orgy of executions during Bloody Week, the mass of arrests that followed, and the appalling conditions imposed on prisoners began to shift public opinion toward sympathizing with the thousands of individuals who died in the fighting or were subjected to repressive measures thereafter. Such people became increasingly viewed as the "victims of Versailles." Although regular military courts replaced summary executions in early June 1871, the government recognized the possibility of error and the value of leniency in some cases and so quickly created a Commission on Pardons. Even before the new commission had begun to pronounce pardons, however, a group of opposition deputies tried to capitalize on the growing sympathy for prisoners by proposing a limited amnesty for accused Communards. Over the winter of 1871–72, these deputies narrowed their proposal to anyone who had not been an officer in the National Guard, had not previously been accused or convicted of a crime, and had not committed crimes during the insurrection.

The proposed amnesty and the new Commission on Pardons represented two sharply different approaches to dealing with the aftermath of the Commune. By its nature, an amnesty is more sweeping than a pardon because it wipes the record clean; in essence, an amnesty excuses deeds more than doers. For that reason, an amnesty could only be granted to classified groups, such as those accused of lesser offenses. In contrast, pardons are sought and granted after trial and conviction, as well as on a case-by-case basis. A report to the National Assembly on 16 July 1872 on the proposed amnesty made the majority's position clear, and did so both morally and statistically. On the moral level, even a limited amnesty was unacceptable because there was "no possible excuse" for "the crime of the Commune."

Furthermore, humanity and justice were already being admirably balanced, it was claimed, through the thousands of decisions rendered by the military courts and the Commission on Pardons. Surely this satisfied concerns about treating too harshly "this mass of misled individuals who had remained in the insurgent groups until the final hour more due to necessity and the demands of life than to culpable ideas."[167] This may not have been "tout comprendre, c'est tout pardoner," but it was a measure of understanding widely ignored by historians.

Despite occasional agitation over the next several years, the National Assembly adhered to its position of denying amnesty for the sake of pardons.[168] But pardons could never equal amnesty—"the stigma of conviction remained."[169] Conservatives strongly believed in personal responsibility; therefore, leniency could only be granted to each Communard as an individual.[170] An amnesty would be political forgiveness applied without discrimination, and could well lead to yet another revolution. Thus, political opposition to an amnesty was stronger in 1875 than it had been in 1872. At the same time, supporters of the Commune, whether in foreign exile, the penal colonies of New Caledonia, or recently released from prison, managed to find greater common ground than they had ever shared during the Commune itself. This is not to say that those who supported the Commune did not feel a sense of solidarity and shared suffering with other Communards. However, they did so more because they had shared experiences of repression than because they shared a preexisting social identity.[171] The growing emphasis on common experiences of repression went hand in hand with forging a collective identity on the basis of shared conditions of labor exploitation.

Annual commemorations of Bloody Week helped to turn the thousands of unidentified dead into martyrs in the struggle of the working class to emancipate itself. Whatever they had been in life, whether art student, law clerk, shopgirl, or stevedore, having become nameless corpses during Bloody Week allowed them all to be turned into workers in death. Eventually, shifting dynamics among political opposition groups produced a republican majority that could only be sustained by granting an amnesty to Communards. This was partial in 1879, then total in 1880.[172] Thus, the judicial process and the Commission on Pardons that had so insisted on individuals being held personally responsible for the Commune eventually gave way to an amnesty that treated all Communards as victims of a state apparatus acting in defense of an unjust social and economic order. In short, Communards not only became identified more as victims than as perpetrators, their identity as individuals became less significant than their supposed

shared identity as members of the working class. In this way the emotional suffering experienced by so many Parisians, regardless of their social status, neighborhood, or even presence in Paris at the time, became transformed into a collective trauma with all the elements suggested by Alexander. This transformation also made Bloody Week into a chosen trauma that came to define the French working class well into the twentieth century.

CONCLUSION

The four episodes of mass violence examined in this study offer rich material to explore cultural developments in the history of France from the sixteenth to the nineteenth centuries. Two concepts—collective trauma and the self—have served as the central heuristics for this exploration. Although the French wars of religion, the Fronde, the French Revolution, and the Paris Commune have been the subject of extensive scholarly research, looking at them again through the lenses of collective trauma and the self has generated fresh insights and raised new issues. Some of these belong to the history of emotions, others relate to visual culture, and yet others belong to more traditional fields of social and political history. In short, methodological ecumenism runs throughout this work. Inspiration for this approach came from an abiding interest in both violence and the self, both of which have received increasing attention in recent decades. All the same, few historians have tried explicitly and systematically to put them together for periods prior to the twentieth century. Moreover, sweeping intellectual histories of the self, such as those by Charles Taylor and Jarrold Seigel, do not consider the influence that periods of widespread violence may have had on changing concepts of the self and personal identity.[1] Rather than try to fill that lacuna in intellectual history, this study has sought to understand cultural change. It has done so by examining how visual and textual representations of four major episodes of mass violence generated distinctive collective traumas, which in turn helped to shape new shared identities and contributed to making the self a more significant part of personal identity.

The self is understood here to be a psychological process that maintains a sense of individual continuity, integrity, authenticity, and relative autonomy within a nexus of social relationships. Cultural factors that stimulate this psychological process increase the sense that the core of personal identity is the self. That each self is also characterized by physical embodiment directs attention to the relationship between brain, mind, and consciousness, although just how this works continues largely to elude scientists. The

growing salience of the self in the past several centuries may well be a form of epigenetic adaptation to the increasing complexities of life, a sort of "phantom village" that provides social and cultural homeostasis. However, neurobiologists such as Antonio Damasio will have to make enormous progress before being able to resolve such issues. In the meantime, the historical rise of the self has been clearly demonstrated culturally, especially through the study of "ego-documents." Memoirs and autobiographical writing are vital, of course, but a more deductive approach can also yield results. It certainly has for historians of art. Moreover, it is commonly accepted that personal identity is heavily influenced by real and imagined belonging to larger groups. These range from family, guild, confraternity, village, and neighborhood (all traditional face-to-face communities) to ethnicity, religion, citizenship, and nationality (all of which extend beyond direct interpersonal interaction). Imagining shared identities that extend beyond traditional communities requires individuals to assess themselves in comparison to generally unknown others. This process of imagining a shared identity stimulates a sense of self. Thus, examining how episodes of mass violence helped to constitute shared identities is vital to understanding how the self developed at the same time.

The concept of collective trauma has proven useful in focusing attention on how mass violence affected various types of shared identity. Scholars such as Jeffrey Alexander have taken the concept of individual psychological trauma, as developed from the 1880s to the 1980s, as the basis for an analogous assessment of larger social and cultural responses to violence and subjugation that went beyond merely multiplying individual traumas. (This formulation explains why this study has not sought evidence that individuals experienced psychological trauma in a modern clinical sense.) Collective traumas are understood to be culturally constructed in ways that distinguish victims from perpetrators. The contested process of "working through" a collective trauma, therefore, helps to shape new group identities.

Understanding how specific episodes of mass violence in French history became collective traumas has required paying close attention to textual and visual representations. In addition, tracing the growing sophistication of these representations between the sixteenth and nineteenth centuries has highlighted their increasing effectiveness in communicating the emotional suffering provoked by various incidents of violence. Concern for human suffering is timeless, but knowledge of it is not sufficient to mobilize responses. Moreover, the level of hardship in ordinary life can inure many people to all but the most extreme forms of suffering in others. Unfortunately, such extremes were repeatedly reached during various episodes of

civil conflict in French history. When representations of these extremes proved effective enough to generate empathy, they had an impact on shared identities and stimulated the self. The logic of these influences becomes more apparent through an overview of the four cases that moves from how the different episodes provoked collective traumas and thereby impacted shared identities, to the representations of suffering in each period, and, finally, to the most direct evidence of violence stimulating the psychology of the self.

Collective Traumas and Shared Identities

First, the wave of massacres that began on Saint Bartholomew's Day in 1572 led to a specific collective trauma in the midst of a generation of religious and political strife. This was due both to the large number of abjurations that followed, including in many communities that did not experience massacres themselves. Thus, knowledge of violence elsewhere effectively destroyed many local Huguenot congregations. The massacres of 1572 also constituted a collective trauma for those who remained faithful to the new religion because recently published accounts and depictions of previous massacres enabled the latest ones to be interpreted as part of a trajectory that combined Catholic fanaticism and royal treachery. This new narrative did even more to set Huguenots apart, making them "Others" in their own communities who developed an imagined affective bond with coreligionists elsewhere as part of their survival. The resulting failure to extirpate supposed heresy in France also shocked Catholics into intensifying their religious identities through expiatory processions and the formation of the ultra-Catholic League in the 1580s.

Second, the crisis that struck Paris in the summer of 1652 produced a collective trauma by compelling the commercial elites of the capital, known as the *bons bourgeois*, to overcome internal differences and adopt coordinated responses both to the mass of impoverished refugees in the region and to the prolonged conflict between *frondeurs* and the monarchy. This unified action was stimulated by a publishing and preaching campaign that tapped into new impulses for increased introspection, such as Jansenism, and thereby inspired Parisian elites to see Christian charity in a new light, both personally and socially. The newfound unity fostered a more stratified social hierarchy in Paris, thereby weakening community bonds based on vertical integration. Later episodes of mass violence contained important elements of religion as well, but it was the impact that they had on secular

identities that seemed most significant and, therefore, has been emphasized in the final two cases.

Third, the violence and coercion deployed against opponents of the revolutionary government in 1793–94 became a collective trauma at the national level largely due to the propaganda that followed the defeat of Maximilien Robespierre. The Thermidorians used revelations of atrocities and narratives of tragedies to propagate the idea that despite the regional nature of the earlier violence, everyone in France had suffered psychologically debilitating fear, if not profound loss, during the Reign of Terror. This Thermidorian version of the Jacobin regime as an orgy of blood-letting turned the Terror into a collective trauma that paradoxically helped to give citizens a greater sense of belonging to the French nation as a whole. However, the amnesty of October 1795, adopted in response to a surge of antirepublican violence, ended efforts to distinguish between victims and perpetrators, thereby ensuring that working through the trauma would be pushed well into the next century.

Fourth, the Bloody Week of May 1871 became a collective trauma that helped to create a working-class consciousness, but only some years later, after socialist commemorations led republican politicians to grant a full amnesty to former Communards. Initial responses were rather different, however. During and immediately after the violence, an unprecedented outpouring of texts and images made it possible for all Parisians, most of whom did not participate directly in events, to grasp in remarkable detail the death and destruction wrought upon their city. These representations fueled outrage at the Commune for reviving revolution, executing hostages, and burning buildings; they also prompted widespread horror at the ferocity of the army's repression, especially the summary executions and mass arrests. Most previous scholars have framed these events largely in terms of social class. And yet a closer look at the representations and responses to them suggests a more individualized interaction with events. That said, the army's often indiscriminate killing in the streets, failure to identify the prisoners it summarily executed, and utter disregard for counting dead rebels offered an opportunity for later reinterpretation. The total number killed was easily exaggerated, and all those who were anonymously buried could be considered members of the laboring classes. Such evidence supports the idea that it was a socialist "recollective reconstruction" of Bloody Week as a massive atrocity inflicted by a bourgeois regime on the laborers of Paris, the "Saint-Bartholomew's Day of proletarians,"[2] that proved instrumental to giving them a shared identity as members of the French working class.

REPRESENTATIONS AND EMOTIONS

As the case studies have emphasized, collective traumas develop from textual and visual representations of mass violence, especially when they seek to convey emotional suffering. Descriptions and depictions of violence, often disseminated together, will elicit different responses from different members of the audience depending on their perceived relationship to participants in the violence and their own personal sensibilities. As a result, general reception is challenging to assess. However, many of the representations studied here incorporated techniques that were clearly intended to provoke emotional responses. The effectiveness of the representational strategies in eliciting particular emotional responses depends on striking a chord with prevailing cultural values, and sometimes even improvising new ones. As a general principle, the more emotional responses go beyond pity to empathy and compassion, the more they foster the individual self as part of sharing a collective identity.

Evidence of either the interiorized self or of empathy that extended beyond direct interpersonal relationships can be difficult to identify historically, especially any earlier than the sixteenth century. This is due to the absence of certain kinds of sources, such as autobiographies, personal correspondence, treatises on suffering, etc. The lack of such sources, it must be emphasized, is itself evidence that neither the modern self nor extended empathy was as prominent in France at that time as they became later. Nonetheless, in searching for the role that representations of violence may have played in increasing the salience of the self, this study has revealed fragmentary elements for a cultural history of compassion beyond interpersonal interactions. The rarity of such expressions before the seventeenth century is especially striking. Even the term "victim," with its origins in religious sacrifice, did not appear in the voluminous *Histoire des martyrs* of 1582 although it included a large section on the religious massacres in France from 1562 to 1572. Nor was the term used in the almost thirty *Relations* published during the Fronde, where spiritual and physical suffering were tightly intertwined. By the late eighteenth century, however, the decline of religious ideas of universal culpability before God and the rise of a culture of sensibility combined to make the term "victim" available for almost ubiquitous use during the Thermidorian period. Thereafter, asserting the status of victim may have contrasted increasingly strongly with notions of masculinity, but the term retained a prominent place in the lexicon of suffering.

Portraying individuals as victims is intended to evoke pity for their plight and animus for their persecutors. Even without using the term "victim,"

Protestant representations of persecution during the wars of religion clearly sought to stimulate responses that went beyond hostility and horror. Common expressions, such as "the pity and compassion" of "the good God" (Pithou; see chapter 1) as well as efforts by Protestant chroniclers to evoke emotional responses that included lamenting the suffering of fellow believers, suggest that fellow feeling could be generated beyond interpersonal relationships developed in local communities. Some of the prints in the series *Wars, Massacres, and Troubles* (1569–70), notably the depiction of the massacre at Vassy, deliberately included powerful emotional content that is best explained as an effort on the part of Jacques Tortorel and Jean Perrissin to evoke "pity and compassion," especially among fellow Huguenots. The absence of such elements in their depictions of the massacre of Catholic leaders at Nîmes strengthens the sense of developing a pictorial strategy that would bring Huguenots together through affective as well as narrative elements. This underscores the originality of the series, as well as its potential impact on Huguenots in the wake of the Saint Bartholomew's Day massacres.

Although the Fronde followed Jacques Callot's series of etchings *The Miseries and Misfortunes of War* by fifteen years, it generated very few images of violence and none that sought explicitly to depict suffering. This lacuna was largely filled by an unprecedented mass of pamphlets. Many of these *mazarinades* contained descriptions of violence, robbery, pillage, and murder, usually perpetrated by marauding troops, sometimes by urban rioters. The *Relations* went further. This series of pamphlets included graphic descriptions in the form of eyewitness accounts of extreme violence. Charles Maignard de Bernières developed this novel approach expressly to inspire elite urban readers to contribute to alleviating the suffering—material and spiritual—of peasants devastated by the civil war. Thus, the *Relations* constituted an original, printed form of "compassionate witnessing." Antoine Le Maistre's contemporary commentary described these pamphlets as "vivid and eloquent paintings depicting the truth." He also made it clear that they had proven highly effective: the *Relations* "had moved those who had appeared insensitive [and] warmed those who had seemed colder than marble" (see chapter 2). As a result, the Fronde inspired an innovation that has long been neglected: the prevailing sentiment of pity toward the abject poor gave way, for a time at least, to a more positive expression of charity that closely resembles Christian humanitarianism.

France was inundated by representations of revolutionary violence in the year *after* the defeat of Robespierre. The Thermidorians' version of overcoming a "reign of terror" left the sentimentalist idiom worn out and

full of holes. Like most politicians and publicists at the time, the Jacobins had made great use of pathos, especially in decrying the fate of various rioters and mutineers. Once they gained power, however, Jacobins needed to suppress the natural feelings of compassion that *hommes sensibles* may have had for individuals about to be executed. Civic virtue required an abstract empathy for all of humanity, which in practice meant a ruthless stoicism in the face of opposition. However, the Thermidorians' subsequent dismantling of the Jacobin regime included greatly exploiting the sentimentalist idiom in its original form. Press reports on atrocities in the Vendée and elsewhere, published narratives of former prisoners, speeches in the Convention on behalf of victims of the Terror such as that by François-Antoine de Boissy d'Anglas in March 1795, printed denunciations of "terrorists," and wood-block prints depicting endless executions, barbarous drownings, and insatiable "drinkers of blood" were all saturated with the highly emotional rhetoric of sensibility and pathos. Apparently never before had weeping been so popular, in print and in practice. As the political pendulum swung to the right, Jacobins found themselves discredited and personally attacked. They responded by turning to the rhetoric of sentimentalism to establish their new identities as victims, rather than perpetrators. Thus, by the summer of 1795, all manner of individuals had donned the well-worn sweater of sentimentalist rhetoric, leaving it baggy and threadbare. Thus, the emergence of a new "emotional regime" (Reddy; see chapter 3) began not after Thermidor, but after the Thermidorian Convention. The amnesty of October 1795 clearly demonstrated the declining power of pathos to impact politics.

In the nineteenth century, numerous artists, philosophers, theorists, and activists combined to nurture the idealistic possibility of extending empathy (although they used the term "sympathy") to all of humanity. An amalgamation of Christian morality and human rights inspired pity and compassion for victims of oppression, such as enslaved Africans or subjugated Greeks. Victor Hugo's *Les Misérables* (1862) helped to extend these sentiments to the laboring poor, thereby making it easier to shift public attitudes from *classes dangereuses* to *classes malheureuses*. By the time of the Paris Commune, western Europe had entered the modern age of international humanitarianism. The International Committee of the Red Cross was founded in 1863 to aid soldiers in the Crimean War regardless of nationality, and the siege of Strasbourg in the autumn of 1870 inspired "the first example of wartime international humanitarian aid on behalf of civilians" in history.[3] (Not surprisingly, compassion and Protestant fellow feeling inspired the Swiss relief effort.) This is an essential context for assessing representations of Bloody Week.

The most remarkable aspect of these textual and visual representations is their detailed and graphic realism, which greatly enhanced their ability to evoke emotional responses. Relatively new media, such as illustrated newspapers, mass-produced lithographs, and collodion-style photographs, combined with an outpouring of published diaries and popular histories to convey with unprecedented speed and accuracy the violence and suffering inflicted on so many Parisians. Contemporary artists may have been reluctant to depict the events of the Commune, thereby leaving it under-studied in artistic terms, but there was certainly no shortage of images produced by other media. The extent to which contemporary images contain indications of sympathy and pity toward the Communards has been largely neglected in favor of more polemical interpretations. For example, historians are much more familiar with lithographic caricatures of *pétroleuses* as wild-eyed furies than they are with contemporary newspaper images of distraught women being summarily shot, or depictions of women, disheveled yet proud, being marched through the streets or huddled in prison compounds. Likewise, the expressions of pity and compassion for ordinary Communards published by observers who were otherwise overtly hostile to the Commune, such as those of Malevina Blanchecotte and Catulle Mendès, belie stereotypes of bourgeois hostility. In fact, the emotional responses in support of perceived victims generated a swift and widespread public backlash against the repression. Newspaper articles about the "slums of Paris" as well as government aid for Communards' families soon followed.

It should be apparent by now that profound changes over three centuries in the types of media that were used to represent incidents of mass violence, which included the growing sophistication of text as well as images, made it increasingly possible to extend empathy beyond immediate personal interactions. As noted earlier, feeling empathy for distant others is a key stimulant of the self, but it is only one of many stimulants that acted over the sixteenth to nineteenth centuries in France. It would be impossible to disentangle these different elements; it is better simply to note where communicating experiences of violence to others evidently affected them psychologically.

EVIDENCE OF THE SELF

Scholars ranging from Marcel Mauss to Charles Taylor have noted Protestant theology as a powerful stimulate of the self. However, they have overlooked the role that sectarian conflict unleashed by the Reformation also played in provoking greater self-reflection. A general atmosphere of

persecution combined with knowledge of various massacres perpetrated around the kingdom to create a crisis of conscience for individual Huguenots throughout France. The rare memoir of Nicolas Pithou provides a good example of this inner struggle. Such tensions reached their peak in 1572. Members of reformed churches who refused to abjure were forced to live as persecuted "Others" in their own communities. The subterfuge of Nicodemism offered a third alternative. However, such duplicity required greater psychological efforts at self-fashioning, especially because it was condemned by Calvinist leaders as the antithesis of martyrdom. Simply pretending briefly to be a Catholic, or adopting a disguise in the midst of a massacre, led to feelings of shame and self-justification, as personal letters indicate.

The interiorization of piety associated with Calvinism also became integral to baroque Catholicism, especially during the middle decades of the seventeenth century. The proliferation of lay confraternities, the teachings of François de Sales on lay piety, and new expectations of intensive soul searching before taking Communion were all important to preparing Parisian elites for their own individual crises of conscience during the Fronde. So too did the sudden escalation of violence in Paris in July 1652, which came only shortly after the massive collective effort to invoke divine intervention by processing the relics of Sainte Geneviève through the city. These events set the stage for Robert Arnauld d'Andilly's hugely successful pamphlet in which he invoked in detail his own emotional anguish at the suffering inflicted by the civil war, as well as the need to set his conscience right. His closing supplication to have God withhold just punishment and instead "ease our pain" and "dry our tears" (see chapter 2) made his religious and political program the fruit of intensifying his own self-reflection and inspiring others to do the same. He clearly believed that performing actions that inherently fostered the self would be successful where collective supplication had failed.

The relationship between mass violence and the individual conscience proved equally important even after religion came under direct assault during the French Revolution. The effort to establish a new social and political order based on the secular ideals of liberty, equality, and fraternity provided an impetus for individualism that would be hard to overstate, as delayed as many of the consequences may have been. What is generally missing from the massive literature on these matters is the influence of violence in also stimulating a more pronounced sense of self. Of course, in basic terms, revolutionary violence was part and parcel of achieving the many social changes that compelled individuals to reimagine their standing in society.

Monarchical subjects became republican citizens, peasants escaped seigneur-ial subjugation, nobles lost their titles, religious (cloistered and not) lost their vocations, wives divorced and remarried, etc. Supporting or opposing such changes often became a matter of life or death. Although the stakes became highest during the Jacobin regime of 1793–94, detailed narratives of one's actions and experiences during the revolution reached their peak the follow-ing year. On one hand, prison diaries and memoirs, though not unprece-dented, became so popular that they seemed to constitute a new literary genre. These first-person revelations described physical deprivation and emotional torment in the strongest language. On the other hand, it was also during the Thermidorian Convention that autodefenses most proliferated. Whether these were published or simply submitted in manuscript to public authorities, *mémoires justificatifs* contained the essential elements of autobi-ography. More even than obtaining a certificate of civic conduct, an autode-fense established a personal identity. This was done through self-description, including moral assessments, combined with attestations from fellow cit-izens. Because these autodefenses were so frequently inspired by either denunciations or victimization, they also deployed detailed statements about emotional states of mind, personal sacrifices, and moral principles. Putting all of this into writing constituted a significant process of balancing interiority with a public persona, in other words, of actively constituting the self.

By the time of the Commune, individualism had become a well-defined concept, albeit one widely deemed threatening to the social order. Rapid increases in literacy, physical and social mobility, urbanization, capitalism, and consumerism all eroded traditional communities and promoted indi-vidualism. At the same time, an unprecedented surge in personal memoirs and autobiographies, especially after the 1820s, overlapped with novelists' efforts to explore the psychological processes of their characters in ever more penetrating and realistic ways. These social and cultural trends pro-vided the basis for remarkably intimate reflections on the cataclysmic events of Bloody Week. The publication of highly personal accounts, whether structured as daily diaries, private letters, or eyewitness chroni-cles, revealed in a rich and vibrant vocabulary the various and sometimes conflicting emotional and psychological responses to the violence. Early histories, too, presented psychological explanations for the violence, seen as a regression to barbarism at the heart of civilization. One reporter apol-ogized to his readers for not being able to write a proper story because he had been "deranged by suffering" when seeing how prisoners were being treated. "I feel myself dying," wrote another when contemplating the loss

of memories that so much devastation had brought him (see chapter 4). The self-revelation that so many of these accounts entailed made vicarious experiences of death and destruction easier than ever before. In fact, the modern self had become a palpable part of the story.

Furthermore, emphasizing the dignity of ordinary individuals, and, therefore, the value of every individual life, gave death that occurred during Bloody Week particular significance for the burgeoning self. The Commune's efforts to honor with a public funeral every *fédéré* killed in combat led to incessant funerary processions winding from the center of Paris to Père Lachaise cemetery. The difficulty of identifying the corpses of *fédérés* led to the creation of multiple viewing morgues around the city, as well as an entirely original system of taking playing-card-sized photographs of each unidentified body. The sheer scale of the killing during Bloody Week eventually overwhelmed all of these practices. Nonetheless, they left painfully gruesome images for survivors to contemplate. Illustrated newspapers contained several images of corpses with individualized faces frozen in distorted grimaces of excruciating pain. Less emotionally expressive, but even more disturbingly personal, were the small photographs of bullet-riddled corpses shown to Parisians in search of missing loved ones. The Versaillais also commissioned photographs in *carte de visite* format of hundreds of captured Communards. Scholars have emphasized the importance of ordinary photographic portraits in constructing a new "social consciousness of self" (Phéline; see chapter 4). Photographs of Communards taken dead or alive were the first individualized portraits of ordinary, laboring Parisians and, thus, had a profound effect on the subjects' sense of self. Those who came to possess photographs of dead relatives would also have been deeply impacted. Thirty years later, after photography had become relatively commonplace, General Jules Bourelly still remembered the effects of seeing the photographs of individual female Communards dead and mutilated. Such photographs seemed to preserve a living self in a dead body.[4]

Furthermore, the unprecedented realism of the textual and visual representations of Bloody Week contributed greatly to shaping personal memories of the experience, and hence the self. This is especially the case with those representations that embodied highly personal elements. At any particular moment, the individualized self is the interiorized telos of a narrative of personal experiences and the influence they have had on one's identity. To be presented with extensive evidence of how others experienced and responded to specific events inevitably colors one's own memory and response, whether shared or contrasted. Intense, extraordinary, and disorienting experiences, ones for which life has offered little precedent or

preparation, such as incidents of mass violence, are naturally difficult to absorb psychologically. It is not surprising, therefore, to learn that imprisoned Communards, "frighteningly tough chaps," "were crying buckets" after hearing Victor Hugo's series of poems *L'Année terrible* describing what most of them "saw and suffered" (Rochefort; see chapter 4). It is also significant that a family who had survived the Commune would assemble various media representations of the tragedy, including photographs and newspaper clippings, and present it as a token of appreciation, as well as an expression of suffering and shame, to their friends and temporary benefactors. Whether words or pictures, whether heard or seen, whether given or received, these representations of the violence of Bloody Week reveal personal concerns and coping strategies on which the modern self battens.

The contrast between the dawning of an age of international humanitarianism and yet another mass slaughter of Frenchmen by fellow Frenchmen underscores an important general point that could be easily missed given the trajectory explored in this study. Medieval ideas about the soul greatly differ from modern notions of the self. This reflects dramatic changes in how personal identity has been understood and constituted over the intervening centuries. However, the increasing salience of the self as a psychological process and the perceived core of every person has not, by all historical evidence, increased moral character or emotional stability. The evidence explored in this study suggests that increasingly effective means to communicate human suffering beyond direct interpersonal exchanges interacted with a complex array of social and cultural forces to strengthen the significance of the self. A key aspect of this process was extending the range of empathy and fellow feeling to persons who were both distant from and different from the audience for such communications. This should not be taken to mean, however, that the emergence of the self or the possibility of eliciting empathy at a distance reflected a growing ascendancy of kindness over cruelty, or even decency over dastardy. Moreover, the self may have emerged over time as a psychological process that enables individuals to secure "sociocultural homeostasis" (Damasio; see introduction), but its development may also reflect an increase in psychological vulnerability and susceptibility to emotional suffering when exposed to violence, either directly or through media representations. Such issues lie beyond the scope of this study, however. Better that it be taken as a provocation to find better ways to explore historically and empathetically the relationship between violence and the self.

NOTES

Introduction

1. Jan Plamper, *The History of Emotions: An Introduction*, trans. Keith Tribe (Oxford: Oxford University Press, 2015).

2. Debora Shuger, "The 'I' of the Beholder: Renaissance Mirrors and the Reflexive Mind," in *Renaissance Culture and the Everyday*, ed. Patricia Fulmerton and Simon Hunt (Philadelphia: University of Pennsylvania Press, 1999), 21–41, examines the role of mirrors as "a paradigm for reflexive self-consciousness" (31) during the Renaissance and concludes that such thinking was unimportant to the sixteenth-century self.

3. Susan Sontag, *Regarding the Pain of Others* (New York: Picador, 2003), explores these issues in the context of the rise of war photography and a modern society saturated with images, but includes Callot and Goya without considering historical differences in audiences.

4. David Freedberg and Vittorio Gallese, "Motion, Emotion and Empathy in Aesthetic Experience," *Trends in Cognitive Sciences* 11 (2007): 197–203, also acknowledges the influence of specific cultural and historical contexts.

5. Lynn Hunt, *Inventing Human Rights: A History* (New York: W. W. Norton, 2007), 39.

6. The relationship between psychic trauma as a clinical diagnosis and the burgeoning self in the twentieth century would seem intuitively obvious. However, Anthony Giddens's seminal work, *Modernity and Self-Identity: Self and Society in the Late Modern Age* (Stanford, Calif.: Stanford University Press, 1991), on how the conditions of "late modernity" generated an enhanced reflexivity of the self has chapters on "ontological security and existential anxiety," "fate, risk, and security," and "tribulations of the self," but never discusses psychic trauma, which indicates just how recent cultural studies of trauma actually are.

7. Jürgen Straub, "Personal and Collective Identity: A Conceptual Analysis," in *Identities: Time, Difference, and Boundaries*, ed. Heidrun Friese (New York: Berghahn, 2002), 56–76.

8. Marcel Mauss, "The Category of the Human Mind: The Notion of Person; the Notion of Self," trans. by W. D. Halls, in *The Category of the Person: Anthropology, Philosophy, History*, ed. Michael Carrithers, Steven Collins, and Steven Lukes (Cambridge: Cambridge University Press, 1985), 1–25, quotations from 3 and 20.

9. Michael Mascuch, "The 'Mirror' of the Other: Self-Reflexivity and Self-Identity in Early Modern Religious Biography," in *Von der dargestellten Person zum erinnerten Ich: Europäische Selbstzeugnisse als historische Quellen (1500–1850)*, ed.

Kaspar von Greyerz, Hans Medick, and Patrice Veit (Cologne: Böhlau, 2001), 55–75, underscores the importance of the authorial self as a modern phenomenon. He states that "before 1700, if not later, the autonomous authorial 'I' of modern auto-biography is not just an anomaly, it is an anachronism, a projection of a modern figure or meaning rooted in a context of writing, onto a few odd examples of script in the past" (56–57), and later adds that "the notion of the authentic self is both a cause and an effect of a new concept of subjective interiority or 'inwardness' in the modern period" (59).

10. Charles Taylor, *Sources of the Self: The Making of the Modern Identity* (Cambridge: Cambridge University Press, 1989).

11. Cf. Jerrold Seigel, *The Idea of the Self: Thought and Experience in Western Europe since the Seventeenth Century* (Cambridge: Cambridge University Press, 2005); Aaron Garrett, Peter E. Gordon, Judith Surkis, Anthony J. La Vopa, and Jerrold Seigel, "Forum: *The Idea of the Self*," *Modern Intellectual History* 3 (2006): 299–344.

12. Giddens, *Modernity and Self-Identity*, 74–80, provides a ten-point description of how late twentieth-century psychotherapists viewed the self. An actual psycho-therapist, Jerome David Levin, provides an even more sophisticated, though not contradictory, assessment in *Theories of the Self* (Washington, D.C.: Taylor & Francis, 1992). Levin combines an acknowledgment that "the self, as well as the under-standing of the self, has changed across time, and is probably still changing" (204) with a catalog of essential experiential elements of the self (208–9) to be under-stood, analyzed, and treated.

13. Roy Porter, ed., *Rewriting the Self: Histories from the Renaissance to the Present* (London: Routledge, 1997), 11.

14. Lynn Hunt, "The Self and Its History," *American Historical Review* 119 (2014): 1576–86.

15. For an astute introduction, see John R. Searle, "The Mystery of Consciousness Continues," *New York Review of Books*, 9 June 2011, reviewing Antonio Damasio, *Self Comes to Mind: Constructing the Conscious Brain* (New York: Pantheon, 2010). Searle does not share Damasio's proposed relationship between consciousness and ontological subjectivity, concluding that "our sense of self is a product of a certain sort of consciousness, not conversely." An earlier work, Antonio Damasio, *Looking for Spinoza: Joy, Sorrow, and the Feeling Brain* (Orlando, Fla.: Harcourt, 2003), 184, describes consciousness as "the process whereby a mind is imbued with a reference we call self, and is said to know of its own existence."

16. "Introduction to the *AHR* Roundtable: History Meets Biology," *American Historical Review* 119 (2014): 1497. See also Daniel Lord Smail, *On Deep History and the Brain* (Berkeley: University of California Press, 2008), esp. 143–44.

17. Ronald Melzack, "Phantom Limbs, the Self, and the Brain (The D.O. Hebb Memorial Lecture)," *Canadian Psychology/Psychologie canadienne* 30 (1989): 1–16; Bishnu Subedi and George T. Grossberg, "Phantom Limb Pain: Mechanisms and Treatment Approaches," *Pain Research and Treatment*, 2011, Article ID 864605, https://doi.org/10.1155/2011/864605.

18. Johanna Louise Folland, "Phantom Villages: Culture, Cognition, and Affect in the Construction of Modern Selfhood" (master's thesis, Binghamton University, State University of New York, 2011) first proposed the idea of the modern self as a "phantom village." Although Folland does not develop the concept in terms

of epigenetic adaptation, she does suggest that neuroscience may be able to offer important insights into how "social-cognitive faculties of the brain" work to achieve a sense of "authenticity" through reconfigured neural responses that compensate for the loss of "embeddedness" that is typical of traditional societies (29).

19. David Warren Sabean, "Production of the Self during the Age of Confessionalism," *Central European History* 29 (1996): 1–18, quote from 17.

20. John Jeffries Martin, *Myths of the Renaissance Individualism* (Basingstoke: Palgrave Macmillan, 2004), esp. 7–20, 130–33, persuasively argues that both Jacob Burkhardt's modernist concept of the "autonomous, individualist self" and Stephen Greenblatt's postmodernist idea of "self-fashioning" are both anachronistic myths that do not fit the social realities of the period because "the culture of the Renaissance never fostered a sense of a clearly bounded self" (13). Interiority certainly existed, but it was not constantly stimulated by issues of personal sincerity or authenticity. In contrast, Moshe Sluhovsky, "Discernment of Difference, the Introspective Subject, and the Birth of Modernity," *Journal of Medieval and Early Modern Studies* 36 (2006): 169–200, offers a suggestive but polemical attack on the contrast between medieval and modern subjectivity and identity. Nicole Eustace, *Passion Is the Gale: Emotion, Power and the Coming of the American Revolution* (Chapel Hill: University of North Carolina Press, 2008) and Lisa Forman Cody, "Sex, Civility, and the Self," *French Historical Studies* 24 (2001): 379–407, emphasize the transitional nature of the eighteenth century.

21. David Warren Sabean, *Power in the Blood: Popular Culture and Village Discourse in Early Modern Germany* (Cambridge: Cambridge University Press, 1994), esp. 30–33, 201–5. Moreover, Sabean notes that "there was as yet no notion of the person as a single, integrated center of awareness. Indeed, one observer noted that villagers 'did not know how to remember'" (35).

22. Levin, *Theories of the Self*, 204, uses the terms the "we-self," which is primarily constituted by others, and the "me-self," which is primarily constituted alone, but considers them two sides of the same coin. This phrasing improves on the common contrast drawn between an interiorized (authentic) self and a (nonauthentic) public persona.

23. Damasio, *Self Comes to Mind*, 26.

24. Damasio, *Self Comes to Mind*, 27 (see also 294).

25. Some human emotions are essentially primordial and determined by the genome, whereas others are socially constituted and reflect more recent evolutionary adaptation. Thus, "social emotions" such as compassion reflect moral principles and underpin ethical systems. Therefore, in order to achieve sociocultural homeostasis, for example, "compassion has to be rewarded if it is to be emulated." Damasio, *Self Comes to Mind*, 126–29.

26. Georges May, *L'autobiographie* (Paris: Presses Universitaires de France, 1979), 18–19. On the development of first-person prose narratives before modern autobiography, see Nicholas D. Paige, *Being Interior: Autobiography and the Contradictions of Modernity in Seventeenth-Century France* (Philadelphia: University of Pennsylvania Press, 2001) and Michael Mascuch, *Origins of the Individualist Self: Autobiography and Self-Identity in England, 1591–1791* (Stanford, Calif.: Stanford University Press, 1996).

27. Carolyn Chappell Lougee, "Emigration and Memory: After 1685 and after 1789," in *Egodocuments and History: Autobiographical Writing in Its Social Context*

since the Middle Ages, ed. Rudolf Dekker (Hilversum, Netherlands: Verloren, 2002), 89–106, esp. 102.

28. Angelica Goodden, *The Backward Look: Memory and the Writing Self in France, 1580–1920* (Oxford: Oxford University Press, 2000).

29. Levin, *Theories of the Self*, 205.

30. E.g., Barbara Donagan, "Atrocity, War Crime, and Treason in the English Civil War," *American Historical Review* 99 (1994): 1137–66; Mark Levene and Penny Roberts, eds., *The Massacre in History* (New York: Berghahn, 1999); David El Kenz, ed., *Le massacre, objet d'histoire* (Paris: Gallimard, 2005).

31. Didier Fassin and Richard Rechtman, *The Empire of Trauma: An Inquiry into the Condition of Victimhood*, trans. Rachel Gomme (Princeton, N.J.: Princeton University Press, 2007), critically examines the moral and political implications of reflexively fusing victimization and traumatization.

32. Wolfgang Schäffner, "Event, Series, Trauma: The Probabilistic Revolution of the Mind in the Late Nineteenth and Early Twentieth Centuries," and Mark S. Micale, "Jean-Martin Charcot and *les névroses traumatiques*: From Medicine to Culture in French Trauma Theory of the Late Nineteenth Century," in *Traumatic Pasts: History, Psychiatry, and Trauma in the Modern Age, 1870–1930*, ed. Mark S. Micale and Paul Lerner (Cambridge: Cambridge University Press, 2001), 81–91, 115–39, respectively; Roger Luckhurst, *The Trauma Question* (London: Routledge, 2008), 34–49.

33. In the late nineteenth century, "the emphasis began to fall on the shattering of the personality consequent on a situation of extreme terror or fright. The traumatized psyche was conceptualized as an apparatus for registering the blows to the psyche outside the domain of ordinary awareness." Ruth Leys, *Trauma: A Genealogy* (Chicago: University of Chicago Press, 2000), 4. Dominick LaCapra, *Writing History, Writing Trauma* (Baltimore: Johns Hopkins University Press, 2001), 41, provides a contemporary definition in commonsense terms: "Trauma is a disruptive experience that disarticulates the self and creates holes in existence; it has belated effects that are controlled only with difficulty and perhaps never fully mastered."

34. Jeffrey C. Alexander, Ron Eyerman, Bernhard Giesen, Neil J. Smelser, and Piotr Sztompka, *Cultural Trauma and Collective Identity* (Chicago: Chicago University Press, 2004), 22. Whereas these authors generally use the phrase "cultural trauma" or "socio-cultural trauma," in several places they also use the phrase "collective trauma" without any discernible difference in meaning (notably Alexander on 27 and Smelser on 41–44). Moreover, their "cultural trauma" makes a "culture" synonymous with a "nation" or a "society." In contrast, "collective trauma" is used here in order to be more specific about the collective identities that were shaped in response to episodes of mass violence.

35. Neil J. Smelser, "Psychological Trauma and Cultural Trauma," in Alexander et al., *Cultural Trauma and Collective Identity*, 48.

36. Twentieth-century armies generally sent healthier and better-fed soldiers into battle. This reduced the importance of basic physical factors and thereby highlighted the destructive effects of warfare on the mind (David Gerber, ed., *Disabled Veterans in History* [Ann Arbor: University of Michigan Press, 2012], 3). Moreover, increasing attention to the psychological consequences of battlefield violence has undoubtedly altered how subsequent soldiers actually experienced warfare. In

short, knowing about professional diagnoses has clearly provided soldiers with ways to frame and explain their suffering.

37. Chris R. Brewin, *Posttraumatic Stress Disorder: Malady or Myth* (New Haven, Conn.: Yale University Press, 2003) covers the possibility that psychiatry invented the disorder but does not discuss the extent to which it may have arisen with changes in how individuals understood and experienced the self.

38. Andrew P. Levin, Stuart B. Kleinman, and John S. Adler, "DSM-5 and Post-traumatic Stress Disorder," *Journal of the American Academy of Psychiatry and the Law* 42 (2014): 146–58; Chris Tennant, "Psychological Trauma: Psychiatry and the Law in Conflict," *Australian and New Zealand Journal of Psychiatry* 38 (2004): 344–47; Daniel Brown, Alan W. Scheflin, and D. Corydon Hammond, *Memory, Trauma Treatment, and the Law* (New York: W. W. Norton, 1998); Smelser, "Psychological Trauma and Cultural Trauma," 31–59; Fassin and Rechtman, *Empire of Trauma*, 24–97.

39. Cathy Caruth, *Unclaimed Experience: Trauma, Narrative and History* (Baltimore: Johns Hopkins University Press, 1996) and *Listening to Trauma: Conversations with Leaders in the Theory and Treatment of Catastrophic Experience* (Baltimore: Johns Hopkins University Press, 2014). Luckhurst, *Trauma Question*, surveys the multiple vectors of contemporary thinking about trauma, including Holocaust survival, poststructuralist literary theory, identity politics, activist psychiatry, and popular media.

40. E.g., Omer Bartov, *Mirrors of Destruction: War, Genocide, and Modern Identity* (New York: Oxford University Press, 2000); Wulf Kansteiner "Genealogy of a Category Mistake: A Critical Intellectual History of the Cultural Trauma Metaphor," *Rethinking History: The Journal of Theory and Practice* 8 (2004): 193–221.

41. Micale and Lerner, *Traumatic Pasts*, 20–21.

42. Joan W. Scott, "The Evidence of Experience," *Critical Inquiry* 17 (1991): 773–97, quote on 797.

43. See Luc Boltanski, *Distant Suffering: Morality, Media and Politics*, trans. Graham Burchell (Cambridge: Cambridge University Press, 1999), 32.

44. The highly influential *Diagnostic and Statistical Manual of Mental Disorders*, 5th ed. (Arlington, Va.: American Psychiatric Publishers, 2013), known as *DSM-5*, while expanding and specifying the types of exposure to traumatic events that qualify for a diagnosis of PTSD, also explicitly rejects indirect exposure to horrific events "via electronic media, television, movies or pictures" as a potential source of PTSD. This does not eliminate the possible impact that such representations may have in inducing other, lesser forms of trauma. See Levin, Kleinman, and Adler, "DSM-5 and Posttraumatic Stress Disorder," esp. 147.

45. The editors' introduction to Antonius C. G. M. Robben and Marcelo M. Suárez-Orozco, eds., *Cultures under Siege: Collective Violence and Trauma* (Cambridge, Mass.: Harvard University Press, 2000), which uses the term "massive trauma" rather than "collective trauma" or "cultural trauma," as used by others.

46. LaCapra, *Writing History, Writing Trauma*, 21, distinguishes between presuming to confuse (or collapse) "self and other"—which would appear to be an entirely postmodern ethics—and empathy, which preserves ethical distance. However, Samuel Moyn, "Empathy in History, Empathizing with Humanity," *History and Theory* 45 (2006): 397–415, turns contemporary skepticism about the moral system created by the Enlightenment against the efforts of Dominick LaCapra, as well as those of

Carol J. Dean, to instruct historians on how best to incorporate empathy into the writing of history, especially about the Holocaust. Such efforts, suggests Moyn, are fraught with uncertainty about the implications of insisting that scholars produce empathic, rather than merely analytic, responses to historical sources and evidence.

47. Eric Schliesser, *Sympathy: A History* (Oxford: Oxford University Press, 2015), 312.

48. For example, Lauren Wispé, *Psychology of Sympathy* (New York: Plenum, 1991), which owes major debts to Schopenhauer and Thomas Nagel. However, her claim that sympathy, rather than empathy, leads to compassion does not accord with the distinctions being made here.

49. Katherine Ibbett, *Compassion's Edge: Fellow-Feeling and Its Limits in Early Modern France* (Philadelphia: University of Pennsylvania Press, 2018), 8.

50. Lou Agosta, "Empathy and Sympathy in Ethics," in *Internet Encyclopedia of Philosophy: A Peer-Reviewed Academic Resource*, ed. James Fieser and Bradley Dowden, http://www.ieup.edu/emp-symp/, and Lauren Wispé, "Sympathy and Empathy," in *International Encyclopedia of the Social Sciences*, ed. D. L. Sills (New York: Macmillan, 1968), 15:441–47, discuss attempts to differentiate these concepts.

51. Wispé, *Psychology of Sympathy*, 79. What immediately follows on p. 80, however, does not conform to the relationship between self and empathy developed here. More helpful is Jean Decety and Claus Lamm, "Human Empathy through the Lens of Social Neuroscience," *Scientific World Journal* 6 (2006): 1146–63.

52. Norman S. Fiering, "Irresistible Compassion: An Aspect of Eighteenth-Century Sympathy and Humanitarianism," *Journal of the History of Ideas* 37 (1976): 195–218, quotes from 204–5.

53. To be clear, however, human rights and humanitarianism diverge considerably in origin and emphasis. Adam J. Davis and Bertrand Taithe, "From the Purse and the Heart: Exploring Charity, Humanitarianism, and Human Rights in France," *French Historical Studies* 34 (2011): 413–32. See also Rachel Chrastil, *The Siege of Strasbourg* (Cambridge, Mass.: Harvard University Press, 2014).

54. Moyn, "Empathy in History," summarizes how sympathy became "the conquering moral notion of the eighteenth-century world" (399) and now stands as a basis for modern ethics.

55. Michael Barnett, *Empire of Humanity: A History of Humanitarianism* (Ithaca, N.Y.: Cornell University Press, 2011), 26.

56. Quoted in Catherine Glazer, "De la Commune comme maladie mentale," *Romantisme* 48 (1985): 67.

57. Micale, "Jean-Martin Charcot and *les névroses traumatiques*," 138.

58. Roger Gould, *Insurgent Identities: Class, Community, and Protest in Paris from 1848 to the Commune* (Chicago: University of Chicago Press, 1995).

59. Robert Gildea, *The Past in French History* (New Haven, Conn.: Yale University Press, 1996), 44–45.

1. Massacres in the French Wars of Religion

1. "The Massacre was a major trauma for all French people, Protestant and Catholic," states Arlette Jouanna, *The St Bartholomew's Day Massacre: The Mysteries of a Crime of State (24 August 1572)*, trans. Joseph Bergin (Manchester: Manchester

University Press, 2013), 181. However, Jouanna analyzes the religious explanations used by Protestants to minimize the impact on themselves, but largely ignores Catholic religious responses.

2. The historical consensus on this matter is well expressed in the introduction to Arlette Jouanna, Jacqueline Boucher, Dominique Bilochi, and Guy Le Thiec, *Histoire et dictionnaire des guerres de religion* (Paris: Robert Lafont, 1998), esp. 32.

3. Charles Taylor, *Sources of the Self: The Making of the Modern Identity* (Cambridge: Cambridge University Press, 1989), 217.

4. On social motives and mechanisms for becoming a Huguenot, see especially Geoffrey Treasure, *The Huguenots* (New Haven, Conn.: Yale University Press, 2013), 107–21, and Timothy Watson, "Preaching, Printing, Psalm-Singing: The Making and Unmaking of the Reformed Church at Lyon," in *Society and Culture in the Huguenot World, 1559–1685*, ed. Raymond A. Mentzer and Andrew Spicer (Cambridge: Cambridge University Press), 10–28. Alan A. Tulchin, *That Men Would Praise the Lord: The Triumph of Protestantism in Nimes, 1530–1570* (Oxford: Oxford University Press, 2010), offers a full range of explanations in which religious conversion was collective as well as individual, created "cognitive dissonance" and introspection, and had implications for political and professional success.

5. Mack P. Holt, *The French Wars of Religion, 1562–1629*, 2nd ed. (Cambridge: Cambridge University Press, 2005), 30.

6. Jürgen Straub, "Personal and Collective Identity: A Conceptual Analysis," in *Identities: Time, Difference, and Boundaries*, ed. Heidrun Friese (New York: Berghahn, 2002), 56–76. Barbara Diefendorf, "Rites of Repair: Restoring Community in the French Religious Wars," *Past & Present*, no. 214, suppl. 7 (2012): 30–51, notes the importance of community, but stretches the term to cover the entire kingdom, which differs from creating shared or collective identities across distinct communities.

7. Luc Boltanski, *Distant Suffering: Morality, Media and Politics*, trans. Graham Burchell (Cambridge: Cambridge University Press, 1999), 6–7, points to the "commerce of prayers" that gave social meaning to the theological concept of belonging to the mystical body of Christ.

8. Thierry Wanegffelen, *Ni Rome ni Genève: Des fidèles entre deux chaires en France au XVIᵉ siècle* (Paris: Honoré Champion, 1997), xvi–xvii. His chapter, "La difficile identité des protestants français entre Réforme et Révocation," in *Identités, appartenances, revendications identitaires (XVIᵉ–XVIIIᵉ siècles)*, ed. Marc Belissa, Anna Bellavitis, Moniqu Cottret, Laurence Croq, and Jean Duma (Paris: Nolin, 2005), 13–32, insightfully distinguishes between adherence to orthodoxy and other characteristics, while stressing the paucity of sources to address this issue. Diaries and memoires written by Huguenots remained extremely rare until the late seventeenth century. Philip Benedict, "Autobiographical Documents in the Reformed Tradition," in *Von der dargestellten Person zum erinnerten Ich: Europäische Selbstzeugnisse als historische Quellen (1500–1850)*, ed. Kaspar von Greyerz, Hans Medick, and Patrice Veit (Cologne: Böhlau, 2001), 355–68.

9. The exaggerated figure comes from the Prince de Condé's Protestant propaganda. Philip Benedict and Nicolas Fornerod, "Les 2150 'églises' réformées de France de 1561–1562," *Revue historique* 311 (2009): 529–60.

10. Treasure, *Huguenots*, 408n17.

11. David El Kenz, *Les bûchers du Roi: La culture protestante des martyrs (1523–1572)* (Seyssel: Champ Vallon, 1997), 61; Mark Greengrass, *The French Reformation* (Oxford: Blackwell, 1991), 36–37.

12. Sebastien Castellion, *Conseil à la France désolée avquel est montré la cause de la guerre présente* (1562), 25, juxtaposed "Catholiques" and "Évangéliques" (not Huguenots).

13. Luc Racaut, "Religious Polemic and Huguenot Self-Perception and Identity, 1554–1619," *Society and Culture in the Huguenot World, 1559–1685*, ed. Raymond A. Mentzer and Andrew Spicer (Cambridge: Cambridge University Press), 33.

14. Jean-Pierre Rioux and Jean-François Sirinelli, eds., *Histoire culturelle de la France*, 4 vols. (Paris: Armand Colin, 1997–2005), vol. 2: Alain Croix and Jean Quéniart, *De la Renaissance à l'aube des Lumières*, 99. Such understanding is difficult because we have extant records from only a few dozen "reformed churches" before 1572. Raymond Mentzer, "La mémoire d'une 'fausse religion': Les registres de consistoires des Eglises réformées de France (XVIe–XVIIe siècle," *Bulletin de la Société de l'Histoire du Protestantisme Français* [hereafter *BSHPF*] 153 (2007): 461–75.

15. Marc Venard, "La grande cassure (1520–1598)," in *Histoire de la France religieuse*, ed. Jacques Le Goff and René Rémond, 4 vols. (Paris: Seuil, 1988–92), 2:246.

16. This first synod was more of a "general assembly" and "the *Discipline* that resulted from it" requires considerable effort and conjecture to reconstitute. Bernard Roussel, "Les *Disciplines Écclesiastiques* et la première culture des réformés, 1559–1572," in *Les deux Réformes chrétiennes: Propagation et diffusion*, ed. Ilana Zinguer and Myriam Yardeni (Leiden: Brill, 2004), 77–109, quotes from 84.

17. Michel Reulos, "Le synode national de La Rochelle (1571) et la constitution d'un 'parti' protestant," in *Actes du colloque L'Amiral de Coligny et son temps* (Paris: Société de l'Histoire du Protestantisme français, 1974), 707–16; Robert Kingdon, *Geneva and the Consolidation of the French Protestant Movement, 1564–1572* (Geneva: Droz, 1967), esp. 194. Glenn S. Sunshine, *Reforming French Protestantism: The Development of Huguenot Ecclesiastical Institutions, 1557–1572* (Kirksville, Mo.: Truman State University Press, 2003). Philip Benedict and Nicolas Fornerod, eds., *L'organisation et l'action des églises réformées de France* (Geneva: Droz, 2012), describes these developments in detail, including the rejection of many groups as suspect in doctrine or practices. See also Roussel, "Les *Disciplines Écclesiastiques*," esp. 79–80.

18. See in particular Denis Crouzet, *La génese de la Réforme française, 1520–1562* (Paris: SEDES, 1996), esp. chap. 5.

19. Watson, "Preaching, Printing, Psalm-Singing," 15–23.

20. Tulchin, *That Men Would Praise the Lord*, 142–56.

21. The metaphor is from the preface by Olivier Christin to Jérémie Foa, *Le tombeau de la paix: Une histoire des édits de pacification (1560–1572)* (Limoges: Pulim, 2015), 11. Foa shows that communities with Protestants managed social mixing and coexistence, as well as the confrontation that forced confessional delineation, through force of arms and recourse to law.

22. Hugues Daussy, *Le parti Huguenot: Chronique d'une désillusion (1557–1572)* (Geneva: Droz, 2014).

23. Compare Michel Nassiet, *La violence, une histoire sociale: France, XVIe–XVIIIe siecles* (Seyssel: Champ Vallon, 2011), 270–77, and Daussy, *Le parti Huguenot*, 318–23, on the range of noble responses and motives.

24. Jean-Marie Constant, *Les français pendant les guerres de religion* (Paris: Hachette, 2002), 161–82.

25. Penny Roberts, *A City in Conflict: Troyes during the French Wars of Religion* (Manchester: Manchester University Press, 1996), 115–17; Philip Benedict, *Rouen during the Wars of Religion* (Cambridge: Cambridge University Press, 1981).

26. Wanegffelen, *Ni Rome ni Genève*, 270–84, quote from 280.

27. Some local churches were revived years later, but only when tolerance became either tacit or official royal policy under Henri IV. Philip Benedict, "Les vicissitudes des églises réformées de France jusqu'en 1598," in *Coexister dans l'intolérance: L'édit de Nantes (1598)*, ed. Michel Grandjean and Bernard Roussel (Geneva: Droz, 1998), 53–73.

28. Racaut, "Religious Polemic," 33.

29. Kingdon, *Geneva and the Consolidation of the French Protestant Movement*, 37–120.

30. Janine Garrisson, *Protestants du Midi, 1559–1598* (Toulouse: Privat, 1991), 229–90, and *Les Protestants au XVI^e siècle* (Paris: Fayard, 1988), 60–78.

31. Olivier Christin, *Une révolution symbolique: L'iconoclasme huguenot et la reconstruction catholique* (Paris: Minuit, 1991), 33–34, 126–27; Louis Chatellier, *Le Catholicisme en France*, vol. 1, *Le XVI^e siècle* (Paris: SEDES, 1995), 140–41.

32. Philip Benedict, "Confessionalization in France? Critical Reflections and New Evidence," in *Society and Culture in the Huguenot World, 1559–1685*, ed. Raymond A. Mentzer and Andrew Spicer (Cambridge: Cambridge University Press), 51–52.

33. Quoted in Roberts, *A City in Conflict*, 116.

34. Treasure, *Huguenots*, 94.

35. Barbara Diefendorf, *Beneath the Cross: Catholics and Huguenots in Sixteenth-Century Paris* (New York: Oxford University Press, 1991), 138–42.

36. David Sabean, "Production of the Self during the Age of Confessionalism," *Central European History* 29 (1996): 1–18; John Bossy, "The Counter-Reformation and the People of Catholic Europe," *Past & Present*, no. 47 (1970): 51–70; Venard, "La grande cassure," 290.

37. Robert J. Knecht, *French Civil Wars, 1562–1598* (Harlow: Pearson, 2000), 97–98; Stuart Carroll, *Martyrs and Murderers: The Guise Family and the Making of Europe* (Oxford: Oxford University Press, 2009), 128–56.

38. Bossy, "The Counter-Reformation," 51–70, surveys the profound personal and social consequences of these changes.

39. Marc Venard, "Catholicism and Resistance to the Reformation in France, 1555–1585," in *Reformation, Revolt and Civil War in France and the Netherlands, 1555–1585*, by Philip Benedict, Guido Marnef, Henk van Nierop, and Marc Venard (Amsterdam: Royal Netherlands Academy of Arts and Sciences, 1999), 133–48.

40. Bossy, "Counter-Reformation," 54. Stuart Carroll, "The Rights of Violence," *Past & Present*, no. 214, suppl. 7 (2012): 127–62, makes a similar argument in passing.

41. Chatellier, *Le Catholicisme en France*, 147–48.

42. A. N. Galpern, *The Religions of the People in Sixteenth-Century Champagne* (Cambridge, Mass.: Harvard University Press, 1976), 182.

43. Megan C. Armstrong, *The Politics of Piety: Franciscan Preachers during the Wars of Religion, 1560–1600* (Rochester, N.Y.: University of Rochester Press, 2004), 22–23.

238 *Notes to Pages 48–53*

44. Holt, *French Wars of Religion*, 68.

45. Robert R. Harding, "The Mobilization of Confraternities against the Reformation in France," *Sixteenth Century Journal* 11 (1980): 85–107; Andrew E. Barnes, "Religious Anxiety and Devotional Change in Sixteenth-Century French Penitential Confraternities," *Sixteenth Century Journal* 19 (1988): 389–406; Denis Crouzet, *Les guerriers de Dieu: La violence au temps de troubles de religion, vers 1525 – vers 1610*, 2 vols. (Seyssel: Champ Vallon, 1990), 1:383–91; Galpern, *Religions of the People*, 52–56.

46. Even histories that make religious differences central to the civil wars of the sixteenth century pay little attention to changes in popular religious practices among Catholics, e.g., Holt, *French Wars of Religion*. Despite its length, Jean-Marie Constant, *La Ligue* (Paris: Fayard, 1996), makes no attempt to analyze new forms of piety and link them to politics.

47. Ann W. Ramsey, *Liturgy, Politics, and Salvation: The Catholic League in Paris and the Nature of Catholic Reform, 1540–1630* (Rochester: University of Rochester Press, 1999).

48. Holt, *French Wars of Religion*, 68.

49. Christin, *Une révolution symbolique*; Philip Benedict, "The Dynamics of Protestant Militancy," in Benedict, Marnef, van Nierop, and Venard, *Reformation, Revolt and Civil War*, 35–50.

50. Venard, "La grande cassure," 261.

51. Natalie Zemon Davis, "The Rites of Violence," *Past & Present*, no. 59 (1973): 51–91, as well as "The Rites of Violence: Religious Riot in Sixteenth-Century France: A Rejoinder," *Past & Present*, no. 67 (1975): 131–35, and the many articles in *Past & Present*, no. 214, suppl. 7 (2012), edited by Graeme Murdoch, Penny Roberts, and Andrew Spicer.

52. The edition of 1570 contained over a million words, and the edition of 1582, assembled by Simon Goulart, was considerably larger yet. See Jean-François Gilmont, *Jean Crespin: Un éditeur réformé du XVIᵉ siècle* (Geneva: Droz, 1981), 165–190, and his *Bibliographie des éditions de Jean Crespin, 1550–1572*, 2 vols. (Verviers: Gason, 1981), 1:169, 225. On the significance of Crespin's martyrologies, see Brad Gregory, *Salvation at Stake: Christian Martyrdom in Early Modern Europe* (Cambridge, Mass.: Harvard University Press, 2001) and Nikki Shepardson, *Burning Zeal: The Rhetoric of Martyrdom and the Protestant Community in Reformation France, 1520–1570* (Bethlehem, Pa.: Lehigh University Press, 2007).

53. Compare Jean Crespin, *Actes des martyrs réduits en sept livres* (Geneva: Crespin, 1564) and Crespin, *Histoire des vrays tesmoins de la vérité de l'Évangile* (Geneva: Crespin, 1570).

54. Donald Kelley, "Martyrs, Myths, and the Massacre: The Background of St. Bartholomew," *American Historical Review* 77 (1972): 1323–42. El Kenz, *Les bûchers du Roi*, shows how the literature on martyrs flowered at the same time as the victims of religious strife multiplied, but without being glorified as martyrs.

55. Crespin, *Histoire des vrays tesmoins*, fol. 709v. This key statement is analyzed by Frank Lestringant, *La lumière des martyrs: Essai sur le martyre au siècle des Réformes* (Paris: Honoré Champion, 2004), 76–77, and Jean-Raymond Fanlo, "Du monument religieux à l'écriture de l'histoire," in *Simon Goulart: Un pasteur aux intérêts vastes comme le monde*, ed. Olivier Pot (Geneva: Droz, 2013), 160–61.

56. Jouanna, *St Bartholomew's Day Massacre*, 186–88.

57. Lestringant, *La lumière des martyrs*, esp. 63–87. D'Aubigné began *Les Tragiques* following Saint Bartholomew's Day, but did not publish it until 1616.

58. Amy Graves-Monroe, "Martyrs manqués: Simon Goulart, continuateur du martyrologe de Crespin," *Revue des sciences humaines* 269 (2003): 53–86.

59. Simon Goulart, *Histoire des martyrs persecutez et mis à mort pour la verité de l'Evangile depuis le temps des Apostres jusques à l'an 1574* (Geneva: Crespin, 1582), fol. 704v, fol. 732v. Although Goulart's supplementary index to this edition only lists those killed by judicial order, he specifically describes victims of massacres as "martyrs" and points out that where names of victims are known they are included in his descriptions of the different massacres.

60. Lestringant, *La lumière des martyrs*, 100–109. See also Jameson Tucker, "From Fire to Iron: Martyrs and Massacre Victims in Genevan Martyrology," in *Dying, Death, Burial and Commemoration in Reformation Europe*, ed. Elizabeth C. Tingle and Jonathan Willis (London: Routledge, 2015), 157–74.

61. Philip Benedict, *Graphic History: The "Wars, Massacres and Troubles" of Tortorel and Perrissin* (Geneva: Droz, 2007). Credit is also due to Pierre Bonnaure, "Des images à relire et à rehabiliter: L'oeuvre gravé de Tortorel et Perrissin," *BSHPF* 138 (1992): 475–514.

62. Robert W. Scribner, *For the Sake of Simple Folk: Popular Propaganda for the German Reformation*, 2nd ed. (Oxford: Oxford University Press, 1994). Andrew Pettegree, *Reformation and the Culture of Persuasion* (Cambridge: Cambridge University Press, 2009), 102–27, provides a good introduction to the other "forms of persuasion" at the time, but disparages the power of printed images accompanied by text; however, Pettegree misses the fact that someone literate was usually on hand, especially in France, where Protestants had notably high rates of literacy.

63. *Histoire universelle, par Agrippa d'Aubigné*, ed. Alphonse de Ruble, 10 vols. (Paris: Renouard, 1886–1909), 1:227.

64. Denis Crouzet, *La nuit de la Saint-Barthélemy: Un rêve perdu de la Renaissance* (Paris: Fayard, 1994), is an exception to this generalization; however, his interpretation is largely thematic and often ignores chronology.

65. Benedict, *Graphic History*, 42–45. Each print was about thirty-two centimeters by fifty centimeters. Most of the production was a French version, but there were also a German, a Latin, and even an Italian version (without the massacres).

66. The most notable of these were Antoine de Chandieu, *Histoire des persecutions et martyres de l'Eglise de Paris, depuis l'an 1557* (Lyon, 1563); Louis, Prince de Condé, *Recueil des choses memorables passees et publiees pour le faict de la Religion et estat de ce royaume . . .*, 3 vols. (Rouen and Strasbourg, 1565–66); Crespin, *Histoire des vrays tesmoins* (1570); Jean de Serres, *Memoires de la III. guerre civile, et des derniers troubles de France* (Geneva, 1570); and Henri-Lancelot Voisin, Sieur de La Popelinière, *La vraye et entiere histoire de ces derniers troubles avenus tant en France qu'en Flandres et pays circonvoisins, depuis l'an 1562 jusqu'en 1570* (Paris, 1571; 2nd ed., Basle, 1572). There is an abundant literature, with major contributions by Donald R. Kelley, Miriam Yardeni, Jean-François Gilmont, and Cécile Huchard, on how these works made a distinctly Protestant contribution to the emergence of history as a discipline. Bruce Gordon, "The Changing Face of Protestant History and Identity in the Sixteenth Century," in *Protestant History and Identity in Sixteenth-Century Europe*, ed. Bruce Gordon, 2 vols. (Aldershot: Ashgate, 1996), 1:1–22, provides a good introduction to this literature.

67. On the *Quarante tableaux* as part of this historiographical process, see Amy Graves-Monroe, *"Post Tenebras Lex": Preuves et propagande dans l'historiographie engagée de Simon Goulart* (Geneva: Droz, 2012), esp. 235–37. Historical writing reached a notably higher level of sophistication after the events of 1572 were incorporated into a larger Protestant narrative.

68. Jean de Serres, *Commentariorum de statu religionis et republicae in regno Galliae*, 3 vols. (Geneva: Crespin, 1571), also covered the period 1557–70, but de Serres's text was notably more polemical, not illustrated, and not translated into French, therefore far less accessible to ordinary French Protestants than *Quarante tableaux*. See Charles Dardier, "Jean de Serres, historiographe du roi: Sa vie et ses écrits d'après des documents inédits, 1540–1598," *Revue historique* 22 (1883): 291–328, esp. 301–9.

69. Scribner, *For the Sake of Simple Folk*, xxvii.

70. David El Kenz, "La sacralisation par l'image au temps des guerres de religion," in *Histoire, Images, Imaginaires (fin XVᵉ siècle – début XIXᵉ siècle)*, ed. Michèle Ménard and Annie Duprat (Le Mans: Université du Maine, 1998), 223–36, esp. 233.

71. Benedict, *Graphic History*, 276, 183–84.

72. Alan A. Tulchin, "Massacres during the French Wars of Religion," *Past & Present*, no. 214, suppl. 7 (2012): 100–126 provides a comprehensive list of massacres, most of which were *not* the subject of prints by Tortorel and Perrissin.

73. David Potter, *The French Wars of Religion: Selected Documents* (New York: St. Martin's, 1997), 99.

74. Letters sent by François Hotman from Geneva in early October 1572 in "La Saint-Barthélemy: Nouveaux textes et notes bibliographiques," *Bulletin historique et littéraire (Société de l'Histoire du Protestantisme Français)* 43 (1894): 432, 434; *Journal de Faurin sur les guerres de Castres*, ed. Charles Pradel (Montpellier: Chroniques de Languedoc, 1878), 62. On the range of figures in contemporary publications, see Philippe Joutard, Janine Estèbe, Élisabeth Labrousse, and Jean Lecuir, *La Saint-Barthélemy ou les résonances d'un massacre* (Neuchâtel: Labor et Fides, 1976), 68.

75. Philip Benedict, "The Saint Bartholomew's Massacres in the Provinces," *Historical Journal* 21 (1978): 205–25, esp. 221.

76. Kingdon, *Geneva and the Consolidation of the French Protestant Movement*, 200.

77. Cécile Huchard, *D'encre et de sang: Simon Goulart et la Saint-Barthélemy* (Paris: Honoré Champion, 2007), 313.

78. Barbara Diefendorf, *The Saint Bartholomew's Day Massacre: A Brief History with Documents* (Boston: Bedford, 2009), 121; Benedict, *Rouen during the Wars of Religion*, 125–50; Crouzet, *Les guerriers de Dieu*, 2:113.

79. Wanegffelen, *Ni Rome ni Genève*, 315.

80. Benedict, *Rouen during the Wars of Religion*, 148. Philip T. Hoffman, *Church and Community in the Diocese of Lyon, 1500–1789* (New Haven, Conn.: Yale University Press, 1984), 33, suggests that the abandonment of reformed churches was at times inspired by a reluctance to accept the discipline imposed by a Calvinist consistory.

81. Janine Garrisson, *La Saint-Barthélemy* (Paris: Complexe, 1987), 138; Mack Holt, "L'évolution des 'Politiques' face aux Églises (1560–1598)," in *De Michel de L'Hospital à l'Édit de Nantes: Politique et religion face aux Églises*, ed. Thierry Wanegffelen (Clermont-Ferrand: Presses universitaires Blaise-Pascal, 2002), 591–607; Wanegffelen, *Ni Rome ni Genève*, 356–64.

82. Wanegffelen, *Ni Rome ni Genève*, 364–85, quote from 365; Diefendorf, *Beneath the Cross*, 142.

83. Knecht, *French Civil Wars*, 166.

84. Diefendorf, *Saint Bartholomew's Day Massacre*, 120. See also Joutard et al., *La Saint-Barthélemy*, 66.

85. Wanegffelen, *Ni Rome ni Genève*, 340–42, insightfully analyzes this passage on the basis of a copy of the manuscript. Subsequent publication of the original as Nicolas Pithou, Sieur de Chamgobert, *Chronique de Troyes et de la Champagne durant les guerres de Religion (1524–1594)*, ed. Pierre-Eugène Leroy, 2 vols. (Reims: Presses universitaires de Reims, 2000) reveals more fully the distress Pithou felt about his actions, both at the time and later, as well as his decision ultimately to suppress the entire passage (2:1056–57).

86. Shepardson, *Burning Zeal*, 108–41.

87. For eyewitness descriptions provided in private letters, see "La Saint-Barthélemy à Orléans racontée par Joh.-Wilh. de Botzheim, étudiant allemand, témoin oculaire, 1572," *Bulletin historique et littéraire (Société de l'Histoire du Protestantisme Français)* 21 (1872): 345–92, and "Un nouveau récit de la Saint-Barthélemy [à Paris] par un bourgeois de Strasbourg," *Bulletin historique et littéraire (Société de l'Histoire du Protestantisme Français)* 22 (1873): 374–77.

88. See the letter written by Beza from Geneva on 24 September 1572 in "La Saint-Barthélemy à Bourges et les assassins de Coligny d'après une lettre inédite du 9 octobre 1572," *Bulletin historique et littéraire (Société de l'Histoire du Protestantisme Français)* 45 (1896): 449.

89. Nicole Cazauran, "Échoes d'un massacre," in *La littérature de la Renaissance: Mélanges d'histoire et de critique littéraires offerts à Henri Weber*, ed. Marguerite Soulié (Geneva: Slatkine, 1984), 239–61, quote on 240.

90. Mark Greengrass, "Hidden Transcripts: Secret Histories and Personal Testimonies of Religious Violence in the French Wars of Religion," in *The Massacre in History*, ed. Mark Levene and Penny Roberts (New York: Berghahn, 1999), 69–88, quote on 83. Historians have relied heavily on Simon Goulart's *Mémoires de l'Estat de France sous Charles neufiesme*, 3 vols. (Geneva: Eustache Vignon, 1576; rev. and expanded, 1578), which contains lengthy descriptions of the massacres of 1572. However, because the original accounts are missing, the compendium should be considered less a "history of events" than a "topography of memory" (Graves-Monroe, *"Post Tenebras Lex,"* 133).

91. *Dialogue auquel sont traitées plusieurs choses advenues aux Luthériens et Huguenots de la France* (Basle, 1573). This pamphlet is better known in its later version, which added a political treatise on tyranny: *Le Réveille-Matin des François et de leur voisins* (Edinburgh [Geneva], 1574). Robert Kingdon, *Myths about the St. Bartholomew's Day Massacres, 1572–1576* (Cambridge, Mass.: Harvard University Press, 1988), 70–87, concludes that "the fundamental purpose of the *Reveille-matin* and its related propaganda [was] to keep alive and exploit memory of the massacres" (86).

92. Most famously, François Hotman, *De Furoribus Gallicis . . .* (Edinburgh [Frankfort], 1573), was published in French as *Discours simple et véritable des rages exercées par la France des horribles et indignes meurtres commis ès personnes de Gaspar de Colligni, Amiral de France . . .* (Basle: Pieter Vuallemand, 1573), which includes documents, describes the massacres in Lyon and Rouen, and claims that thirty days of unrelenting killing across France had created some one hundred thousand widows and orphans reduced to begging (lxxv–lxxvi). The regionally important but anonymous *Discours du massacre de ceux de la religion reformée fait à Lyon par les Catholiques*

Romains, le vingt-huictiesme du mois d'aoust et jours ensuivants de l'an 1572 (Lyon, 1574), also came well after events.

93. Pithou, *Chronique de Troyes*, 2:664. Pithou wrote in similar terms about the suffering of small groups—"But the good God, having pity and compassion on these poor prisoners"—as well as the suffering of a single person: "Nevertheless, the good God, having pity and compassion on him, left him few days in this misery." (2:714, 1:317). Katherine Ibbett, *Compassion's Edge: Fellow-Feeling and Its Limits in Early Modern France* (Philadelphia: University of Pennsylvania Press, 2018), notes the common use of the expression "pity and compassion" in the seventeenth century and argues that they served more to confirm fellow feeling among coreligionists than to overcome differences. This reification implicitly confirms the analysis offered here for the sixteenth century.

94. The register of the Company on 15 September 1572 quoted in Auguste Bernus, *Le ministre Antoine de Chandieu d'après son journal autographe inédit, 1534–1591* (Paris: Imprimeries réunies, 1889), 62.

95. Crouzet, *La nuit de la Saint-Barthélemy*, 112–13.

96. *Discours entier de la persecution et cruauté exercée en la ville de Vaissy, par le Duc de Guyse, le 1 de Mars 1562* (n.p., 1563), reprinted in Crespin, *Actes des martyrs réduits en sept livres* and Crespin, *Histoire des vrays tesmoins*.

97. de Serres, *Memoires de la III. guerre civile*, 2–3.

98. For the full poem, see "Ode de M. de Chandieu sur les misères des églises françaises qui ont esté par si longtemps persécutées," *Bulletin historique et littéraire (Société de l'Histoire du Protestantisme Français)* 33 (1884): 77–86, and for commentary on it, see Sara K. Barker, "Les armes de l'encre et de papier: La vie d'Antoine de Chandieu en vers," *BSHPF* 156 (2010): 15–36, esp. 30. Barker's larger study, *Protestantism, Poetry and Protest: The Vernacular Writings of Antoine de Chandieu (c. 1534–1591)* (Aldershot: Ashgate, 2009), 282, concludes that "the everyday experience of interpersonal violence provoked a crisis in the French Protestant consciousness, most evident in the years after 1572. [It was particularly] after this date that [Chandieu] and many of his fellow poets began to concentrate primarily on verses which explored the processes of death, and encouraged inner contemplation."

99. Twenty-three of the images, including three of the five scenes of massacres, have no known published antecedents; it was only later Protestant histories of the wars that provided many of the details of events first depicted in the *Quarante tableaux*. Benedict, *Graphic History*, 123–49.

100. Venard, "La grande cassure," 295.

101. Philip Conner, "Huguenot Identities during the Wars of Religion: The Churches of Le Mans and Montauban Compared," *Journal of Ecclesiastical History* 54 (2003): 23–39, esp. 29.

102. Crouzet, *La nuit de la Saint-Barthélemy*, 99–177, provides a detailed discussion of the competing contemporary discourses on the causes of the massacre.

103. E. H. Gombrich, *Art and Illusion: A Study in the Psychology of Pictorial Representation* (Princeton, N.J.: Princeton University Press, 1960), as well as key works in the study of "visual culture"—as opposed to the more formalistic history of art—such as David Freedberg, *The Power of Images: Studies in the History and Theory of Response* (Chicago: University of Chicago Press, 1989); W. J. T. Mitchell, *Picture Theory: Essays on Verbal and Visual Representation* (Chicago: University of Chicago

Press, 1994); and Barbara Maria Stafford, *Good Looking: Essays on the Virtue of Images* (Cambridge, Mass.: Harvard University Press, 1996) provide theoretical approaches to the relationship between images and texts, and the psychological responses they provoke from viewers. Studies of "visual culture" revived the importance of authorial intent and used it as the basis for anticipating viewers' responses, thereby rejecting "semiotic poststructuralism and socially based approaches" (William Innes Homer, "Visual Culture: A New Paradigm," *American Art* 12 [1998]: 6–9). Freedberg in particular emphasized that among other emotional responses, pictures and sculptures move people "to the highest levels of empathy and fear" (*Power of Images*, 1).

104. David Freedberg and Vittorio Gallese, "Motion, Emotion and Empathy in Aesthetic Experience," *Trends in Cognitive Sciences* 11 (2007): 197–203, proposes "a theory of empathic responses to works of art that is not purely introspective, intuitive or metaphysical but has a precise and definable material basis in the brain" (199).

105. Joutard et al., *La Saint-Barthélemy*, 66.

106. Swann Galleries, New York, sale 2273, lot 186, March 23, 2012. See also Fritz Hellwig, *Franz Hogenberg—Abraham Hogenberg: Geschichstblatter* (Nordlingen: Verlag, 1983), 13, and Folge III, 52.

107. In addition to Graves-Monroe, *"Post Tenebras Lex,"* see also Kingdon, *Myths about the St. Bartholomew's Massacres*, and especially Huchard, *D'encre et de sang.*

108. The supposedly lofty purposes of the massacres gave Catholic authors the license to print unabashed descriptions of the grizzly events, including dark humor, e.g., Huguenots "Were all thrown in the water / In order to carry the news / Down to Rouen without a boat." Cazauran, "Échos d'un massacre," 255.

109. Crouzet, *Les guerriers de Dieu*, 2:119–20.

110. "De Tristibus Galliae," Bibliothèque municipale de Lyon, MS 156. Sara Petrella, " 'Des tristibus Galliae' et Jean Perrissin," in *Peindre à Lyon au XVIᵉ siècle*, ed. Frédéric Elsig (Milan: Silvana, 2014), 119–46, dates this manuscript to 1584–85 during a period of intensifying Catholicism in France.

111. Catholic polemicists only introduced realistic images of Protestant atrocities into France after religious strife had been raging in Europe for more than a quarter of a century. The most notorious such work is Richard Verstegan, *Theatrum credelitatum haereticorum nostri temporis* (Antwerp: Adrian Hubert, 1587), which covered the Netherlands, France, and England. Verstegan, an English Catholic in exile since 1581, produced a French translation in 1588.

112. Mark Greengrass, *Christendom Destroyed: Europe 1517–1648* (New York: Viking, 2014), 371.

113. Gabriel de Saconay, *Discours des premiers troubles advenus à Lyon* (Lyon: Michel Jove, 1569).

114. Jacques Semelin, *Purify and Destroy: The Political Uses of Massacre and Genocide*, trans. Cynthia Schoch (New York: Columbia University Press, 2007).

115. Olivier Christin, "France et Pays-Bas—Le second iconoclasme," in *Iconoclasme: Vie et mort de l'image médiévale. Catalogue de l'exposition* (Paris: Somogy, 2001), 62.

116. Printed in two works by Gabriel de Saconay, *Discours des premiers troubles*, and *Généologie et la fin des huguenaux, & descouverte du Calvinisme* (Lyon: Benoit Rigaud, 1572).

117. Saconay, *Généologie*, also printed an eschatological image linking the biblical Apocalypse to the religious troubles in France. Its caption quoted the book of Revelation 12:12 (KJV): "Woe to the inhabiters of the earth and the sea, for the devil is come down unto you, having great wrath," but omits the end of the verse, "because he knoweth that he hath but a short time."

118. Marc Venard, "Les confréries en France au XVIᵉ siècle et dans la première moité du XVIIᵉ siècle," in *Société, culture, vie religieuse aux XVIᵉ et XVIIᵉ siècles,* ed. Yves-Marie Bercé (Paris: Presses universitaires de Paris-Sorbonne, 1995), 48–49. See also Jouanna et al., *Histoire et dictionnaire des guerres de religion,* 293–97.

119. Andrew E. Barnes, "The Wars of Religion and the Origins of Reformed Confraternities of Penitents, a Theoretical Approach," *Archives de Sciences Sociales des religions* 64 (1987): 117–36; Harding, "Mobilization of Confraternities"; Galpern, *Religions of the People,* 184–86; Crouzet, *Les guerriers de Dieu,* especially 1:344–57; Venard, "Catholicism and Resistance," 141. Penitential confraternities did not always impress laymen either. Jean Burel, a merchant-tanner who served in a Catholic militia at Le Puy, criticized the local bishop for starting a society of "penitents and flagellants" in 1584, noting that when they passed he could not forget that the bishop "had the hypocrisy to present a handsome body on the outside, full of piety and devotion, [despite] a heart filled with iniquity, hypocrisy, and spitefulness." Augustin Chassaing, *Mémoires de Jean Burel, bourgeois du Puy* (Le Puy-en-Velay: Marchessou, 1875), 86–87.

120. Quoted in Boltanski, *Distant Suffering,* 7.

121. Benedict, *Graphic History,* 50.

122. A "chosen trauma" is one that has developed into a cohesive image of an event that caused a large group of people to feel victimized and humiliated, and thus suffer psychologically. Vamik D. Volkan, "On Chosen Trauma," *Mind and Human Interaction* 3 (1991): 13.

123. This was the main message of the hugely influential *Le Réveille-Matin des François.* Jouanna et al., *Histoire et dictionnaire des guerres de religion,* 205–6.

124. Crouzet, *Les guerriers de Dieu,* 2:241–42.

125. Sabean, "Production of the Self," 17.

2. The Fronde and the Crisis of 1652

1. Pierre Goubert, *Mazarin* (Paris: Fayard, 1990), 223.

2. Ernst Kossman, *La Fronde* (Leiden: Universitaire Pers Leiden, 1954), 260.

3. Katherine Ibbett, *Compassion's Edge: Fellow-Feeling and Its Limits in Early Modern France* (Philadelphia: University of Pennsylvania Press, 2018), makes no mention of the Fronde or the Christian humanitarianism it provoked, which reflects historians' neglect of the topic as well.

4. Joseph Bergin, *Church, Society and Religious Change in France, 1580–1730* (New Haven, Conn.: Yale University Press, 2009) and Élisabeth Labrousse and Robert Sauzet, "La lente mise en place de la réforme tridentine (1598–1661)," in *Histoire de la France religieuse,* vol. 2, *Du roi très chrétien à la laïcité républicaine, XVIIIᵉ–XIXᵉ siècle,* ed. Jacques Le Goff and René Rémond (Paris: Seuil, 2001), 323–471, both provide superb introductions to the changing religious landscape of the period.

5. Dominique Deslandres, *Croire et faire croire: Les missions françaises au XVIIᵉ siècle (1600–1650)* (Paris: Fayard, 2003), 57–59.

6. Marie-Hélène Froeschlé-Chopard, *Dieu pour tous et dieu pour soi: Histoire des confréries et de leurs images à l'époque moderne* (Paris: Harmattan, 2006).

7. Bergin, *Church, Society and Religious Change*, 258.

8. François de Sales, *Introduction à la vie dévote*, ed. Henry Bordeaux, based on the edition of 1619 (Paris: Nelson, 1910), 20.

9. Bergin, *Church, Society and Religious Change*, 320. Jacques Depauw, *Spiritualité et pauvreté à Paris au XVIIᵉ siècle* (Paris: Boutique de l'histoire, 1999), 73–91, explores the theology of "works" in this new religiosity.

10. Labrousse and Sauzet, "La lente mise en place," 354.

11. Few people could discern just how *Augustinus*, with its thirteen hundred pages of double-column Latin spread over three volumes, differed from the church's interpretation of Saint Augustine, hence the protracted debates and confused papal bulls that came to define Jansenism over the next century. Jean Delumeau, *Catholicisme entre Luther et Voltaire* (Paris: Presses universitaires de France, 1971), 155–91; William Doyle, *Jansenism: Catholic Resistance to Authority from the Reformation to the French Revolution* (Basingstoke: Palgrave Macmillan, 2000), 16–34.

12. Quoted in Robin Briggs, *Communities of Belief: Cultural and Social Tension in Early Modern France* (Oxford: Oxford University Press, 1989), 341.

13. Delumeau, *Catholicisme entre Luther et Voltaire*, 164–66; Bergin, *Church, Society and Religious Change*, 258–62.

14. Jansenism "arrived with sudden force . . . largely through the medium of print." The "two most notorious titles" of over one hundred were *Augustinus* and *On Frequent Communion*: their impact "came like an explosion." Henri-Jean Martin, *Print, Power, and People in 17th-Century France*, trans. David Gerard (Metuchen, N.J.: Scarecrow, 1993), 390.

15. Brian E. Strayer, *Suffering Saints: Jansenists and "Convulsionnaires" in France, 1640–1799* (Brighton: Sussex Academic Press, 2008), 34–35.

16. Jean Orcibal, "Le premier Port Royal: Réforme ou contre-réforme?," *La Nouvelle Clio* 5–6 (1950): 239–80; Labrousse and Sauzet, "La lente mise en place," 366.

17. Strayer, *Suffering Saints*, 34–35; Doyle, *Jansenism*, 24–25. The evidence comes from the correspondence of Vincent de Paul; Arnauld claimed in 1686 that most bishops in France had come to recommend his position on delaying absolution. Jean Delumeau, *L'aveu et le pardon: Les difficultés de la confession, XIIIᵉ–XVIIIᵉ siècle* (Paris: Fayard, 1990), 144.

18. Barbara B. Diefendorf, *From Penitence to Charity: Pious Women and the Catholic Reformation in Paris* (Oxford: Oxford University Press, 2004), 7–13.

19. Depauw, *Spiritualité et pauvreté*, 62–63. Ibbett, *Compassion's Edge*, parses many discourses on pity and compassion in seventeenth-century France, but not those of François de Sales or Vincent de Paul.

20. Letter to Mlle Perdreau at Blois, 25 May 1652 in *Lettres de la mère Agnès Arnauld, abbesse de Port-Royal*, 2 vols. (Paris: Thorin, 1858), 1:235–36.

21. *Lettres de la mère Agnès Arnauld*, 1:155.

22. See the introduction (p. 6) to the *Recueil des relations contenant ce qui s'est fait pour l'assistance des pauvres: Entre autres ceux de Paris, & des environs, & des Provinces de Picardie & Champagne, pendant les années 1650, 1651, 1652, 1653, & 1654* (Paris: Charles Savreux, 1655) and Bibliothèque Nationale de France [hereafter BNF], L 747. 57; BNF Microfiche M-12518 cites Daniel's advice to King Nebuchadnezzar

of Babylon from Daniel 4:27: "buy back your sins with alms, and your injustices with works of mercy toward the poor, perhaps then God will forgive your sins."

23. Antoine d'Arnauld, *De la fréquente communion: ov les sentimens des Peres, des Papes, des Conciles, touchant l'vsage des sacremens de Penitence et d'Eucharistie . . .* (Paris: Antoine Vitré, 1643), chap. XVII, quote from 778.

24. André Féron, *La vie et les oeuvres de Charles Maignart de Bernières (1616–1662): L'organisation de l'assistance publique à l'époque de la Fronde* (Rouen: Lestringant, 1930), 18–19.

25. Compare Emanuel Chill, "Religion and Mendicity in Seventeenth-Century France," *International Review of Social History* 7 (1962): 400–425, and Bergin, *Church, Society and Religious Change*, 382–84.

26. In fact, some *dévots* associated with the Company showed clear Jansenist tendencies in the 1640s. Chill, "Religion and Mendicity," 412; Féron, *La vie et les oeuvres de Charles Maignart de Bernières*, 201.

27. Quoted in Bernard Pujo, *Vincent de Paul the Trailblazer*, trans. G. G. Champe (Notre Dame, Ind.: University of Notre Dame Press, 2003), 253.

28. Quoted in Louis Abelly, *Vie de S. Vincent de Paul*, 2 vols. (Paris: Herman frères, 1843–54), 2:49.

29. René Taveneaux, *La vie quotidienne des Jansénistes aux XVIIe et XVIIIe siècles*, 2nd ed. (Paris: Hachette, 1985), 259.

30. Quoted in Gilles Feyel, *L'annonce et la nouvelle: La presse d'information en France sous l'ancien régime (1630–1788)* (Oxford: Oxford University Press, 2000), 152.

31. J.-P. Seguin, *L'information en France avant le périodique: 517 canards imprimés entre 1529 et 1631* (Paris: Maisonneuve et Larose, 1964).

32. Louis Trenard, "La presse française des origines à 1788," in *Histoire générale de la presse française*, ed. Pierre Renouvin, 5 vols. (Paris: Presses Universitaires de France, 1969–76), 1:83–94.

33. Christian Jouhaud, *Mazarinades: La Fronde des mots*, 2nd ed. (Paris: Flammarion, 2009), 27.

34. Guy Patin quoted in Trenard, "La presse française," 96.

35. See issues 2, 10, and 11 in particular. The *Courrier françois* was closed after the Peace of Saint-Germain allowed Renaudot to return to Paris and enforce his monopoly privilege. Hubert Carrier, *La presse de la Fronde (1648–1653): Les Mazarinades*, 2 vols. (Geneva: Droz, 1989–91), 2:276; Feyel, *L'annonce et la nouvelle*, 201–29.

36. *Le Burlesque On de ce temps renouvelé, qui sait tout, qui fait tout et qui dit tout*, an overtly *frondeur* periodical, produced only six issues in the summer of 1649. Carrier, *La presse de la Fronde*, 1:275–76.

37. Eleven verse letters written by Loret to Mlle de Longueville (and later gathered together as the *Muze historique*) were published irregularly between August and October 1652, whereas the *Journal contenant les nouvelles de ce qui se passe de plus remarquable dans le royaume pendant cette guerre civile* appeared weekly from 23 August to 31 October 1652, but was not widely distributed and was seen as part of the Prince de Condé's propaganda. Carrier, *La presse de la Fronde*, 1:280–81.

38. Stéphane Haffemayer, *L'information dans la France du XVIIe siècle: La Gazette de Renaudot de 1647 à 1663* (Paris: Honoré Champion, 2002), 573–75, 588, 764.

39. Jouhaud, *Mazarinades*, 28–29.

40. For the little that is known of this world, see Maxime Préaud, "Intaglio Print-making in Paris in the Seventeenth Century or, The Fortune of France," and Mari-anne Grivel, "The Print Market in Paris from 1610–1660," both in *French Prints from the Age of the Musketeers*, ed. Sue Welsh Reed (Boston: Museum of Fine Arts, 1998), 6–12, 13–19; and Antony Griffiths and Craig Hartley, *Jacques Bellange, c. 1575–1616: Printmaker of Lorraine* (London: British Museum, 1997), 33.

41. On the history of Callot's original copperplates, see Paulette Choné, "Biog-raphie: Chronologie raisonnée," in *Jacques Callot, Actes du colloque organisé par le Ser-vice culturel du Musée du Louvre et la ville de Nancy, à Paris et à Nancy, 25–27 juin 1992*, ed. Daniel Ternois (Paris: Klincksieck, 1993), 59–79. I thank Sue Welsh Reed, cura-tor emerita at the Boston Museum of Fine Arts, for bibliographic suggestions, as well as Andy Weislogel, curator at the Johnson Museum of Art, Cornell University.

42. Callot authorized the printer Israël Henriet to publish works from the plates that he had made in Paris (except those of sieges), which allowed him to respond easily to market demand. Édouard Meaume, *Recherches sur quelques artistes lorrains* (Nancy: Grimblot et Veuve Raybois, 1852), 15, and "Recherches sur la vie et les ouvrages de Jacques Callot," *Mémoires de l'Académie de Stanislas*, 1852, 191–327; Robert Froté, "De François Langlois à Pierre II Mariette (Étude d'inventaires inédits ou le commerce de l'estampe à Paris, de Callot à Watteau)," *Gazette des Beaux-Arts* 102 (October 1983): 111–18; Benjamin Graham Larkin, "The Elusive Oeuvre of Jacques Callot" (PhD diss., Harvard University, 2003), 33–34; Grivel, "Print Market in Paris," 15.

43. The first state (1633) appeared without verses and the second state (1633) had verses approved by Callot. The third state probably appeared after the death of Henriet in 1661 because his *excudit* has been replaced by *Callot inv. et fec.* However, Henriet also published in 1636 (i.e., shortly after Callot's death) smaller, preliminary prints of six scenes that later appeared in the "large" series. See Édouard Meaume, *Recherches sur la vie et les ouvrages de Jacques Callot*, 2 vols. (Paris: Renouard, 1860), 2:265–70; Jules Lieure, *Jacques Callot*, 8 vols. (Paris, 1924–27; repr., New York: Collec-tors Editions, 1969), 7:70–72; Daniel Ternois, *Jacques Callot, catalogue complet de son oeuvre dessiné* (Paris: Klincksieck, 1962), 196–99.

44. Translation from Howard Daniel, *Callot's Etchings: 338 Prints* (New York: Dover, 1974), image 273.

45. Daniel, *Callot's Etchings*, xxii, describes the *Miseries* as "one of the first and clearest indictments of war as the most pointless and destructive of all human activities." For analyses that are more sensitive to the seventeenth-century context, see Katie Hornstein, "Just Violence: Jacques Callot's *Grandes Misères et Malheurs de la Guerre*," *Bulletin of the University of Michigan Museums of Art and Archaeology* 16 (2005): 29–48; Paulette Choné, "Les Misères de la guerre ou 'la vie du soldat': La force et le droit," in *Jacques Callot (1592–1635): Catalogue de l'exposition*, ed. Pau-lette Choné (Nancy: Musée Historique Lorrain, 1992), 396–411; Diane Wolfthal, "Jacques Callot's *Miseries of War*," *Art Bulletin* 59 (1977): 222–33.

46. The details in Callot's print depicting the pillaging of a farmhouse are con-firmed by a letter written in 1652 by "la Grande Mademoiselle," who had heard complaints about soldiers "having committed all kinds of violence imaginable, so they say, burning the feet of peasants in order to get their money." However, like others in the elite who preferred to downplay the devastation committed by

soldiers, she dismissed such claims as "fantastic tales that are told to the simple women of the countryside." Quoted in Jean-Pierre Barlier, "La période dite de la Fronde vue du nord et du nord-ouest de la région parisienne: Guerre, violence, et épidémie de 1649 à 1652," *Mémoires de la Société historique et archéologique de Pontoise, du Val-d'Oise et du Vexin* 87 (2005): 5–131, esp. 11–12.

47. On the work of Callot and Franck in historical context, see Bernd Roeck, "The Atrocities of War in Early Modern Art," in *Power, Violence and Mass Death in Pre-modern and Modern Times*, ed. Joseph Canning, Hartmut Lehmann, and Jay Winter (Aldershot: Ashgate, 2004), 129–40, and Martin Knauer, "War as Memento Mori: The Function and Significance of the Series of Engravings in the Thirty Years War," in *1648: War and Peace in Europe*, ed. K. Bussmann and H. Schilling (Münster: Westfälisches Landesmuseum, 1998), 509–15.

48. Alphonse Feillet, *La misère au temps de la Fronde et Saint Vincent de Paul* (Paris: Didier, 1862), 227.

49. Reproduced in Hubert Carrier, *La Fronde: Contestation démocratique et misère paysanne; 52 mazarinades*, 2 vols. (Paris: EDHIS, 1982), unpaginated.

50. Léonce de Piépape, *Turenne et l'invasion de la Champagne (1649–1650)* (Paris: Champion, 1889), 6–7, and especially Philippe Martin, *Une guerre de trente ans en Lorraine, 1631–1661* (Metz: Serpenoise, 2002), 304–9, 314, covers the devastating military activities of Charles IV. Barlier, "La période dite de la Fronde vue du nord et du nord-ouest de la région parisienne," 5; Jean Jacquart, "La Fronde de princes dans la région parisienne et ses conséquences matérielles," *Revue d'histoire moderne et contemporaine* 7 (1960): 257–90, and *La crise rurale en Île-de-France, 1550–1670* (Paris: Armand Colin, 1974), esp. 660–76, and Martin, *Une guerre de trente ans*, 197–231, all detail the economic and demographic impact of the confluence of war, famine, and plague on the region, which included death rates over one-quarter of the rural population.

51. Pierre Coste, *Saint Vincent de Paul et les Dames de la Charité* (Paris: Bloud et Gay, 1918), 412.

52. François-Nicolas Baudot Dubuisson-Aubenay, *Journal des guerres civiles*, ed. M.-J.-J.G. Sage, 2 vols. (Paris, 1883–85), 2:336 (November 1650): "Les dames de Lamoignon et de Herce présidentes [i.e., Madeleine Potier, wife of Guillaume de Lamoignon, and Jeanne Charlotte de Ligny, wife of Michel Vialart dit de Herse] et autres et les sieurs de Bernières, Le Nain, etc. y opèrent journellement." (See also Feillet, *La misère au temps de la Fronde*, 228–32.) Other names to which various *Relations* referred donors included the wife of President (Antoine de) Nicolay (Anne-Marie Amelot), the widow of President (Antoine) Goussault (Geneviève Fayet, herself cofounder of the Daughters of Charity), the sister of President (Blaise) Méliand, the mother of Procureur-Général Nicolas Fouquet (Marie de Maupeou Fouquet), the wife of Guy Joly, counselor at the Châtelet, the young widow Madame Marie de Miramion, and "Mademoiselle Viole" (Madeleine Deffitta), who (according to Depauw, *Spiritualité et pauvreté*, 197) acted as treasurer for Vincent de Paul, and was probably kin to the Carmelite mother superior, Anne Viole, dit du Saint-Sacrement. On the various roles of such elite women in charitable activities, see Diefendorf, *From Penitence to Charity*.

53. Original reproduced in Carrier, *La Fronde*, unpaginated.

54. Christian Jouhaud, Dinah Ribard, and Nicolas Schapira, *Histoire, littérature, témoignage: Écrire les malheurs du temps* (Paris: Gallimard, 2009), 270, describes similar texts written a decade later as "témoignages de compassion."

55. Geoff Mortimer, *Eyewitness Accounts of the Thirty Years War, 1618–1648* (Basingstoke: Palgrave, 2002), esp. 15–28, 164–78, helpfully parses the significance of eyewitness detail, secondhand accounts, and more general tropes associated with mass civilian death in the seventeenth century.

56. *Mois d'Octobre 1650. Estat des pauvres de la frontiere de Picardie, & des environs de Soissons ou les Armées ont campé* (in *Recueil des relations contenant ce qui s'est fait pour l'assistance des pauvres* [hereafter *Recueil des relations*]).

57. *Extraict de quelques informations des violences, & desordres commis par les troupes du General Roze* . . . , reproduced in Carrier, *La Fronde*.

58. *Nouvelle relation Du mois de Ianvier 1652. Contenant l'estat des Pauvres de quelques endroits de Picardie & Champagne, ou les Armées ont passé, & de ce qui s'est fait pour leur soulagement* (in *Recueil des relations*).

59. *Abregé veritable, Contenant le particulier de ce qui s'est fait pour le soulagement des Pauvres des Villages du Diocese de Paris, la necessité de soustenir cette entreprise par des Aumosnes extraordinaires, & pareillement de les employer à la continuation de l'assistance du grand nombre des malades des Faux-bourgs* (in *Recueil des relations*).

60. *Nouvelle relation Du mois de Ianvier 1652* and *Nouvelle relation Du mois de Ianvier 1651* (both in *Recueil des relations*).

61. Roy Porter, "Does Rape Have a Historical Meaning?," in *Rape*, ed. Sylvana Tomaseli and Roy Porter (Oxford: Blackwell, 1986), 216–79, esp. 235.

62. See especially *Mois de Fevrier 1651. Suite de la Relation, Contenant l'estat des pauvres de Picardie & Champagne ou les armées des ennemies ont campé, & de ce qui s'est fait pour leur soulagement* (in *Recueil des relations*).

63. *Mois de May & Iuin 1651. Suite de la Relation contenant l'estat des Pauvres de Picardie & Champagne ou les Armées ont passé, & de ce qui s'est fait pour leur soulagement* (in *Recueil des relations*).

64. *Relation de Mois de Fevrier 1652. Contenant l'estat des Pauvres de quelques endroits de Picardie & Champagne, ou les Armées ont passé, & de ce qui s'est fait pour leur soulagement* (in *Recueil des relations*).

65. *Mois de May & Iuin 1651.*

66. *Relation de Mois de Fevrier 1652.*

67. *Relation generale des mois de Mars & Avril. Contenant l'estat des Pauvres des faux-bourgs & villages des environs de Paris. Ce qui se peut faire pour leur soulagement. Ensemble la suitte de ce qui s'est passé pour ceux de Picardie & Champagne pendant les mois de Mars & Avril 1652* (in *Recueil des relations*).

68. *Recueil des relations*, 5.

69. Quotations in this paragraph are from *Relation veritable de ce qui s'est passé ès environs de la Ville de Rheims, depuis le 20 May 1651. Et l'estat deplorable du Pays. Tirée de diverses Lettres ecrites de ladite Ville de Rheims* (Paris, June 1651). This sixteen-page pamphlet is not in the *Receuil des relations*, but Carrier, *La Fronde*, treats it as part of that larger series.

70. Antoine Le Maistre, *L'Aumosne chrestienne, ou la tradition de l'église touchant la charité envers les pauures*, 2 vols. (Paris, 1651), 1:18.

71. Le Maistre, *L'Aumosne chrestienne*, 1:17–26.

72. Kossman, *La Fronde*, 228.

73. However, recently Jouhaud, Ribard, and Schapira, *Histoire, littérature, témoignage*, 298–304, took note of the remarkable novelty of Bernières's approach and distinguished its historicity from other forms of literary production at the time.

74. Depauw, *Spiritualité et pauvreté*, 202–6.

75. Féron, *La vie et les oeuvres de Charles Maignart de Bernières*, 244; Le Maistre, *L'Aumosne chrestienne*, 1:20.

76. Chill, "Religion and Mendicity," 421–23, notes the rise in the underclass in Paris in the first half of the seventeenth century. His interpretation of the motives for responding with both charity and repression, however, overemphasizes a Berullian theology of "self-abnegation" as "the basis of a *social asceticism* in which hatred of the self fed a revulsion from 'disorder,' and in which help to the suffering, since it served 'higher' purposes, had to be kept within confessional limits." Such an explanation fails to account for the surge in charity during the Fronde, which preceded the "grand renfermement" of the 1660s and beyond.

77. Le Maistre, *Aumosne chrestienne*, 1:3–4. Much of the material in this work came from the writings of Saint-Cyran. Taveneaux, *La vie quotidienne des Jansénistes*, 259.

78. A counsel is advice; a precept is an obligation. However, a precept is less binding than a church law because it applies to individuals in the present, whereas a law is promulgated for whole communities in the present and future. Similar arguments appeared in *Recueil de quelques propositions sur le commandement de l'aumosne* (Paris, May 1652), which referenced Thomas Aquinas on the spiritual obligation of the wealthy to provide alms.

79. Antoine Godeau, *Exhortation aux Parisiens sur le secours des pauvres des provinces de Picardie, et de Champagne ov il est provvé . . . que l'Aumosne en ce temps, est de Precepte, & non pas de Conseil* (Paris, 1651), 24.

80. BNF MS français 17792, fols. 133–34, Angélique Arnaud to Le Maistre, 26 January 1652.

81. *Mois de May 1652. Relation sommaire Contenant le denombrement des dix à douze mile Pauvres des Parroisses des Faux-bourgs de Paris, dont les parroissiens sont dans l'impuissance de les secourir* (in *Recueil des relations*). This figure, along with the inability of Parisians to cope with the problem, was repeated in *Moyen pour obtenir de Dieu une veritable Pais, par l'intercession de Sainte Geneviesve, en la solemnité de la descente de sa Chasse* (Paris, 1652).

82. *Journal de Jean Vallier, maître d'hôtel du roi (1648–1657)*, ed. Henri Courteault and Pierre de Vaissière, 4 vols. (Paris: Laurens, 1902), 3:260.

83. *Le voeu des Parisiens a sainte Geneviefve leur patronne, Par un bon Religieux, Touchant les miseres presentes* (Paris: Boisset, 1652), 6, which also claimed that almost half the population of France had crowded into Paris. See also Moshe Sluhovsky, *Patroness of Paris: Rituals of Devotion in Early Modern France* (Leiden: Brill, 1998), 130.

84. Barlier, "La période dite de la Fronde vue du nord et du nord-ouest de la région parisienne," 86, provides a detailed map of troop movements and the devastation they caused around Paris.

85. *Memoires* of Omer Talon, 487, quoted in Kossman, *La Fronde*, 222.

86. BNF, 76 C 78201.

87. The account in Renaudot's *Gazette* is available as a separate item at the Bibliothèque historique de la Ville de Paris [hereafter BHVP], piece 903564, *Les cérémonies observées en la descente de la châsse de sainte Geneviève*. See also Robert Descimon, "Autopsie du massacre de l'Hôtel de Ville (4 juillet 1652) de Paris et la 'Fronde des princes,' " *Annales: Histoire, Sciences Sociales* 54 (1999): 319–51, esp. 340.

88. BNF MS français 17792, fol. 88, Angélique Arnauld to Le Maistre (ca. 9 June 1652).

89. *Mémoires de Mme de Motteville sur Anne d'Autriche et sa cour*, ed. M. F. Riaux, 4 vols. (Paris: Charpentier, 1886), 4:12–13; Simone Bertière, *Condé, le héros fourvoyé* (Paris: Éditions de Fallois, 2011).

90. Moshe Sluhovsky, "La mobilisation des saint dans la Fronde d'après les mazarinades," *Annales: Histoire, Sciences sociales* 54 (1999): 353–74, esp. 363.

91. Jean Delumeau and Yves Lequin, *Les malheurs des temps: Histoire des fléaux et des calamités en France* (Paris: Larousse, 1987), 298–300.

92. Michel Pernot, *La Fronde, 1648–1653* (Paris: Tallandier, 2012), 296–300; Jacquart, "La Fronde des princes," 260–63.

93. Quoted in J. H. M. Salmon, *Cardinal de Retz: The Anatomy of a Conspirator* (London: Macmillan, 1970), 220.

94. See the brief chronology in Descimon, "Autopsie," 320–22.

95. Jean Le Boindre, *Débats du Parlement de Paris pendant la Minorité de Louis XIV*, ed. Isabelle Storez-Brancourt, 2 vols. (Paris: Champion, 2002), 2:479–80, 488; *Les "Gazettes parisiennes" d'Abraham de Wicquefort pendant la Fronde (1648–1652)*, ed. Claude Boutin, 2 vols. (Paris: Champion, 2010), 2:1179.

96. Marigny to Lenet, 7 July 1652, appendix to Victor Cousin, *Madame de Longueville pendant la Fronde, 1651–1653* (Paris: Didier, 1859), 448; *Relation contenant la suite et conclusion du Iournal de tout ce qui s'est passé au Parlement, pour les affaires publiques. depuis Pasques 1652. iusque en Ianvier 1653* (Paris: Gervais Alliot et Jacques Langlois, 1653), 12. J.-A. Taschereau "Nouvelles à la main, 1652–1655: Journal de la Fronde," *Revue rétrospective, ou, Bibliothèque historique, contenant des mémoires et documents authentiques inédits et originaux*, 3ᵉ séries (1838) 3:46–88, 125–86, states that "there were three or four judges and masters of requests killed, a city councillor or two, and at least thirty bourgeois" (87–88).

97. *Liste générale des morts et blessés, tant Mazarins que Bourgeois de Paris, . . .* (Paris, 4 July 1652), reprinted in C. Moreau, *Choix des Mazarinades*, 2 vols. (Paris: Renouard, 1853), 2:383–86, indicates the social status of some victims, but is incomplete. Both Orest Ranum, *The Fronde: A French Revolution, 1648–1652* (New York: W. W. Norton, 1993), 332, and Descimon, "Autopsie," 322, estimate at least a hundred dead, although this figure also includes rioters and militiamen.

98. Le Boindre, *Débats du Parlement*, 2:497. For other indications of contemporary responses, see *Recit veritable de tout ce qui s'est passé touchant le desordre arrivé à l'hostel de ville, pour la destruction du Cardinal Mazarin* (Paris, 1652), BHVP 126904, and *Le Mercure de la Cour, contenan la trahison des Mazarins brassées dans la Ville de Paris . . . quatrième partie* (Paris, 1652), BHVP 196787.

99. Antoine Le Roux de Lincy and Louis Douët d'Arcq, eds., *Registres de l'Hôtel de Ville de Paris pendant la Fronde*, 3 vols. (Paris: Le Roux de Lincy et Douët d'Arcq, 1846), 3:68.

100. See the suggestive remarks in Francesco Benigno, *Mirrors of Revolution: Conflict and Political Identity in Early Modern Europe* (Turnhout: Brepols, 2010), 196–97, 221.

101. Descimon, "Autopsie," 350.

102. Descimon, "Autopsie," 324–26; Pernot, *La Fronde*, 295–300.

103. Hubert Carrier, *Le labyrinthe de l'État: Essai sur le débat politique en France au temps de la Fronde* (Paris: Champion, 2004), 137–44, notes the provocation to popular violence in the pamphlets *Les Cautèles de la paix* (Paris, [May] 1652) and *La Véritable Fronde des Parisiens* (Paris, June 1652).

104. Georges Mongrédien, *Le Grand Condé* (Paris: Hachette, 1959), 116–25; Riaux, *Mémoires de Mme de Motteville*, 4:28, emphasizes the unintended consequences of the prince's orders "being poorly given or poorly understood."

105. Moreover, "the two or three hundred [*sic*] victims are barely mentioned." Feyel, *L'annonce et la nouvelle*, 258.

106. These began with following two alarmist pamphlets, *Relation véritable de la sédition faite à Bordeaux des Principaux Bourgeois de cette ville par l'Assemblée de L'ormière* (Paris: Iouste la Copie Imprimée à Bourdeaux, 1652) and *Extraict de tout ce qui s'est fait & passé à Bordeaux depuis le 29 Iuin 1652 touchant le party de Messieurs les Princes, & celuy des Mazarins* (Paris: Jacob Chevalier, 1652). *Le journal de tout ce qui s'est fait et passé dans la ville de Bordeaux, depuis le 24 juin jusques à présent* . . . (Paris: Jacob Chevalier, [mid-July] 1652).

107. Sal Alexander Westrich, *The Ormée of Bordeaux: A Revolution during the Fronde* (Baltimore: Johns Hopkins University Press, 1972), 38, and Ranum, *Fronde*, 254, both claim sixty dead *ormistes* as well as three or four on the side of the judges. William Beik, *Urban Protest in Seventeenth-Century France* (Cambridge: Cambridge University Press, 1997), 236, states, "There had been at least nine houses put to the torch and casualties on both sides—perhaps ten defenders and sixty ormistes."

108. Jouhaud, *Mazarinades*, 201–2, notes the change of dates and other fabulations. A closer comparison reveals other significant changes, including an attack on the Hôtel de Ville of Bordeaux that enhanced the parallel to events in Paris: see *Extraict de tout ce qui s'est fait & passé à Bordeaux* and *Relation véritable de tout ce qui s'est fait et passé dans la Ville de Bordeaux à l'attaque de l'Hostel de Ville, par ceux de l'Ormière, auecque la prise de trois pièces de Canon, & autres Bagages* ([Paris]: Iouxte la copie imprimée à Bordeaux, 1652).

109. *La Mercuriale* (Paris, [12 July] 1652) and *Le Guide au chemin de la liberté* (Paris, [ca. 18 July] 1652), analyzed in Carrier, *Le labyrinthe de l'État*, 46, 138–44, 586.

110. Westrich, *Ormée of Bordeaux*, 40–59; Roger Chartier, "L'Ormée de Bordeaux: Note critique," *Revue d'histoire moderne et contemporaine* 21 (1974): 279–83.

111. Alanson Lloyd Moote, *The Revolt of the Judges: The Parlement of Paris and the Fronde, 1643–1652* (Princeton, N.J.: Princeton University Press, 1971), esp. 342.

112. Carrier, *Le labyrinthe de l'État*, 553–55, maps the increased unity acquired by the bourgeois of Paris during the summer and autumn of 1652, although he treats it as a return to previous conditions, whereas Descimon considers it a novel social realignment along class lines.

113. Antoine Godeau, *Advis aux Parisiens sur la descente de la chasse de Sainte Genevefve & la Procession qui se doit faire pour demander la paix* (Paris, 1652), BHVP 26929.

114. Adrien Bourdoise, a missionary to the diocese of Chartres, had a similar message. God intended catastrophes such as the plague not to be divine judgment, but to inspire the sort of fear that would provoke individuals to examine their own consciences. Delumeau and Lequin, *Les malheurs des temps*, 303.

115. *La verité toute nue, ou Aduis sincère et désintéressé sur les véritables causes des maux de l'Estat et les moyens d'y apporter le remède*, reprinted in Moreau, *Choix des*

Mazarinades, 2:406–38, where it is dated 7 August 1652. This is the source of all quotations in this paragraph and the next.

116. Sheila Page Bayne, *Tears and Weeping: An Aspect of Emotional Climate Reflected in Seventeenth-Century French Literature* (Tubingen: Gunter Narr, 1981), 79.

117. Jouhaud, *Mazarinades*, 188–89, has inspired this analysis.

118. *Revelation de Sainte Genevieve a un Religieux de son Ordre, sur les miseres du Temps, Ou elle luy declare la raison pour laquelle elle n'a pas fait Miracle cette Année* (Paris, 1652), BHVP 102060.

119. *Paris en Deuil, reflechissant sur son estat present, les perils ausquels elle a esté exposée, & les pertes qu'elle a faites la semaine derniere, & les dangers qui la menascent encor à l'advenir* (Paris, 1652), BHVP 101665.

120. *Les Bourgeois saturnien, errant par la ville de Paris; Pour apprendre ce qui se fait & passe, tant du Parlement, de l'hostel de ville, que du peuple de Paris* (Paris, 1652), BHVP 100434.

121. The assembly of 21 June, in an obvious political maneuver, sought to impose a substantial sum on each member of the Parlement; however, this remained voluntary. Le Boindre, *Débats du Parlement*, 2:478–79; Carrier, *Le labyrinthe de l'État*, 593–94; Le Roux de Lincy and Douët d'Arcq, *Registres de l'Hôtel de Ville*, 2:401.

122. *Relation generale des Mois de Iuin & Iuillet 1652.*

123. Between July 1650 and July 1656, the Ladies of Charity raised close to 350,000 livres (Abelly, *Vie de S. Vincent de Paul*, 2:43). Leading members are listed in Vincent de Paul, *Correspondence, Entretiens, Documents*, ed. Pierre Coste, 14 vols. (Paris: Lecoffe, 1920–26), 14:108–9; total membership figures are ibid., 2:45.

124. Pierre Coste, *Les Filles de la Charité* (Paris: Desclée de Brouwer et Cie., 1933), esp. 27–31; Diefendorf, *From Penitence to Charity*, 210–16, 230–35; Susan E. Dinan, *Women and Poor Relief in Seventeenth-Century France: The Early History of the Daughters of Charity* (Aldershot: Ashgate, 2006), esp. 79–82.

125. Quoted in Pujo, *Vincent de Paul the Trailblazer*, 203.

126. *Abregé veritable, Contenant le particulier.*

127. *Estat sommaire des misères de la campagne et besoins des pauvres aux environs de Paris des 20, 22, 24, et 25 octobvre 1652* (Paris, 1652); Alphonse Feillet, "Un chapitre inédit de la Fronde," *Revue de Paris* 33 (1 August 1856), 266, identifies the author as the abbé Féret, grand vicar to the archbishop of Paris.

128. Vincent de Paul, *Correspondence*, 4:539; Feillet, *La misère au temps de la Fronde*, 147–50; Michel U. Maynard, *Saint Vincent de Paul: Sa vie, son temps, ses oeuvres, son influence*, 4 vols. (Paris: Retaux–Bray, 1874), 4:260–78.

129. Quoted in Cousin, *Madame de Longueville*, 171.

130. *Nouvelle relation, Pour les Mois de Ianvier, Fevrier, Mars, & Avril 1655. Contenant ce qui s'est passé pour l'assistance des Pauvres de Picardie & Champagne; Et qui fera voir que, manque de fonds, l'on va cesser cette entreprise, si la Charité des particuliers ne se réchauffe* (in *Recueil des relations*).

131. Introduction (p. 5) to the *Recueil des relations*.

3. The Thermidorians' Terror

1. Norman S. Fiering, "Irresistible Compassion: An Aspect of Eighteenth-Century Sympathy and Humanitarianism," *Journal of the History of Ideas* 37 (1976): 195–218. David Hume and Adam Smith helped to stimulate this cultural shift by seeking to

base moral philosophy on humans' supposedly natural capacity for fellow feeling. Their theories emphasized that "sympathy rescues us from solipsism" and thereby provides the basis for both shared aesthetic judgments (taste) and compassion for others (empathy). John Mullan, "Feelings and Novels," in *Rewriting the Self: Histories from the Renaissance to the Present*, ed. Roy Porter (London: Routledge, 1997), 125; Lou Agosta, "Empathy and Sympathy in Ethics," in *Internet Encyclopedia of Philosophy: A Peer-Reviewed Academic Resource*, ed. James Fieser and Bradley Dowden, http://www.ieup.edu/emp-symp/.

2. Anne Vincent-Buffault, *The History of Tears: Sensibility and Sentimentality in France*, trans. Teresa Bridgeman (Basingstoke: Palgrave Macmillan, 1991), notably 9 and 96. Mullan, "Feelings and Novels," 127, asserts that "the novel was [the Enlightenment's] true imaginative enactment . . . [because] it was in novels that the individual self—the experience of the self as individual—was most affectingly represented."

3. Paul Friedland, *Seeing Justice Done: The Age of Spectacular Punishment in France* (New York: Oxford University Press, 2012), 165–91.

4. Dror Wahrman, *The Making of the Modern Self: Identity and Culture in Eighteenth-Century England* (New Haven, Conn.: Yale University Press, 2004), xiii.

5. Peter Fritzsche, "Specters of History: On Nostalgia, Exile, and Modernity," *American Historical Review* 106 (2001): 1587–1618, quote from 1617.

6. William M. Reddy, *The Navigation of Feeling: A Framework for the History of Emotions* (Cambridge: Cambridge University Press, 2001). Jan Goldstein, *The Post-Revolutionary Self: Politics and Psyche in France, 1750–1850* (Cambridge, Mass.: Harvard University Press, 2005), analyzes the discourses of the self that emerged among French intellectuals and educators in the period, whereas Gregory S. Brown, "Am 'I' a 'Post-Revolutionary Self'? Historiography of the Self in the Age of Enlightenment and Revolution," *History and Theory* 47 (2008): 229–48, astutely sets this perspective in a larger scholarly context.

7. "Thermidorians" were politicians and publicists whose public lives came to be shaped by their opposition to Montagnards, Jacobins, and *sans-culottes*. Quite a few Thermidorians had belonged to these groups but turned against their erstwhile allies for reasons of political expediency. Such an obvious volte-face derived in large part from the public backlash against the political rhetoric, social leveling, and coercive methods of Year II.

8. For an alternative approach that focuses on diagnosing the psychological damage done to *individuals*, see Ronen Steinberg, "Trauma before Trauma: Imagining the Effects of the Terror in Post-Revolutionary France," in *Experiencing the French Revolution*, ed. David Andress (Oxford: Oxford University Press, 2013), 177–99. On the other hand, Barry Shapiro, *Traumatic Politics: The Deputies and the King in the Early French Revolution* (University Park: Penn State University Press, 2009), suggests that using modern diagnoses of personal trauma helps to explain shared responses among deputies of the National Assembly in 1789.

9. Mark S. Micale and Paul Lerner, eds., *Traumatic Pasts: History, Psychiatry, and Trauma in the Modern Age, 1870–1930* (Cambridge: Cambridge University Press, 2001), 20–21.

10. Annie Jourdan, "La journée du 5 septembre 1793: La terreur a-t-elle été à l'ordre du jour?," in *Visages de la Terreur: L'exception politique de l'an II*, ed. Michel

Biard and Hervé Leuwers (Paris: Armand Colin, 2014), 45–60, and Mary Ashburn Miller, *A Natural History of Revolution: Violence and Nature in the French Revolutionary Imagination, 1789–1794* (Ithaca, N.Y.: Cornell University Press, 2011), 149–50, 200, both support and correct Jean-Clément Martin, *Violence et Révolution: Essai sur la naissance d'un mythe national* (Paris: Seuil, 2006), 186–93.

11. Olivier, a surgeon from Monségur (Gironde), explained his situation as a suspect even after being released from prison during Year II: "the terror being still the order of the day at my place / in me" ("la terreur étant encore chez moi à l'ordre du jour"). Archives Nationales [hereafter AN], DIII 102, d. 2.

12. Michel Biard, *Missionaires de la République: Les répresentants du peuple en mission (1793–1795)* (Paris: CTHS, 2002), 326.

13. Donald M. Greer, *Incidence of the Terror during the French Revolution: A Statistical Interpretation* (Cambridge, Mass.: Harvard University Press, 1935). Laurent Brassart, "'L'autre Terreur': Portrait d'une France (presque) épargnée," in Biard and Leuwers, *Visages de la Terreur*, 167–83, sketches the sharp contrasts between various regions and cities.

14. Historians too often discuss the origins and justifications for the Terror as if everything that occurred at the time was more or less known to the functionaries who served the regime throughout France. E.g., Patrice Gueniffey, *Politique de la Terreur: Essai sur la violence révolutionnaire* (Paris: Fayard, 2000).

15. Alain Gérard, *"Par principe d'humanité . . .": La Terreur et la Vendée* (Paris: Fayard, 1999).

16. Quoted in Bronislaw Baczko, *Comment sortir de la Terreur: Thermidor et la Révolution* (Paris: Gallimard, 1989), 191.

17. Jules Michelet, *Histoire du XIXe siècle*, 3 vols. (Paris: Baillière, 1872–75), 1:79.

18. [Charlotte Biggs], *A Residence in France, during the Years 1792, 1793, 1794, 1795, Described in a Series of Letters from an English Lady . . .* , 2 vols. (London: Longman, 1796–97), 2:139–40.

19. The literature on the repression of 1793–94 is enormous, but the point made here can be easily discerned in Colin Lucas, *The Structure of the Terror: The Example of Javogues and the Loire* (Oxford: Clarendon, 1973); D. M. G. Sutherland, *France 1789–1815: Revolution and Counterrevolution* (London: Fontana, 1985), 192–247; Martin, *Violence et Révolution*, 155–236; and Biard, *Missionaires de la République*, 183–279.

20. *Le Moniteur*, 14 Fructidor II (31 August 1794).

21. *Le Moniteur*, 29 Ventôse III (19 March 1795).

22. Compare Haim Burstin, "Entre théorie et pratique de la Terreur: Un essai de balisage," in *Les politiques de la Terreur, 1793–1794*, ed. Michel Biard (Rennes: Presses Universitaires de Rennes, 2008), 39–52, and Mona Ozouf, "The Terror after the Terror: An Immediate History," in *The French Revolution and the Creation of Modern Political Culture*, ed. Keith Michael Baker, vol. 4: *The Terror* (Oxford: Pergamon, 1994), 3–18.

23. Carla Hesse, "Print Culture in the Enlightenment," in *The Enlightenment World*, ed. Martin Fitzpatrick, Peter Jones, Christa Knellwolf, and Iain McCalman (New York: Routledge, 2007), 366–80.

24. R. A. Houston, *Literacy in Early Modern Europe: Culture and Education, 1500–1800* (London: Longman, 1988), 116–54, offers an insightful introduction to assessing literacy rates; François Furet and Jacques Ozouf, *Reading and Writing:*

Literacy in France from Calvin to Jules Ferry, trans. Rupert Swyer (Cambridge: Cambridge University Press, 1982).

25. Jack Censer, *The French Press in the Age of Enlightenment* (London: Routledge, 1994), 6–11, seeks to define and count the number of periodicals in France during the period.

26. Jeremy Popkin, *Revolutionary News: The Press in France, 1789–1799* (Durham, N.C.: Duke University Press, 1990), 24. See also Censer, *French Press*, 15–53.

27. Hugh Gough, *The Newspaper Press in the French Revolution* (London: Routledge, 1988), 26.

28. Popkin, *Revolutionary News*, 144–68.

29. Jean-Paul Bertaud, "La presse en l'an II: Aperçu de travaux récents," *Annales historiques de la Révolution française*, no. 300 (1995), 161–72; Gough, *Newspaper Press*, 83–117.

30. Xavier Martin, *La France abimée: Essai historique sur un sentiment révolutionnaire, 1780–1820* (Bouère: D. M. Morin, 2009), 134–64, argues that this drive to conformity extended to inner thoughts.

31. Laura Mason, "The Culture of Reaction: Demobilizing the People after Thermidor," *French Historical Studies* 39 (2016): 445–70. The leading right-wing papers in Paris, such as the *Journal de Perlet* and *Nouvelles politiques*, also greatly facilitated the Thermidorian cause.

32. For a general discussion of Thermidorian propaganda, see Baczko, *Comment sortir de la Terreur*, and Sergio Luzatto, *L'automne de la Révolution: Luttes et cultures politiques dans la France thermidorienne*, trans. Simone Carpentari Messina (Paris: Honoré Champion, 2001), esp. 75–118.

33. François Gendron, *La jeunesse dorée* (Quebec: Presse de l'Université de Québec, 1979), 36–37; Michel Biard, "Après la tête, la queue! La rhétorique antijacobine en fructidor an II – vendémiaire an III," in *Le tournant de l'an III: Réaction et Terreur blanche dans la France révolutionnaire*, ed. Michel Vovelle (Paris: Éditions du CTHS, 1997), 201–13.

34. The most revelatory pamphlet came from none other than F.-A.-L. Phelippes-Tronjolly, former president of the Revolutionary Tribunal at Nantes: *Noyades, fusillades, ou, Réponse au rapport de Carrier, représentant du peuple, sur les crimes & dilapidations du Comité révolutionnaire de Nantes, & dont le procès commencera le 25 vendémiaire, au tribunal révolutionnaire, à Paris* (Paris: Ballard, 1794).

35. Gilles Feyel, ed., *Dictionnaire de la presse française pendant la Révolution, 1789–1799: La presse départementale*, 5 vols. (Ferney-Voltaire: Centre d'Étude du XVIIIᵉ siècle, 2005–16), 1:275. In its mission to instruct peasants around Colmar, this paper wrote, "Every municipality had its committees of denunciation and incarceration; every department had its guillotine and its Revolutionary Tribunal; every Revolutionary Tribunal had its Dumas and its Fouquier" (273–74).

36. Baczko, *Comment sortir de la Terreur*, 202–3.

37. A published summary of the two trials helped to fix the main features in the popular imagination: *La Loire vengée, ou Recueil historique des crimes de Carrier, et du Comité révolutionnaire de Nantes*, 2 vols. (Paris: Meurant, an III [1794]), as did immediate histories such as Helen Maria Williams, *Letters Containing a Sketch of the Scenes which Passed in Various Departments of France during the Tyranny of Robespierre* (London: Robinson, 1795), 40–47, published immediately in French as *Lettres sur*

les événements qui se sont passés en France, depuis le 31 mai 1793 jusqu'au 10 thermidor (Paris: L'Imprimerie de la rue de Vaugirard, 1795).

38. Baczko, *Comment sortir de la Terreur*, 191. Georges-Victor Vasselin, before describing the actions of Carrier, emphasizes the emotional responses such revelations generated in readers: "Twenty times my heart faltered while recounting this hideous picture; twenty times my quill slipped from my trembling hands. Oh, you sensitive and compassionate beings whom nature has not built strong enough to contemplate with a steady eye the palpitations of a man expiring in the midst of the torments of torture, do not read this paragraph; you will not complete it without frightening convulsions." *Mémorial révolutionnaire de la Convention, ou, Histoire des révolutions de France, depuis le 20 septembre 1792 jusqu'au 26 octobre 1795*, 4 vols. (Paris: Baillio et Collas, 1797), 3:203.

39. *Réimpression de l'ancien Moniteur*, 30 vols. (Paris: Henri Plon, 1840–45), 22:118.

40. *Réimpression de l'ancien Moniteur*, 22:675. Such exaggerations and their effect on contemporaries are missing from positivist inquiries such as that of Émile Le Gallo, "L'affaire Bédoin," *La Révolution française* 300 (1901): 289–310.

41. Bronislaw Baczko, "'Comment est fait un tyran?': Thermidor et la légende noir de Robespierre," in his *Politiques de la Révolution française* (Paris: Gallimard, 2008), 133–64; Jean-Clément Martin, *Robespierre: La fabrication d'un monstre* (Paris: Perrin, 2016), 240–61.

42. *Rapport fait au nom de la commission chargée de l'examen des papiers trouvés chez Robespierre et ses complices, par Ed.-B. Courtois* (Paris: Imprimerie Nationale des lois, 16 Nivôse III [1795]) and *Rapport fait au nom de la Commission des vingt-un, . . . pour l'examen de la conduite des Représentans du Peuple Billlaud-Varennes, Collot-d'Herbois & Barère, membres de l'ancien Comité de Salut Public, & Vadier, membre de l'ancien comité de Sûreté générale, fait par . . . Saladin* (Paris: Imprimerie Nationale des lois, 12 Ventôse III [1795]).

43. E.g., *L'Anti-terroriste, ou Journal des principes* (Toulouse), 28 Ventôse III (18 March 1795), reproduced the report's opening paragraph verbatim.

44. *Relation du siège de Lyon: contenant le détail de ce qui s'y est passé d'après les ordres et sous les yeux des représentans du peuple Français* (Londres [Neuchâtel], 1794).

45. "Massacre at Lyon, ordered by Collot d'Herbois" is known from a copy in the BNF dated "London published June 22, 1804." It was stipple engraved by Giacomo Aliprandi (anglicized to James Idnarpila) on the basis of an original image (now lost) by Jacques Bertaux, who was living in Paris in 1795 when the subject matter obsessed the public. The caption, in both English and French, begins: "The Massacre at Lyon ordered by Collot d'Herbois at the head of 10000 sans-culottes. On that day 6000 persons were murdered, either by grape shot from the mouths of canon, or by sword and their bodies thrown into the Rhone."

46. Emmanuel de Waresquiel, *Fouché: Les silences de la pieuvre* (Paris: Tallendier/Fayard, 2014), 135–208, explains how Fouché eluded responsibility for his role at Lyon.

47. The public revelations began on 28 Thermidor II (15 August 1794) when Pierre-François Réal's account of life in the Luxembourg prison provoked "reactions of indignation and horror" among members of the Jacobin Club. Alphonse Aulard, ed., *La Société des Jacobins*, 6 vols. (Paris: Jouaust, Noblet, Quantin, 1889–97),

6:341–46. Joachim Vilate, ex-priest and former juror on the tribunal, fueled outrage by publishing some of the most successful pamphlets of the Thermidorian period while himself in prison: *Causes secrètes de la Révolution du 9 au 10 thermidor . . .* (Paris: Baudoin Frères, 15 Vendémiaire III [1794]); *Continuation des causes secrètes . . .* (Paris: Baudoin Frères, 25 Brumaire III [1794]); *Mystères de la mère de Dieu dévoilés* (Paris: Baudoin Frères, 8 Pluviôse III [1795]). Alphonse Dunoyer, *Fouquier-Tinville, Accusateur public du Tribunal révolutionnaire, 1746–1795* (Paris: Perrin, 1913), 190–408, covers the trial itself.

48. *Liste générale et très-exacte, des noms, âges, qualités et demeures de tous les Conspirateurs qui ont été condamnés à mort par le Tribunal Révolutionnaire . . .* , 10 issues (Paris: Marchand, Berthé, Channaud, 1793–95) covered from 17 August 1792 to 11 Brumaire III (1 November 1794). A supplement (issue 11), which covered the period until the court ceased operations on 31 May 1795, raised the total to 2,807 *guillotinés*.

49. On 12 Ventôse III (2 March 1795), the deputy Armand Guffroy presented the Convention with *Les secrets de Joseph Le Bon et de ses complices, deuxième censure républicaine* (Paris: Guffroy, an III [1795]), which ran to over six hundred pages.

50. Louis-Eugène Poirier and Montgey notably published *Les angoisses de la mort, ou idées des horreurs des prison d'Arras* (Paris: Marchands de nouveautés, Thermidor II [1794]; 2nd ed. augmented, an III [1795]); *Idées des horreurs des prisons d'Arras, ou les crimes de Joseph Lebon et de ses agens* (Paris: Marchands de nouveautés, an III [1794]); *Atrocités commises envers les citoyennes ci-devant détenues dans la maison d'arrêt dite de la Providence à Arras, par Joseph Lebon et ses adhérens* (Paris: Marchands de nouveautés, Nivôse III [1794]). During the trial, Poirier added *Le dernier gémissement de la humanité, contre Jh. Lebon et complices adressé à la Convention nationale* (Paris: Marchands de nouveautés, Messidor III [1795]). Le Bon himself noted the success of this literature, which inspired a preassembled crowd to mock him during his transfer to prison, saying, "Go, villain, go, they will give you women to enjoy, then guillotine them afterwards. Oh, the monster!" *Joseph Le Bon à la Convention nationale, lettres justificatives* (Paris: Imprimerie nationale, an III), lettre 1, note 2. See also Ronen Steinberg, "Terror on Trial: Accountability, Transitional Justice, and the Affaire Le Bon in Thermidorian France," *French Historical Studies* 39 (2016): 419–44.

51. A few right-wing journalists acted in concert to help define and dismantle the Terror, but even a participant in this group admitted the powerful influence of publicists outside his circle. Charles de Lacretelle, *Dix années d'épreuves pendant la Révolution* (Paris: Allouard, 1842), 198–208.

52. These included the *Courier patriotique* (Grenoble), the *Courrier de Calais*, the *Chronique de Bordeaux*, and the *Journal du Club national de Bordeaux*, which changed its title in year III to *Feuille de Bordeaux*. Feyel, *Dictionnaire de la presse française*, 1:409; 2:281; 4:185–86, 227–28, 322–43.

53. The politics of *L'Anti-terroriste* (Toulouse) are obvious, but despite innocuous titles, the following had a similar bias: the *Journal de Lyon*, the *Journal de Bordeaux*, the *Observateur de l'Europe* (Rouen), the *Strassburger Kurier*, the *Décadaire marseillais* (renamed the *Courrier de Marseilles*), and the even more strident *Journal de Marseilles*. Most of the editors had suffered personally during 1793–94 and used their newspapers to blacken that regime. Feyel, *Dictionnaire de la presse française*, 1:93–94, 257, 343; 3:408, 5:519–20, 528–29; Gough, *Newspaper Press*, 120–23.

54. On the politics of individual papers, see Feyel, *Dictionnaire de la presse française*, 1:409 (Grenoble); 2:81 (Calais), 242 (Reims), 262 (Arras), 338–39 (Aurillac); 3:6 (Brest), 167–68 (Dijon), 392 (Vesoul), 444 (Figeac); 5:306–7 (Montargis), 596 (Avignon), 606–7 (Nice).

55. Quotes from Feyel, *Dictionnaire de la presse française*, 2:339; 3:305, 249.

56. Bernard Bodinier, "Un département sans Terreur sanguinaire: L'Eure en l'an II," in Biard, *Les politiques de la Terreur*, 111–26.

57. According to François-Antoine de Boissy d'Anglas, his home department of the Ardèche "had escaped *as if by miracle* the crimes of the men of blood" (emphasis added). *Réimpression de l'ancien Moniteur*, 22:701.

58. AN DIII 102, d. 17, petition from Jean Gauzan describes "l'atrocité du jugement rendu" against him; AN DIII 104, d. 28, petition from Jean-Edmont Serres describes a verdict "rendu révolutionnairmement, c'est-à-dire atrocement."

59. Ronen Steinberg, "Reckoning with the Terror: Retribution, Redress, and Remembrance in Post-Revolutionary France," in *The Oxford Handbook of the French Revolution*, ed. David Andress (Oxford: Oxford University Press, 2014), 487–502.

60. Bronislaw Baczko describes them as "a new Thermidorian literary genre." "Les peurs de la Terreur," in *La peur au XVIIIe siécle: Discours, représentations, pratiques*, ed. Jacques Berthtold and Michel Porret (Geneva: Droz, 1994), 69–86, quote from 84. See also Julia V. Douthwaite, *The Frankenstein of 1790 and Other Lost Chapters from Revolutionary France* (Chicago: University of Chicago Press, 2012), chap. 4. Nonetheless, there were antecedents in the Enlightenment, and even in the early Revolution, with the publication of *La Bastille dévoilée, ou Recueil des pièces authentiques pour servir à son histoire*, 3 vols. (Paris: Desenne, 1789). I am grateful to Jeffrey Freedman for his observations on this chapter and providing me with a manuscript version of his article "The Dangers Within: Fears of Imprisonment in Enlightenment France," *Modern Intellectual History* 14 (2017): 339–64.

61. Honoré Riouffe, *Mémoires d'un détenu, pour servir à l'histoire de la tyrannie de Robespierre*, 2nd ed. (Paris: Mathé, Louvet, an III [1795]), v.

62. *Almanach des prisons* (Paris: Michel, an III [1794–95]), Avertissement de l'éditeur.

63. Philippe-Edme Coittant, *Tableau des prisons de Paris, sous le règne de Robespierre Pour servir de suite de l'Almanach des prisons . . .* (Paris: Michel, an III [1794]); *Second tableau des prisons de Paris . . .* (Paris: Michel, an III [1795]); and *Troisième tableau des prisons de Paris . . .* (Paris: Michel, an III [1795]). As Coittant explained to readers in the *avertissement* (p. 3) to *Tableau des prisons de Paris*, "Our goal, after publishing the *Almanach des prisons*, was to produce a complete work on all the bastilles that covered the soil of Paris, but the public's curiosity, which seeks to know immediately the smallest details about the victims of the petty tyrants who devastated France, as well as the horrors to which they fell prey, prevented us from undertaking such an immense task."

64. Anne Coudreuse, *Le goût des larmes au XVIIIe siècle* (Paris: Presses Universitaires de France, 1999), esp. 8–9.

65. P.-J.-B. Nougaret, *Histoire des prisons de Paris et des départements*, 4 vols. (Paris: L'Éditeur, an V [1797]), 1:3. See also A.-F. Delandine, *Tableau des prisons de Lyon, pour servir à l'histoire de la tyrannie de 1792 et 1793* (Paris: Daval, 1797), 3: "As for me, I only want to recall precious memories and console myself with soft tears over the pains

I suffer. Even in my prison, I want to soften them by describing them. My heart holds no desire to call for the punishment and massacre of men who were often more misled than guilty."

66. Hector Fleischmann, *Les prisons de la Révolution* (Paris: Publications modernes, 1908), 16, notes that the merits of these accounts came from having the "charm of reality" as well as the "sensibility of the period, in the sentimentalist manner of Jean-Jacques Rousseau," which moved contemporaries emotionally, even though they "often seem ridiculous" a few generations later.

67. Guffroy, *Les secrets de Joseph Le Bon et de ses complices.*

68. See Jean-Clément Martin, "Dénombrer les victimes de la Terreur: La Vendée et au-delà," in Biard and Leuwers, *Visages de la Terreur*, 155–65. Vasselin, *Mémorial révolutionnaire de la Convention*, 3:246, calculated that two million Frenchmen had been imprisoned and that five hundred thousand had died violently.

69. *Proscription d'Isnard* (Paris: Marchand de nouveautés, an III [1794]), 41–43; *Réimpression de l'ancien Moniteur*, 23:618 (issue of 18 Ventôse III [8 March 1795]).

70. However, Howard G. Brown, "Robespierre's Tail: The Possibilities of Justice after the Terror," *Canadian Journal of History* 45 (2010): 503–36, combines both perspectives.

71. André Morellet, *Le cri des familles, ou Discussion d'une motion faite à la Convention nationale, par le représentant du peuple Lecointre, le 22 frimaire de l'an troisième de la République, relativement à la révision des jugemens des tribunaux révolutionnaires* (Paris, an III [1795]). See also *Mémoires de l'abbé Morellet de l'Académie française sur le dix-huitième siècle et sur la Révolution* [1821], ed. Jean-Pierre Guicciardi (Paris: Mercure de France, 1988), 399–400.

72. Luzzatto, *L'automne de la Révolution*, 170, astutely connects Boissy d'Anglas's speech to Morellet's pamphlet, but overstates the relationship ("Boissy took everything from Morellet, the title, the tone, the arguments").

73. *Réimpression de l'ancien Moniteur*, 24:22–24 (30 Ventôse III [20 March 1795]) is the source of all subsequent quotations.

74. The survivors among seventy-two Girondin deputies who had been imprisoned for protesting the events of 2 June 1793 regained their seats in the National Convention in November 1794, and twenty-three other Girondin leaders were reinstated in March 1795.

75. Cecilia Feilla, *The Sentimental Theater of the French Revolution* (Farnham: Ashgate, 2013), 12, distinguishes between sensibility and sentimentalism: "Sensibility was the intuitive capacity for immediate moral and aesthetic responsiveness to others, and particularly to the suffering of others. Humanity, pity, and tenderness were among its privileged terms. 'Sentimental' [refers] by contrast, to a set of aesthetic conventions and practices aimed at eliciting and directing sensibility."

76. David Denby, *Sentimental Narrative and the Social Order in France, 1760–1820* (Cambridge: Cambridge University Press, 1994), 154. Denby views "misfortune" and the "status of a victim" as crucial to the sentimental novel (13, 71) and the preoccupation with the interior life as a key characteristic of sentimentalism (25, 29).

77. Pierre Trahard, *La sensibilité révolutionnaire (1789–1794)* (Paris: Boivin, 1936) emphasizes the tension between *sensibilité* and revolutionary violence. Denby, *Sentimental Narrative*, esp. 139–65, broadens the discussion. See also Vincent-Buffault, *The History of Tears*, 77–96.

78. Denby, *Sentimental Narrative*, 3, explicitly makes this claim.

79. David Andress, "Living the Revolutionary Melodrama: Robespierre's Sensibility and the Creation of Political Commitment in the French Revolution," *Representations* 114 (Spring 2011): 103–28.

80. This conclusion may have been drawn from contemporary critics of the Revolution who "saw [the Terror] as the result of artificial and ultimately inhumane sensibility exalted throughout the century." Coudreuse, *Le goût des larmes*, 6.

81. Reddy, *Navigation of Feeling*, quotes from 200 and 194 respectively.

82. Anne C. Vila, *Enlightenment and Pathology: Sensibility in the Literature and Medicine of Eighteenth-Century France* (Baltimore: Johns Hopkins University Press, 1996), 2–3.

83. Quotations here are excerpts from longer texts in Denby, *Sentimental Narrative*, 152, 155.

84. Both quotations are from Trahard, *La sensibilité révolutionnaire*, 84–85.

85. Madame de Staël, *De l'influence des passions sur le bonheur des individus et des nations* (1796), 252, quoted in French in Denby, *Sentimentalist Narrative*, 198. Martin, *La France abimée*, 165–74, provides evidence of revolutionaries suppressing displays of pity or compassion. Moreover, contemporaries were fully attuned to this tension: a theatrical production in Lille in 1795, *Encore un Brutus, ou le tribunal révolutionnaire de Nantes*, included the line, "What will become of humanity if pity and sensibility are crimes?" Feilla, *Sentimental Theater*, n. 120.

86. See Trahard, *La sensibilité révolutionnaire*, 100–132. Sophie Rosenfeld, "Thinking about Feeling, 1789–1799," *French Historical Studies* 32 (2009): 697–706, surveys research on emotions during the French Revolution.

87. Reddy, *Navigation of Feeling*, 196–97.

88. "Continually repulsed by crime, intrigue and ignorance, I was soon put in irons; I carried them with pride: the time had come when it was shameful to be spared." Coittant, *Tableau des prisons*, 192.

89. Charlotte Biggs noted all the symbols of patriotism displayed in a chateau where she was a guest and "went to bed ruminating on the improvements which the revolution must have occasioned in the art of dissimulation. Terror has drilled people of the most opposite sentiments into such an uniformity of manner and expression, that an aristocrat who is ruined and persecuted by the government, is not distinguishable from the Jacobin who had made his fortune under it." *Residence in France*, 2:319.

90. Reddy, *Navigation of Feeling*, 208.

91. *Réimpression de l'ancien Moniteur*, 22:721–22 (20 Frimaire III [10 December 1794]). "You owe a gesture of humaneness (*regard d'humanité*) to the widows and orphans of the unfortunate victims sacrificed to the passion of these modern Neros. Their pleas will penetrate your hearts, and they will rediscover in the organs of justice the beloved beings they lament."

92. Denby, *Sentimental Narrative*, 4.

93. Jean-Louis Halpérin, "Les décrets d'annulation des jugements sous la Convention," in *La Révolution et l'ordre juridique privé: Rationalité ou scandale?*, ed. Michel Vovelle (Orléans: CNRS, 1988), 457–68.

94. Général Herlaut, "Les certificats de civisme," *Annales historiques de la Révolution française*, no. 90 (1938): 481–536. The entangling of suspicion and emotion in this period is revealed by the Paris Commune's directive denying *certificats de civisme*

to individuals who "mysteriously speak about the Republic's misfortunes, taking pity on the people's fate, and [who] are always ready to spread bad news with an affected sadness" (516).

95. Richard Cobb, "Thermidor or the Retreat from Fantasy," in *History and Imagination: Essays in Honor of H. R. Trevor-Roper*, ed. Hugh Loyd-Jones, Valerie Pearl, and Blair Worden (London: Holmes & Meier, 1982), 272–95, provides a brilliant, tongue-in-cheek critique of the process of reviewing civic conduct, which exposes the extent to which public life and private life were brutally juxtaposed as ultimately antithetical, rather than compatible: " 'Where were you on the 10 August?'—'I was fishing on the Petit Morin'—*Out*—'I had gone to the funeral of my mother-in-law'—*fail*, . . . 'What were you before the Revolution?'—'A valet'—*fail* . . . 'Where were you on May 31?'—'I was in bed with a prostitute'—*fail and expulsion*," etc. (292).

96. Lise Andries, "Récits de survie: Les mémoires d'autodéfense pendant l'an II et l'an III," in *La Carmagnole des Muses: L'homme de lettres et l'artiste dans la Révolution*, ed. Jean-Claude Bonnet (Paris: Colin, 1988), 261–73.

97. Many of these printed texts, especially those produced by prominent figures in the Revolution, can be found in libraries; even more were produced in limited quantities and can only be found in archival collections alongside manuscript versions. Two series among the papers of the Legislation Committee of the National Convention (AN DIII 1–308 and BB30 90–113) indicate that manuscript and printed *mémoires justificatifs* overlapped considerably in style and content. Although having one's autodefense printed, and therefore more easily circulated among the public, tended to indicate prosperity, wealth alone did not determine publication.

98. Quoted in Andries, "Récits de survie," 273.

99. Sara Maza, *Private Lives and Public Affairs: The "Causes Célèbres" of Pre-Revolutionary France* (Berkeley: University of California Press, 1993).

100. This, too, may have been inspired by the culture of sensibility; after all, sentimental novels had taught how exposing an individual's inner life, especially one who had suffered misfortune, could provide the basis for almost universal empathy.

101. AN DIII 102, d. 17. André Toebarts, who had been condemned to death at Bordeaux, but whose brother had been mistakenly executed in his place, had dozens of prominent neighbors sign a carefully worded statement of his identity in order to recover his own property. AN DIII 99, d. 4. See also Alex Fairfax-Cholmeley, "Defence, Collaboration, Counter-Attack: The Role and Exploitation of the Printed Word by Victims of the Terror, 1793–1794," in Andress, *Experiencing the French Revolution*, 137–54.

102. It is worth noting that this approach actually produced results. For example, in response to the *Mémoire justificatif pour Jean-Baptiste Saint-Julien . . . condamné à la peine de la déportation à vie*, the Legislative Commission annulled the verdict by explaining, in part, "that he had always been an example of civic duty to his fellow citizens and that he always enjoyed the confidence of the people of Cahuzac and of Tasque." AN BB30 113, directive of 2 Messidor III (20 June 1795).

103. AN DIII 112, d. 12.

104. AN DIII 106, letter from J.-L. A. Juin, 1 Vendémiaire IV (23 September 1795).

105. AN DIII 99, d. 1.

106. Eleven issues averaging a dozen pages each were published between January and June 1795. All of the evidence here comes from the extraordinarily detailed

article on this ephemeral publication by Gilles Feyel in his *Dictionnaire de la presse française*, 5:312–37.

107. *Réimpression de l'ancien Moniteur*, 24:24 (30 Ventôse III [20 March 1795]).

108. *Réimpression de l'ancien Moniteur*, 24:190 (21 Germinal III [10 April 1795]).

109. Albert Mathiez, *After Robespierre: The Thermidorian Reaction*, trans. Catherine Alison Philips (New York: Knopf, 1931), 178–80, 220.

110. J. B. Duvergier, *Collection complète des loix, décrets, ordonnances, règlements, et avis du Conseil d'État*, 33 vols. (Paris: Éditions officielles du Louvre, 1834), 8:168–70, 329–30.

111. Law of 28 Thermidor III (15 August 1795), *Réimpression de l'ancien Moniteur*, 25:406–7. A total of 134 tribunals, courts, and commissions had condemned to death using "revolutionary procedures" at least 16,500 individuals between 10 March 1793 and the end of July 1794. Greer, *Incidence of the Terror during the French Revolution*. The number of those condemned to other sentences, such as fines, deportation, imprisonment until the peace, etc., remains unknown, but it surely doubled the number of official "victims" as defined by the law of 21 Prairial III (9 June 1795).

112. AN DIII 105, dos. 3, shows that some magistrates used this as the basis for prosecutions until the amnesty of 4 Brumaire IV.

113. Brown, "Robespierre's Tail," 509–16, describes the complexities of this process.

114. The ceremony took place on the second anniversary of the uprising against the local *sans-culotte* administration of Châlier on 29 May 1793. The fullest description is Alphonse Balleydier, *Histoire politique et militaire du peuple de Lyon*, 3 vols. (Lyon: L. Curmer, 1845–46), 3:135–43. There was also a "fête de la réhabilitation de Bédoin" held on 15 Floréal III (4 May 1795): Le Gallo, "L'affaire Bédoin," 310.

115. On the role of vengeance in national politics after Thermidor, see Bronislaw Baczko, "Une passion thermidorienne: La revanche," in his *Politiques de la Révolution française*, 165–338.

116. Michel Vovelle, "Massacreurs et massacrés: Aspects sociaux de la contre-révolution en Provence après Thermidor," in *Les résistances à la Révolution*, ed. François Lebrun and Roger Dupuy (Paris: Imago, 1987), 141–50. Some local Thermidorians took it upon themselves to publish lists of such potential targets. See the infamous pamphlet *La liste générale des dénonciateurs et des dénoncés, tant dans la ville de Lyon que des communes voisines et de celles de divers départements* (Lausanne: Société typographique, 1795), and *L'Observateur à Rouen*, as quoted in Feyel, *Dictionnaire de la presse française*, 1:90.

117. Colin Lucas, "Themes in Southern Violence after 9 Thermidor," in *Beyond the Terror: Essays in French Regional and Social History, 1794–1815*, ed. Colin Lucas and Gwynne Lewis (Cambridge: Cambridge University Press, 1983), 152–94; D. M. G. Sutherland, *The Chouans: The Social Origins of Popular Counter-Revolution in Upper Brittany, 1770–1796* (Oxford: Oxford University Press, 1982) and *Murder in Aubagne: Lynching, Law and Justice during the French Revolution* (New York: Cambridge University Press, 2009).

Colin Lucas, "Les thermidoriens et les violences de l'an III," in *1795: Pour une république sans Révolution*, ed. Roger Dupuy and Marcel Morabito (Rennes: Presses universitaires de Rennes, 1996), 39–48, explores the relationship between Thermidorian tropes and antirevolutionary violence in 1795 and thereafter.

118. Quoted in Baczko, "Une passion thermidorienne," 226.

119. Armand-Gaston Camus in Council of 500 on 15 Floréal IV (4 May 1796), *Le Moniteur*, an IV, 919.

120. AN DIII 94, d. 6. Note that Maury included a certificate of civic conduct as well as attestations from other officers in his battalion.

121. AN DIII 94, d. 6.

122. For most of this paragraph, see Brown, "Robespierre's Tail." For more on the inability of the amnesty to achieve cultural closure, see Megan Anne Donaldson, "The Remains of Revolution: Representations of Mass Violence in the Aftermath of the Vendée, 1794–99" (BA honors thesis, University of Melbourne, 2006), 32–33.

123. [Biggs], *Residence in France*, 2:440.

124. For an introduction to this work, see Joseph Zizek, " 'Plume de fer': Louis-Marie Prudhomme Writes the French Revolution," *French Historical Studies* 26 (2003): 619–60.

125. *Chronique de la Sarthe*, 24 Brumaire VI (14 November 1798). See the Jacobin broadsheet reproduced in Walter Grab, *The French Revolution: The Beginning of Modern Democracy* (London: Bracken, 1989), 142.

126. "Massacre arrivée à Montpellier," anonymous engraving, BNF, QB-1 (1798–02–03)-FOL.

127. AN F^7 7447, B5 8421; Laurent Dubois, *Avengers of the New World* (Cambridge, Mass.: Harvard University Press, 2005); *L'Accusateur public*, 3rd issue, 9.

128. Béatrice Didier, *Écrire la Révolution, 1789–1799* (Paris: Presses Universitaires de France, 1989), 275.

129. Eugen Weber, *Peasants into Frenchmen: The Modernization of Rural France, 1870–1914* (Stanford, Calif.: Stanford University Press, 1976).

4. The Paris Commune and the "Bloody Week" of 1871

1. Most recently, John Merriman, *Massacre: The Life and Death of the Paris Commune* (New York: Basic Books, 2014), esp. 61–62.

2. Jean Dubois, *Le vocabulaire politique et social en France de 1869 à 1872* (Paris: Larousse, 1962), 14–23, 37–44.

3. Jacques Rougerie, *Procès des Communards* (Paris: Julliard, 1964), 126–32, claimed that the "quasi-totality" of those arrested for supporting the Commune were wage earners, even while stating that they were "neither true artisans, nor true proletarians" and composed "an intermediary type of working class." His later research turned "quasi-totality" into "three-quarters" of supporters (*Paris libre, 1871* [Paris: Seuil, 1971; rev. ed., 2004], 259). However, this figure dubiously includes *domestiques* (domestic servants), *concierges* (building caretaker-managers), and *employés* (office clerks). If these last three categories are excluded, workers constitute only 65 percent of those arrested and 51 percent of those convicted.

4. Alain Cottereau, "The Distinctiveness of Working-Class Cultures in France, 1848–1900," in *Working-Class Formation: Nineteenth-Century Patterns in Western Europe and the United States*, ed. Ira Katznelson and Aristide R. Zolberg (Princeton, N.J.: Princeton University Press, 1986), 111–54, provides some powerful counterarguments to linear and teleological thinking about the emergence of "working-class

consciousness." See also Jacques Rougerie, "Le peuple de 1870/1871," in *Paris le Peuple, XVIII^e–XX^e siècle*, ed. Jean-Louis Robert and Danielle Tartakowsky (Paris: Sorbonne, 1999), 156. William Serman, *La Commune de Paris (1871)* (Paris: Fayard, 1986), 302, summarizes workers' attitudes during the Commune itself: "Workers at war do not think like producers. Mostly unemployed, they react as fighters and consumers."

5. Robert Gildea, *The Past in French History* (New Haven, Conn.: Yale University Press, 1996), 44–45. Bertrand Taithe, *Citizenship and Wars: France in Turmoil, 1870–71* (London: Routledge, 2001), emphasizes that later histories of the Commune largely determined its significance (78) and that "the socialism of the Communards was retrospective rather than prospective" (165).

6. Robert Tombs, "How Bloody Was *la semaine sanglante* of 1871? A Revision," *Historical Journal* 55 (2012): 679–704, extends the mythologizing of the violence of the Commune to major historians without socialist leanings, and states, "What needs to be explained [is] the creation of a traumatic and yet inspiring *myth* of violence going far beyond reality. . . . It is the creation of myth, not the suppression of memory, that is the issue" (700).

7. Roger Gould, *Insurgent Identities: Class, Community, and Protest in Paris from 1848 to the Commune* (Chicago: University of Chicago Press, 1995).

8. Louis Chevalier, *La formation de la population parisienne au XIX^e siècle* (Paris: Presses Universitaires de France, 1950), 152–53, advised historians to pay attention to the diversity of trajectories from different provincial locales, some long established as sources of immigration to Paris, as well as to the great difference that occupational experience made to social integration in the city.

9. Catherine Bonvalet and Yves Tugault, "Les racines du dépeuplement de Paris," *Population* 39 (1984): 463–81, esp. 463–68.

10. Martin Phillip Johnson, *The Paradise of Association: Political Culture and Popular Organizations in the Paris Commune of 1871* (Ann Arbor: University of Michigan Press, 1996).

11. About 30 percent of the three thousand companies of national guardsmen in Paris at the time adhered to the National Guard Federation (i.e., supported the Commune), but the rate of adherence varied enormously, ranging from only 1 percent of companies in the 8th arrondissement (furthest west) to 82 percent of companies in the 20th arrondissement (furthest east). Gérard Jacquemet, *Belleville au XIX^e siècle: Du faubourg à la ville* (Paris: Éditions de l'École des hautes études en sciences sociales, 1984), 180.

12. Roger Gould, "Multiple Networks and Mobilization in the Paris Commune," *American Sociological Review* 56 (1991): 716–29.

13. John Milner, *Art, War and Revolution, 1870–1871: Myth, Reportage and Reality* (New Haven, Conn.: Yale University Press, 2000), 104–5.

14. Gould, *Insurgent Identities*, esp. 187.

15. Nathalie Jakobowicz, "Les figures du peuple de Paris au XIX^e siècle," in *Le peuple parisien au XIX^e siècle entre sciences et fictions*, ed. Nathalie Preiss, J.-M. Privat, and J.-C. Yon (Strasbourg: Presses universitaires de Strasbourg, 2013), 29–43.

16. Quentin Deluermoz, *Policiers dans la ville: La construction d'un ordre public à Paris, 1854–1914* (Paris: Sorbonne, 2012), 43, notes the numerous vigilante assaults provoked by the rapacity of landlords and the brutality of the police.

17. Three-quarters of those arrested as Communards were born in the provinces. Rougerie, *Procès des Communards*, 126.

18. Rougerie, *Paris libre, 1871*, i–ii.

19. Laure Godineau, *La Commune de Paris par ceux qui l'ont vécue* (Paris: Parigramme, 2010), 129–39.

20. Dubois, *Le vocabulaire politique et social*, 192; Steven Lukes, *Individualism* (New York: Harper & Row, 1973), 3–16. Alexis de Tocqueville noted in *De la démocratie en Amérique*, published in 1835, how rare the word *individualisme* was at the time. Charly Coleman, *The Virtues of Abandon: An Anti-Individualist History of the French Enlightenment* (Stanford, Calif.: Stanford University Press, 2014), 291. Coleman's larger antiteleological analysis is premised on ideas about the self and individualism being inextricably entangled as personal subjectivity.

21. David Harvey, *Paris, Capital of Modernity* (New York: Routledge, 2003) helpfully integrates the social, cultural, and physical transformations of the city in the three decades after 1848.

22. David P. Jordan, *Transforming Paris: The Life and Labors of Baron Haussman* (New York: Free Press, 1995), esp. 348–49.

23. Jeanne Gaillard, *Paris, la ville (1852–1870)* (Paris: Honoré Champion, 1976), 139–42.

24. Jacquemet, *Belleville au XIXᵉ siècle*, esp. 186, 381; Chevalier, *La formation de la population parisienne*, 245–46.

25. In addition to the works of Gaillard and Jacquemet, see the rich overview in Serman, *La Commune de Paris*, 31–48.

26. Anthony Giddens, *Modernity and Self-Identity: Self and Society in the Late Modern Age* (Stanford, Calif.: Stanford University Press, 1991), 80–88, is especially insightful on the importance of life plans and lifestyles in developing the self.

27. Fabrice Laroulandie, *Ouvriers de Paris au XIXᵉ siècle* (Paris: Christian, 1997), 117–20, 124–39, 153–55.

28. See the chapter "Déchristianization ouvrière?," in Gérard Cholvy and Yves-Marie Hilaire, *Histoire religieuse de la France contemporaine, 1800–1880* (Toulouse: Privat, 1985), 235–58.

29. Theodore Zeldin, *France, 1848–1945*, 2 vols. (Oxford: Oxford University Press, 1977), 2:794.

30. *La Presse*, 2 February 1862 (feuilleton), quoted in Baron Sirtéma de Grovestins, *IIIᵉ et IVᵉ lettres d'un Bénédictin* (Paris: Dentu, 1862), 16.

31. On initial responses to *Les Misérables*, see Pierre Malandain, "La réception des 'Misérables' ou 'Un lieu ou des convictions sont en train de se former,'" *Revue d'histoire littéraire de la France* 86 (1986): 1065–79, and Jean-Marc Hovasse, *Victor Hugo*, vol. 2, *Pendant l'exil (1851–1864)* (Paris: Fayard, 2001), 699–725.

32. Mario Proth, *Le mouvement à propos des "Misérables"* (Paris: Castel, 1862), 13, 19.

33. That said, *Les Misérables* followed the path first cut by the hugely successful *Les Mystères de Paris* (1842–43) by Eugène Sue.

34. Hovasse, *Victor Hugo*, 703; Malandain, "La réception des 'Misérables,'" 1073.

35. *La Presse*, 2 April 1862.

36. Jan Goldstein, *The Post-Revolutionary Self: Politics and Psyche in France, 1750–1850* (Cambridge, Mass.: Harvard University Press, 2005), esp. 171–232. Goldstein also

notes, however, that the Cousinian concept of the a priori self that came to dominate French *lycées* did not logically require the exclusion of workers or women (316–24). Moreover, Charles Renouvier's concept of an affective republican self ("a cerebral synergy, always relative and incomplete") formed in individuals who were able to choose personal beliefs and to will personal action, including women and workers. Alice Bullard, *Exile to Paradise: Savagery and Civilization in Paris and the South Pacific, 1790–1900* (Stanford, Calif.: Stanford University Press, 2000), 98–120, quote from 111.

37. On the distinctiveness of Pepys's diary, see Claire Tomalin, *Samuel Pepys: The Unequalled Self* (London: Viking, 2002), esp. 78–84. The seven works in Mark Traugott, *The French Worker: Autobiographies from the Early Industrial Era* (Berkeley: University of California Press, 1993), have an entirely different tone and reveal little evidence of sustained introspection.

38. *Rapport d'ensemble de m. le général Appert sur les opérations de la justice militaire relatives à l'insurrection de 1871* (Versailles: Cerf et fils, 1875).

39. Gould, *Insurgent Identities*, 177–78.

40. BHVP, MS 1130, fol. 89.

41. This did not prevent psychiatrists and novelists alike from trying to forge links between individual and collective madness. See Catherine Glazer, "De la Commune comme maladie mentale," *Romantisme* 48 (1985): 63–70.

42. "The animal degradation of its poor, on the border-lines of starvation and crime, appeared as a constant menace to bourgeois society," writes Zeldin, *France, 1848–1945*, 1:736.

43. Jean-François Lecaillon, *La Commune de Paris racontée par les Parisiens* (Paris: Bernard Giovanangeli Editeur, 2009), 207–9.

44. Paul Vignon, *Rien que ce que j'ai vu! Le Siège de Paris—La Commune* (Paris: E. Capiomont, 1913), esp. 178–80, 184–85, 192–93.

45. BHVP, MS 1129, fol. 39. Prosper-Olivier Lissagaray, *L'histoire de la Commune de 1871* (Paris, rev. ed. 1896; Maspero, 1982), 392, states that "a large number of bosses" sought to obtain the release of employees. At the time, "90% of bosses had fewer than 10 employees, 80% fewer than 4." Laroulandie, *Ouvriers de Paris*, 37.

46. Paul Lidsky, *Les écrivains contre la Commune* (Paris: Maspero, 1970), among others.

47. Bertrand Tillier, *La Commune de Paris: Révolution sans images?* (Paris: Champ Vallon, 2004), 68, notes how common this title was for works published in 1871–72, as well as how inexpensive many of these were, which indicates that their market included ordinary artisans.

48. Tillier, *La Commune de Paris*, 397–403; Jeannene M. Przyblyski, "Moving Pictures: Photography, Narrative, and the Paris Commune of 1871," in *Cinema and the Invention of Modern Life*, ed. Leo Charney and Vanessa R. Schwartz (Berkeley: University of California Press, 1995), 253–78.

49. Augustine Malevina Blanchecotte, *Tablettes d'une femme pendant la Commune* (Paris: Didier, 1872), 307–8, 352–60.

50. [A.-J. Coquerel], *Sous la Commune: Récit et souvenirs d'un parisien* (Paris: Dentu, 1873), 109–10, 31.

51. Richard B. Grant, "Edmond de Goncourt and the Paris Commune," in *Revolution and Reaction: The Paris Commune, 1871*, ed. John Hicks and Robert Tucker (Manchester: Manchester University Press, 1973), 177–78.

52. Catulle Mendès, *Les 73 journées de la Commune* (Paris: Lachaud, 1871), 327–28. See also the mix of hostility and pity expressed by Théophile Gautier, *Tableaux de siège: Paris, 1870–1871* (Paris: Charpentier et Fasquelle, 1871), 243–45.

53. Flora Groult, preface to Geneviève Bréton, *Journal, 1867–1871* (Paris: Éditions Ramsay, 1985), 9.

54. Bréton, *Journal*, 226–43.

55. Roger Pérennès, *Déportés et forçats de la Commune: De Belleville à Nouméa* (Nantes: Ouest Éditions, 1991), 49.

56. Lecaillon, *La Commune de Paris*, 13. On the opposing traditions that prevented such a perspective from emerging earlier, see Éric Fournier, *"La Commune n'est pas morte": Les usages politiques du passé, de 1871 à nos jours* (Paris: Libertalia, 2013).

57. Rupert Christiansen, *Paris Babylon: The Story of the Paris Commune* (New York: Viking, 1994), 373. Robert Tombs, *The War against Paris, 1871* (Cambridge: Cambridge University Press, 1981), provides a detailed account of the areas of the city that saw significant fighting.

58. A word on terminology is in order. First, the French army's Reffye *mitrailleuse* closely resembled the Gatling gun used in the American Civil War, so much so that a contemporary account described the French army using "les grosses *gatling*" ([Coquerel], *Sous la Commune*, 106). Second, *pétrole* is too often translated as petrol (i.e., gasoline) but was, in fact, kerosene, which became a common fuel for illumination in the 1860s. Kerosene was notoriously dangerous and became symbolic of the Commune's deliberate destructiveness. Eric Fournier, *Paris en ruines: Du Paris haussmannien au Paris communard* (Paris: Imago, 2008), 153–56.

59. Stephen Bann, *Distinguished Images: Prints in the Visual Economy of Nineteenth-Century France* (New Haven, Conn.: Yale University Press, 2013), 89–92.

60. Michèle Martin, *Images at War: Illustrated Periodicals and Constructed Nations* (Toronto: University of Toronto Press, 2006), 25–29.

61. Marie-Laure Aurenche, "Du *Magasin pittoresque* (1833) à *L'Illustration* (1843): La naissance du nouvellisme illustré," in *Presse et Plumes: Journalisme et littérature au XIX^e^ siècle*, ed. Marie-Ève Thérenty and Alain Vaillant (Paris: Nouveau Monde, 2004), 169–84. *L'Illustration* reached a national circulation of thirty-five thousand (twelve thousand by subscription) in 1848. Its principal editor, Alexandre Paulin, contributed mightily to the history and memory of the revolutions of 1848 as a European phenomenon by publishing (in ten deliveries of ten installments each) *Journées illustrées de la révolution de 1848: Récit historique de tous les événements* (Paris: L'Illustration, 1849), which included six hundred images, most of them previously unpublished in France. Jean-Pierre Bacot, *La presse illustrée au XIX^e^ siècle: Une histoire oubliée* (Limoges: Presses universitaires de Limoges, 2005), 56–57.

62. Lithographic images were considerably more expensive to produce than wood engravings, and the techniques needed to reproduce a photograph in a newspaper as photogravures were not fully developed until the 1880s. Paul Jobling and David Crowley, *Graphic Design: Reproduction and Representation since 1800* (Manchester: Manchester University Press, 1996), 19–28.

63. Bacot, *La presse illustrée au XIX^e^ siècle*, 56–62. Hélène Puiseux, *Les figures de la guerre: Représentations et sensibilités, 1839–1996* (Paris: Gallimard, 1997), 61–97, examines the role of illustrated newspapers in reporting the Crimean War (1854–55), thereby giving birth to the modern journalism of war.

64. Quoted in Bacot, *La presse illustrée au XIX^e siècle*, 80.

65. Bann, *Distinguished Images*, 13–14, 98–100, makes this point about lithography, but it applies even more strongly to the impact of illustrated newspapers.

66. "We can speak of a mass culture with the creation of *Le Petit Journal* in 1863 by Moise Millaud, sold at one sou (5 centimes), which reached spectacular print runs: 260,000 copies a day by the end of 1865." Laroulandie, *Ouvriers de Paris*, 160.

67. Martin, *Images at War*, 25–29; Bacot, *La presse illustrée au XIX^e siècle*, 114–22, 137–38; BHVP 10035.

68. Martin, *Images at War*, 113–14.

69. Gustave Lefrançais, *Étude sur le mouvement communaliste à Paris en 1871* (Paris: Éditions d'Histoire Sociale, 1968 [facsimile reprint of Neuchâtel: Guillaume fils, 1871]), 349–50.

70. Lefrançais, *Étude*, 349. His full description makes it clear that he is recalling an engraving published in London by *The Graphic* on 10 June 1871.

71. Quoted in Ouriel Reshef, *Guerre, mythes et caricature: Au berceau d'une mentalité française* (Paris: Fondation Nationale des Sciences Politiques, 1984), 5.

72. Lissagaray, *L'histoire de la Commune*, 391.

73. See in particular Milner, *Art, War and Revolution in France*, 49–50.

74. *L'Illustration*, May 1871.

75. See Robert Tombs, "Communeuses," *Violences, Sociétés et Représentations* 6 (June 1998): 47–65, which also provides a valuable corrective on this issue.

76. Archives de la Préfecture de Police [hereafter APP], B^A 476, "Opérations judiciaires concernant les femmes: rapport d'ensemble: Le capitaine Briot, 9 février 1872," indicates both the government's harsh attitudes toward female participants and, paradoxically, that of the 1,051 women arrested for participating in the Commune, 850 had their cases dropped due to lack of evidence. See also Edith Thomas, *The Women Incendiaries*, trans. James Atkinson and Starr Atkinson (New York: George Braziller, 1966), esp. 165–88, Gay Gullickson, *Unruly Women of Paris: Images of the Commune* (Ithaca, N.Y.: Cornell University Press, 1996), esp. 159–90, and Carolyn J. Eichner, *Surmounting the Barricades: Women in the Paris Commune* (Bloomington: Indiana University Press, 2004).

77. Léonce Schérer, *Souvenirs de la Commune*, http://collections.vam.ac.uk/item/O1029325/souvenirs-de-la-commune-par-print-scherer-leonce/; Nix, *Communardiana*, http://www.bildindex.de/obj00111195.html#|home.

78. Milner, *Art, War and Revolution in France*, 36.

79. E.g. the series *Insurrection de Paris* produced at Haguenthal in APP Y 26.

80. In the early days of June 1871, Malevina Blanchecotte ironically invited provincial and foreign tourists alike to "visit the debris of our poor Paris . . . it is necessary to see these horrors." *Tablettes d'une femme*, 321.

81. To appreciate the full range, compare Alfred d'Aunay, *Les ruines de Paris et ses environs, 1870–71: Cents photographies par A. Liébert*, 2 vols. (Paris: A. Liébert Photo, 1871), in-folio; Justin Lallier, *Album photographique des ruines de Paris* (Paris: Librairie, 1871) in-quarto oblong; H. de Blaignerie and E. Dangin, *Paris incendié, 1871: Album historique . . .* (Paris: Hachette, 1871) in-octavo oblong; and photographs of ruins as *cartes de visite* in APP Y 25.

82. D'Aunay, *Les ruines de Paris et ses environs*, vol. 2, photographs by Appert.

83. *L'Illustration*, 3 June 1871.

84. For example, compare the two versions of d'Aunay's album (above) catalogued as BHVP Paris-Album-Fol-008, 009 (122 images) and BHVP 10771 (100 images).

85. Quoted in Alisa Luxenbourg, "Le spectacle des ruines," in Quentin Bajac, *La Commune photographié* (Paris: Réunion des Musées Nationaux, 2000), 26.

86. *Le Gaulois*, 26 May 1871.

87. Quoted in Alisa Luxenberg, "Creating *Désastres*: Andrieu's Photographs of Urban Ruins in the Paris of 1871," *Art Bulletin* 80 (March 1998): 113–37, quote from 130.

88. Fournier, *Paris en ruines*, 198–202, underscores the diversity of the photographers' objectives, aesthetics, and strategies when creating images that ranged from the antique beauty of monumental ruins to the apocalyptic destruction of residential streets.

89. Édouard Auguste Moreau and Pierre Petit, *Guide-recueil de Paris-brulé: Événements de mai 1871* (Paris: Dentu, 1871), 2.

90. Louis Énault, *Paris brulé par la Commune: Ouvrage illustré par douze gravures, dessinées par L. Breton d'après des photographies* (Paris: Henri Plon, 1871). A detailed textual, rather than pictorial, account of the destruction wrought in Paris provided a far more balanced view, despite its title: John Mottu, *Les désastres ordonnés et causés par la Commune dans la seconde quainzaine de mai 1871 (publiés dans le Moniteur universel)* (Paris: Librairie Internationale, 1871). The introduction notes that visitors to Paris, expecting the whole city to be in ruins, were astonished "to find neighborhoods intact, without any sign of fire or projectiles."

91. Mendès, *Les 73 journées*, 83–84.

92. Mendès, *Les 73 journées*, 100–101.

93. BHVP, MS 1130, fol. 118, Rochefort to Hugo, 30 April 1872.

94. Lynn Hunt, *Inventing Human Rights: A History* (New York: W. W. Norton, 2007), 38.

95. These latter were soon published separately in July 1871 as Charles Guasco, *Douze visites à Mazas; le président Bonjean, ôtage de la Commune* (Paris: Charles Guasco, July 1871).

96. Benoît Malon, *La troisième défaite du prolétariat français* (Paris: Guillaume, 1871), 466.

97. Henry Vizetelly, *My Adventures in the Commune, Paris, 1871* (London: Chatto & Windus, 1871), 179.

98. Mendès, *Les 73 journées*, 312.

99. *Histoire de la Commune de Paris (18 mars – 31 mai 1871) avec plan* (Paris: Bibliothèque populaire, Au bureau de l'Éclipse, 1871), 100.

100. *Paris insurgé: Histoire illustrée des événements de Paris du 18 mars au 31 mai 1871* (Paris: Au bureau du journal *Le Voleur*, 1871) was even more fully documented. It was sold by subscription (ninety to one hundred issues of eight pages each that would produce a "superb volume"). As the advertisement on the back page also explained, "This publication is not a didactic history [nor] a commentary, it is a daily *memento* [that provides a] living picture, animated and picturesque, of Paris during two months of revolutionary crisis." BHVP Réserve 153335.

101. Paul Lanjalley and Paul Corriez, *Histoire de la Révolution du 18 mars* (Paris: A. Lacroix, Verboeckhoven, et Cie., 1871), 554.

102. BHVP, MS 1130, fol. 94, veuve Grossman to General Vinoy, 3 June 1871.

103. Tombs, *War against Paris*, 172–88, Serman, *La Commune de Paris*, 517–24, and Merriman, *Massacre*, 187–224, provide summaries of the only partially systematized killing of supposed Communards.

104. The printed "7th list of prisoners taken by the Army of Versailles since 18 March 1781" had over eight hundred names. APP BA 365–5.

105. Tombs, *War against Paris*, 120–21, see also 172–73.

106. Tombs, *War against Paris*, 234. The ambulances and hospitals of Paris handled 3,315 wounded insurgents (*Le Gaulois*, 8 June 1871). [Coquerel], *Sous la Commune*, 1–29, provides a vivid account of operating ambulances during the fighting, including the varied emotions of thousands of women looking for their missing menfolk.

107. The Communard official Georges Jeanneret first introduced the figure of thirty thousand killed during Bloody Week in *Paris pendant la Commune révolutionnaire de 71* (Neuchâtel: Guillaume, 1871), 173, 225, 255. Tombs, "How Bloody Was *la semaine sanglante* of 1871?," exposes the tendentious misconstrual of evidence used to support some of the most common figures put forward by contemporary supporters of the Commune, including Benoît Malon (thirty-seven thousand killed: twelve thousand *fédérés* prior to the invasion of Paris and twenty-five thousand, including four thousand women and children, during Bloody Week), Prosper-Olivier Lissagaray (twenty thousand or more killed during Bloody Week), and Camille Pelletan (a minimum figure of thirty thousand dead).

108. Tombs, "How Bloody Was *la semaine sanglante* of 1871?," 680–81.

109. Between the start of operations in April and the end of Bloody Week, the Army of Versailles had suffered 877 killed, 6,454 wounded, and 183 missing. Serman, *La Commune de Paris*, 502.

110. Tombs, *War against Paris*, 694–99, provides a superb description of the killing process and the role of hospitals and field stations in handling casualties, all of which underscores the uncertainty about who died and how.

111. E.g., Taithe, *Citizenship and Wars*, 140–41.

112. Tombs, "How Bloody Was *la semaine sanglante* of 1871?," estimated the number of "Communards" killed by the military repression of Bloody Week at between fifty-seven hundred and seventy-four hundred. Once Tombs includes nine hundred "non-Communard dead (hostages, soldiers, and civilians)," his estimate of those who died violently that week rises to between sixty-six hundred and seventy-eight hundred. However, his minimum numbers are clearly too low because they are based on subtracting eight hundred corpses deposited in the *carrières d'Amérique*, a quarry at Belleville (a mistake first made by Maxime Du Camp, *Les convulsions de Paris*, 2 vols. [Paris: Hachette, 1878], 2:422–26) and they omit up to one thousand corpses buried in the Bois de Boulogne. Both of these matters had been brought to Du Camp's attention in 1874 when the Prefecture of Police checked the data he had obtained from the inspector general of cemeteries (APP DB 420, "R," chef de division, cabinet de la préfecture, 4 mars 1874, which includes a "Table indicating the number of bodies buried without a permit from 20 to 30 May 1871"). Du Camp acknowledged these additional bodies in previous, less polemical, publications ("L'État civil à Paris," *Revue des deux mondes*, 15 March 1874, 368, and *Paris, ses organes, ses fonctions et sa vie*, vol. 5 [Paris, 1875], 99–100), which Tombs does

not cite. Tombs also treats reports of burning bodies as hearsay, improbable, and lacking evidence; however, an article in *Le Temps* on 16 June 1871 describes such activities in detail (see text).

113. Lissagaray, *L'histoire de la Commune*, 203–4.

114. Pierre Pierrard, *L'église et les ouvriers en France (1840–1940)* (Paris: Hachette, 1984), 270–71.

115. Médiathèque de Saint-Denis, Rc MS C2–3, Desfrançois, "Journal du siège de Paris, 1870–1871," manuscript in 2 vols.

116. Louis Fiaux, *Histoire de la guerre civile* (Paris: Charpentier, 1879), 567; Henri Dabot, *Griffonnages quotidiens d'un bourgeois du Quartier Latin, du 14 mai 1869 au 2 décembre 1871* (Paris: Quentin, 1895), 232; Blanchecotte, *Tablettes d'une femme*, 348–50, as well as Alphonse de Neuville's drawing *Enlèvement des fusiliés à l'Hôtel de Ville, 28 mai 1871* (Musée d'art et d'histoire de Saint-Denis, 2010.0.835).

117. Anonymous, no title (labeled on reverse: "inhumation provisoire"), Musée d'art et d'histoire de Saint-Denis, 2010.0.647.

118. Lissagaray, *L'histoire de la Commune*, 380–81, describes turning fortification casements "packed with corpses" into "crematoria" and suggests "mysterious tragedies in the Bois de Boulogne."

119. Nadar quoted in Godineau, *La Commune de Paris*, 233–34.

120. Suspect prisoners experienced up to four prosecutorial reviews before having their cases dropped due to lack of evidence (APP BA 400, 1e division militaire, Service de la Justice, to Commission des Graces, 15 June 1872, Versailles). There were police files on another 14,250 suspects, but 45 percent of them lacked the evidence needed to prosecute (Report presented by Deputy Depeyre and annexed to the minutes of the National Assembly for 16 July 1872 [no. 1318]).

121. BHVP, MS 1130, fol. 133.

122. *L'Événement illustré*, 70 and 114.

123. Blanchecotte, *Tablettes d'une femme*, 310–11.

124. Lissagaray, *L'histoire de la Commune*, 389, indicates an official figure of 399,823 denunciations, no more than a fifth of them signed; *L'Univers illustré*, 24 June 1871, 126, put the figure at 379,828 "anonymous denunciations" between 22 May and 13 June.

125. See the examples in BHVP, MS 1130, fol. 17 and fol. 27.

126. Georges Tersen, "L'opinion publique et la Commune de Paris (1871–1879)," *Bulletin de la société d'études historiques, géographiques et scientifique de la région parisienne* 107–8 (April–September 1960): 30.

127. In the early 1870s, 63 percent of burials were in common graves; Parisians who had money could either rent an individual plot for five years (27 percent) or buy one in perpetuity (10 percent): Maxime Du Camp, "Les cimetières de Paris," *Revue des deux mondes*, 15 April 1874, 812–51.

128. Du Camp, "L'État civil à Paris," 367.

129. *Souvenirs d'un ambulancier: La Commune à l'ouest de Paris. Carnet de croquis du peintre Alfred Auteroche, mars–juin 1871* (Paris: Initiative Art Conseil, 2008).

130. See Drew Gilpin Faust, *This Republic of Suffering: Death and the Civil War* (New York: Vintage, 2008), esp. 61–62. Some 40 percent of Union soldiers and an even higher percentage of Confederate soldiers were buried without identification (102). Subsequent efforts to identify and rebury fallen soldiers redefined "the

meaning of both names and bodies as enduring repositories of the human self" (136).

131. Christian Phéline, *L'image accusatrice* (Paris: Cahiers de la Photographie, 1985), 103.

132. Scholars have clearly been misled by the labels given to copies of this photograph held at the Musée Carnavalet and the BNF. See, for example, J. Bruhat, J. Dautry, and E. Tersen, *La Commune de 1871*, 2nd ed. (Paris: Éditions sociales, 1970), 285.

133. Musée d'art et d'histoire de Saint-Denis, 2011.0.883. Some scholars, though unaware of this copy of the famous photograph, had already questioned the usual interpretation of it by pointing to its strong similarity to photographs taken of national guardsmen killed in the battle of Buzenval (e.g., Bajac, *La Commune photographié*, 112). A less famous photograph entitled "Au coin de la morgue à l'Hôpital, 1871" and published in *Paris sous la Commune par un témoin fidèle: La photographie* (Paris: Charaire, 1895), shows the torsos of four men in civilian attire on the ground side by side and arranged so that each face is in profile and quite recognizable. These are more likely to have been victims of Bloody Week.

134. Most recently, it was reproduced with the label "Communard corpses," but without further description, in Merriman, *Massacre*, 247.

135. Bodies were kept on display for four days—the Ambulance de la Presse had as many as seventy-five bodies on any one day—then photographed and buried at the Commune's expense in a specially designated part of Père Lachaise cemetery. Archives de l'Assistance publique-Hôpitaux de Paris, 542 FOSS 121, Chef de l'administration générale de l'Assistance publique, 26 avril 1871; *L'Illustration, Journal universel*, 28 May 1871, 314–15; General Jules Bourelly, "Souvenirs de l'insurrection de 1871: L'organisation militaire de la Commune," *Le Correspondant: Religion, philosophie, politique* 164 (1900), 839.

136. Médiathèque de Saint-Denis, Rc MS E2, fols. 8 and 9.

137. On the Paris morgue's viewing practices, see Vanessa Schwartz, *Spectacular Realities: Early Mass Culture in Fin-de-Siècle Paris* (Berkeley: University of California Press, 1998), 45–88.

138. Médiathèque de Saint-Denis, Rc MS E2, fol. 4, registrar for the Ambulance des Champs-Élysées, 5 April 1871.

139. *L'Illustration* had described Lançon as "a naive artist. . . . he is interested in neither the style, nor the form, nor the *chic* in fashion. He renders what he sees, nothing but what he sees, and like a witness, recounts facts briefly and precisely. One can trust him." Quoted in Martin, *Images at War*, 84.

140. Lithographs depicting the revolution of 1830 managed "to convey the turbulence of events, [but] do not portray any faces in close-up." Bann, *Distinguished Images*, 101. In discussing early uses of photography in the Crimean War and American Civil War, Susan Sontag notes that photographs of corpses on the field of battle clearly violated a contemporary taboo, and that "with our dead, there has always been a powerful interdiction against showing the naked face." *Regarding the Pain of Others* (New York: Picador, 2003), 42, 55.

141. Details of the arrest and almost certain execution, on 23 May, by a military tribunal of the Neapolitan engraver Saro Cucinotta illustrate how difficult it was to determine the fate of missing individuals; even though his friends made "a

thousand attempts" and the ambassador from Naples "opened an enquiry," they learned nothing. Maxime Vuillaume, *Mes cahiers rouges au temps de la Commune* (Paris: J. Crémieu, 1908), 185–88.

142. BHVP, MS 1127, fol. 399 and fol. 440, receipts for numerous photographs of unidentified *fédérés* taken by Eugène Pirou at the amphithéatre de Clamart in mid-May 1871. According to Bourelly, "Souvenirs de l'insurrection de 1871," 828, Disdéri also photographed corpses for the Commune.

143. Tillier, *La Commune de Paris*, 66–67.

144. See the suggestive comments of Phéline, *L'image accusatrice*, 24–26. See also Gen Doy, "The Camera against the Commune," in *Illuminations: Women Writing on Photography from 1850 to the Present*, ed. Liz Heron and Val Williams (Durham, N.C.: Duke University Press, 1996), 21–31.

145. Phéline, *L'image accusatrice*, 26.

146. Armand Dayot, *L'invasion, le siège, 1870, la Commune, 1871, d'après des peintures, gravures, photographies, sculptures, medailles, autographes, objects du temps* (Paris: Flammarion, 1901), 303, 335, 352–53; Godineau, *La Commune de Paris*, 110, 142.

147. Bourelly, "Souvenirs de l'insurrection de 1871," 827.

148. APP DB 421, list of orders.

149. All political prisoners in penal colonies serving sentences of more than six months were also photographed in case of escape or recidivism. Donald E. English, *Political Uses of Photography in the Third French Republic, 1871–1914* (Ann Arbor, Mich.: UMI Research Press, 1984), 74–75.

150. See the image showing fifty photographs (*cartes de visites* format) of members of the Commune fanned out across two pages of *Le Monde illustré*.

151. The scale of production is indicated by a lawsuit over the sale of would-be photographs of a popular Communard general (Ladislas Dombrowski) killed during Bloody Week. English, *Political Uses of Photography*, 65–67.

152. Tillier, *La Commune de Paris*, 269–72.

153. APP BA 476, pieces 158–59.

154. English, *Political Uses of Photography*, 67–68.

155. APP BA 476, pieces 161, 179.

156. *L'Univers illustré*, 369, 371.

157. The National Assembly had launched its inquiry in the summer of 1872, but the final report was not delivered until the so-called government of moral order had assumed office in 1875; as a result, the report did not reflect much of the information gathered in the process. The growing politicization of the issue in the interim can be discerned from *Rapport présenté au nom de la 2e sous-commission* [de la Commission d'enquête sur les conditions du travail en France, présidence de M. Le Duc d'Audiffret-Pasquier] *par M. Louis Favre, Secrétaire de la Commission*—19 June 1874. AN C 3025, pièce 57. The actual results of the inquiry are in C 3018–20.

158. APP BA 400. The other mention is from the nearby *quartier d'Amérique* where, according to the local *commissaire de police*, relations between bosses and workers were "rather tense" following the Commune because workers had been misled by demagogues to demand unrealistic social conditions.

159. APP BA 407, 30 May 1872. Two recent works take a disparate cultural approach to trauma after the Commune, but neither seeks to grasp popular responses: Peter Starr, *Commemorating Trauma: The Paris Commune and Its Cultural*

Aftermath (New York: Fordham University Press, 2006) and Colette E. Wilson, *Paris and the Commune, 1871–78: The Politics of Forgetting* (Manchester: Manchester University Press, 2007).

160. Adolphe Blanqui, *Des classes ouvrières en France pendant l'année 1848* (Paris, 1849), 222, quoted in Cottereau, "Distinctiveness of Working-Class Cultures," 135.

161. APP B^A 400, response to the parliamentary inquiry on workers from the *commissariat du quartier de la Sorbonne (5^e arrondissement)*, 4 October 1872. Another official from the *quartier de la Monnaie (6^e arrondissement)* criticized the better paid workers in the printing industry for excessive drinking and their wives for spending money on their "toilette."

162. APP B^A 400, response to the parliamentary inquiry on workers from the *commissariat du quartier de Javel (15^e arrondissement)*, 4 October 1872.

163. APP B^A 400, second response to the parliamentary inquiry on workers from the *commissariat du quartier de Charonne (20^e arrondissement)*, no date (October 1872).

164. Taithe, *Citizenship and Wars*, 164.

165. APP D^B 400, circular from prefect of police to *commissaires de police*, 5 January 1872, indicates that a list of recipients had been compiled for every neighborhood in Paris.

166. The remaining funds were to be distributed at a rate of 17 percent of verified losses to residents in communes just outside of Paris, as well as to those as yet uncompensated in the outer arrondissements of southeastern and eastern Paris. APP D^B 400, newspaper article clipped from an unidentified paper dated 29 July 1872.

167. *Rapport fait au nom de la Commission chargée d'examiner: 1^er. La proposition de M. de Préssense . . . 2^e. La proposition d'amnestie déposée par M. Henri Brisson . . . par M. Octave Depeyre* (Paris: Assemblée Nationale, 1872). By 15 July 1872, in little more than a year of judicial operations, the charges against 21,610 persons had been dropped, 2,103 persons had been acquitted, and 9,192 convicted. Furthermore, the Commission on Pardons had already handled 1,623 requests and reduced or commuted 531 sentences.

168. By the time the Commission on Pardons disbanded in 1876, it had handled almost eighty-two hundred requests and had showed leniency in 38 percent of them.

169. Jean T. Joughin, *The Paris Commune in French Politics, 1871–1880*, 2 vols. (Baltimore: Johns Hopkins University Press, 1955), 1:90.

170. Gould, *Insurgent Identities*, 225–26, persuasively claims that in contrast to the impromptu firing squads of Bloody Week, the subsequent military courts meted out punishments largely according to level of involvement in the Commune, rather than according to preconceived biases based on social status or identities.

171. Bullard, *Exile to Paradise*, esp. 187–209, offers valuable insight into the psychological struggles of Communards exiled to New Caledonia, notably the manifest tension between *nostalgie* (physically debilitating homesickness based on loss of community) and the "self-possessed individual" who could cope with deracination. As criminals in exile, *nostalgie* could not be cured by a return home, but had to be overcome by developing both a stronger sense of self and a new sense of community in exile, a civilized one that contrasted with the "savagery" of the indigenous Kanak.

172. Joughin, *Paris Commune in French Politics*, 1:92ff.

Conclusion

1. Aaron Garrett's contribution to "Forum: *The Idea of the Self*," *Modern Intellectual History* 3 (2006): 299–304, shows how Seigel's choice of key thinkers to analyze for the seventeenth century would have changed had he thought less in terms of the "scientific revolution" and more in terms of theorists who wrote in response to the intense conflicts of the period.

2. Benoît Malon, *La troisième défaite du prolétariat français* (Paris: Guillaume, 1871), 451.

3. Rachel Chrastil, *The Siege of Strasbourg* (Cambridge, Mass.: Harvard University Press, 2014), 151.

4. Drew Gilpin Faust, *This Republic of Suffering: Death and the Civil War* (New York: Vintage, 2008), 187, explores contemporary connections between dead bodies and the selves they had contained.

Index

abjuration, 25, 36, 48, 52, 64–65, 74, 218; refusal of, 224
Alsace, 123
Anne du Bourg, 54, 58, 74
Anne of Austria, 96, 108, 110
Aubigné, Agrippa d', 53, 55, 61
Alexander, Jeffrey, 15–16, 21, 103, 135, 213, 215, 217
amnesty: of 1652, 15; of 1795, 30, 154–55, 219, 222; debate of 1870s, 163, 213–14, 219
Anabaptism, 40
Apocalypse, 49–51, 72, 244n117
Apostasy, 25, 42, 53–54
Appert, Eugène, 174, 188, 208
Appert, Félix Antoine, 171
Arnauld, Angélique (Mère), 83
Arnauld, Antoine, 81, 83–84
Arnauld d'Andilly, Robert, 106, 210
Arras, 29, 126, 129, 130, 134, 259n54
artisans, 31, 36, 80, 171; in nineteenth-century Paris, 162–64, 167–68, 179, 267n47; supporters of Ormée, 104
atrocities, 14; during Commune, 32, 33, 174–75, 194, 219; during French Revolution, 29, 115–16, 122–59, 219, 222; during Fronde, 91; during wars of religion, 51, 86, 243n111
Auteroche, Alfred, 202
autobiography, 11, 29, 171, 217, 225; essence of, 147, 229–30n9, 231n26; origins of, 12
autobiographies, 133, 171, 220, 225
autodefenses (mémoires justificatifs), 29, 143–47, 150–54, 225, 262n97

Baczko, Bronislaw, 124
Bailleul, Jacques-Charles, 119
baptism, 42, 44, 46, 73, 206
Barère, Bertrand, 129
barricades, 171, 174, 184, 187, 200–201, 204; during Fronde, 75, 100, 102–3; images of, 177–80, 187, 206, 208; women on, 184, 187
Bastille, fortress, 100, 121; place de la, 196
Bédoin, 124, 156, 263n114
Belleville, 167, 197, 207; quarry in, 195, 271n112
Benedict, Philip, 55
Bernières. See Maignard de Bernières

Bérulle, Pierre de, 79, 81
Beza, Theodore, 43, 50, 66
Bible, 44, 47, 50, 68, 97
Biggs, Charlotte, 118, 154–55, 261n89
Blanchecotte, Malevina, 174–75, 190–91, 200, 223, 269n80
Blanqui, Adolphe, 211
Blondet-Lablossière, Charles Claude François, 146–47
Bois de Boulogne, 195, 197, 271n112
Boissy d'Anglas, François-Antoine de, 136–38, 141–42, 148, 153, 222, 259n57
Bonjean, Louis, 191
bons bourgeois de Paris (or bourgeois of Paris), 28, 88, 100–112, 218. See also bourgeois
Bordeaux, 63, 82, 134, 144, 146, 262n101; during Fronde, 100, 103–4, 112, 252n108
Bourbon, Louis de, 64, 104
Bourelly, Jules, 207, 226
bourgeois, 96, 100, 162, 165, 171, 252n112; in Bordeaux, 103; emotional response, 32, 188; fleeing Paris, 165, 175; reactionary, 31, 176, 201, 212; as victims, 251n96. See also bons bourgeois de Paris
bourgeoisie, 108, 161–63, 171
brain, 7–9, 12, 19, 216
Bréton, Geneviève, 175–76
Buzenval, battle of, 203

Caen, 41
Cahors, 57–58, 74
Callot, Jacques, 27, 62, 89–91, 221, 229n3, 248n47
Calvin, John, 40, 43, 50, 63
Cambrai, 129
Carrier, Jean-Baptiste, 123, 136, 147, 153, 159
catechism, 44, 79, 83
Catholic League, 25, 48, 51, 71, 75, 82, 99, 218
cemeteries, 10, 195–97, 201, 203, 226, 271n112
Champagne, 91–92, 94, 96, 108
Chandieu, Antoine de, 67, 242n98
charity, 37, 47, 78, 221; as basis for piety, 80, 83, 92, 97, 218; as response to civil war, 105, 107–8, 111–12, 218; surge during Fronde, 84, 96, 109–10, 250n76

Tours, 60–61, 74
tragedies, 74, 135, 138; accounts of, 29–30, 135, 153–56, 209, 219; compared to atrocities, 131–32; experienced vicariously, 191; mass, 22; memento of, 189; personal, 17–18, 122, 156, 166, 176, 189
Trent, Council of, 46–47, 75, 81
Tridentine Catholicism, 36, 46–48, 50, 79
Trohel, J., 171
Troyes, 38, 41–42, 66
Turenne, Henri de la Tour d'Auvergne, Viscount of, 100
Turreau, Louis-Marie, 124

urbanization, 2, 31, 163, 206, 225

Vallier, Jean, 98
Vassy, 58–59, 74, 221
Vendée, civil war, 116–18, 123, 134, 151, 158, 222
Versailles, 194, 203; army of, 166, 194–96, 200, 204, 271n109; government of, 165, 175, 187, 194, 208, 213; imprisonment at, 176, 198, 200

villages, 110; attacks on, 89–90, 93–95; as communities, 9, 35, 37, 42, 164, 217; incorporated into Paris, 167–68; migrants from, 31, 164. *See also* phantom village
Vizetelly, Henry, 192

Wahrman, Dror, 113–14
Weber, Eugen, 160
Weber, Max, 168
witnessing; 20, 52, 56, 94–95, 100, 190, 273n139; eye-, 3, 62, 65–67, 104, 190, 197, 221, 225, 241n87; compassionate, 27, 78, 92, 221
workers, 31–33, 130, 162–65, 172, 176, 264n3n4; as individuals, 266–67n36; living conditions of, 209–11, 275n161; relationship to bosses, 172, 210–11, 274n158; as victims, 209–10, 213–14. *See also* class consciousness; proletariat
worker organizations, 163

Zwinglism, 36